"I bought myself an old Pentax with a 400mm lens, just like the one I had when I was a boy, and I got my picture of Stirling Moss. That's all I wanted…"

Tim Hain

LAP OF HONOUR

"Tim's pictures are really great.
What amazes me is that he has never held a press pass."

Sir Stirling Moss

Pitch Publishing Ltd
A2 Yeoman Gate
Yeoman Way
Durrington
BN13 3QZ

Email: info@pitchpublishing.co.uk
Web: www.pitchpublishing.co.uk

First published by Pitch Publishing 2019
Text © 2019 Tim Hain

1

A CIP catalogue record for this book is available from the British Library.

13-digit ISBN: 9781785315558
Design and typesetting by Olner Pro Sport Media. Visit www.olnerpsm.com
Printed in India by Replika Press Pvt. Ltd.

LAP OF HONOUR

A PHOTOGRAPHIC JOURNEY WITH SIR STIRLING MOSS

Tim Hain

Contents

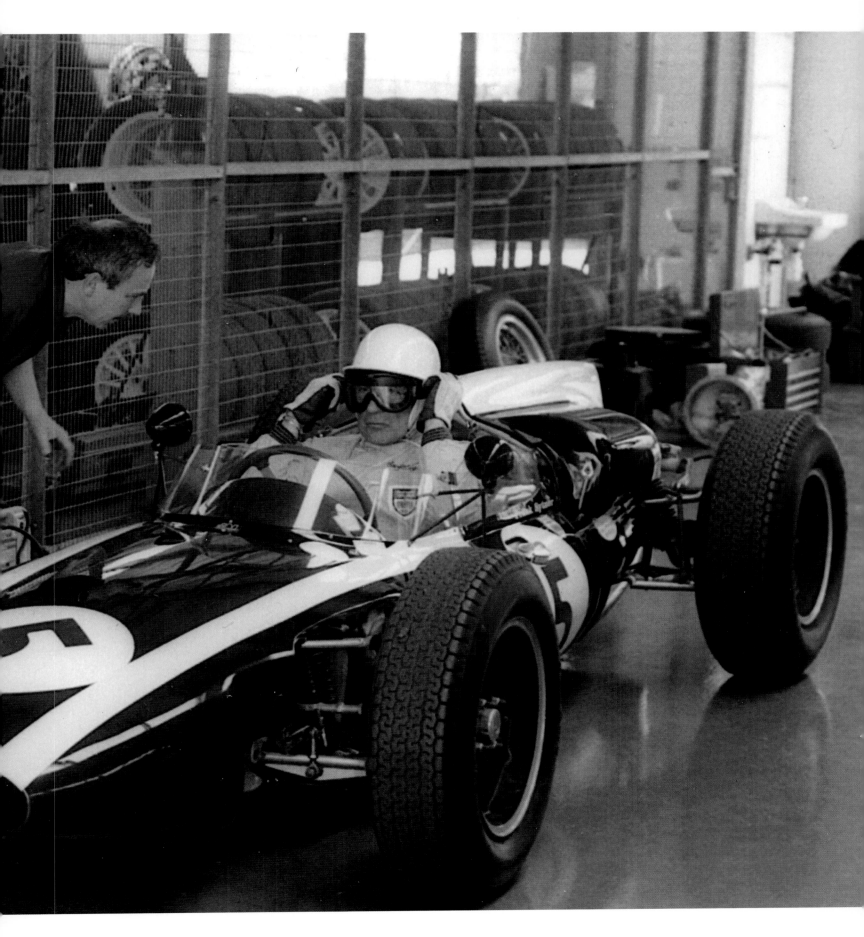

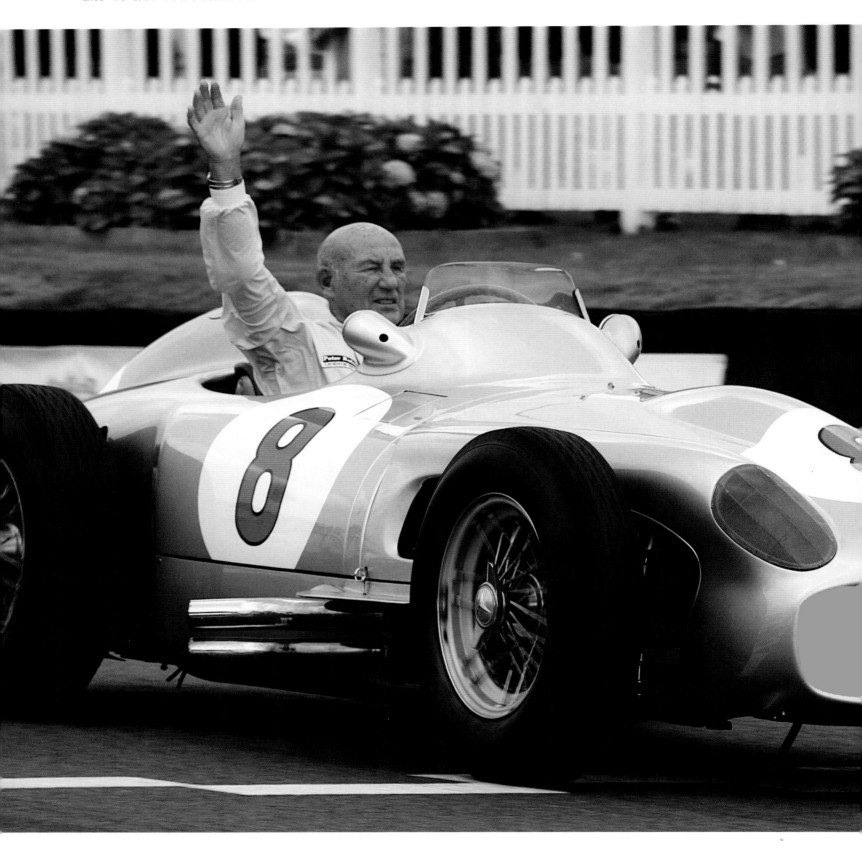

Foreword by Sir Stirling Moss, OBE

'It's amazing what you can get from your wife's gynaecologist! Awaiting me on my return from the Australian Grand Prix in 2000 was a very nice letter from Herbert Reiss, who delivered our son Elliot, and who was an old friend of Tim Hain's family.

Enclosed was an outline for this book. The idea sounded very charming. I was not sure how I could help, but I was happy to welcome Tim to my home for a chat. He told me he wanted to include a photographic tribute to me in as many cars as possible, and asked for my help. I invited him to accompany me to a test session at Silverstone. Since then, the tally has risen to 33 cars and a motor scooter. He has even caught me napping, asleep at the wheel of my Mille Miglia winning Mercedes!

To be asked to provide a foreword to a book which includes a portrait of oneself, and written by a fan who respects what one has achieved, is difficult. Susie has pointed out that the book is as much about Tim as it is about me. His perspective, his style of writing, is so different. He is riding with me, and I get to stand back and see myself through somebody else's eyes.

Nonetheless he is embarrassingly kind about me, but I do realise that this might change in the final version! It's a hell of a lot easier to defend oneself from brickbats than it is to defend oneself from accolades. With criticism, I always feel I have an answer. With praise I don't.

If I had the ability, I'd love to have written my own biography. I don't have the patience or the recall. To get stories out of me, I need a catalyst. Tim certainly brought back memories and I think this book is a lot of fun. Or as Susie would call it, "absolutely enchanting". Parts of it make her quite tearful, but then she is a soppy old thing!

Above all, Tim's pictures are really great. What amazes me, and makes the book unique, is that he has never held a press pass. I told him he should definitely let this be known...just to show all the other hopefuls that it can be done. I hope you enjoy it as much as I have.'

Introduction

They say 'every picture tells a story,' but what about the story behind the picture?

Take this one for example. It shows a racing car being driven hard at Brands Hatch in the summer of 1965. Richard Attwood is at the wheel, urging his Formula 2 Lola to sixth place. A simple story. But what the picture doesn't tell you is that the photographer was only 14 years old, and that this photograph won him the British Automobile Racing Club's Motofoto competition for the third year running, after which they scrapped the contest. It doesn't tell you that his Edixa 35 mm single lens reflex was fitted with a 400 mm Tamron lens which cost a mere 14 guineas, much to the dismay of Ted Lewis, the official BARC photographer, nor that he developed and printed it himself. It doesn't tell you how his youthful passion was extinguished in its prime, to be rekindled 35 years later with the help of the greatest legend of them all.

Welcome to 'Lap Of Honour', the revival and incredible journey of a young motor racing photographer.

Richard Attwood, F2 Lola, Brands Hatch '65. Taken with an Edixa Mat 35 mm single lens reflex fitted with a 400 mm Tamron Lens which cost me 14 guineas, much to the dismay of Ted Lewis, official BARC photographer

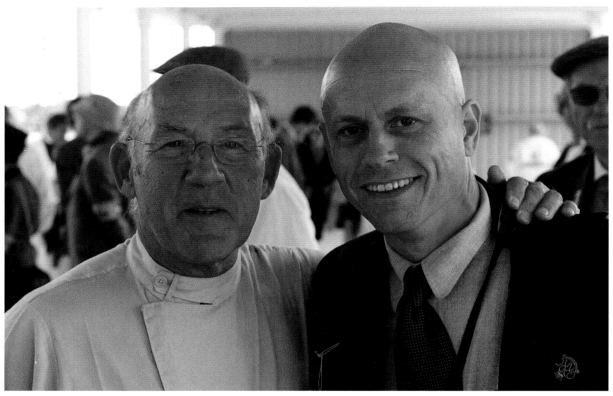

The author with Stirling
Moss, Goodwood 2001

As a lad I loved filling my viewfinder with racing cars.
It was the perfect antidote to a broken home and a brutal boarding
school. For three years, during school holidays, I was on fire with my
camera, winning competitions and getting my pictures published.

The spark was lit on Christmas Day 1961 with the
arrival of a Scalextric set. Trains, planes and dinosaurs were
swiftly relegated to the closet as a racetrack of infinitely variable
proportions spread itself across the nursery floor.

The bearer of this exciting gift was my stepfather Jimmy
Sanders. One minute I was stalled on the starting grid of life,
choking on a silver spoon and getting my backside tanned. The
next, I was given a pair of Le Mans racers, a green light, and an
open road to another world. My excitement burned in the back seat
of his Rolls every time he took us to Goodwood or Brands Hatch, or
whenever I drove my 2½ horsepower go-kart round the estate. But
I felt it first that Christmas morning as I raced my sister under the
Dunlop Bridge and past the pits, lap after lap. I favoured the green
Aston Martin. She preferred the yellow D-type Jaguar.

The following Easter Monday we were taken to Goodwood
for our first real race meeting. It turned out to be a solemn occasion
which almost claimed the life of Stirling Moss, my first hero. That
day, with a single twist of fate, the goddess of motor racing claimed
one more victim and one more devotee. With a further twist, she
conspired to bring us together nearly four decades later.

*As a lad I loved
filling my viewfinder
with racing cars.
It was the perfect
antidote to a broken
home and a brutal
boarding school.*

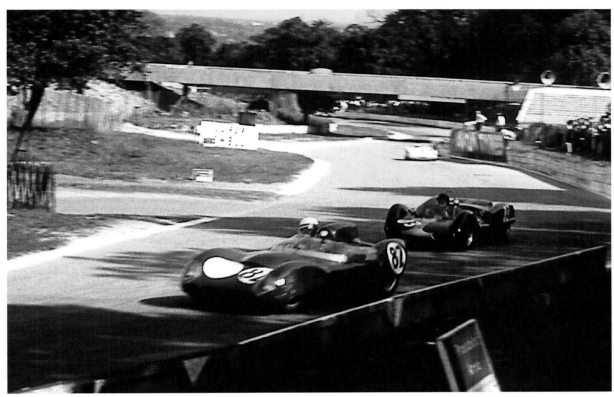

Later that same year, on a sun-drenched September
afternoon at Crystal Palace, I borrowed my mother's Kodak Retina
and took my first racing pictures. The meeting was memorable for a
compelling duel for the lead between two family friends, Roy Pierpoint
(soon to become British Saloon Car champion) and my maverick
mentor 'Dizzy' Addicott, whose 'day job' was test pilot. It was an edge-
of-the-seat tussle, Dizzy's nimble Elva harrying Roy in the twisty bits,
whilst the extra power of Roy's Climax-engined Lotus allowed him
to pull away on the straights. On the last corner of the last lap, right
under our noses, Dizzy was pounced upon by the third place man who
had been sneaking up on the dicing leaders. The move failed. Contact
was made. Dizzy was knocked very sideways. I held my breath. He
caught the slide and held his place.

The company of such men was manna from heaven for a lad
whose dad had moved to Switzerland, and who was exiled to boarding
school for months on end. Dizzy and Roy screwed together my first
kart, then played Santa by delivering it late Christmas Eve when I was
fast asleep. Dizzy was also a keen photographer, and when the results
of my new hobby began to manifest, he advised my mother on which
camera to buy me.

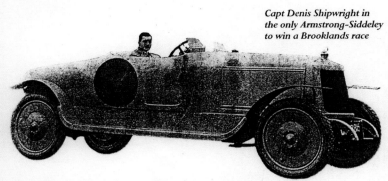

Capt Denis Shipwright in the only Armstrong-Siddeley to win a Brooklands race

Shipwright's Special

IN THE VINTAGE YEARS THE QUICKEST-EVER Armstrong-Siddeley, and the only one to race at Brooklands, was that of Capt Denis E B K Shipwright. He was later to come back to the Track in 1936, heading his notepaper "Brooklands Expert – 15 years", to be associated with the 'water-fuel' demonstration of Baron Coreth zu Coredo, and form a drivers' instructional school with little flags stuck in a map of Brooklands, to indicate the rough bits.

But in 1928 he was busy with a 30hp Armstrong Siddeley two-seater, one of those massive cars with a 5-litre six-cylinder push-rod engine at £775 for the chassis which competed, pricewise, with the Austin 20, Daimler Light 30, Vauxhall 25 and Wolseley 20. Its mascot was a Sphinx, to suggest the silence and power of this legendary figure. To prepare his for racing, Shipwright removed the heavy mudguards, fitted two Claudel-Hobson carburettors, put in larger valves, changed the back-axle ratio, and used 880mm instead of 820mm tyres. It was entered for five races at the BARC Autumn

Meeting and dubbed the 'Baby Tank', but the handicappers were unkind to it, although it lapped at 72mph, when a standard car was good for only just over 60mph.

Before competing at the May 1921 Meeting, Shipwright had driven from Hyde Park Corner in London to St Ives in Cornwall at a running average of 33.7mph and at 34¾mph for the return, a distance each way of 275 miles, good on the roads of those times. At the Track the car was unplaced but at the Summer 1921 Meeting, in spite of a sober standing-start lap at 66.85mph, it built up to lap at 77.69mph and, flagged away four seconds before Birkin's DFP, it *won* – from a TT Vauxhall and the DFP – the 100mph Long Handicap. It was never as quick again, and after many abortive attempts it faded away. For 1922 Shipwright ran a 3-litre SPA, with a smart polished aluminium Hawker body said to have cost £500. He drove it in 12 events, its best lap speed 77.81mph, but with no results, in spite of kind handicaps. But this was part of the attraction of Brooklands, all those years ago.

My fascination with speed must have been genetic.

My fascination with speed must have been genetic. My grandfather, Captain Denis Shipwright, DSO, DFC, World War Two night-fighter pilot, raced an Armstrong-Siddeley at Brooklands before the war. Some years ago I found an article about him in *Motor Sport* magazine (reproduced above with permission).

My response to this piece was published in the next issue:

'Sir, it was with surprise and delight that I came upon a picture of my Grandfather, Captain Denis Shipwright, in the November issue of Motor Sport. The article was passed among my family and greeted with interest and amusement. Bill Boddy unwittingly captured Gramps' penchant for line shooting as he reports:

'He was later to come back to the track in 1936 heading his notepaper "Brooklands Expert - 15 years." That I should learn so much about my own blood relation through the pages of your magazine underlines the esteem in which I hold it. Lastly, I do not wish to suggest that this in any way reflects on my grandfather's ability behind the wheel, but my mother tells me his car was known as "The Shipwreck Special." I am Yours etc.'

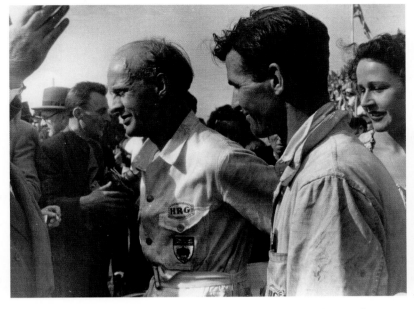

Mother, on right, as Le Mans class winner Thompson is greeted by President Auriol

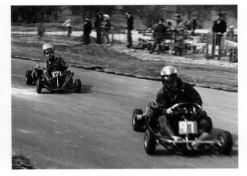

(Top) Me in kart 171 at Blackbushe, taken by Pop

(Above) Pop airborne on my kart

Gramps' son, my father, loved sports cars, and owned a Triumph TR3 with the numberplate 'TR3'. At the tender age of seven I was quite comfortable doing the 'ton' for the first time with Pop, on a long straight road somewhere in Somerset, with the hood down. As for my mother, she clicked the watches at Le Mans in 1949 for Eric Thompson who came 8th, winning his class. The first car I recall her owning was a white MGA.

As for me, apart from enjoying two spells as a photographer, I enjoyed two spells as a kart racer, coming second to Terry Fullerton (who beat Ayrton Senna to become World Karting Champion) at Blackbushe in 1966, and 27 years later winning my class in the National Kart Racing Association Grand Finals at Three Sisters. At the tender age of 66 I still occasionally rent a Rotax Max kart at Daytona Sandown and somehow manage to post fastest time. I also ache for a week afterwards.

Jimmy Sanders (right) watches as my kart is scrutineered at Eelmore Plain

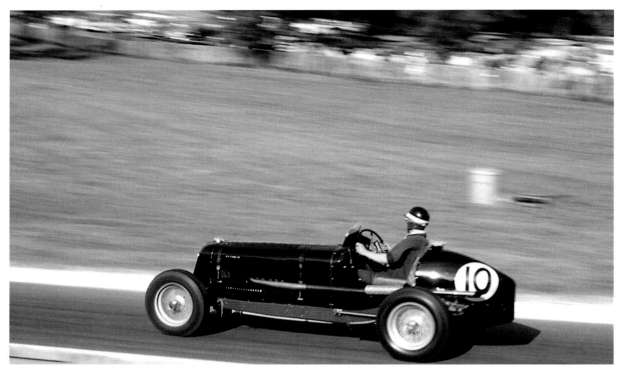

ERA at Crystal Palace
- on my first day with
a camera

The world of motor racing, via my weekly copy of *Autosport*, made term time almost bearable. It would have been handy had I been able to stuff the magazine down my trousers to soften the blows, but the headmaster insisted on beating his boys on naked buttocks. Mercifully, the school sat beside the A3, the road to Goodwood, and on summer Saturday evenings I would escape to a secret hideaway among the trees beside the school's corrugated iron perimeter fence, and wait. I would soon be rewarded.

Back then, racing cars were often driven to and from races, and before long I would hear the sound of an approaching ERA, or catch sight of a single seater on a trailer. This was my refuge, my oasis. Nobody knew I was there. I recently drove past the school, and that old fence is still standing, five decades on.

Back then, racing cars were often driven to and from races, and before long I would hear the sound of an approaching ERA, or catch sight of a single seater on a trailer. This was my refuge, my oasis.

You Can't Keep a Good Snapper Down

After my second 'Motofoto' competition win, I received a letter from Ted Lewis, the official BARC photographer, offering to take me under his wing. I was duly summoned to his darkroom and initiated into the secrets of developing and printing my own pictures. A darkroom was set up for me in the depths of the family mansion, and pretty soon I was getting the hang of breaking open 35 mm film cassettes in total darkness and loading rolls of Kodak Tri-X into one of those ancient cylindrical developing tanks. Once my negatives were ready, I would become absorbed for hours on end, creating prints with my enlarger, watching images form under a pale red light…

In 1964 I started at Bryanston School in Dorset, and joined the photographic society, which had a darkroom. One evening, the legendary *Daily Express* photographer Victor Blackman came to give us a talk. I knew his work, and that he specialised in motor racing, so I showed him some of my prints. Impressed, he passed them on to *Ford Times* magazine, which ran a feature on me.

Sportscar magazine published and paid for this picture of a posing Mike Beckwith, rapid teammate to a moonlighting Jim Clark

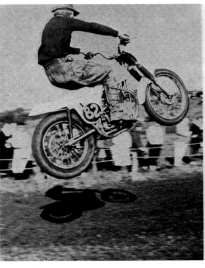

Prizewinner

This month we have a winner who is only 14 years old

He is Timothy Hain, of Cobham, Surrey, who takes the £5 with a very good action shot. The rider is unidentified, but the picture was secured at Bulbarrow Hill, near Blandford, Dorset. Proud owner of a Mansfield Auto 35-mm camera, Tim used a 1/250-sec exposure and the camera looked after the aperture setting. The film was Ilford FP3, developed in Acutol.

WINNING pictures in our regular monthly competition appear on these pages. Another selection will be made next month, and the next . . .

All pictures are judged by the same standards as others published in Motor Cyclist Illustrated; on technical ability and subject matter combined. They can be of trials, scrambles, road racing or any other form of motor cycle sport; and a good intimate paddock shot could take priority over a routine speed picture.

First of the one guinea consolation prizes goes to R. A. Kirby, of Erith, Kent, who took the picture below, of Pip Harris (BMW) at Dingle Dell Corner at Brands Hatch. Using an Ediflex camera with a 135-mm Hanimex lens, he employed a 1/500-sec exposure.

Ford Times article from July 1965

YOU CAN'T KEEP A GOOD SNAPPER DOWN

Taking good pictures at motor sport events is easy for the professionals, the amateurs say. There they are in pit and paddock, always within camera range, always in the best positions, always close to the high and the mighty. What chance has the general public, confined to the stands? TIM HAIN (bottom left), a public schoolboy who is barely 14, answers the question with these pictures—every one of which he took from a public enclosure—and outlines his method of working.

IT'S a very good idea to check the facilities for taking pictures in advance. At an international meeting I try to get to the track for practice, when there is more freedom to move around than on race day.

If I haven't booked a stand seat, I find it an advantage to arrive very early on the big day, pick a good spot—and stick to it.

The best action pictures can usually be obtained at one of the corners. For instance, there is little doubt that, at Brands Hatch, Paddock Bend sees a great many spins, slides and other nonsenses. If I have a grandstand seat, I keep my camera focused steadily on Paddock, which means that I shoot the cars from the rear.

During practice—or perhaps a Club meeting—when there is a relatively small crowd, I prefer a position one-third of the way up Pilgrim's Rise. From there, I have a bird's-eye view of everything that goes on. For 'long' shots I use a 400 mm lens, which magnifies eight times.

I always hold my camera at the ready, just below eye-level. (I have been caught out on more than one occasion by being unprepared!)

Before I got this particular lens, I used a much shorter one. I could not get so close in to subjects, but a good 'panning' shot (where you get the car in focus but the background blurred) could be caught—and there are many places which are actually more suited to a shorter lens, such as Druids (Brands) or just about anywhere at Crystal Palace.

My 400 mm lens is a Hanimex Tamron f.7·5; it cost 19 guineas. Its physical length has caused me embarrassment occasionally—at Crystal Palace I nearly swiped an innocent gent on the nose with it!

The camera I use is an Edixa-mat Reflex, and I load with Kodak Tri-X film rated at 800 ASA, developed in E24 (Adox).

Enlargements are made on Agfa Brovira paper, and exposures are mostly 1/500th of a second at f.16 (on a sunny day).

Such a short exposure is possible on account of the very fast film—which also gives much greater depth of field with a 400 mm lens.

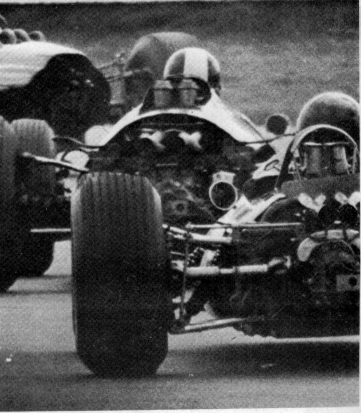

45

No Such Word as 'if' In the 60s they used to say 'there's no such word as "if" in motor racing.' So let me put it this way: Had Pop been a working dad, and had I not been born into so-called 'privilege', I might have been steered towards earning a crust with a camera. With no example of a working parent, and in such an affluent environment, I only ever saw photography as a hobby. So unthinkably, instead of focussing on becoming a globetrotting lensman, I succumbed to the parental push towards my gaining a place at Oxford or Cambridge. Nonetheless, the instinct must have been there. I had started to take my camera to kart meetings and between my own races I would take pictures of other competitors. At the next meeting I would earn extra pocket money by flogging my self-processed prints to the drivers at 5 bob a go.

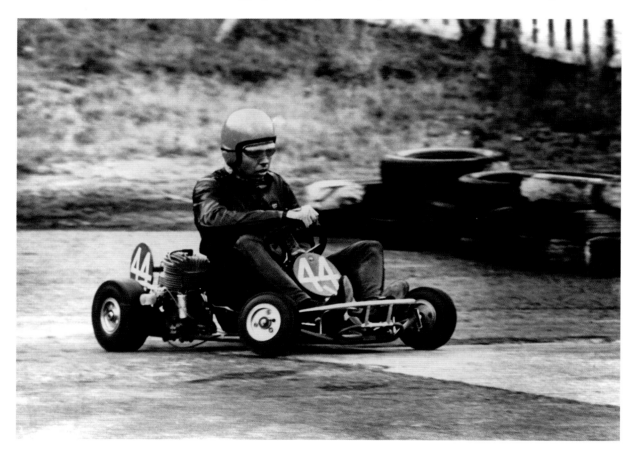

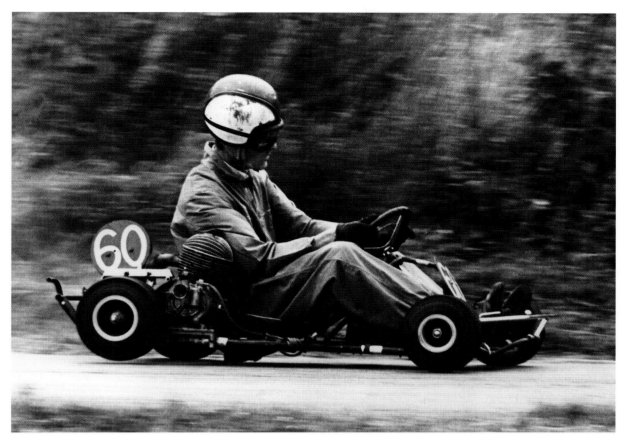

Three action shots from Surbiton, my local kart club; No. 60 is Colin Vandervell, son of Tony Vandervell, creator of Britain's first GP winner, the Vanwall in Stirling Moss's hands

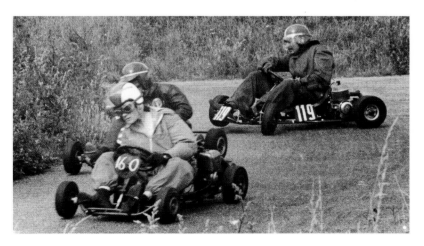

When my idol Jim Clark lost his life, I lost interest. I failed to get into Oxford to read a subject I had no enthusiasm for, and eventually turned down a place at Reading University because I couldn't decide what to study. When my engine seized at a kart meeting at Blackbushe, that was it for me. Inspired by Jimi Hendrix, I sold my kart, bought my first guitar, and drifted off in another direction, My darkroom was disassembled, and my camera given to a sister.

Stirling Moss/Martin Brundle - Goodwood Revival, 1998

Rebirth

Twenty years later I was having a blissful scene with a beautiful American girl who had a Canon camera and a keen eye for a picture. To impress her I took her to the old family seat to show her my photographs, only to find that my collection of negatives and prints had been unceremoniously thrown out. It was a huge blow, later softened by the chance discovery by my nephew of some colour transparencies in a cupboard, and a handful of prints in a drawer. In all I managed to retrieve about 60 usable images – a fraction of what I once had, but enough to kick-start this story.

Ten years on, in 1998, I heard about the upcoming Goodwood Revival, where the clock was to be wound back to the 50s and 60s. Cars and drivers from that era would be competing, with everything in period, even the clothes we were asked to wear. I felt a strong urge to attend and to revive my former hobby. My old camera no longer worked, so I bought myself an old Pentax Spotmatic with a heavy 400 mm lens for £120, similar to the one I had as a boy.

I arrived at the track early one sunny September Sunday in a state of great excitement. I had no tripod, as I had always shot 'handheld' even with a long lens. I didn't even know that 'autofocus' existed. I only discovered its benefit years later, after a pair of old Pentaxes had died. Only then did I enter the world of digital photography, but not before relearning my craft the traditional way.

'It was as if my Scalextric set had come back to life.'

On that idyllic day I found myself standing at the exit of St Mary's Corner with all my old skills and instincts returning, and with Stirling Moss in my viewfinder. Moss, then 69 years young, was dicing with the recently retired Formula One driver Martin Brundle, thrashing a man half his age. By some uncanny coincidence he was driving a green Aston Martin, and Brundle a yellow D-type Jaguar. It was as if my old Scalextric set had come back to life! Anyway, I got my picture of Stirling Moss. That's all I wanted. I had no idea where that one picture would lead me.

Eighteen months and another 'Revival' later, the impossible happened. Thanks to an unexpected introduction through a family friend, I found myself sitting with the newly knighted Sir Stirling Moss in his living room. He had seen my picture, as a result of which I had been thrilled to receive a letter from him inviting me to his home for a chat. Naturally I felt very nervous as I approached his famous townhouse in Shepherd's Market, but when we sat down together it felt like meeting an old pal I hadn't seen for 38 years.

MM

MOSS
MOMENT

TH *"That's the first time I ever saw you race - at the Revival in '98, when you had that wonderful dice with Martin Brundle."*

SM *"Well that's the Aston. Nice picture actually…I was going along in this thing, and I didn't realise it was Martin Brundle. He was in a D-type, and I thought, 'No way should a D-type be in front of an Aston, that's ridiculous!' So I put my foot down, and got past him. If I'd known actually I'd have made signs at him! Put up two fingers!"*

I bought myself an old Pentax, similar to the one I had as a boy, and I got my picture of Stirling Moss. That's all I wanted…

Stirling Moss in an Aston at Goodwood, 1998

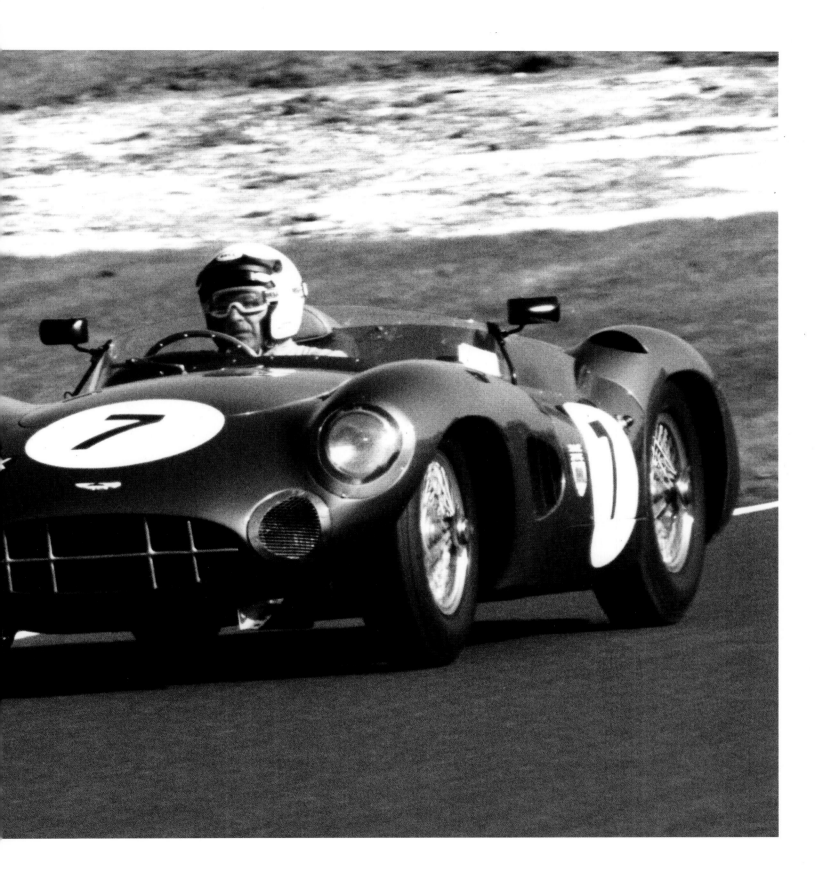

Portrait of Sir Stirling Moss with Susie in Austin 7

Our meeting yielded a colourful conversation, reproduced in the book, which ended with another surprise invitation. He asked if I would like to accompany him to Silverstone the following week for a test session. This was way beyond my wildest dreams, and it only got better from there.

Stirling thought my pictures were 'really great', and enjoyed the fact that I have never held a press pass. At a subsequent Revival I was invited to carry his iconic white helmet - a fair substitute! With help from him, his Lady Susie, and their ever-patient security man Darren, I have now managed to portray him in 33 different cars, on a motor scooter, in a clown car, and as a passenger in both a 'Glamcab' and an Austin 7.

So I invite you to join me on this lap of honour. It began as a simple idea, and turned into a 20-year ride on which I have been both passenger and driver. It was not pre-planned or scripted. It simply unfolded. My role was to be watchful, camera at the ready, to respond to the next random opportunity or inspiration. It has far exceeded my

Pentax Spotmatic Camera

To have ridden in the Revival's colourful cavalcade with its greatest hero, 'Sir Goodwood' himself, has been my immeasurable good fortune. Yet, true to the 'period' ethic of the event, this 'Magical Step Back In Time' has been tinged with tragedy.

Dizzy in 1999 with his Golf GTI, 'The Equaliser'

expectations. Everything you see here has found its way onto the page thanks to the kindness and encouragement of a true champion whose standing is huge, but whose nature is humble. He and Lady Moss have enabled an undreamed dream to come true. I could never have imagined that 10 years on from taking that first photograph of him in the Aston, I would be sitting with him and Murray Walker discussing my pictures, with Murray telling us a hilarious story about a prank Gerhard Berger played on Ayrton Senna. No way could I have foreseen that arguably the greatest legend in racing history would be calling me to tell me a joke I daren't relate here.

A photograph has always meant much more to me than an autograph, so I'm happy to have been able to capture so many candid portraits of so many heroes. I hope my images bring to life their charm and character, and that of the cars they drove and the circuits they drove round. To have ridden in the Revival's colourful cavalcade with its greatest hero, 'Sir Goodwood' himself, has been my immeasurable good fortune. Yet, true to the 'period' ethic of the event, this 'Magical Step Back In Time' has been tinged with tragedy.

In the end, my second childhood has far surpassed my first, and that, in a nutshell, is the 'story behind the picture'.

As I reflect on opportunities and images lost along the way, and these new ones which have manifested, I recall Dizzy's wise and prophetic words whenever the traffic lights turned against us:

'There's always an equaliser, old lad.'

LAP OF HONOUR

Part One RAISING GHOSTS

"In which this schoolboy photographer revisits his favourite haunts and heroes with an old Pentax, after 32 years."

Chapter 1
The Ghosts of Goodwood

Roy Salvadori famously said 'Give me Goodwood on a summer's day and you can forget the rest of the world'. Easter Monday 1962, my first visit to any race track, was grey and overcast and would darken dramatically.

On pole for the big race was Stirling Moss in his pale green Lotus. Like every schoolboy I knew who he was – already familiar with the image imprinted on the national psyche – of England's greatest racing ace at the wheel in his white jockey's helmet. I didn't know what 'pole' was, so I was happy to learn that it meant he had gone quickest in practice, thus winning the prime starting position. I knew none of the other drivers' names, except perhaps Jack Brabham, only because he was mentioned in a Tintin book. It would not be long before I came to know them all, and to follow their exploits: Graham Hill, Jim Clark, Innes Ireland, John Surtees, Bruce McLaren, and of course Jack. But on this day of my motor racing baptism, my one and only number one had outpaced them all, so to me they were just the supporting cast.

I was disappointed when a mechanical problem delayed him, which meant he could not win. It wasn't supposed to be this way. But true to his motto, 'there's always the lap record', Stirling was typically giving his all, and we adoring fans our money's worth, when the unthinkable happened. His huge accident, still unexplained 56 years on, left him in a coma for a month, and paralysed for six. It caused an unforgettable hush to fall upon the crowd, and grabbed every front page the next morning. I remember waiting by the front door for the *Daily Sketch* to fall through our letterbox, eager for news of him. Sure enough, there he was on the front page, unconscious in the wreckage of his crumpled Lotus, being tended to by rescue workers.

It was a harsh baptism,
but I was hooked.

Susie Moss with Annie Strudwick, the then
19-year-old nurse on every front page 40
years earlier, attending to Moss at the scene
of his crash

The most
famous helmet
in history

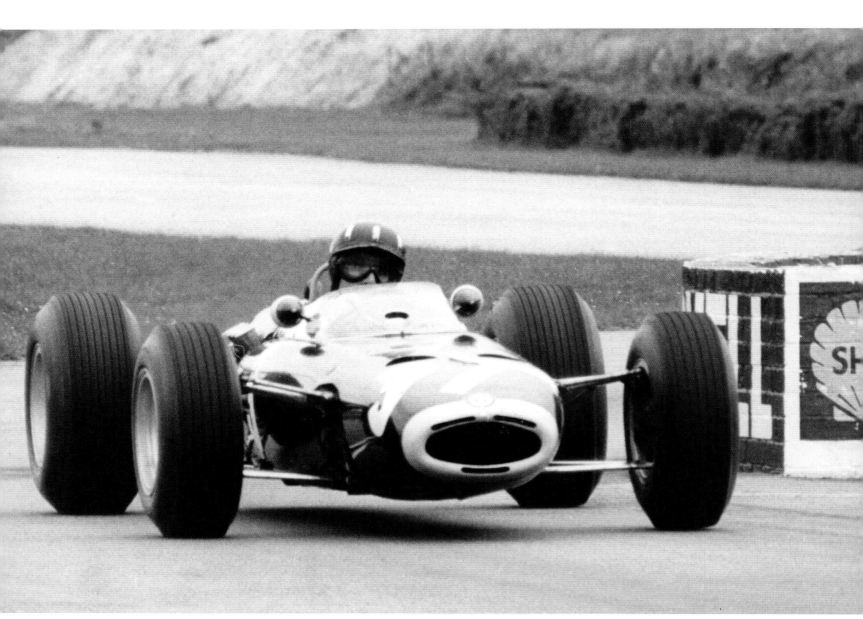

Graham Hill, BRM Goodwood chicane 1965

The Racing Line

Threading the needle through the most famous chicane in the world, Graham Hill perfectly personifies 'The Racing Line.' He is pictured here driving the 'T (spare) car during practice for the 1965 Glover Trophy, captured from a vantage point normally reserved for professionals, not some precocious kid with an oversize lens.

Graham won the first race I ever saw, on that fateful Easter Monday, in the stack-exhaust BRM, pictured at exactly the same spot some forty years later, driven by his son Damon. Because of his win and Stirling Moss's career-ending crash, Graham became my new hero. I cheered him all the way down to South Africa where he narrowly beat Jim Clark to the world title. When our racer friends Dizzy Addicott and Roy Pierpoint told me that Clark was the better driver, Graham's position as my number one was swiftly usurped.

Back in the day, I could usually manage to sweet talk an official into letting me take pictures at the chicane, and once ensconced, I would try and look as professional as possible. At the 2002 Revival I heard that Damon was to lead a parade of his father's cars in this very BRM. I was determined to create a photographic father and son match.

However, I discovered that access to the chicane was strictly denied to all but official photographers, so I had to revise my tactics. I went to the Revival Press Office, pleaded my case and dropped a few names to Janet and Louise. They took pity on me and struck a deal. They kindly entrusted me with a pass on the understanding that I would return it as soon as the parade was over. I got my picture, and they got their armband back 20 minutes later.

This picture of Damon is therefore the only one I ever obtained with a press pass!

There are many dynasties in motor racing – the Andrettis, the Unsers, the Brabhams, the Villeneuves, and the Phil Hills, but it was Graham and Bette Hill whose boy became the first World Champion son of a World Champion father – 'The Racing Line.'

This record stood for 20 years, until 2016, when the Hills were joined by the Rosbergs.

This picture of Damon is the only one I ever obtained with a press pass!

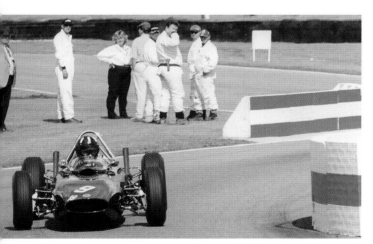

Damon Hill BRM, at the same spot

New Toy

As I got into the swing of taking pictures with my new toy, a German SLR camera with interchangeable lenses, I came to favour the most famous chicane on earth as my prime vantage point. Strictly speaking I should not have had access on the inside. I remember running excitedly through the pedestrian tunnel to try my luck. With youth on my side, it usually worked, especially during practice. From the official grandstand my 400 mm lens could reach both the Chicane and Woodcote Corner.

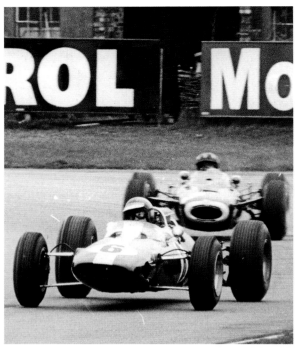

Mike Spence, Lotus 25, leads Graham Hill, BRM at Woodcote, from chicane grandstand

Club racers at the chicane, both sides, c. 1963

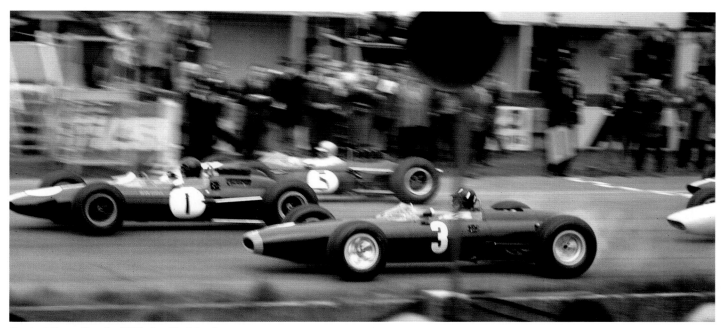

Start of Glover Trophy 1965. Jim Clark leads

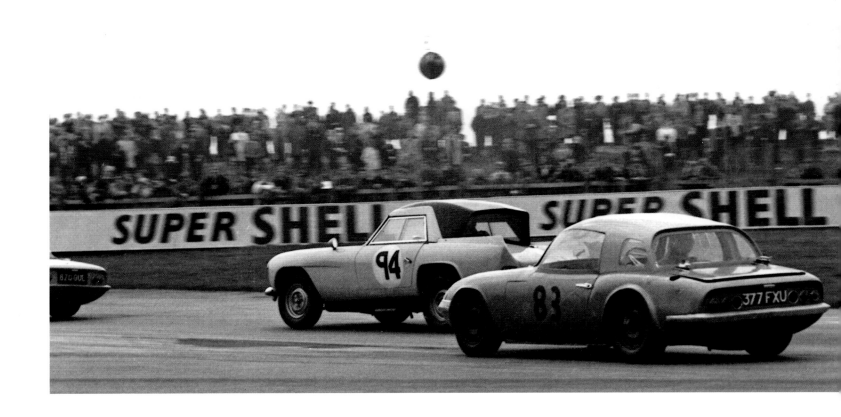

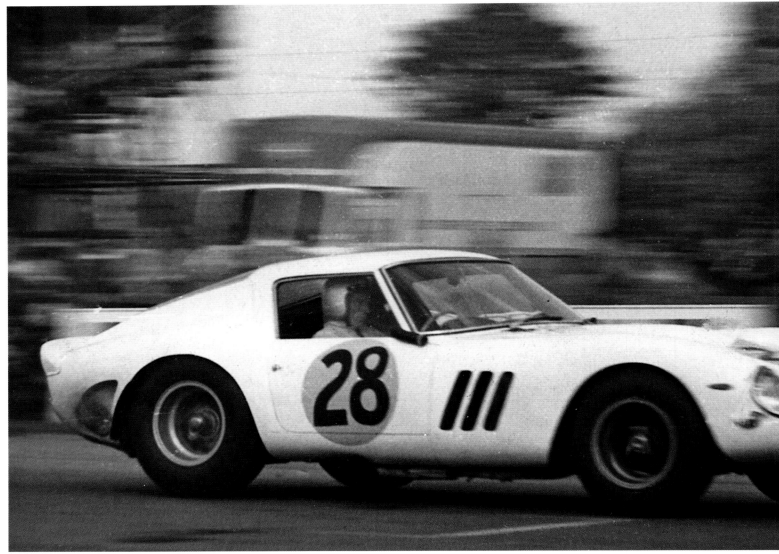

Ferrari 250 GTO: 1965

Sunny Memories

Goodwood provides many sunny memories from half a century ago:
like being driven at a fair old lick one gorgeous evening on an 'A'
road near Chichester, sitting in the backseat of my stepfather's Rolls.
Practice for the 1962 Tourist Trophy had finished, and we were
returning to our holiday house. A roar over my left shoulder made
me turn to see Jim Clark's gorgeous Zagato bodied Aston, 2 VEV,
inching past us. I could have reached out and touched it as it cruised
past. Mechanic Jim Endruweit was at the wheel with a mate beside
him. He was wearing brown overalls and a trance-like expression
– wide eyed, a faint grin, utterly focussed. I guess they were testing
a few "tweaks" after the circuit had closed, or merely taking the
opportunity to enjoy their mighty charge.

2 VEV, under auction at
Bonhams, Goodwood

One magazine published a photograph of the two cars ensconced in the scenery using Shell's prophetic advertising slogan for the race as a caption: 'Surtees gets the Madgwick touch with Shell'.

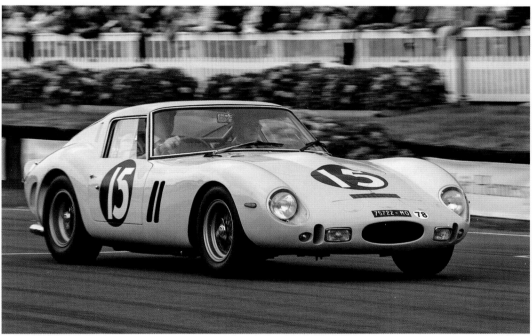

Ferrari 250 GTO: 2009

In the race Clark tangled with Surtees' Ferrari 250 GTO at Madgwick Corner, and a very expensive accident ensued. Thankfully neither driver was hurt. The press had a field day. One magazine published a photograph of the two cars ensconced in the scenery using Shell's prophetic advertising slogan for the race as a caption: 'Surtees gets the Madgwick touch with Shell'. Another caption read: 'Loads of money in the bank.'

Innes Ireland won the Tourist Trophy that day, in a pale green Ferrari 250 GTO, the same colour, and run by the same team as the Lotus in which Moss had crashed just months earlier.

MM | MOSS MOMENT

TH "That's you behind Surtees in the Ferrari which won the Tourist Trophy in 1962, with Innes Ireland."

SM "Yes, British Racing Partnership. That's the colour they had."

TH "If you hadn't had your accident would you have been racing that car in 1962?"

SM "Oh yeah. I had an agreement with them. We'd just done a deal with Ferrari: Formula One for Rob (Walker) and then the sports car for BRP. Enzo did build it you know, and delivered it in Rob Walker's blue. He asked me, would I drive for him, and I spoke to Fangio who said 'Drive for him but don't sign with him.' So I said to Enzo if you'll make me a 246 and Rob Walker runs it I'll drive it. And he agreed."

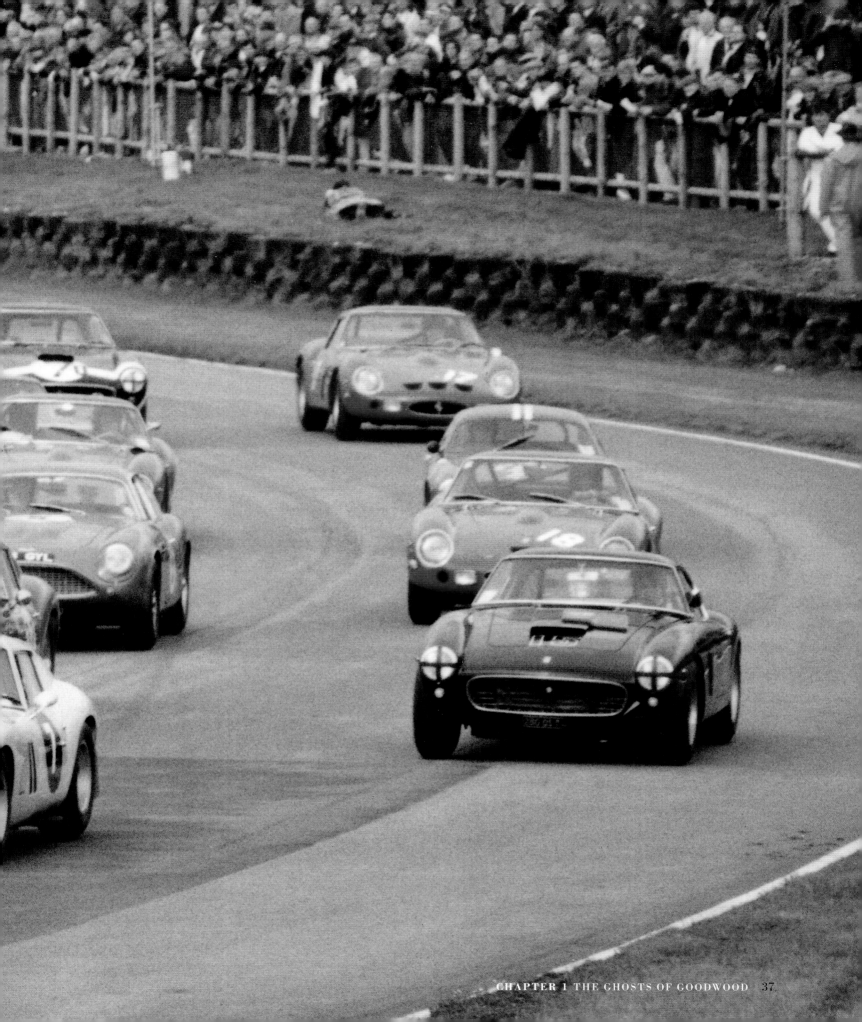

Innes Ireland. An irreverent talent

Innes Ireland was not my favourite character. At one point during his victorious Tourist Trophy run I watched him avoid the chicane by taking a shortcut for no apparent reason other than to pass a slower car. I thought this most unsporting. My bias against him was fed by a story told to me by my school mate Simon Perks, who claimed he overheard Innes telling a young autograph hunter to 'stuff it up your jumper!'

In recent years, as a born again Revivalist, I have learned that the late Mr Ireland was actually much loved. He became a motoring journalist. A prankster and an outspoken raconteur, his charm would always win him a prize spot in cramped and crowded press rooms, even if he did turn up at the last minute with a glass of Scotland's finest liquid gold. In the light of this, my chum's story begs a little scrutiny. A young boy sees only a halo around his hero, not the pressure he is under. There must be times when a racing driver is as finely tuned and temperamental as his machinery, and at such times the last thing he needs is another bloody kid seeking a signature. The Earl of March writes in his foreword to *The Glory of Goodwood* that as a boy he would often attend parties for the drivers at Goodwood House. On one such occasion he approached Graham Hill who 'looked down at this small boy with his plastic autograph book and said simply, "Bugger off!"'

Innes In the BRP–BRM 1964, and (left) fifty years later, the ghost of Innes, car and helmet, at the 'Revival'

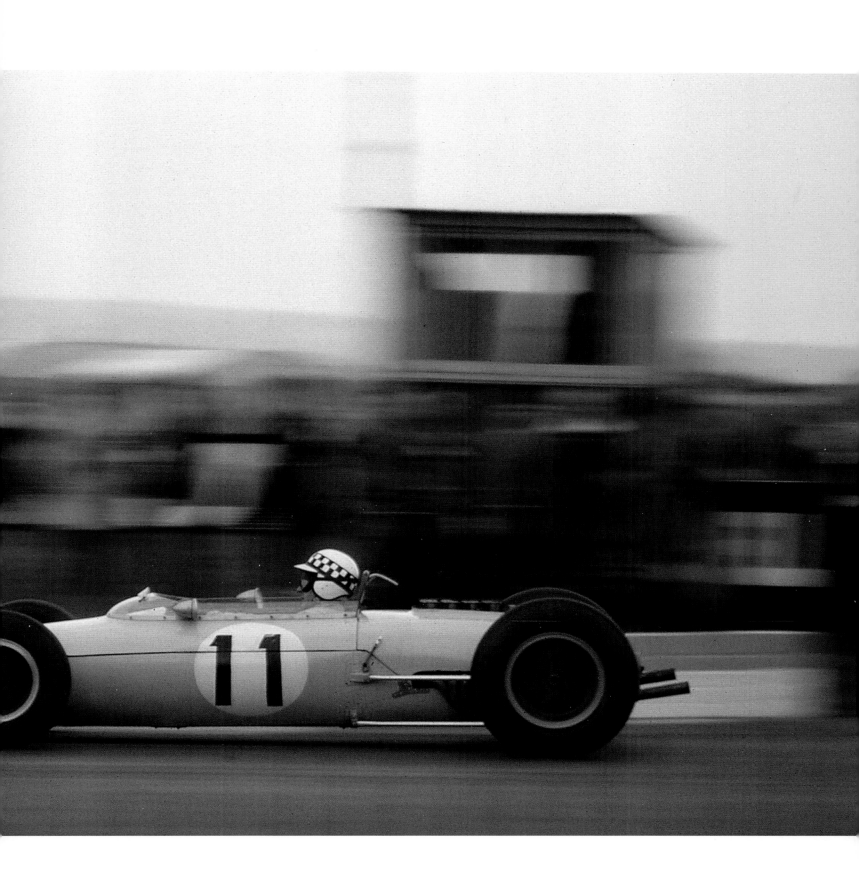

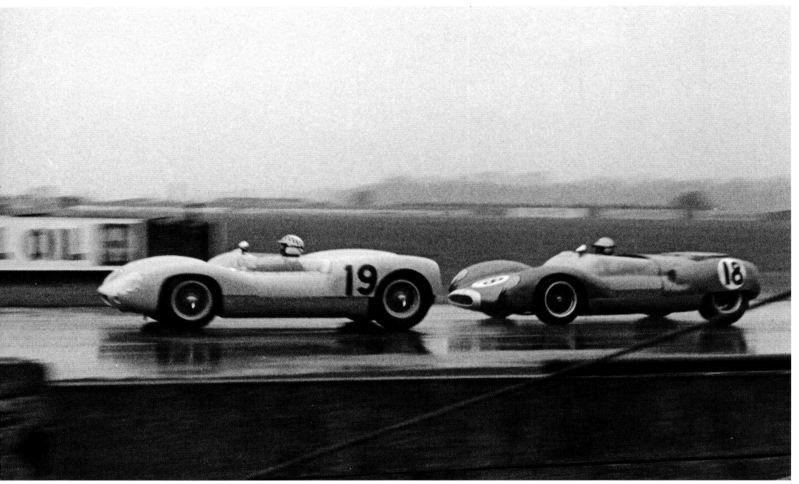

Innes and Salvadori '64

Regarding that incident at the chicane, the late John Blunsden, who in the sixties published my favourite magazine, *Motor Racing*, told me:

'Innes was not the sort to cheat. He probably had brake trouble.'

Innes rose immeasurably in my estimation when, at 60 years of age, he track tested a late eighties Formula One car for *Road and Track* on the Silverstone Grand Prix circuit. The turbocharged Benetton he drove had almost 1,000 brake horsepower on tap, five times more than the single seaters he used to race. He absolutely relished the enormous challenge of getting to grips in one fell swoop with slick tyres,

'Innes was not the sort to cheat. He probably had brake trouble.'

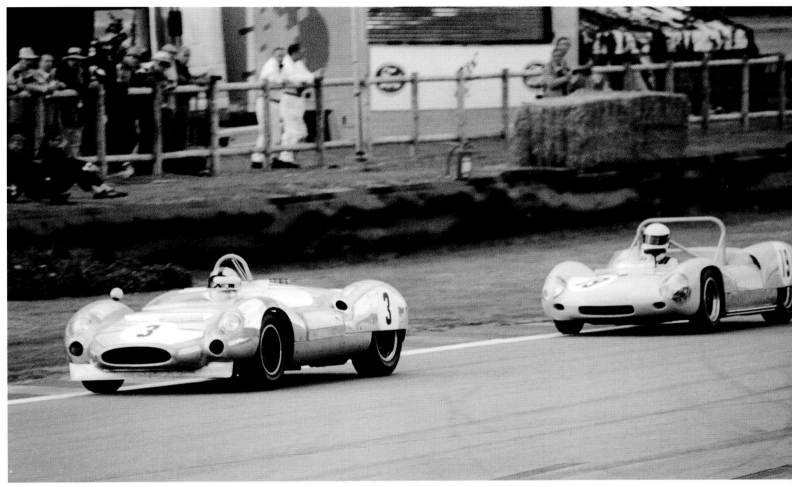

The same cars at Revival 2001

downforce, rocket-like acceleration, braking to match, and high g-forces. His conclusions were highly entertaining. He said he greatly envied the men who drove these cars for a living and the fun they must have had. He even made a case for himself. Since he, at the age of 60, and with no prior experience of these machines could lap only 20 seconds off the pace, all he needed was a little more practice!

Raising the Ghosts of Goodwood
A Gallery of Mirror Images Captured
up to 50 Years Apart

F3 Cooper
Jackie Stewart
1964 and 2005

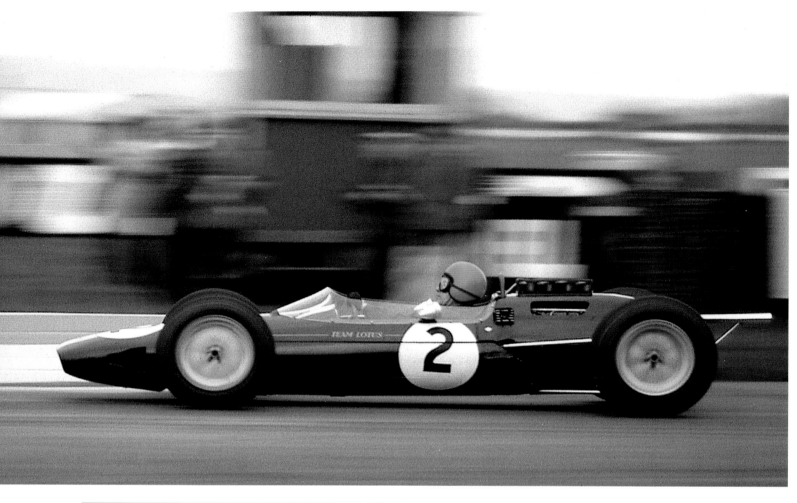

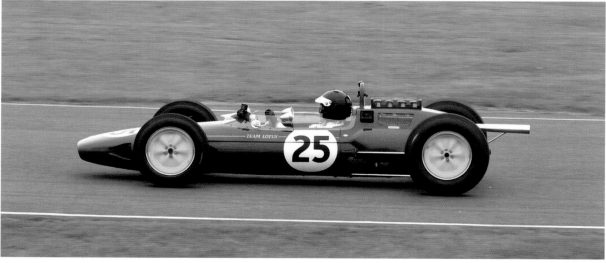

Lotus 25
Peter Arundell
1964; Dario
Franchitti 2014

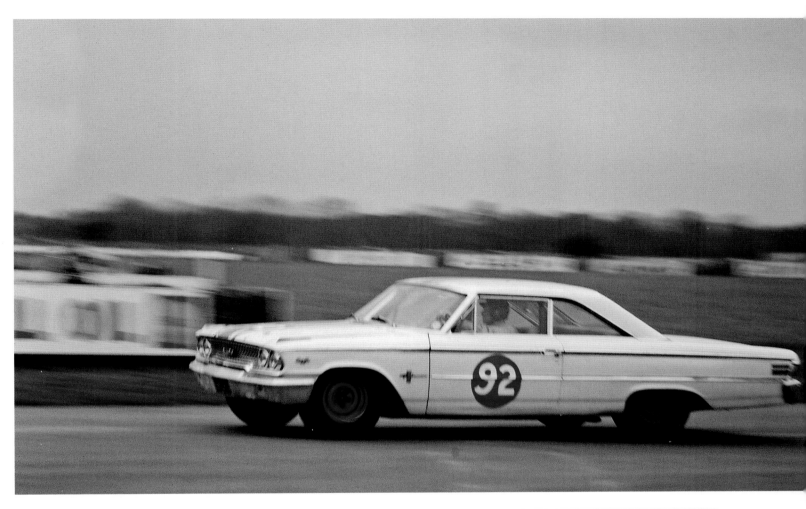

Ford Galaxie
Jack Sears 1964;
Rob Wilson 1998

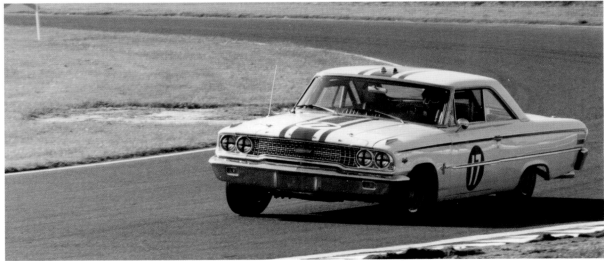

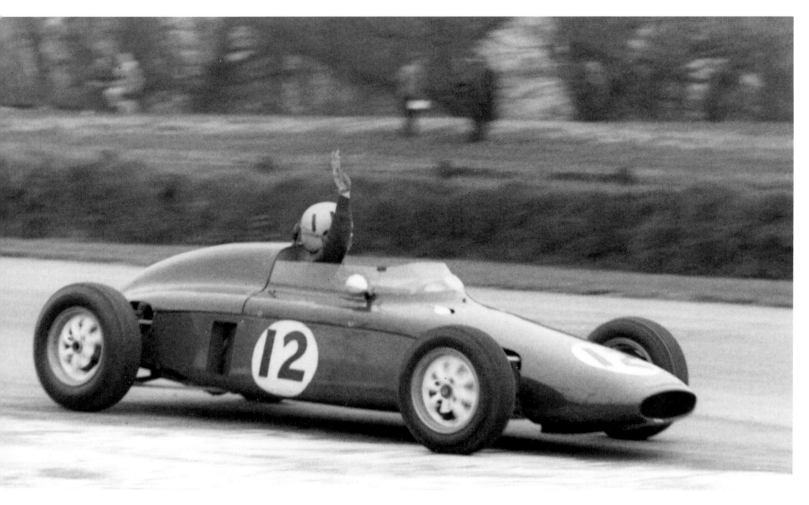

Caravelle FJ
1965 – 1999

AC Cobra 1965
(Jack Sears)
and 1999

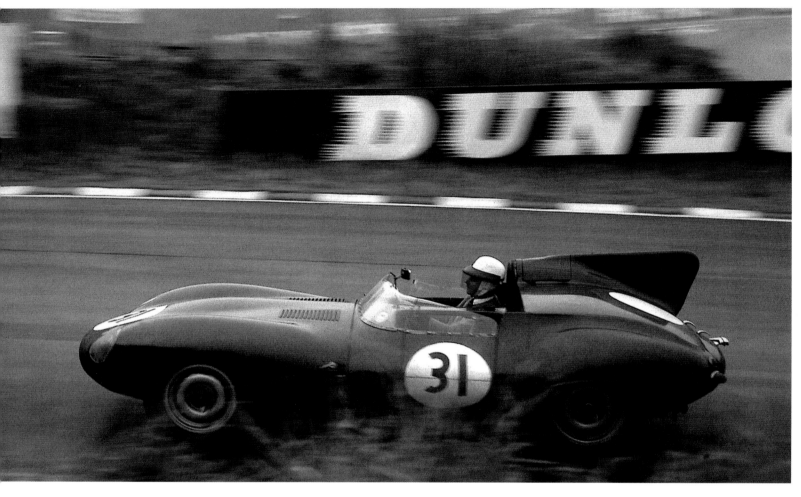

Jaguar D-type
1964, and 2001
(Willie Green)

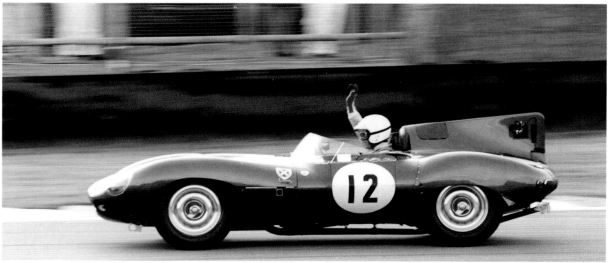

Jaguar Mk1
1964 and 2014

Adieu Goodwood.
Or is it Au Revoir?

Rowan Atkinson in his Jaguar Mk 7.
His expression suggests he
recognises the chap who had stood
on his foot 20 years earlier

Goodwood fell silent in 1966, and I had to seek my fix elsewhere. I returned 20 years later to be hurtled round the circuit in a pair of Porsches. It was a private event which attracted many famous names, held on a ghostly grey day which harked back to that fateful Easter Monday. I had been invited by Pink Floyd's recording engineer James Guthrie, who took me round in his rapid 911 Turbo. I later hitched a ride with Floyd guitarist David Gilmour in his 928.

It was a day of flashbacks. As we drove down from London, I recognised a road I had travelled on a warm, sunny day in the sixties, in a Ford Falcon driven by saloon car champion Roy Pierpoint with one hand on the wheel and one hand on the roof. The 911 felt very twitchy on the old track's bumpy surface, and I found myself tensing up each time we approached the spot where Moss had cannoned into the bank.

David Gilmour's 928 felt smoother, and more planted. Charging down the Lavant straight, I glimpsed the remains of a marshal's post, and had a strange sense that this was where Bruce McLaren had crashed to his death. Not for the first time that day, I became sharply aware of my mortality. We were doing nearly 160 miles an hour as Woodcote Corner rushed towards us, and I realised that this was the quickest I had ever travelled on land except for taking off in a Jumbo Jet.

As we navigated the chicane for the last time and slowed to pull into the pits, David asked me if I was scared. Despite my day of dramatic flashbacks, I answered with a simple 'no'. My nonchalance did conceal an inner critic and former kart racer who was rabbiting away like Harry Enfield's annoying 'Only me!' character: 'No, no no! You don't want to do it like that! You braked much too early for Woodcote Corner! And you really should be getting your bloody boot on the loud pedal far sooner exiting St. Mary's!'

But that is no way to talk to one of your guitar heroes, so I kept quiet.

The day is also memorable for a little incident in the crowded drivers' briefing. I took a step back and unwittingly trod on the foot of the person behind me. I turned round and apologised to Rowan Atkinson, who was pulling his best rubbery face.

I had revelled in the experience. The Ghosts of Goodwood had made their presence felt, but they hadn't intimidated me. I bade the circuit 'adieu', with no inkling that it was actually 'au revoir'.

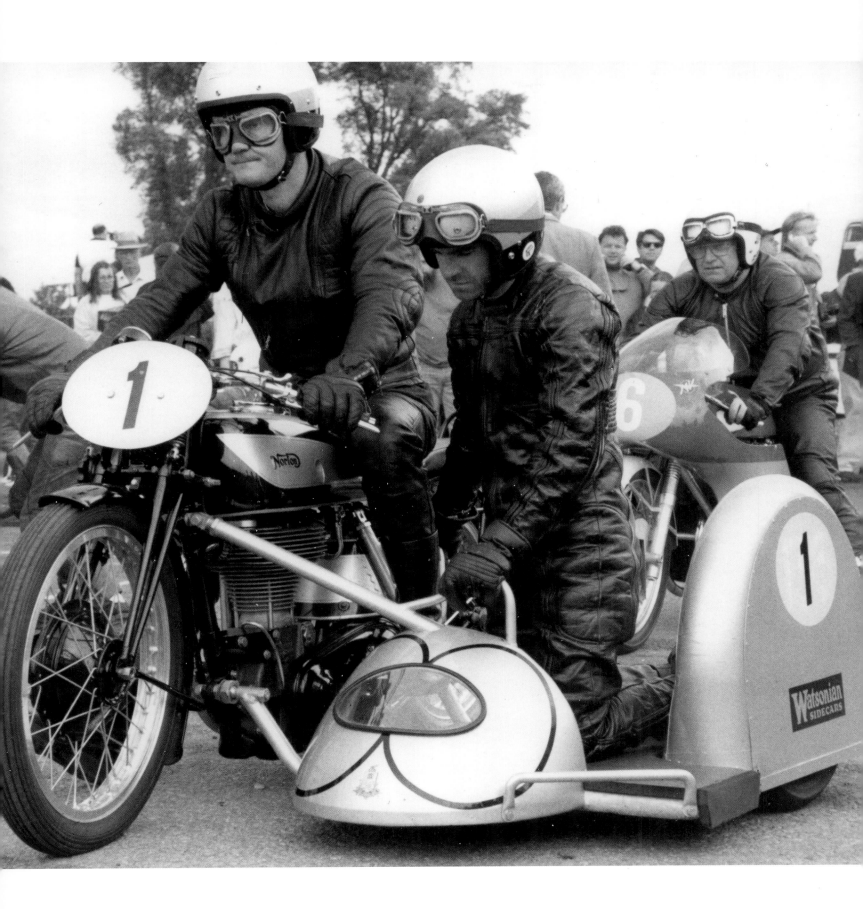

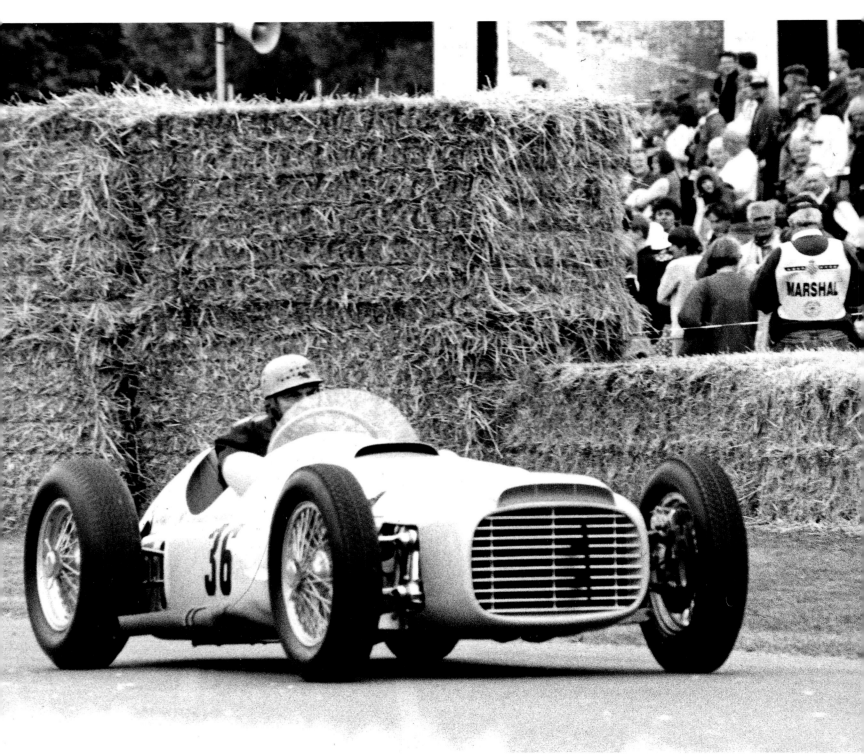

Froilan Gonzales, the 'Pampas Bull' in the V16 BRM

The Seeds of Revival

Fast forward to Flaming June, 1994. I had just been convicted of dangerous driving, and relieved of my licence for a year. Ironically it was the prosecuting lawyer who seemed to think that the case against me was overblown, but the judge was merciless. Zigzagging between two rows of waiting cars either side of a level crossing just as the gates were about to be lowered warranted a fine of £800, or two weeks in prison if I could not pay. Plus the ban.

So there I was, stranded in my garden waiting for Winston, my Jamaican taxi driver friend. He had promised to take me to a hillclimb at Goodwood House. The previous year Lord March had organised a so-called Festival Of Speed, and a feature on TV had left me feeling that I'd missed something a bit special – not least my old hero Stirling Moss tackling the course in his first racing car. I was determined not to miss out again. It was a perfect day for a hillclimb. The sun beat down as I waited. And waited. Winston finally showed at 4pm.

I missed it again the following year. I was serving my ban in California, driving around in a Ford 'Rentarelic' with an International driving licence craftily obtained the day before I went to court, and playing the blues with the finest local musicians. Finally, on a misty morning in June 1996, I parked on a hill overlooking Goodwood House, and hearing the crackle of an unsilenced motor, ran to intercept it, with a borrowed Canon in hand. I reached a gap in the trees just in time to see a silver motorcycle and sidecar flash past, driver and rider in black leathers, open face helmets and goggles. I thought I'd seen a ghost – the first of many, as it transpired.

Two years later I was at the first Goodwood Revival. I have returned every year since.

Paul Frere, racing legend, and author of the autobiography *From Starting Grid To Chequered Flag*, which I loved, and which he offered to sign

Zigzagging between two rows of waiting cars either side of a level crossing just as the gates were about to be lowered warranted a fine of £800, or two weeks in prison if I could not pay.
Plus the ban.

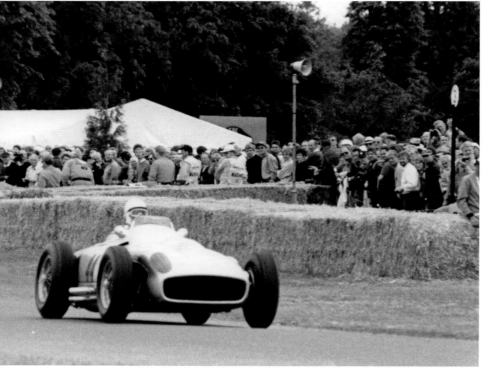

Sir Stirling Moss in Mercedes W196

MM MOSS
MOMENT

SM *"That's the W196 and I presume that's at
Goodwood. That car I remember most from
when I went to test it at the end of 1954.
I'm not sure which track it was, probably
Solitude. They brought the thing out - I
got in it and drove it round and when I got
out I had a black face with white round the
eyes from the goggles, and the black from
the inboard brakes and the dust… and
I'm trying to find a bit of rag to wipe my
face and up came this German mechanic,
clicked his heels and bowed forward and
he'd got a bowl of water. it was hot water,
and in his hand he'd got a cake of soap
and over his arm he'd got a towel. It
impressed me I must say, I thought,
"'Pretty good, these people!'"*

TH *"Imagine seeing that in the McLaren
pit these days!"*

SM *"Well…different scene!
Good picture though."*

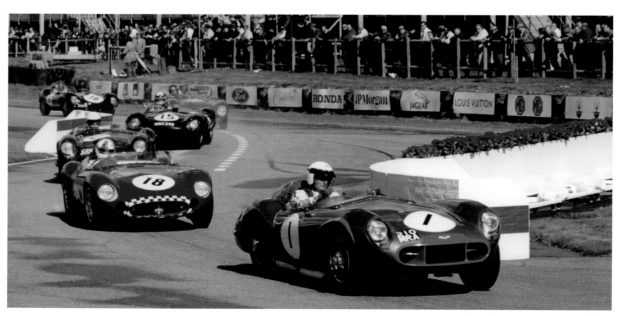

Goodwood on a summer's day

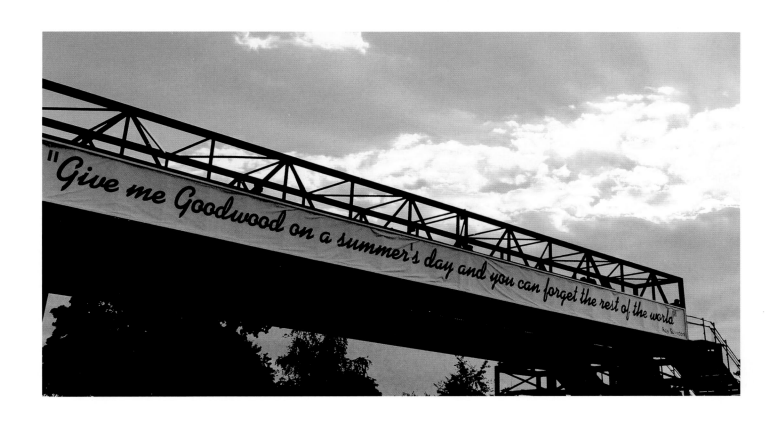

"*Give me Goodwood on a summer's day and you can forget the rest of the world.*"

ROY SALVADORI

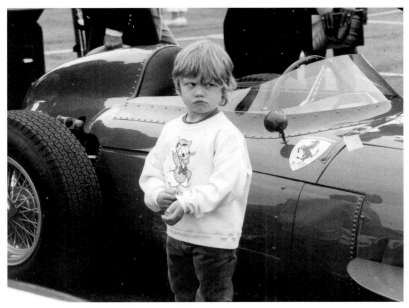

'But I don't want to go home!'

Chapter 2
Brands Hatch

A Life Through a Lens

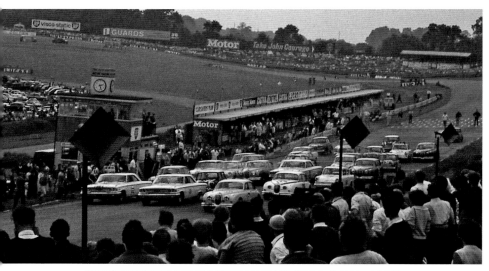

Brands Hatch was a young photographer's dream. It rose and fell, twisted and turned, and from a front row seat in the Paddock Hill grandstand the entire 'club' circuit was visible. Paddock Hill Bend had to be the best spot on earth to watch a motor race, sitting on top of the most exciting corner in the country. It looked daunting even to a spectator and somebody would always get it wrong

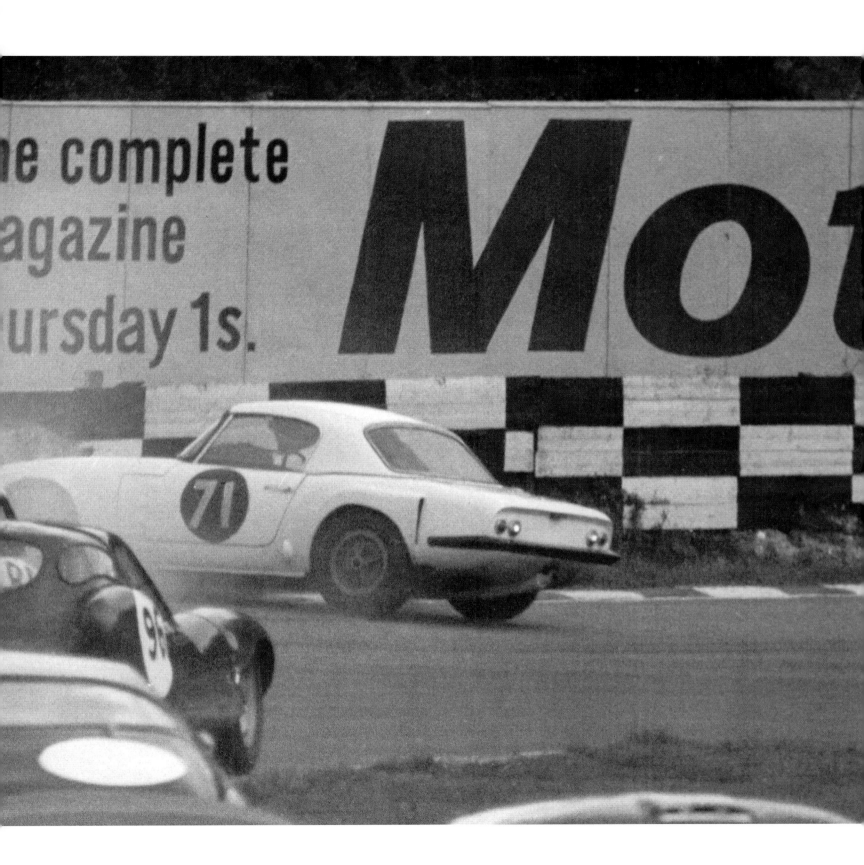

It'll Never Replace the Horse!

When the first automobile appeared some bloke declared, 'It'll never replace the horse'. Given our ingenuity in reinventing both the wheel and the traffic jam, this may yet prove prophetic. Just don't mention it to a racing driver.

One enchanted evening in August 1962, following practice for the International Bank Holiday meeting at Brands Hatch, I was sitting in the back seat of a Mk 2 Jaguar being driven the way nature intended by Roy Pierpoint, soon-to-be British Saloon Car Champion. Sitting beside him was my mercurial mentor Dizzy Addicott, egging him on as we headed home from the circuit along the sun-dappled, picturesque, curvaceous and conveniently empty A25.

Roy was a bloody good driver, and I felt bloody good. You'd have felt bloody good too. Incidentally, had I used the 'b' word at school, it would have meant an instant thrashing, but knowing it to be the favourite expletive of my exalted racing buddies, using it made me feel invincible. Suddenly, somewhere near Westerham, Roy hit the brakes, and from a healthy gallop we came to an abrupt standstill. Two equestrians, looking terribly prim and proper, had begun their exodus from a lane to our left. As the horses ambled past the steaming bonnet of the stationary Jaguar, turning to take their rightful place on the Queen's highway, Roy rolled down his window. Incensed at having his rhythm broken by these stuffed up clippety-cloppers, he vented his feelings in the true spirit of a man steeped in the summer wine of Brands Hatch: 'You bloody people!' he roared. 'Get those things off the road!'

Incidentally, had I used the 'b' word at school, it would have meant an instant thrashing, but knowing it to be the favourite expletive of my exalted racing buddies, using it made me feel invincible.

Roy Pierpoint in the Attila he designed and built

Roy Salvadori in his Cooper Monaco

During the saloon car race he crashed his
Mark 2 Jaguar. Apparently his foot slipped off
the brake pedal. We were told that tiredness
was the cause of this uncharacteristic error.

Graham Hill

Sister came too

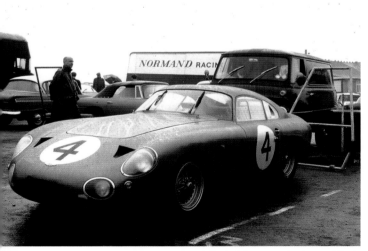

One of the hairiest cars in the paddock

The 1962 August Bank Holiday meeting fell right in the middle of my 'Graham Hill' period. The previous day he had won the German Grand Prix in heavy rain at the Nurburgring – hailed by *Autosport* as one of the best wet weather drives of all time. Saturday's practice at Brands had taken place in perfect summer weather, but when Graham flew home to compete on the Monday, he brought the rain with him.

During the saloon car race he crashed his Mark 2 Jaguar. Apparently his foot slipped off the brake pedal. We were told that tiredness was the cause of this uncharacteristic error. It meant he would not be taking part in the main event. Graham was still my main man, so thank heavens for Dizzy, who starred on a soaking wet track, working his way up to 7th overall and a dominant class win in the tiny works Elva, running rings sound cars with engines almost three times the size. The road to Brands was no M25 sprint in those days. An endless hour and a half along the A25 brought us to

a steep uphill intersection near Eynsford. The Rolls would never roll backwards with my stepfather at the wheel, but it was always a relief to emerge from this awkward junction, turn right onto the A20 and roar up the charmingly named 'Death Hill' at the top of which was the track. We would then take a tight left turn into a narrow country lane which led to my mecca – the Brands Hatch Paddock. 'Death Hill' has long since been renamed something forgettable.

Along with the 'b' word, 'hairy' was an important adjective to describe a car with muscle, or a muscular on-track move. On a baking summer day, a mate and I spotted one of the hairiest cars in the paddock, a beautiful Zagato-bodied Aston Martin. Its driver was relaxing with his overalls half off, revealing the hairiest of backs. We wondered, as cheeky young boys would, how a gorilla could drive such a beast. There was one driver almost as famous for his facial hair as for his hairy command of a Mini Cooper – the very rapid Frenchman Mick Clare. One afternoon, hanging out in the paddock with Dizzy and his Australian buddy Paul Hawkins, Mick drove past sporting his perfect Lord Kitchener moustache. Mr Hawkins turned to me and grinned: 'Howzat for whiskers, son?'

The Rolls would never roll backwards with my stepfather at the wheel, but it was always a relief to emerge from this awkward junction, turn right onto the A20 and roar up the charmingly named 'Death Hill' at the top of which was the track.

Dizzy Addicott in works Elva-Alfa, in the scrutineering and collecting bay, Boxing Day 1962. He came second with a frozen radiator.

Picture by sister Fiz

A Lap Through the Lens

PADDOCK HILL

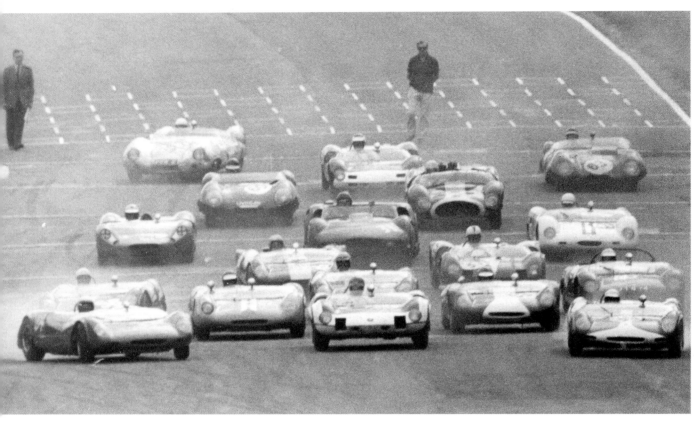

Heavy metal sports car race, 1965. Note officials on track

Mike Beckwith at Paddock. Mike was an up-and-coming young gun who, like the very best of his day, was quick in a variety of cars. He made a name for himself in Formula 2 and in Lotus 23 sports cars. He would seriously worry a moonlighting Jim Clark, who would from time to time join the Normand team for which Mike drove, as temporary number one. Mike decided to go motor racing after seeing Dizzy Addicott spin off at Brands Hatch. Climbing from his car cursing loudly, Dizzy removed his helmet and revealed his grey hair. Mike's comment was 'If an old man can do that, so can I!' We got to know him through Dizzy and Roy Pierpoint

Poetry in Motion – Denny Hulme, Formula 2 Brabham, shows how modern day racing misses the sight of the driver at work

Jackie Stewart and Bruce McLaren, when Grand Prix stars regularly raced in other categories

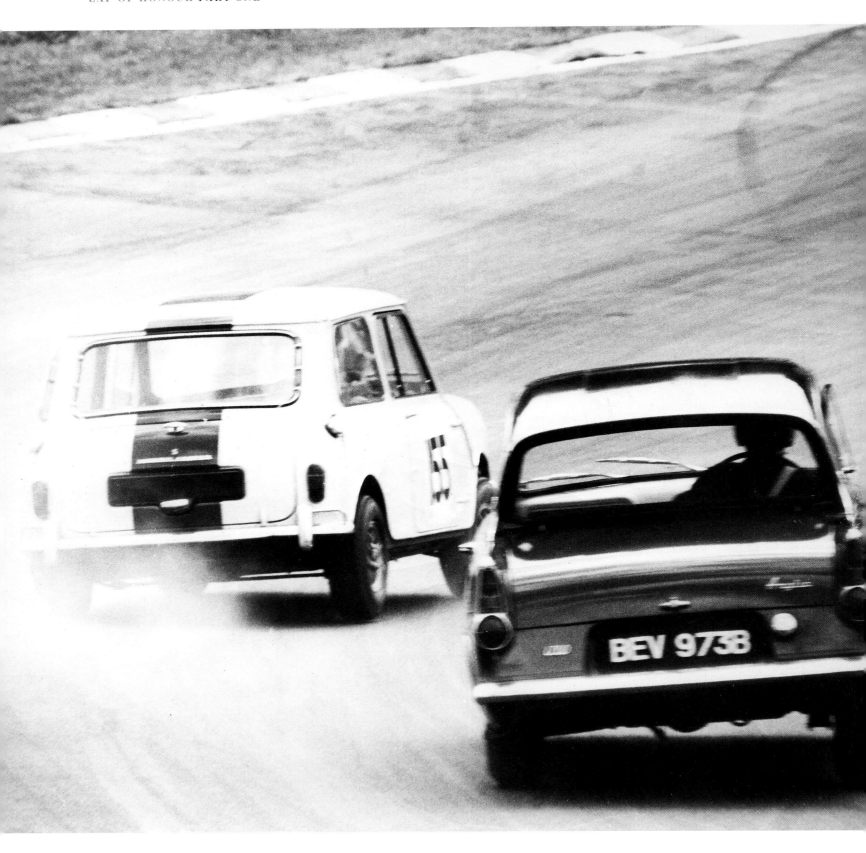

Then as now

A spectator once referred to my 400mm lens as 'Blackpool Tunnel'. Opposite our stand and well within the tunnel's range was the drop from Druids hairpin. Cars would sweep from one side of the track to the other in pursuit of the perfect line, powering downhill through 'Bottom Bend' and onto 'Bottom Straight'. They follow the same procedure 50 years on, except that 'Bottom Bend' has been re-profiled and renamed 'Graham Hill Bend'.

Then as now 2

A Lap Through the Lens
PILGRIMS RISE

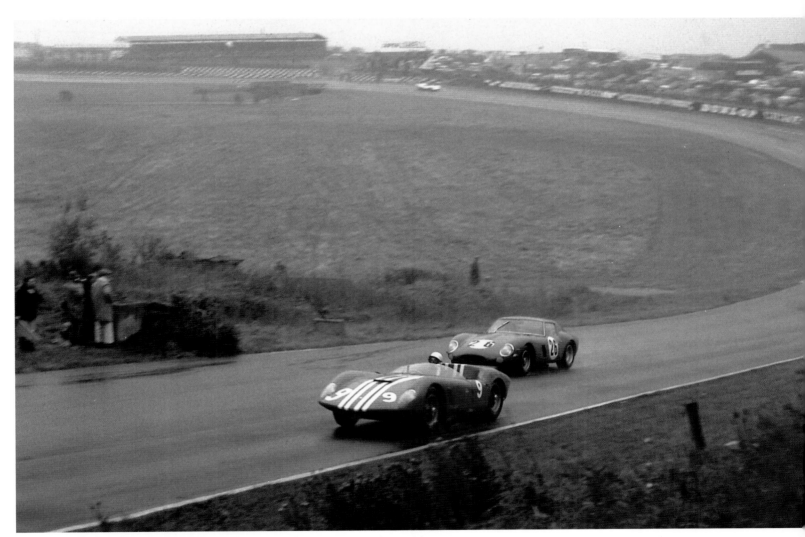

I would wander far afield during practice days when the crowds were minimal but the cars no less photogenic. Being shorter than the average race-goer, my equipment would often include a box to stand on

A Lap Through the Lens
DRUIDS HILL BEND

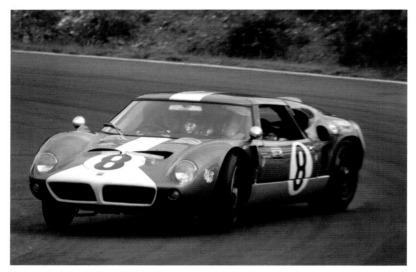

A.J. Foyt and a handful of GT40

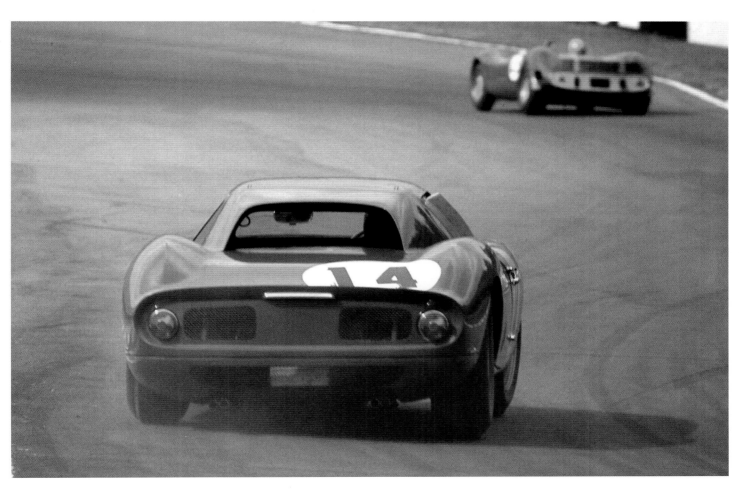

A Lap Through the Lens
BOTTOM BEND

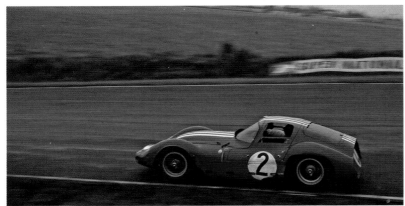

Practice for Guards Trophy 1963, Ferrari, Maserati, Cooper Xerex

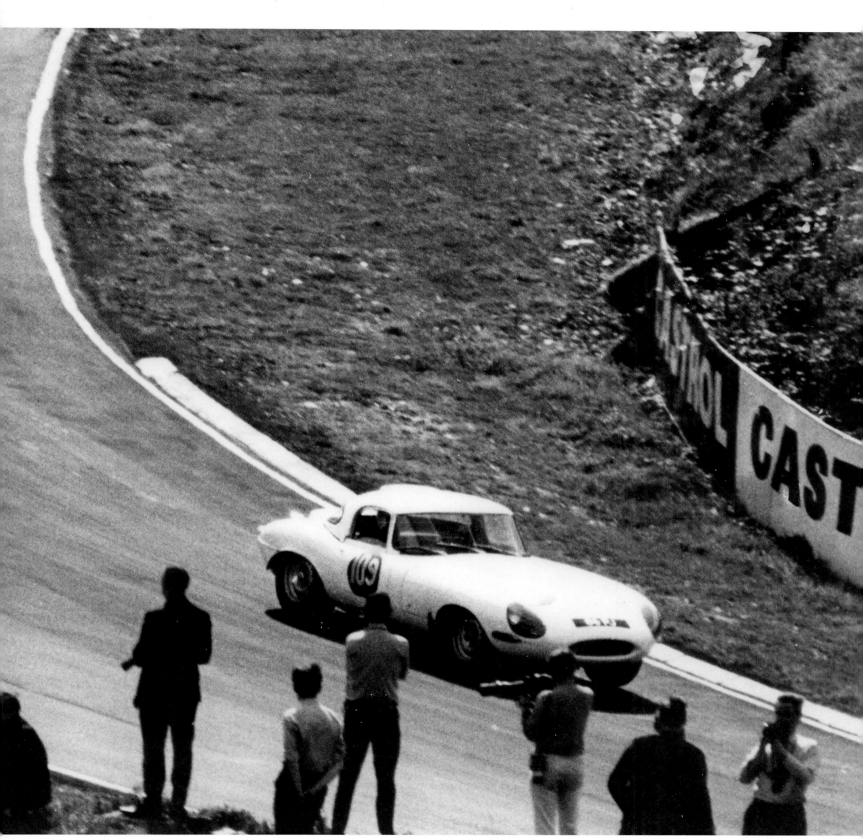

E-types and photographers, long before 'Health and Safety'

A Lap Through the Lens
SOUTH BANK BEND

'Saloon cars' invariably took top honours for pure entertainment, with Jim Clark's Lotus Cortina on two wheels, Jag 3.8s leaning over, thundering Ford Galaxies and so on. Nothing provoked a bigger smile than a gaggle of Minis in mid-corner, scrubbing off speed by throwing themselves sideways, no brakes, blinding the opposition beneath a blanket of rubber smoke

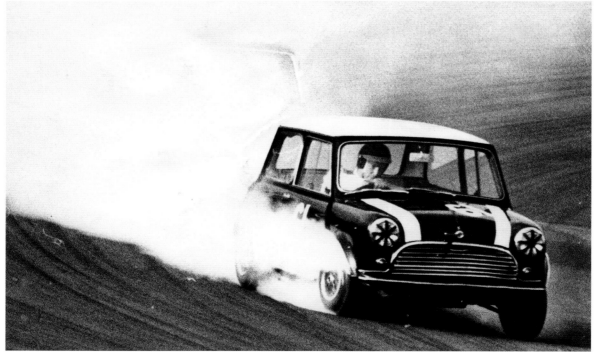

The 'works' cars didn't always have things their own way. They were frequently upstaged by the likes of Mick Clare and pretty piano teacher Christabel Carlisle. No other form of racing created these classic 'David and Goliath' situations, in which mighty, lumbering giants were humbled by nimble little chariots with tiny wheels, able to corner far more quickly. No racing projectile drew more applause, 'oohs', 'aahs', and even laughter from the crowd than the Mini Cooper. Especially when deploying their ultimate secret weapon – the Smokescreen

John Rhodes and John Love – Mini Legends

TH *"I have a wonderful photograph, I think it's you, because you are the shortest of the three Johns
who raced Mini Coopers, sideways at South Bank Bend, which I took when I was knee high to a
grass-hopper. I know the other John quite well, John Whitmore, and we've talked quite a lot about
him developing the style of throwing minis sideways into a corner, but who can actually claim to
be the one who developed that style?"*

JR *"It has to be me because I had a test at Silverstone. I was there with John Love and Tony Maggs.
And I was testing the Formula One car at the time, so I jumped out of that which was Bob Gerard's
car and straight into this Mini. I realised the brakes were hopeless so I shot into Copse, and thought
I'll throw it sideways, oversteer, and then counteract it with the throttle because we had a limited slip
diff, and it worked beautifully. Clouds of smoke. So every corner from then on I'd let the back end go
and just compensate by accelerating at the front. And it worked. So it was me, definitely. I used more
tyres than anybody else."*

JL *"Being a lot younger I had to learn from John you see. But also he drove mainly the bigger ones.
I drove the 970. We couldn't do it that way because it just scrubbed off too much speed so we had
to be gentle. He was all the smoke and mirrors and all the rest of it – we did it gently!"*

TH *"Thank you gentlemen, at least now I know the identity of the man in the picture."*

A Lap Through the Lens
CLEARWAYS

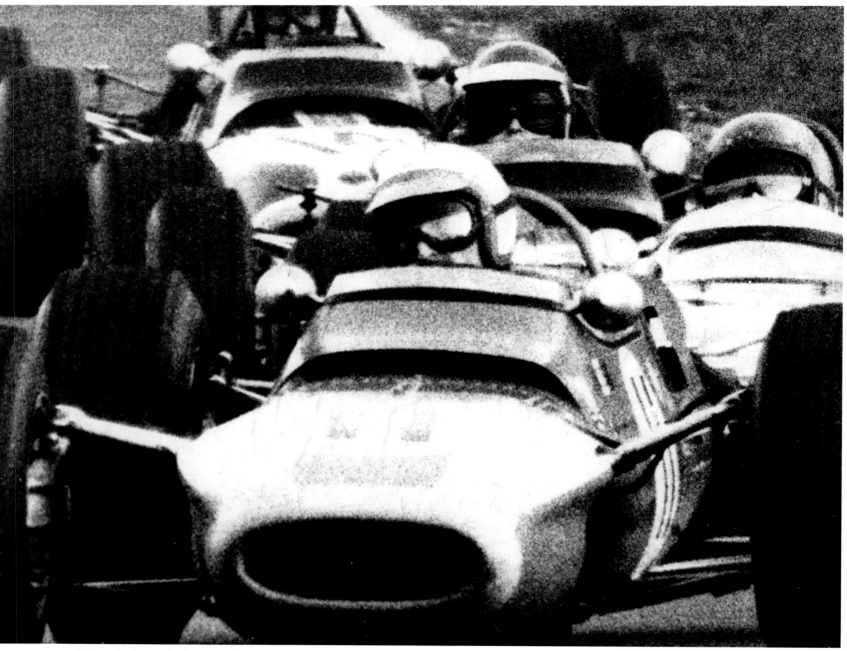

This grainy image depicts several giants of Formula 2 coming off the 'Grand Prix loop' and into 'Clearways'. It demonstrates the combination of a telephoto lens, and late nights in the darkroom blowing up negatives as far as my equipment would allow. Formula 2 was the great equaliser – the formula of giantkillers. It gave the next generation the opportunity to compete with 'moonlighting' Grand Prix drivers on a level playing field. It enabled hungry young drivers to pit their talents against the best, and punters to become talent spotters, cheering the underdog as he harried and often beat the 'big boys'

The Song of Victory

It took three racing seasons to complete a photographic lap of the "club" circuit – a journey which took in every aspect of the English weather; snow on Boxing Day, midsummer mud, and that peculiar translucent August sun, which seems to drench the leaves on the trees, causing them to glow.

At every meeting, after every race, the 'Brands Hatch National Anthem' would burst forth from the same spontaneous ensemble assembled along 'Bottom Straight'. As the garlanded victor took his Lap Of Honour and drove past, arm raised, 'The song of Victory' would be sounded by the world's wackiest orchestra – hundreds of cars hooting their horns in appreciation!

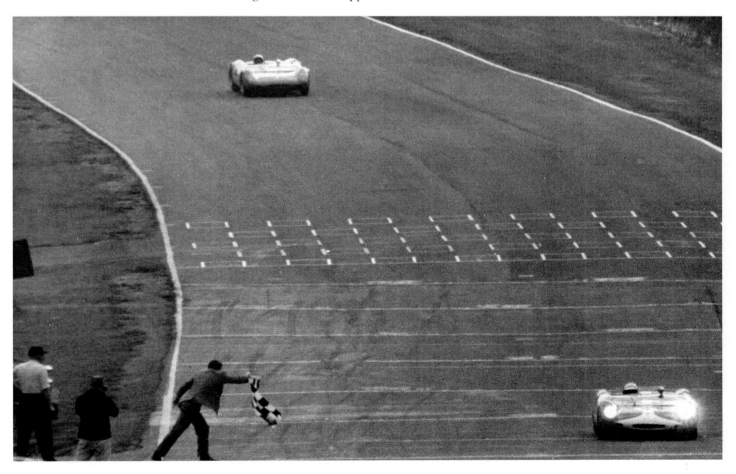

Chapter 3
Crystal Palace

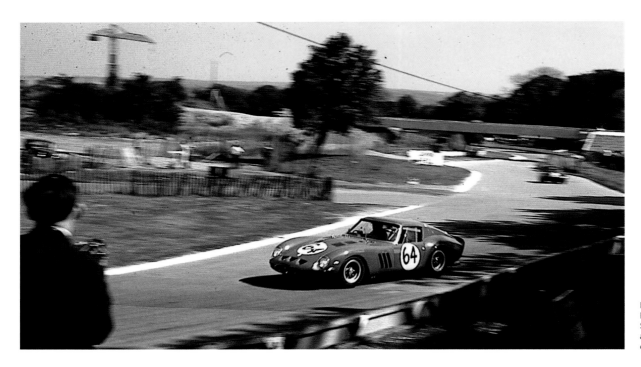

David Piper's
Ferrari 250 GTO,
September 1962,
against a backdrop
of South London

Twilight Zone

On an overcast Saturday evening in the summer of 1985, I found myself in the dressing room of the Crystal Palace Bowl after a concert by a female pop-reggae band. I had been invited there by the dreadlocked drummer, the only male in the group and an old friend. I had fancied the lead singer for a long time, and this was a good opportunity to get close, so I hoped, but when I saw her and a band-mate in a huddle, inhaling something from a piece of tin foil that I wouldn't touch with a barge-pole, I made a hasty exit, seriously deflated, without so much as a farewell to anyone.

Eager to get as far away as I could, I strode into the gathering dusk with no sense of direction. I came to a glade and for no apparent reason I stopped. Everything went very still and quiet, save for the distant hum of traffic. A sense of 'deja vu' crept over me. I realised that the tarmac strip winding its way beneath my feet was the old racetrack, long since out of commission.

Eager to get as far away as I could, I strode into the gathering dusk with no sense of direction. I came to a glade and for no apparent reason I stopped. Everything went very still and quiet, save for the distant hum of traffic. A sense of 'deja vu' crept over me.

The old Crystal Palace racetrack revisited showing
North Tower Bend, The Glade, the back straight
with burnt out car, Ramp Bend, The Esses, and
Maxim Rise heading towards South Tower

I began to get my bearings. There was a corner to my left, which had to be what they used to call 'North Tower Bend' at the end of the start-finish straight. The track then snaked its way through 'The Glade' where I stood, before dropping downhill into the braking area of a 90 degree right-hander whose exit dipped sharply onto the back straight.

So this is where Dizzy and Roy disappeared to every lap during their epic battle! I had been on the edge of my seat over on the far side of the circuit at 'South Tower Bend'. I never forget a circuit configuration – testimony to my karting experience, and an outline of the circuit is still visible on the London A-Z. It resembles a simple, lopsided square. What it doesn't reveal are the daunting details – the gradients, the kinks, the narrowness, and the trees lining its edge. One tiny error and there would be no way round them. I marvelled at my twilight discovery, my mind spinning back 23 years to a sunny September afternoon when the colourful racing circus dropped by to party at the Palace, and on which I had taken my first pictures.

I never forget a circuit configuration
– testimony to my karting experience,
and an outline of the circuit is still
visible on the London A-Z.

Me, aged 11, in Dizzy's Elva Mk 6 which would finish a close second to Roy Pierpoint's more powerful Lotus 15

The remains of the circuit are still visible despite the speed bumps along the back straight and the burnt-out wreck of an abandoned car – symbols of modern urban life. The evidence is still there beneath the trees, behind the Sports Centre, under the feet of the joggers, the strollers and their dogs. They wander along, oblivious to the drama and spectacle that once took place here, an Elva and a Lotus contesting a race lead; a young upstart known as 'Hunt the Shunt' resorting to fisticuffs after an on-track duel that went wrong, later televised on a programme called *Great Sporting Moments*.

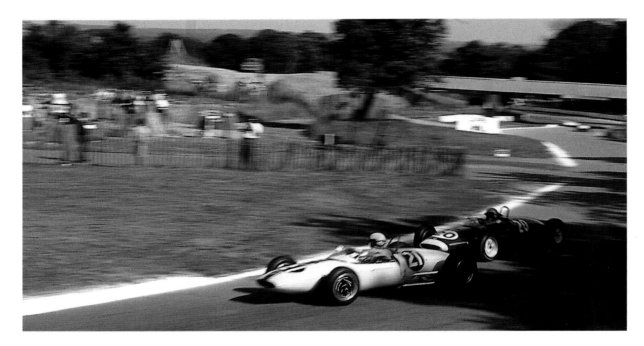

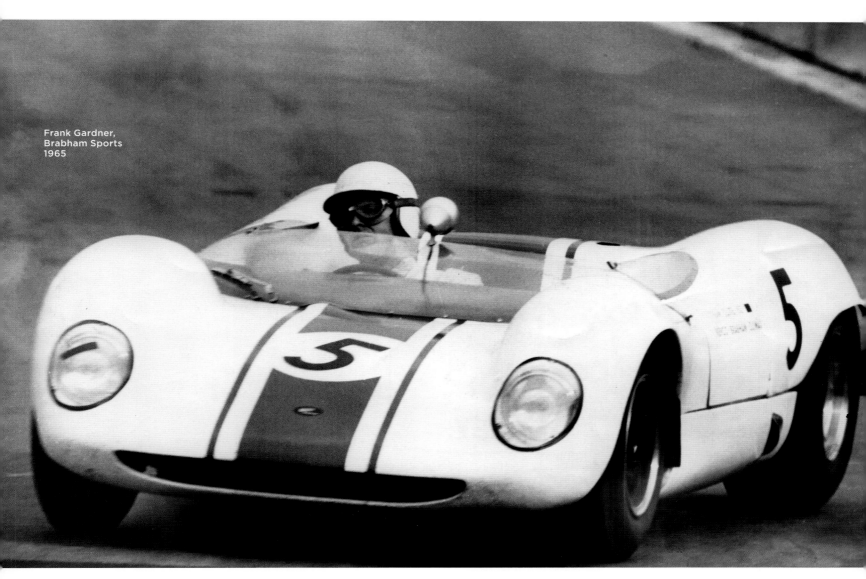

Frank Gardner,
Brabham Sports
1965

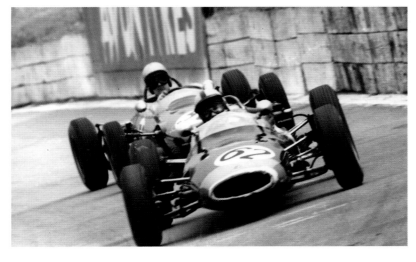

It is a place of wildly contrasting memories: brave men chasing glory in racing cars and brazen women 'chasing the dragon' – two separate lifetimes. I wish I could have been there the day my sister hung out with Jim Clark, but I was locked away in my boarding school prison, wildly jealous, while she flirted with my hero. Jim was moonlighting with the Normand Team, whose regular number one was our pal Mike Beckwith. I would also love to have witnessed a duel of a very different nature, when the late great blues guitarist Freddie King, who always grabs me where it hurts, stepped onto that same bandstand. His tone has been described as 'a Chevy truck full of cement' and he proceeded to challenge Eric Clapton with his fiery licks. I returned again for a sprint meeting in 2002, held on this same section of the old track. The day provided a few sweet memories, and a clutch of photographs. A pleasant dose of nostalgia, minus the glamour and glory of the sixties.

I told Dizzy about my twilight discovery before his passing in 2005, and how awed I was that he and his peers actually had the balls to race there. Being old school, one who lived on the edge as a matter of pride, his response was perhaps a tad predictable: 'Listen old lad, we never used to bother about that sort of thing. But then some chap called Jackie Stewart came along, whinging about safety.'

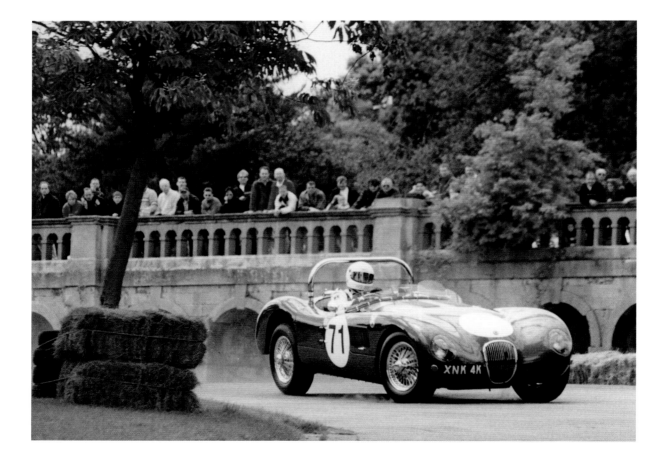

Dizzy with Elva, after his race-long tussle for the lead

Chapter 4
Aintree

The Colonel's Patch

On a misty morning in April 1963 I looked down from high up in Aintree's grandstand onto a flat expanse of green grass and white fences melting into the haze. Through the mist the distant ghosts of factories and houses were just about visible. The grandstand was empty, save for one 12-year-old boy checking out a vantage point to capture the start of the Aintree 200 with his mother's Kodak Retina. A stillness hung over the place – a pregnant silence begging to be broken by the most beautiful cacophony on earth.

At last the morning mists rolled back, parted by the howl of a racing engine bursting into life. This was joined by another, and then another, until the paddock below pulsed with a wild chorus of thoroughbred racing cars eager to be unleashed.

The mechanics had waited for this moment all morning to begin their final adjustments, with their drivers in the cockpit blipping the throttle. Like old-time musicians they tuned by ear, filling the air with a rhythmical revving, calibrating the carburation until the engine's bark had the perfect bite. Like an orchestra preparing for a symphony, it was a sound to set the pulse racing, and me scampering down from the grandstand to join them.

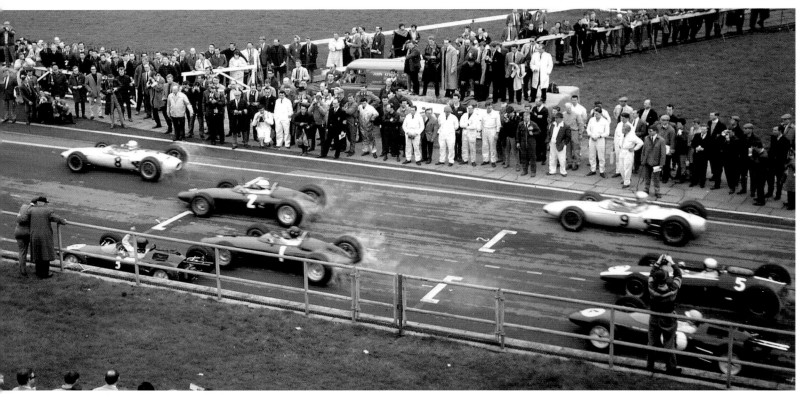

Start of the Aintree 200, 1963. Jim Clark is stranded on the grid, engine dead

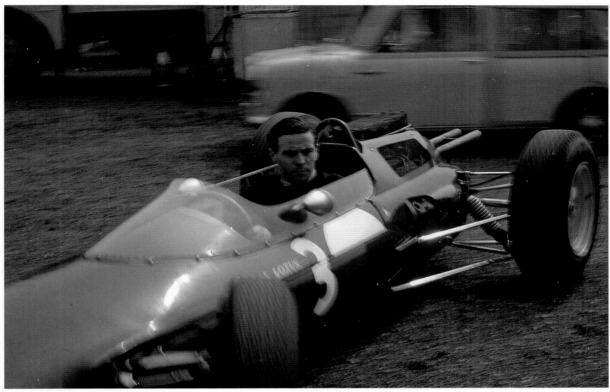
Jim Clark manoeuvres his Lotus 25 on the cinder surface of the paddock

Birth of a Champion

The previous afternoon, down in the paddock, I'd had my first close encounter with Grand Prix cars and their doting families – mechanics in brown overalls and drivers in pale blue 'Dunlop' race suits. In warm April sunshine, I had feasted my eyes upon a pretty 'Bowmaker-Yeoman' Lola, slate blue with a red nose for John Surtees; a 'works' Cooper for Bruce McLaren – dark green with white stripes, just like on my Scalextric model; a pale green UDT Laystall Lotus 24 for Innes Ireland; a metallic green BRM for world champion Graham Hill, and Jim Clark's stunningly beautiful green and yellow Lotus 25, which I had managed to photograph with Jim on board.

Most of the fancied runners sported eye-catching twin exhausts in shining chrome, protruding purposefully from the top of the engine cowling – the hallmark of the latest V8s from Coventry Climax. The previous year they had helped to take British revenge over the Italians, whose Ferraris had vanquished our underpowered four cylinder units in '61, despite the heroic efforts of Stirling Moss. His genius alone had managed to beat 'those bloody red cars' at Monte Carlo and the Nurburgring – the two circuits where a driver can make the difference – even in an outdated, underpowered Lotus run by privateer Rob Walker.

Most of the fancied runners sported eye-catching twin exhausts in shining chrome...

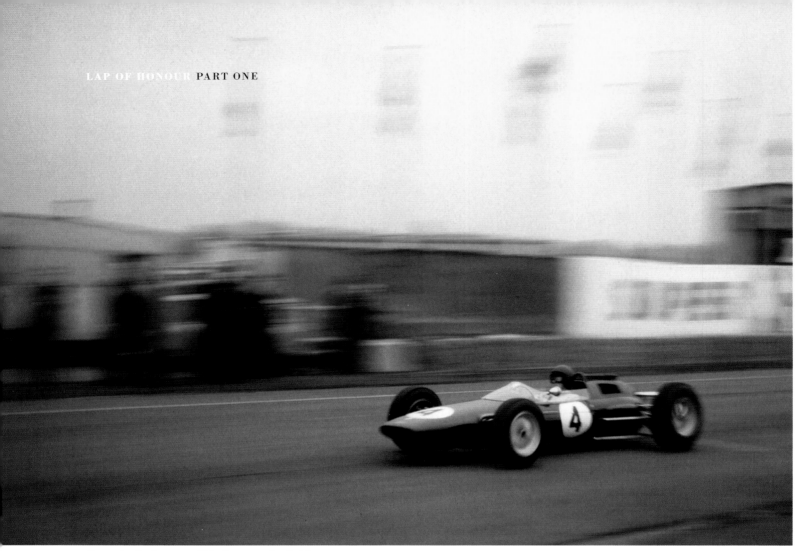

Jim embarked on a spellbinding comeback drive
from last place, straight into my heart. It earned
him third place. I don't recall who won

The exception was BRM's V8. It had won the championship
with impressive four-a-side 'stack' exhausts pointing to the sky, but
these had been re-configured. Wonderful as they had looked and
sounded, they had a habit of falling off.

When the cars eventually lined up on the starting grid for
the main event, the engines were shut down for the National Anthem.
Graham Hill was the only driver to remove his helmet, respectfully
standing to attention beside his car for The Queen. When the moment
came to fire up the engines for the race, Jim Clark's motor refused
to start, leaving him stranded on the grid with a flat battery. He
eventually got away over a lap in arrears. Lotus team boss Colin
Chapman responded by signalling him and teammate Trevor Taylor
into the pits to swap cars, since the 'number two' driver was running
much higher up the order. Jim then embarked on a spellbinding
comeback drive, clawing his way through the field and straight into
my heart. The crowd was enthralled, the commentator delirious. It
earned him third place closing on second. I don't even recall who
won. Aintree was set in the heart of the industrial north on the

*Graham Hill was the only
driver to remove his helmet,
respectfully standing to
attention beside his car for
The Queen.*

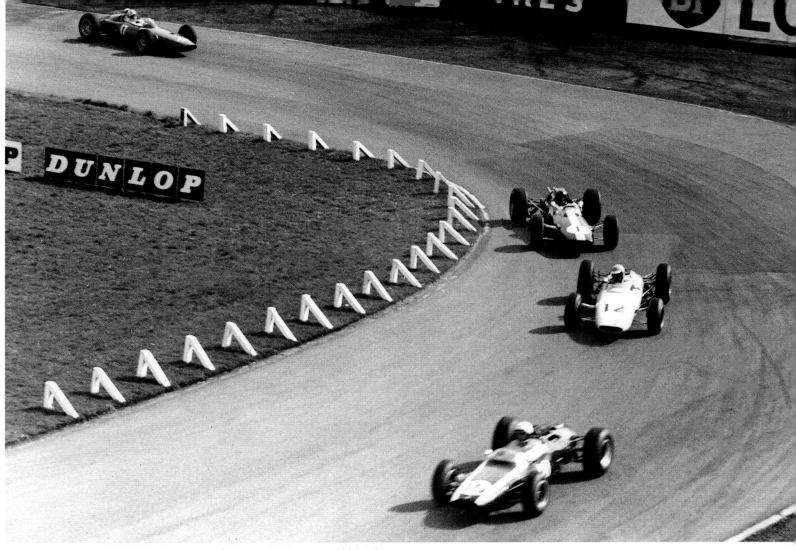

Phil Hill leads a group of F1 cars at Tatts corner 1964, taken with my newly acquired Edixa Mat single lens reflex

outskirts of Liverpool, hardly the most inspiring of locations, but with a history you could feel. In 1954 a local lad in school uniform came to watch his first motor race. His name was George Harrison, who later rightly claimed: 'I've been in motor racing longer than Bernie Ecclestone.'

Many a famous race had been run there on four legs as well as on four wheels, under the direction of Mrs Mirabel Topham. According to the late Eric Thompson, winner of the 1953 Goodwood Nine Hours, she was a difficult woman who did not take kindly to motor racing, despite the fact that history had twice been made there thanks to young Stirling Moss. In 1955 he narrowly beat his team leader Juan Manuel Fangio to take his first Grand Prix victory, in front of his home crowd. To this day nobody knows whether or not he was gifted the victory by his generous mentor.

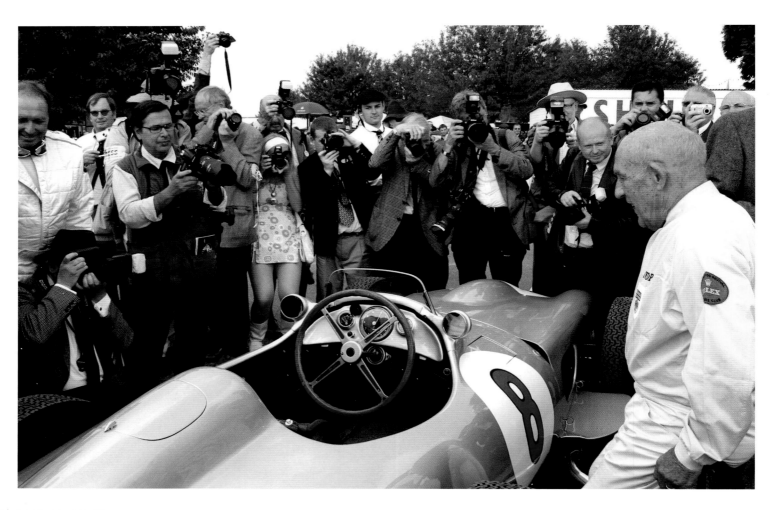

MM MOSS
MOMENT

TH *"Did Fangio let you win that day, at Aintree?"*

SM *"I don't know. I asked him and he said 'No, you were on form, and that was your race.' But he's the sort of person who would have said that anyway. But actually I think I did get pole in practice and then (in the race) he got ahead of me and then somebody got in the way so I caught him. Until you got a 30-second lead it was a free race. Then they'd put out a sign that said 'REG-regulare' which meant 'hold your position'. So I don't know. I don't know."*

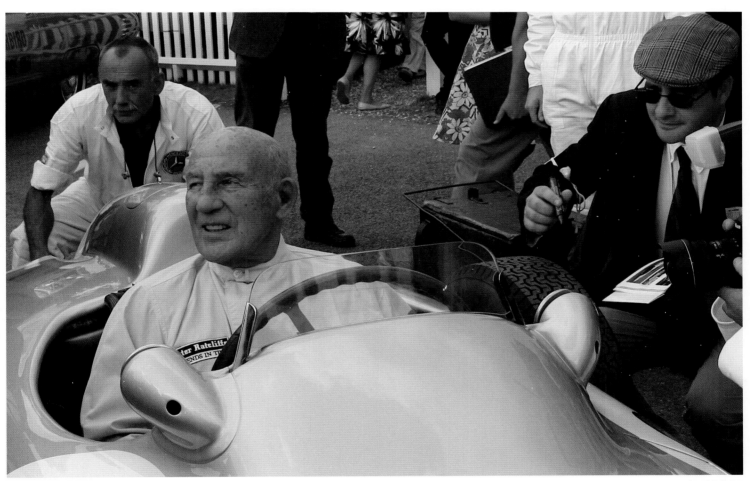

Moss and British GP
winning Mercedes. W196
at Goodwood 2009

*Two years later, Moss was to score the first Grand Prix
win for a British car – the Vanwall.*

The Colonel's Patch

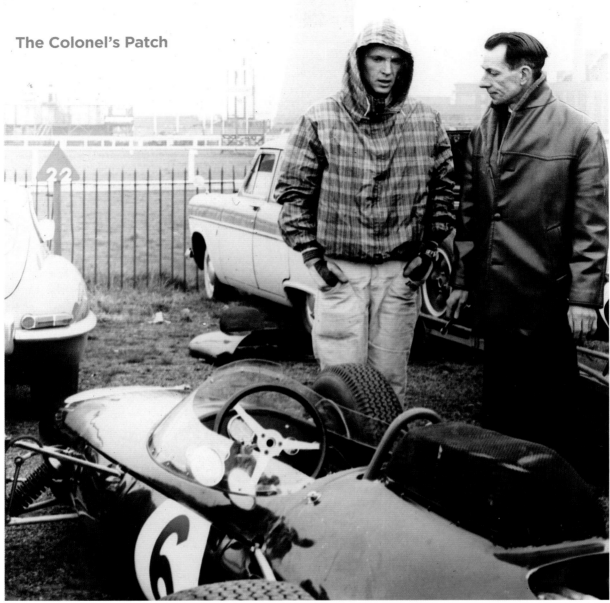

American ace Dan Gurney with Ron Tauranac

Aintree is best known as the home of Britain's premier horse race – the Grand National. How times and priorities change! These days horse racing could never compete with the global enterprise that F1 has become. Yet, in this place where high profile motor sport is long gone, the Grand National remains.

My mother and I went there twice, as guests of her friend Colonel Eric St. Johnston, Chief Constable of Lancashire and subsequently Chief of Police of England. He was a very gracious host. I was under strict instructions to be on my best behaviour and to address him as 'Sir' – a small price to pay. Prior to Princes William and Harry, no young motor racing enthusiast was treated more royally then me. The Colonel arranged for me to be driven round the circuit in an open-top police MGB, granted us easy access to the paddock and pits, and introduced me to my heroes, Graham Hill and Jim Clark. I got their autographs along with Bruce McLaren's, and another which read:

Prior to Princes William and Harry, no young motor
racing enthusiast was treated more royally

'To Tim with all the best, Dan Gurney.' The Colonel was a big man with
bushy eyebrows. He commanded respect, but thankfully a vein of humour
ran through his love of formality. He told a great anecdote about a failed
police experiment with car-mounted megaphones back in the Z-Cars
era: An errant lady motorist was being repeatedly loud-hailed: 'Will the
woman in the white Morris Minor please pull over!' No response. 'Will the
woman in the white Morris Minor wearing the red hat please pull over.'
Still no response. The announcement was repeated in ever greater detail
until she finally got the message. She panicked, and stopped dead in the
middle of the road. Forgetting to switch off the megaphone, the police
voice continued: 'Now look what the silly bitch has done!'

Richie Ginther, in the works BRM V8, enters the pits

Spoof on 60s advertising slogan – TOGETHER WE CHOSE A MORRIS-MINOR

Speaking of silly bitches, the Colonel and his wife had a golden retriever. As we sat in the drawing room, polite conversation was rudely interrupted by a fox hunt in full cry on the television. This stirred the sleeping hound, who bounded off under the TV set in pursuit of the pack, barking madly.

Like the Aintree that was, the Colonel is no longer with us. No doubt he is up there swapping stories with the late great heroes he introduced me to, or interrogating Fangio as to what REALLY happened that historic day in 1955: 'Come on man, did you or did you not let our Stirl win?'

I last saw the Colonel years later at our family home in Surrey, having acquired that change in perspective and behaviour that comes with late teens – hanging out with the wrong crowd, spurning an elite education, playing electric guitar and daring to indulge in the occasional left-handed cigarette. I came home one evening a bit stoned, and was alarmed to find his car in the driveway with its instantly recognisable number plate 'STJ1'. I also had a chunk of something illegal in my pocket, and here was the UK's Chief of Police dining with my mother! I shook his hand nervously, but was relieved to find him 'alcoholically challenged', in a pleasant sort of way. Somehow I managed to keep a straight face as he lay back in a large armchair urging me to 'travel, young man, travel,' between puffs on a huge cigar and sips from a generously filled brandy glass. He drove home that night visibly over the limit, but with that number plate there would be no stopping him.

God bless you, Sir. I shall never forget your wonderful hospitality.

Aintree Gallery

Mad Minis at Tatts

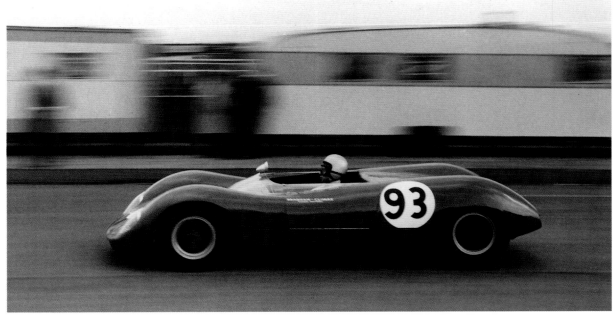

Roger Nathan's Brabham at speed

Mike Beckwith in Elan

John Bolster – legendary motoring journalist

Jim Clark's office

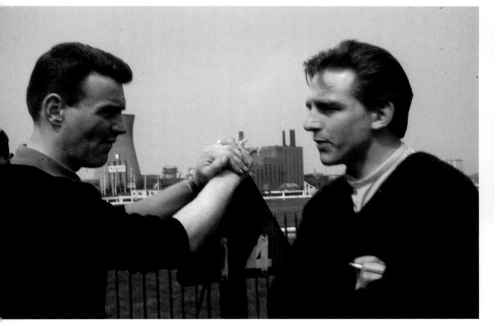

Different days! Drivers Trevor
Taylor and Mike Beckwith having
a chat and a smoke

MM | MOSS MOMENT

SM *"Did you take this one of Brucie?"*

TH *"Yes, at Aintree." A long pause…Stirling stares at the picture.*

SM *"Nice boy, Bruce was."*

Bruce Mclaren signs an autograph. This image was rescued from a 35mm contact print

Chapter 5
Silverstone

Silverstone never captured my imagination like the other tracks I frequented. Perhaps it was the bleakness, or perhaps it was the long straights between corners which made spectating less spectacular. I only visited twice in the 60s, my small collection of photographs taken on a practice day for the International Trophy meeting, which featured a non-championship Formula One race – one of several run on England's circuits in those days, before the official Grand Prix season began. My first visit was on an overcast test day

Bleak and Blessed Memories

Pit scene; Sears in AC Cobra

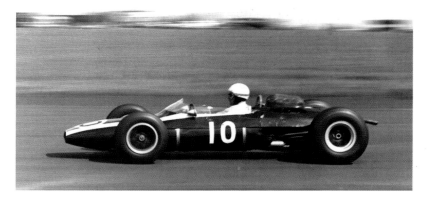

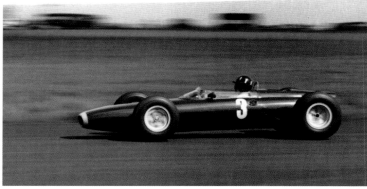

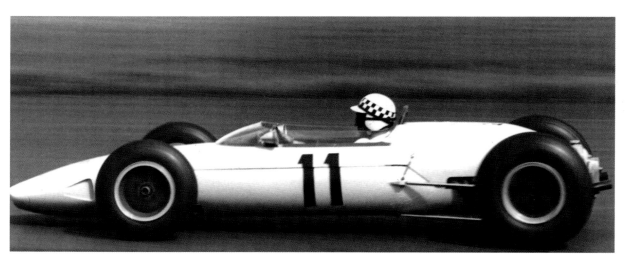

Braking for Woodcote – Innes Ireland, Phil Hill, and Graham Hill

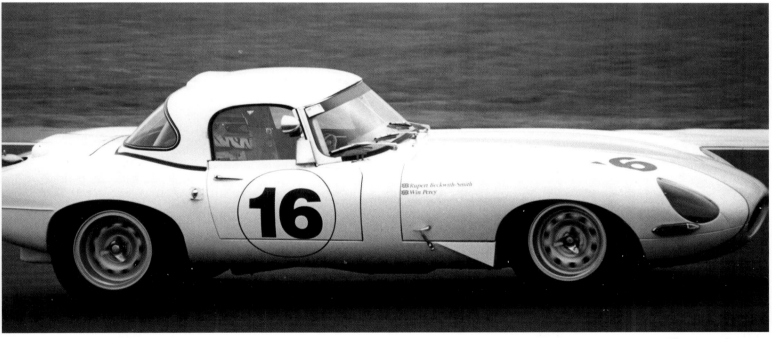

Silverstone Spectres:
E-type Jags, 1963 and 2000

Panoramic pit scene

held on the club circuit in 1962. Dizzy Addicott took me and my mother up in his van, towing his race-winning, boundary breaking, fearsome looking black Lotus Buick 15, numberplate DIZ1. Two months earlier the car had been the feature of a track test in *Motor Racing Magazine*. Our pits were separated from the main straight by nothing more than a line of oil cans. Beside us was a single seater we could not identify. Its owner told us: 'It rejoices in the name of Fred, which stands for Ford Rear Engined Device!'

After a few laps in the Lotus to 'make sure everything is screwed together' Dizzy drove into the makeshift pits, plonked a helmet on my head, and sat me in the passenger well with no actual seat or safety belt. Once on track he did not hold back. I clung on for dear life as the wind got under my helmet, pushing it back and making my eyes water. I was not afraid, just totally in awe, watching Dizzy saw away at the wheel. The car was obviously a handful, lurching from understeer to oversteer, with far more power than grip.

I was not yet 12. Thank goodness 'Health and Safety' had yet to be invented.

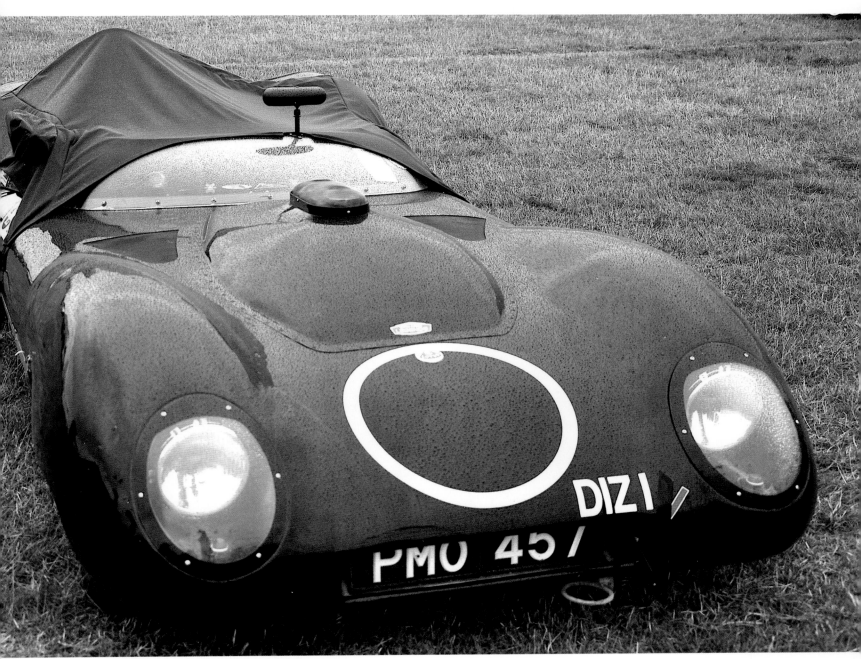

Dizzy's Lotus-Buick, restored, at Goodwood

Chapter 6
Dizzy Heights

There is an unsung hero whose name will surely ring a bell if you frequented Britain's circuits in the early sixties. It also appears in the credits of the movie *Memphis Belle*, as captain of the B-25 Mitchell stunt aircraft.

'Dizzy' Addicott was an ace test-pilot, and a rapid privateer racer who often took the fight to those whom the Goodwood Revival loves to honour. Above all, he was my mentor, hero and pal, and always looked out for me in my dark school days. He was a rough diamond, a passionate photographer, womaniser, raconteur, rebel and revolutionary. He had the bright idea of sticking a large American 'lump' into a British sports-racer. Thus, with his fearsome and triumphant Lotus-Buick, he became the spiritual father of CAN-AM. As Harry Palmer would say, 'Not a lot of people know that.'

The late John Blunsden, in his track test of the car for the August 1962 edition of *Motor Racing* reported: 'Dizzy likes living dangerously. Some of the things he does as a matter of course, such as locking up a Swift's wheels at around 200mph "to check the coefficient of friction with the runway" would turn the average man's blood to water, so it comes as no surprise to hear that when he goes motor racing he prefers a real hairy motor car, "something that will get the old adrenalin juices flowing."'

As Dizzy put it to me: 'I like to go through life with a little bit of fear, and the Lotus-Buick gives me just the right amount.' After sampling it in the wet, I know exactly what he means!

I have never forgotten his home telephone number, nor the timbre of his voice when he answered: 'Walton 24837'. He told me that my headmaster's frequent calls to the aerodrome, complaining about the air traffic over 'his' school, were always treated with disdain. This inspired Dizzy to repeatedly buzz the school one afternoon at less than minimum height in his Swift fighter jet. Sadly the headmaster was out, but it made me feel like a million dollars, and certainly gave me the 60s schoolboy equivalent of 'street cred'.

He took me on several racing exploits, and I loved being his young sidekick in the paddock. In 1964 he invited me and my mother to the Farnborough Airshow. As his special guests we spent the day in the pilots' enclosure at the end of the runway, a tremendously exciting vantage point which enabled some great shots of classic aircraft. He invited the legendary test pilot John 'Cat's Eyes' Cunningham to have lunch with us, which was an added thrill.

We lost touch when I was about 16, and would not meet again for over 30 years, shortly after the initial Goodwood Revival.

Farnborough Air Show Gallery

Red Arrows

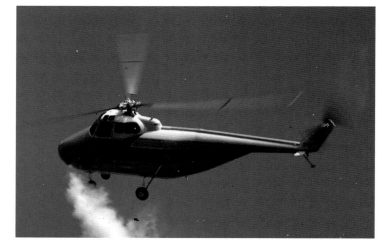

Whirlwind helicopter

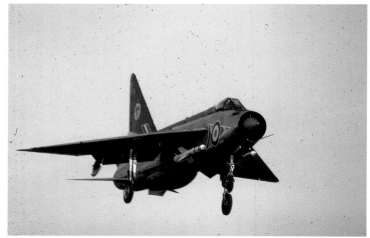

English Electric Lightning

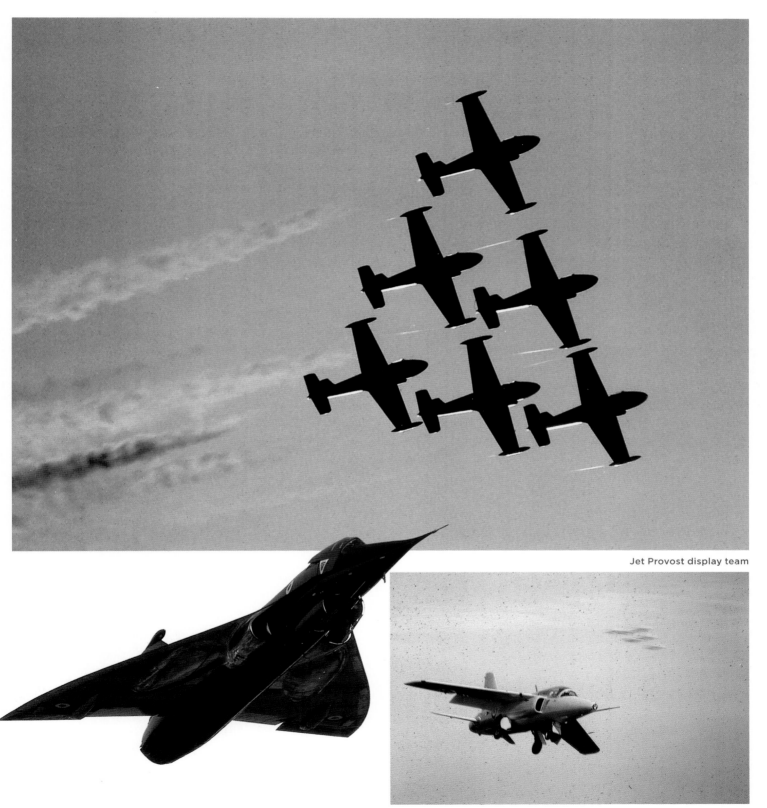

Jet Provost display team

Delta, modelling 'droop-snoot' for Concorde

Folland Gnat

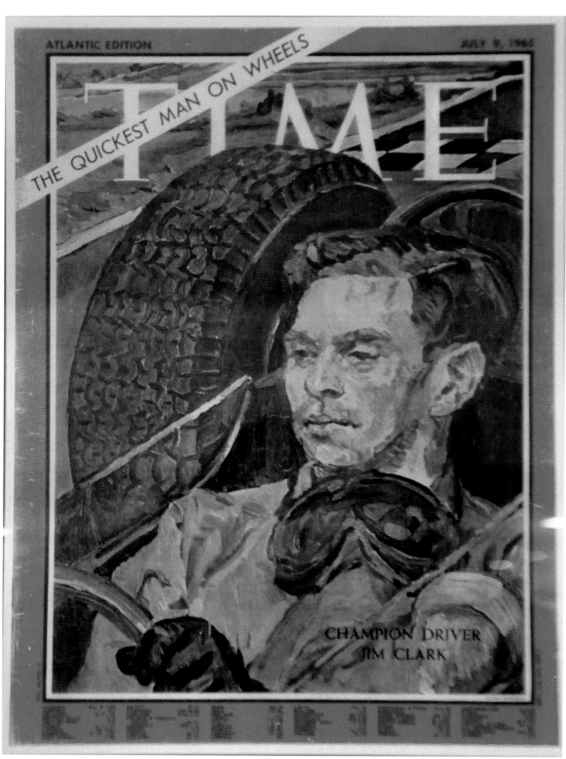

Jim on cover of *TIME* magazine 1965

Chapter 7
The Day the Music Died

'Where were you when Kennedy was shot?' This was a frequently asked question back in the day. I remember exactly where I was, and the hushed tones and concerned looks on the faces of my headmaster and his coterie.

Such events create shockwaves, uniting people all over the world. As I emerged from Kensington High Street tube station one sunny September afternoon, I saw a stark headline on an *Evening Standard* poster, and time stopped. 'Hendrix dead' was all it said. Jimi was my idol. His poster hung on my bedroom wall and I was obsessed with learning his licks.

So it had been with Jim two and a half years earlier. He was the driver I most loved. His effortless talent, his smile and his modesty gave him an aura of quiet invincibility in an era when the driver was particularly vulnerable, as demonstrated by Moss's accident at Goodwood. He was peerless - a multiple World Champion, effortlessly the quickest of them all. He could step into any vehicle,

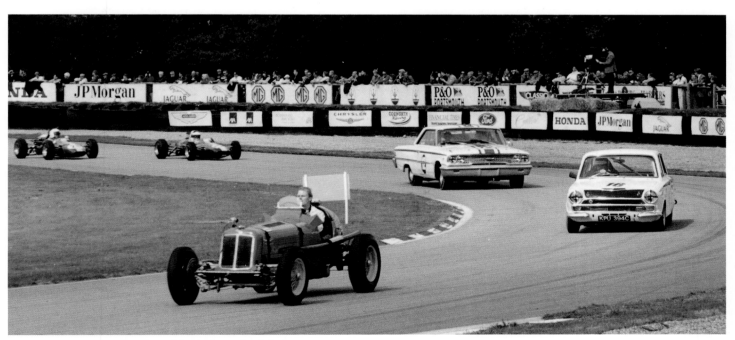

Goodwood Revival parade of Jim's cars

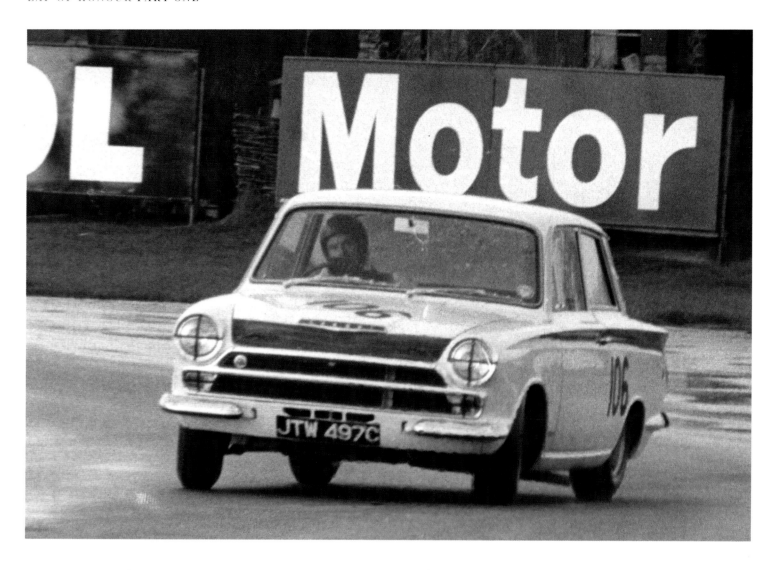

from a vintage ERA to a state of the art Indy single seater, and outdrive anyone. He was the benchmark. Etched into motor racing memory is the image of his blue bubble helmet poking out from the cockpit of his beautiful Lotus 25, sailing to victory, inch perfect. Or picture his Lotus-Cortina, out of shape but never out of control, waving a front wheel to his fans on the inside of Bottom Bend at Brands, on the way to winning the British Saloon Car Championship. Such versatility, particularly from a World Champion, could never be demonstrated today (except perhaps at the Goodwood Revival by the likes of Barrie 'Whizzo' Williams).

MM MOSS MOMENT

TH *"This is one of my very early photographs. You know who that is? Perhaps 'The Man' in Lotus-Cortinas."*

SM *"Is that Clark? It looks like him. Did you take that?"*

TH *"Yes, when I was very small!"*

SM *"It's a good picture!"*

I am young enough to remember seeing Jim win in Grand Prix cars, saloon cars, and sports cars, all on the same day.

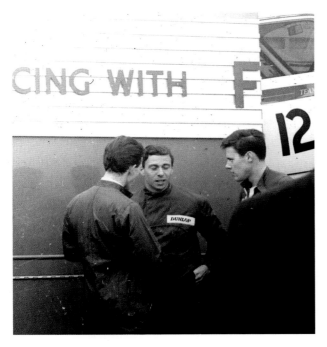

Jim was the one driver you would most want to run into. Early on race morning at Aintree, I came across my hero standing in the middle of the paddock with a friend. There was no-one else around. They were engrossed in the latest edition of *Automobile Year*. I heard him say to his mate, 'That's a bit naughty!' Sensing that this inquisitive youth beside him was itching to sneak a peek, he graciously lowered the book, allowing me to see a full page image of him at the British Grand Prix, inches from the camera with both inside wheels on the grass, kicking up the dirt. I later bought the book. The caption reads: 'Farmer goes grazing. Jim Clark takes a

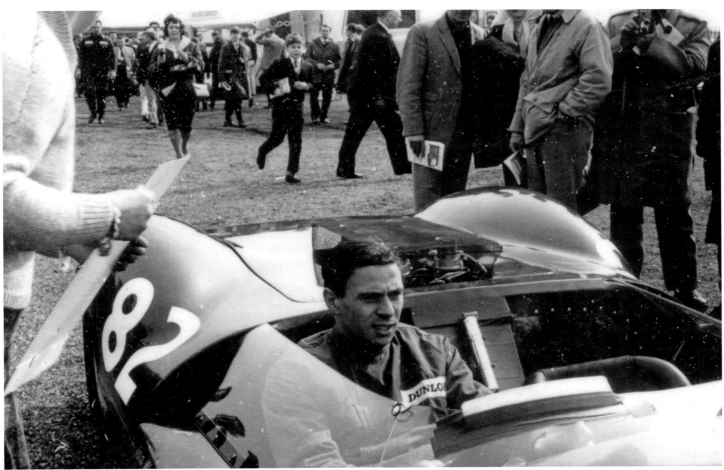

shortcut through Melling Crossing on his last, winning lap.' He
was probably playing to the camera. He certainly had a reputation
for alerting photographer friends to be ready, and then on the
following lap 'posing' with a photogenic four-wheel drift.

 He seemed untouchable, yet his life was suddenly
snuffed out in a relatively insignificant race, driving a car that was
not even competitive on the day. They reckon it was a deflating
tyre which caused him to lose control on a damp track, and fly
into the trees lining the circuit. Chris Amon expressed the sense
of vulnerability felt among the drivers when the news hit the
paddock: 'If it can happen to Jim, it can happen to any of us.'

 That same disbelief reached high into the French Alps,
to the village of Chamonix where I had been placed with a French
family, prior to re-sitting my A-level exams in the hope of making
me eligible for an interview at Oxford. When I heard of his death
I sat on my bed, speechless. The son of the house, who had never
previously admitted to an interest in motor racing, shook his head
and simply said: 'Pas Clark. Pas Jim.'

'Pas Clark. Pas Jim.'
This was my
'Kennedy moment.'

This was my 'Kennedy moment.'

I didn't yet know it, but I was done with motor racing. Several days later I was sitting in a cafe with my father who had driven up from his Lausanne home to visit me. In the corner, on an old black and white TV, The Aynsley Dunbar Retaliation, a British blues band, was beaming in live from Paris. 'I got a whisky-head woman,' growled Victor Brox, the burly organist and vocalist. I watched intently as the lead guitarist, John Morshead, played scintillating fills on a big blond Gibson.

I got the blues, there and then…

LAP OF HONOUR

Part Two REVIVED!

"In which this schoolboy photographer takes a Lap of Honour, and ends up hitching a ride with the greatest legend of them all."

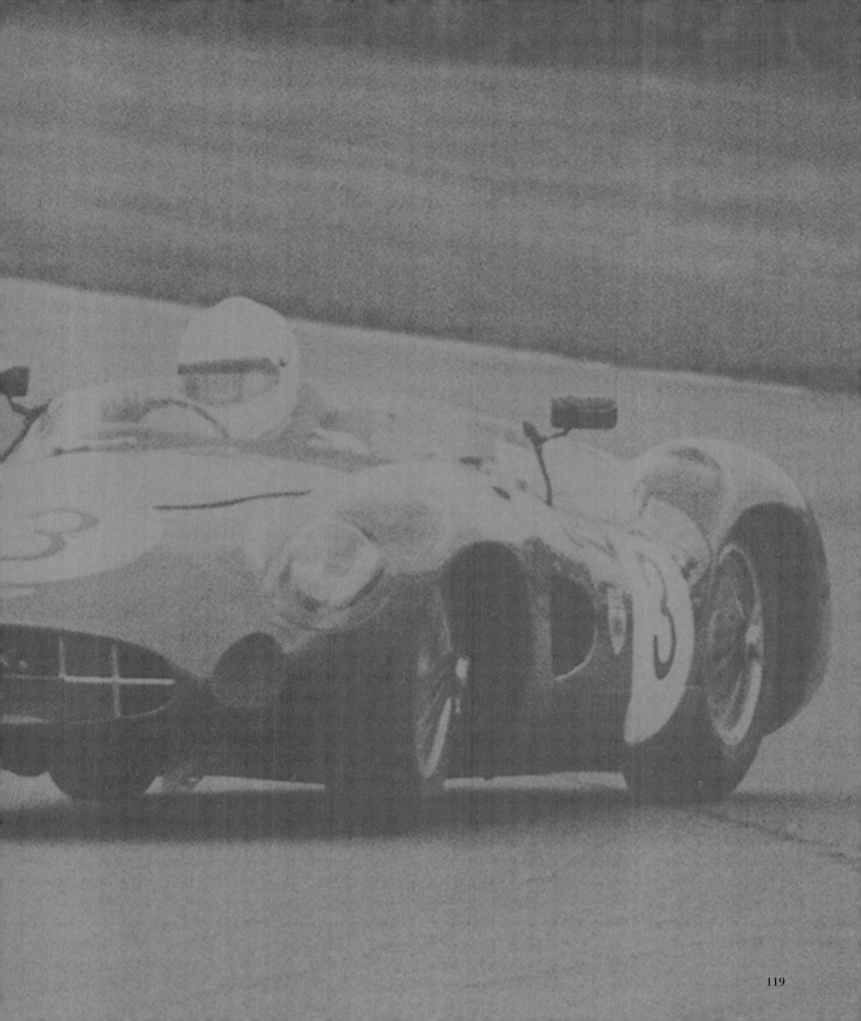

Chapter 8
Country Roads Take Me Home

Sunday morning, 20 September 1998. I wake up far too early with the sunrise in my eyes. I rouse my new girlfriend (and wife-to-be), put on my 'period' pants, shirt and tie as requested by our host Lord March, and load the first of many films into the 'period' Pentax I have acquired specially for the day. This vintage piece has set me back £120, complete with 400 mm lens, similar to the one I used to have. I'm all set for a 'Magical Step Back in Time.'

We are soon wending our way along sun-dappled leafy lanes and over the Sussex downs to the newly re-opened 'Home of British Motor Racing,' closed since 1966. My 75-year-old mother, who took me to my first race meeting here 36 years earlier, is with us. To mark the occasion she has packed a hamper, including white wine.

Joining the inevitable traffic queues, we are welcomed by Spitfires, Messerschmitts and Mustangs in the sky above. It is still barely 9am. There is magic in the air, and excitement in my belly. On the ground the Ghosts of Goodwood are coming back to life. Beautiful chariots, some driven by their original drivers, are once again joined in combat. The whole breathtaking spectacle revives memories, and fills the senses with sights, sounds and smells to die for.

"There is magic in the air, and excitement in my belly."

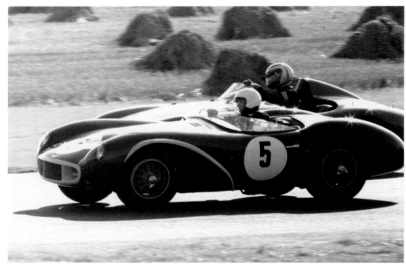
Sun glinting on bodywork...

Cover of race programme

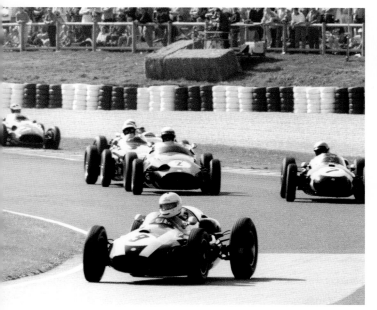

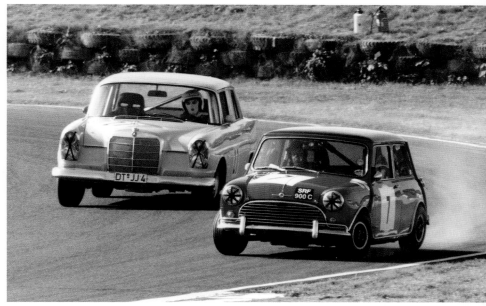

Single seaters – F1 Cooper leads Saloons at Lavant

Somebody has turned the clock back four decades, welcoming me back to the best days of my youth. I dash about with all the energy of a 12-year-old in pursuit of his next picture. The whole process quickly becomes second nature: Set shutter speed and aperture; review depth of field; find a mark on the tarmac and focus on it. Not easy hand-holding a 400 mm lens, especially with no 'autofocus'. Ready, aim, hold your breath - here they come! My viewfinder is once again filled with glorious old Astons and Ferraris, ducking and diving, sun glinting on bodywork.

This is a hallowed moment in time-stood-still; a return to sanity in a world gone round the bend; sunshine, hay bales and a golden harvest of memories come alive. Stirling Moss is once more behind the wheel, and a pre-teen enthusiast is born again. All's right with the world, and God's in His Heaven. Or is He?

The voice of Canon Lionel Webber bursts over the tannoy breaking off from his morning prayers and track blessing. Like an excited schoolboy he exclaims:

'God's not in Heaven this weekend, He's here at Goodwood. If He's not, He's crackers!'

Canon Lionel Webber: 'I got in a lot of trouble for that! (laughs) A lot of the more fundamentalist evangelicals thought it was blasphemy!'

TH *"God doesn't drive racing cars!"*
LW *"Oh yes he does!"*

God's not in Heaven this weekend, He's here at Goodwood.
If he's not, he's crackers!

Such Treasures We Bring...

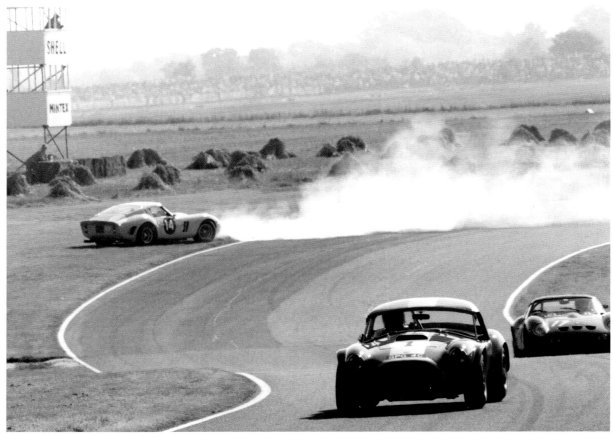

...only to fling...

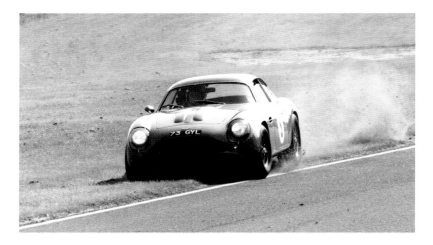

...our priceless machinery...

'Such treasures we bring, only to fling
Our priceless machinery
At the warm and welcoming
Sussex scenery.'

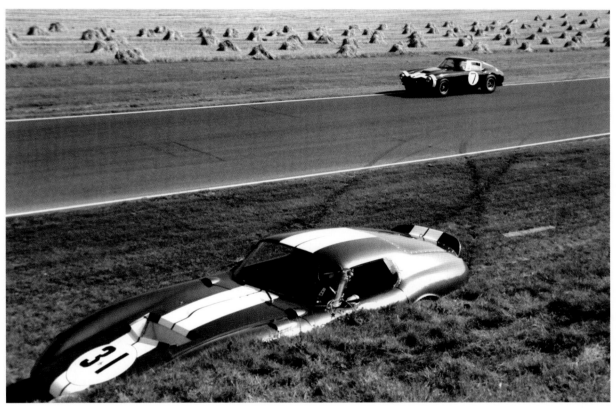

...at the warm and welcoming...

...Sussex scenery

Still in the Blood

I stand at the approach to Lavant Corner, gazing expectantly up the road towards St. Mary's. Opposite me, acres of cornfield bathed in golden sunlight stretch towards the South Downs. Once again I have come to play at the foot of these hills, and once again, I rest my eyes on their familiar contours - the unchanging backdrop to countless classic images of racing cars on the limit.

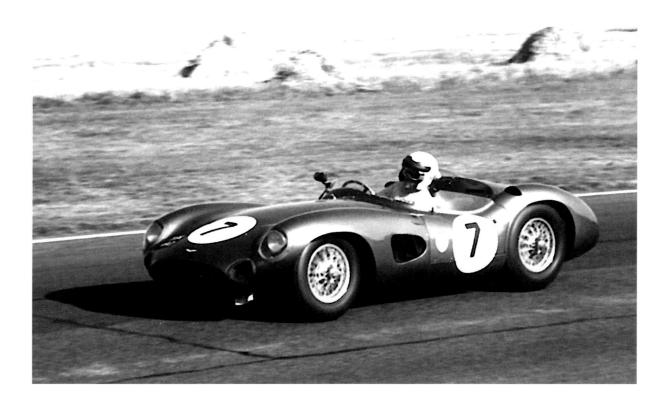

"He's still the one to watch whether in first or last place."

The green Aston Martin lunges into view, diving into the dip on the exit of the left hander where the car goes light as you put the power on - too much too soon and you're off for a picnic in the corn. The driver judges it perfectly, using every inch of the road. Number 7. White helmet tilted left into the curve - who else but the Maestro himself? Sixty-nine years and two days old and he's not hanging about. Just as on that mystical Easter Monday 36 years ago, the first and last time I'd seen him race, he's still the one to watch whether in first or last place. Now, nearly four decades later, I marvel at the magic of the man and at the spectacle unfolding before me.

I'd observed others entering the braking area for the double-apex right hander to come. Willie Green in the scarlet Ferrari, an ace in cars of this ilk; Martin Brundle, fresh out of Formula One in John Coombs' bright yellow D-type. Both have been swapping places with the Old Man throughout the race, and he isn't letting them off lightly.

Into the braking zone he comes. Yup! No doubt about it. He's still managing to hit the anchors two car lengths later than anyone else.

'Still in the blood after all these years,' I'm thinking. 'And he's not out there today just as some bloody celebrity!'

As he himself would say: *'One's a racer or one's not'*.

"I'm not as fast as I was.
I drive as hard as I used to, but my balls are smaller..."

MOSS FOUR YEARS LATER, REPORTING IN *AUTOSPORT* ON HIS DRIVE IN AN AC COBRA.

Chapter 9
Revelations of a Gentleman Racer

A history lesson with Eric Thompson – May 2000

The late Eric Thompson was a true 'gentleman racer' of the post-war era. We met on a sunny afternoon in the first spring of this new Millennium at his home in the heart of Surrey. It was an afternoon full of surprise and revelation concerning the sport we love…and my family history! He and my mother were obviously an item before I was born. Together they travelled Europe in pursuit of motor racing adventure.

His semi-professional career behind the wheel was not without distinction. Stirling Moss remembers him as '…a good driver, a proper amateur. A lovely man.' He began competing in the late 40s, as the post-war world was slowly getting back to normal. 'After the war we were given a gratuity of 340 quid, having served in the army for five years. Some of us spent it wisely. I bought an HRG!' In 1949 he placed 8th at Le Mans in it, winning his class with Jack Fairman. I asked him about my mother's role in the team. His response was: 'She was very good on the watches.' As the official timekeeper, she was totally committed and only went to the loo once in 24 hours, so she told me. 'She'd had good practice at the Montlhery 12 hours!' he said. Thus, devotion to the sport was indelibly etched into my genes.

The economic climate was very different then, and sponsorship unheard of. 'The problem as a racing driver was we only got two weeks' holiday a year. Just enough to go to Le Mans or Montlhery. The rest of the weekends we would turn up on Saturday, practise, and race in the afternoon. There was never any testing. When I finished with the HRG, an outdated thing, I bought a 1,000cc Cooper with a Vincent engine. The only chap who knew how to tune these things was a chap called Jack Surtees. Massive man. Used to pick up the engines just like that! There was this little 12-year-old lad running around - John! Later I was under contract to Aston Martin for five years. The first year's retainer was 25 quid!' He laughed at the absurdity of this figure - barely enough to buy a round of drinks these days. It was worth a bit more then. 'Stirling was also under contract and he got 50 quid!'

This led to victory in the 1953 Goodwood 9 Hours. Looking at a photograph of him in the winning DB3S he recalled: 'We burnt a car the year before. It was a regular feature!' A second fire in the pits during the Tourist Trophy race some years later destroyed the works Aston of Roy Salvadori, who narrowly escaped serious injury. A pall of black smoke from the car famously rose high into the Sussex skies. Moss was Salvadori's co-driver. He took over another team car and clawed back a sizeable disadvantage to claim victory.

Stirling was the first truly professional racing driver, but Eric had other fish to fry: 'I was unable to go to places like Sebring and the Mille Miglia - I was an Insurance Broker at Lloyds insuring ships like the Hains'!' More laughter. The Hain Steamship Company, founded by my great grandfather, accounted largely for the family fortune. The fleet heroically shipped supplies in wartime, and many vessels were sunk by enemy submarines.

'She was very good on the watches. As the official timekeeper, she was totally committed and only went to the loo once in 24 hours, so she told me.'

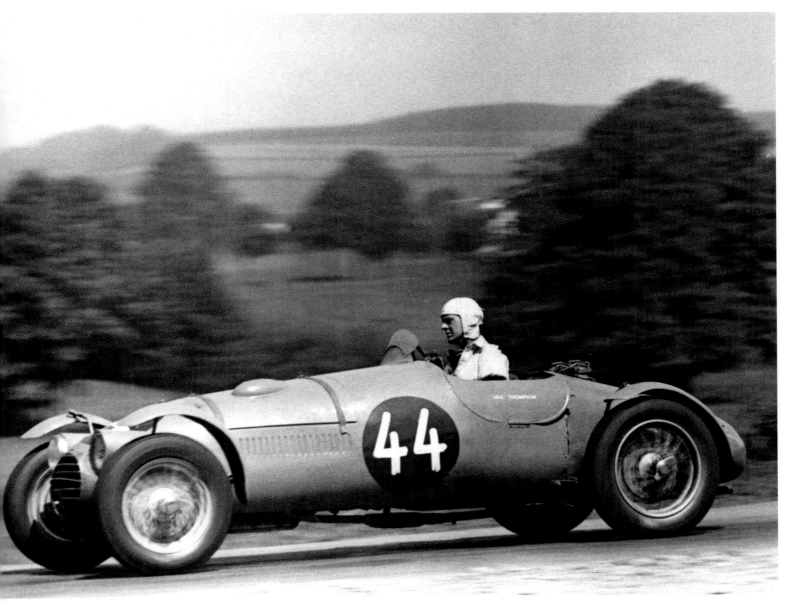

Louis Klementaski shot
of Eric in HRG

We both had concussion.
We drove with bandages round our heads!

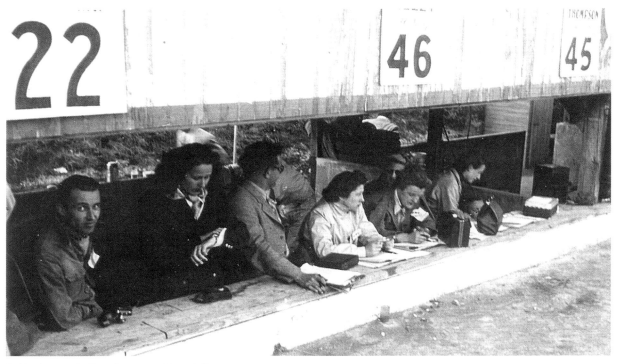

Author's mum in the pits, second from left

Eric was part of a lively social scene at my family home before I was born. He told me it was the happening place for parties, poetry readings, and music, or in plain English, wine, women and song. 'We all used to meet up at the Running Mare pub in Cobham (whose walls to this day are adorned with photographs of racing cars), but then, sadly, we have to earn a living!'

'There's someone you might recognise,' he said, handing me a photograph: It was indeed my mother doing the timekeeping for the Douze Heures du Paris in 1948. 'Pretty strenuous! She's in the pits, which were the pits as you can see - ground level. The night before, Robin Richards and myself were savaged by a "camion" ('lorry' en anglais), head on. We both had concussion. We drove with bandages round our heads!' He handed me another picture - of President Auriol presenting him with the trophy for his class win at Le Mans. There was my mother again!

Eric and author's mother, Eastbourne 1948

He seemed to enjoy winding me up. 'Eastbourne Rally,' he said, handing me another print, with a mischievous grin. The glamorous girl in the passenger seat convinced me that he and my mother were more than friends. There's a delightful story behind this picture which illustrates the ingenuity of the dashing post-war pioneer and his thirst for adventure:

'If you wanted petrol in Cobham during rationing you'd go down the hill to the bridge, and there was a guy there who sold flowers. You'd go up to him and say, "got any buns for the elephant?" He'd say "How many do you want, guv?" "Ten gallons please!" And he'd give you coupons for ten bob. It was an absolutely wonderful black market situation and your mum and I had enough petrol to get down to the Eastbourne Rally in my MG TC, to compete against all the HRGs and things. By some fluke we got a Premier award, and because of that Robin Richards asked me to join his team to race at Montlhery. We

"Got any buns for the elephant?"
He'd say "How many do you want, guy?"
"Ten gallons please!"

Barrie Williams slides Connaught, Goodwood 1999. "That was the car I drove, that very car! It went to Johnny Claes (in Belgium) and they painted it yellow." Eric finished fifth in the British Grand Prix with it

were very limited as to what we could do. People would run on funny mixtures of God knows what! The man with the coupons certainly helped.'

At the start of the Millennium Stirling Moss declared: "Grand Prix racing today is a great occasion, but not a sport." Here we were harking back to a time when motor racing was both. Life was simpler then with a straightforward solution to every problem. 'Whenever we broke down it was always "the plugs". We didn't blame the tyres or gearbox, It was the plugs! Oiled up! I don't know what KLG or Champion used to say about that!'

We moved from the living room to Eric's study, packed neatly with motor racing books and back issues of *Motor Sport* spanning decades. We bemoaned the diminishing of ethics and honour, and the creeping disease of commercialism. 'It's the same in any sport isn't it? Perhaps rowing is the only one that still remains slightly amateur! The drivers are unable to speak honestly. They're programmed. The scene changed when engines went in the back, and with all the advertising. No "BRDC" (British Racing Drivers' Club) badge on their overalls! No room for it today…'

'Whenever we broke down it was always "the plugs". We didn't blame the tyres or gearbox, it was the plugs! Oiled up! I don't know what KLG or Champion used to say about that!'

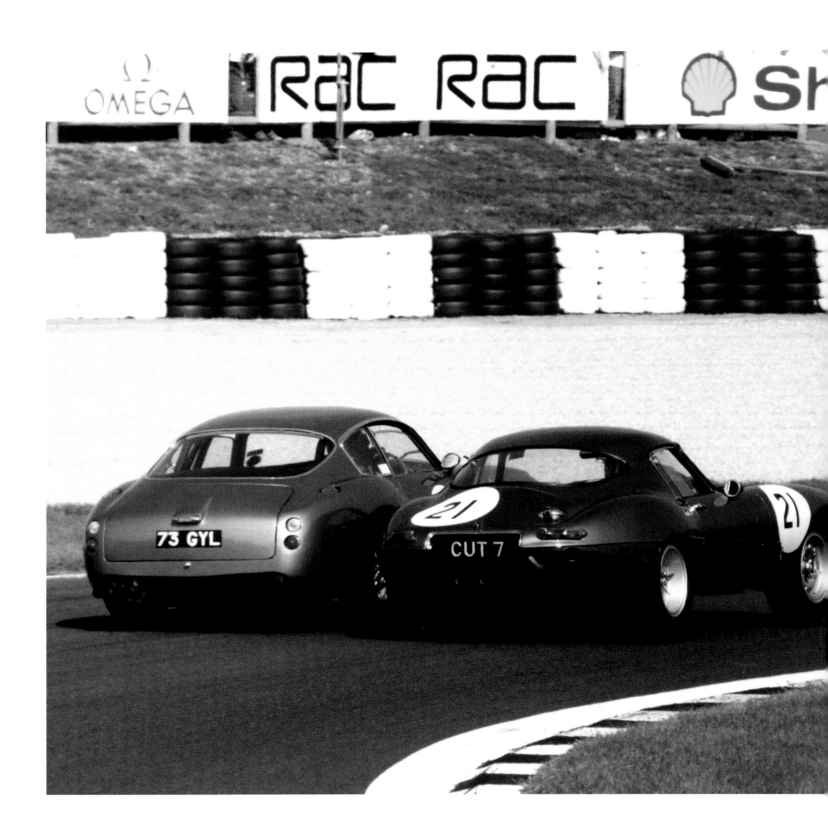

We agreed that the Goodwood Revival has successfully recaptured the magic of that era, although Eric had reservations about the driving standards, given the costly accidents which befall these priceless vehicles.

Appropriately, Eric took part in the first Revival, on a Parade Lap. 'I was due to drive my DB2, the Le Mans car, but we entered it in the TT and at the drop of the flag the driver ran across the road, jumped in, put it into gear and broke the back axle, so I couldn't use it. Rowan Atkinson

Revival '98: E-type and Zagato in close proximity, 1998 Revival. Eric poured scorn upon so-called 'professional' drivers who rub doorhandles 'and then hand it back to the owners without even saying thank you!'

had another DB2 which he very kindly lent to me for the parade. I took my granddaughter who was then twelve down to the Goodwood Festival of Speed and introduced her to Stirling Moss. Afterwards she said "Oh dear! I had hoped it would be Rowan Atkinson!"

It is all too easy, he said, to view the past through rose-tinted spectacles. Stirling Moss and writer Simon Taylor have both observed that the past is not better, merely different. Undoubtedly that is correct, but I know which era I prefer. Stirling has admitted that he was glad he was involved "when the pleasure was there", even if the perils were far greater.

My father told me that Mike Hawthorn's body was found on the back seat of the Jaguar in which he died on the Guildford bypass. A trick to lessen the impact of an impending accident was to jump into the back. 'Yes, I've heard that,' said Eric. 'You must be jolly agile!' he laughed. 'There were all kinds of theories, like hand operated throttles he was experimenting with.'

I said I had read in *Motor Sport* that Hawthorn had some terminal illness - he knew he was going to die which gave him extra courage. Eric was having none of it: 'I don't think so! Fat feet or something from excess of alcohol!' Wikipedia claims: "The impact caused Hawthorn fatal head injuries and propelled him onto the rear seat" and that he was racing (team owner) Rob Walker in a Gullwing Mercedes on a wet road…

'Peter Collins - that was a tragedy. In those days it was horrendous. One year, something like twelve or fifteen people were killed throughout the motor racing world.' We discussed Spa 1960, when two people were killed and Moss had a serious accident; plus an early Tourist Trophy at Dundrod, in which four drivers lost their lives, and of course Imola in May 1994, when Barrichello nearly lost his life, and Ratzenberger and Senna lost theirs - the first fatalities in a decade since Elio de Angelis burned to death.

Eric summed up how things have progressed regarding safety, but not necessarily for the good of the sport. 'These days you can have your accident at 190 mph and cut your finger! Stirling is very positive that an element of danger has to remain, which it doesn't.' Stirling's point is simple: No danger, no respect.

Attempting to lighten up the conversation, I told Eric about my high speed passenger ride around Goodwood with Pink Floyd guitarist David Gilmour. That mischievous glint returned to his eye:

'You in your 928 were at far greater risk than any Grand Prix driver today,' he said, pausing to let it sink in. 'That gets the adrenalin racing!'

With that, our good-humoured, enlightening and nostalgic exchange drew to a close. I was happy and humbled to have met the man who had introduced my mother to the world of motor racing, and was thus partly responsible for my own obsession.

'You in your 928 were at far greater risk than any
Grand Prix driver today,' he said, pausing to let it sink in.
'That gets the adrenalin racing!'

Aston DB2 similar to Eric's, in the Goodwood paddock

Chapter 10
Don't it Make You Dizzy?

Dizzy Addicott – The 'Unsung Hero'

The inaugural Revival inspired me to track down my old mentor and pal Dizzy Addicott, after 33 years apart. It was a joyful reunion, despite an initial scare. He opened his front door and fell into my arms, unconscious. I feared the worst, but he quickly awoke, and apologised for being narcoleptic. I remember he did love a nap, but his flabbergasted me. I asked him how he had got away with it, given his profession and pastime: 'My excuse was that I'd been with a bird the night before!'

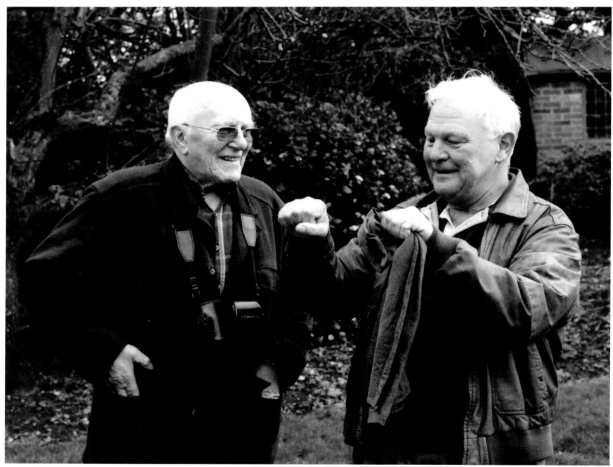

Dizzy with former mechanic John Dabbs

Dizzy aged 78 on his recently acquired BSA bike

Dizzy pretending to lift the engine of his motor cycle

Dizzy was always a feisty free spirit, at peace on the edge. He relished pushing the envelope in any suitable vehicle, be it the Lotus-Buick, or his jet-black Swift fighter jet. He met and impressed my mother at Goodwood in 1961, on a day when he took a win and a lap record. He subsequently dated my sister half his age. Having made repeated low passes over my school one afternoon in the Swift, he invited me to the aerodrome and let me sit in the cockpit. During school holidays I would accompany him on his racing exploits, which included that unforgettable ride in his mighty Lotus.

Known as a 'type hog', he flew a wide variety of aircraft, and raced everything from Cooper 500s in 1952, to Vauxhall and DKW saloons in the 60s. He shone brightest in sports cars, but in 1961 he gladly accepted a last-minute opportunity to race Hugh Dibley's Formula Junior Lola at Goodwood, thanks to an irregularity with the owner's licence. "Unaccustomed as I am to driving one of these darn things…" he said, having never previously sat in the car. He won, giving Lola their first rear-engined Formula Junior victory. This, and other wins and fastest laps are listed in the book *The Glory of Goodwood*. He achieved similar results at most circuits.

He serially owned and raced three Lotuses. The first, a humble road-going Seven, netted him second place in a wet 'Formula Libre' race at Brands Hatch. *Autosport*'s 'Driver of the day' accolade read: "Dizzy is a test pilot on the mighty 'Valiant' bomber. Afterburners not allowed, sir!"

Next came the Eleven, his favourite. 'I'd always lifted off slightly for Fordwater, until I took my heart off the windscreen and left my foot hard on the loud pedal. I went onto the grass on the outside, clipped the apex aiming for the grass at the far end, and a photographer friend waved at me. I took my hand off the wheel and waved back a "V" sign! I wish I hadn't because suddenly the Eleven went sideways! I left my foot hard down because the car was very forgiving. If you had the courage, you could keep going whatever the car's attitude - the de Dion back end would sort it out. From then on I went through Fordwater "Harry Flatters", but with both hands on the wheel!'

A desire for something hairier inspired him to purchase David Piper's Lotus 15 on the way home from Oulton Park. In went the Buick. Despite its success and charisma, this groundbreaking hybrid was 'an appalling car to drive, not nearly as good as the Eleven. Colin Chapman made a complete hash of the rear end. If I'd had any sense, I'd have bought a Lotus 23 and stuck the Buick in the back of that. That would have been uncatchable! You can get 500 horsepower out of those Buicks nowadays.'

Dizzy with
Marcus Pye,
Silverstone 2000

If I'd had any sense, I'd have brought a Lotus 23
and stuck the Buick in the back of that.

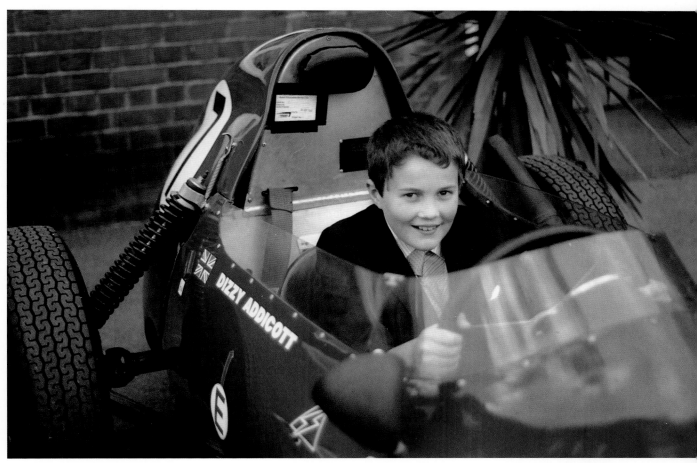

Dizzy's grandson seated in
Elva at Brooklands

In 1962 he drove for Elva. He bagged five class wins, a second, and several lap records in six starts, including a giant-killing 7th overall at Brands Hatch in a drenched International Guards Trophy. The Elva's handling was markedly inferior to that of its main rival, the Lotus 23, which Dizzy beat 5-1. 'At Snetterton Jimmy Clark came over and said "Dizzy, that looks a real handful. I was following you and in every corner you had at least three wheels off the ground!"' Despite his results, he was dropped by Elva for 'not taking things seriously enough.' Furthermore, the sponsors took a dim view of an old codger outpacing the fashionable young hotshots they wanted to hire.

When invited to test a Lotus 23, his friend Mike Beckwith warned: 'Remember what Chapman's like - if you break it you pay for it!' 'I didn't try terribly hard. I did three laps. But the second was 2.6 seconds quicker than the works driver. Mike Costin said "Dizzy, you drive far too fast for an old man!" And that was the end of that.'

He didn't give a stuff about fame, and his disdain for authority and protocol often got him into trouble. Having qualified a tiny DKW an astounding 4th amongst Galaxies and suchlike in a Silverstone downpour, due to some special Michelins pumped up so hard they 'effectively sliced through the water', Clerk of the Course John Eason Gibson cautioned him for driving 'dangerously fast'. John Dabbs, Dizzy's longtime mate and former mechanic back in the day, reckons it was Dizzy's typically robust response that got him banned from the meeting.

Dabbs, who once worked for Nick Mason's 'Ten Tenths' stable, was responsible for squeezing the 3.5-litre V8 into the Lotus. He and Dizzy shared a den of iniquity – a bachelor flat in Walton, whose occupants worked for an undertaker. 'I was looking after the Lotus in a funeral yard,' Dabbs recalls. 'We had to check we weren't sending funeral cars out with Diz asleep in the back. He was a test pilot but had a sleeping sickness! At Goodwood there was a hold-up on the startline and he nodded off. Next thing "Gloves" Cade (clerk of the course) is shouting "Get that man off the grid, he's asleep!" I managed to wake him in the nick of time, and he went on to win.'

'One year Diz broke the up to 1,500cc sportscar lap record with his Lotus 11,1220 Climax at 1' 35" dead. They refused to acknowledge it, because it was held by Jean Behra in an RSK Porsche. They didn't believe he could have done the time. But he had!'

Dizzy's innovations were oft thwarted by poor business sense. At the Racing Car Show in 1963 he launched the DART, which to his enduring regret became the Mini-Marcos, with no credit to him.

He also planned an assault on the world land speed record. 'I bought a Swift. I planned to take off the outer sections of the wings, and fair in the undercarriage. After doing high speed landings on a wetted runway with touchdown speeds of over 350 miles an hour, I figured I hadn't got to go much faster to break the record. 410, I needed. What if I put two BS605 rocket motors in the stub wings? Rolls Royce offered me 15,000lbs of thrust with modified reheat - which would have given me 23,000lbs of thrust in a machine that weighed only 15,000 lbs. It had a much higher power to weight ratio than a modern Harrier. It would have been too easy - the cheapest land speed record ever! My British Aircraft Corporation bosses put a stopper on it. I could have gone ahead but I needed a job, so it came to a grinding halt. Theoretically, it could have gone supersonic.'

Dizzy, whose widow Judy was once Stirling Moss's secretary, is fondly remembered by his more renowned contemporaries. At an early Goodwood Revival meeting, David Piper asked me to 'give Dizzy my best. He's a star.' Jack Brabham is unlikely to have forgotten him. In a sports car race at Brands Hatch the wily Australian was outfoxed by Dizzy: 'Somehow I appeared on the front row alongside such luminaries as Jack. In order to maintain my advantage I mentioned that there was oil on the first corner. Jack said "You're jokin' sport!" John Coombs lit about four cigarettes at once! I said "They're cleaning it up, but I'm taking it dead easy first time around." Of course there wasn't any oil, and when the flag dropped I went hell for leather into Paddock and built up quite a lead!'

He drove me to the 1999 Revival in his rapid Golf. It took me back thirty years. He flung the car over the Sussex downs, flair undimmed, describing in intimate detail the 'birds' he once enjoyed on those roads. He recalled nearly losing the Eleven on a daunting downhill bend near Goodwood racecourse. He was towing it, and the trailer got into a tank-slapper. He had 'crumpet' with him, and was therefore driving one-handed.

Some things never change. On our walk from his cottage into Farnham for our reunion lunch, a pretty woman gave me the eye. 'Bollocks, Tim!' said the 78-year-old, 30 years my senior, 'what have you got that I haven't got?'

After doing high speed landings on a wetted runway with touchdown speeds of over 350 miles an hour, I figured I hadn't got to go much faster to break the record.

'Some things never change' –
Dizzy with author's sister 1965

'Some things never change' – Dizzy with
admirer at Goodwood 1999

Chapter 11
Meet the Maestro

An Invite from the Maestro, May 2000

Early in the new Millennium the telephone rang. It was my mother. 'Darling, would you like to meet Stirling Moss? I thought it might be useful for your book.' I almost said, 'Is the Pope a Catholic?' But since she was raised a Catholic and never made promises lightly, I just said 'how come?'

She explained that she and the Mosses had a mutual friend in Herbert Reiss, a gynaecologist, who delivered their son Elliot, and also my niece and nephew. She gave me Herbert's address, and I subsequently wrote and made my request, enclosing an outline of a rough idea for a book based on the beginnings of this story and a copy of the picture I had taken of Stirling in the Aston. Herbert replied that he had passed my request on, along with the picture which he liked very much. He said he expected Stirling would get in touch with me direct. 'When pigs fly', I thought.

Weeks later, having forgotten all about it, I returned home after a day instructing at a kart school to find in my letter box a hand-typed white envelope with the initials 'SM' embossed on the back, in British Racing Green. Sharp intake of breath. It hit me that the Great Man had actually written to me! With disarming warmth he told me that he had read my outline and found it 'very charming.' He wasn't sure how he could help, but he would be happy to welcome me at his home 'for a chat'. Thus the die was cast for a meeting with the Maestro.

To be summoned by him was a big thrill. To then enjoy an engaging and lively hour with him was an enormous gift (see 'Stirling Talk' page 324) but when I mentioned that I wanted to photograph him in many different cars, he responded by suggesting I ride up with him the following week to Silverstone, where he would be testing an old Ferrari, which he described as an 'interesting vehicle.'

And just like that, with one generous, spontaneous, unexpected, jaw-dropping invitation, Stirling Moss laid down the track, and set the direction for *Lap Of Honour*.

"With disarming warmth he told me that he had read my outline and found it very charming."

SM letter

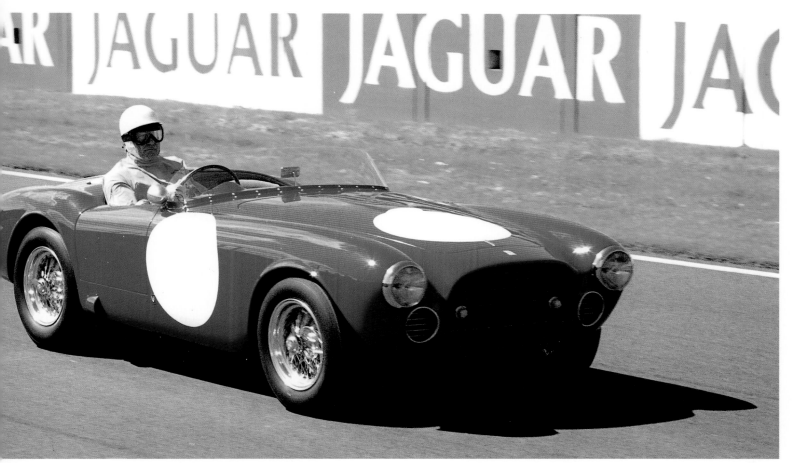

Stirling's blind date with an "interesting vehicle" turned out to be a short, fraught affair. What's wrong with this picture? There's a clue in his expression, but mostly in his posture. The 'Classic Moss Pose' at the wheel was reclined, arms outstretched. Here he is sitting bolt upright. That's what's wrong. Several years later I showed him this picture:

MM | MOSS MOMENT

TH *"Here's one you didn't like. You don't look comfortable. It had a very upright seating position."*

SM *"Oh really? I don't remember that at all."*

Say no more. Simply not his type. Thankfully, an old flame lurked in the garage – a Tasman Cooper.

Lunch Break

"Same as it ever was…"

 Stirling's session with the Cooper at Silverstone had been somewhat compromised by having to share the track with modern cars, which meant his concentration was as much on keeping out of their way as on the road ahead. Three days later, his request for separate sessions was granted. They closed the Brands Hatch short circuit for lunch to allow Moss and the car to properly reacquaint themselves. The solitary young marshal up at Druids got a kick out of that. 'It's the man himself!' he said with a smile, as I hurried along on a mission to capture the moment.

 It would be something to talk about with his mates over a pint, and a welcome change from cocky amateurs on motorcycles far too quick for their own good. He told me practice had already been halted that morning to allow the ambulance to reach one poor fool.

 Many times I had climbed this hill, but never with such intent. Here we were, just the marshal and me, privileged to be witnessing a legend at work - a locked wheel on the first lap, a touch of oversteer on the next corrected in a microsecond, and an old acquaintance forged again.

 He could relax now and enjoy himself. Head back, arms outstretched in the classic Moss Pose, turning in on the brakes, hugging the apex, making it look so smooth and easy. Same as it ever was.

A little later, I entered a suite in race control where a spread had been laid on in his honour. Stirling looked up and asked enthusiastically, 'Did you get what you want?' An enthralled and reverent Brands Hatch director was enjoying a large slice of Moss memoirs. He attempted to recall who else had raced the Ferguson P99, the only four-wheel drive Formula 1 car ever to win a race (in his hands at Oulton Park in '61). I jogged his memory. 'Jack Fairman,' I said, having recently seen a picture in a magazine.

'This chap really knows his history,' he said. I had to give credit to my seat of learning, so to speak, and told him I learn a lot reading *Motor Sport* on the loo.

We then hitched a ride in a Merc, but just to the other end of the paddock where his own Merc was parked. He did tell me when first we met, that he hates walking. We said our goodbyes. He offered me a lift into London, but sadly, I had my own car.

I asked about the possibility of borrowing a copy of what he then considered to be the definitive book about himself, *All But My Life*, by Ken Purdey. 'You'll have to remind me old boy,' he replied. 'My memory isn't so hot.'

'Except for cars and circuits!' I protested.

"He could relax now and enjoy himself.
Head back, arms outstretched in the classic Moss pose."

Chapter 12
Karting Dad

John Surtees, June 2000

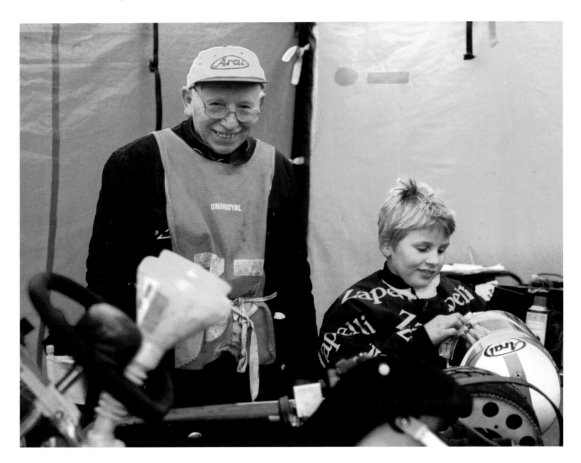

Encouraged by my auspicious meeting with "Mister Motor Racing" I decided to take a chance on pursuing another significant encounter with another significant champion.

I had heard that John Surtees, the only man ever to be crowned world champion on two wheels and four, was going to be running his nine-year-old son at a kart meeting at Buckmore Park. I was familiar with the place, having won my first race there in my second incarnation as a kart racer, in my 100cc Allkart-Parilla, prepped by 60s karting legend Bruno Ferrari.

I found the multiple champ pacing the paddock, in visible orange jacket and grey Arai cap. He looked 100% involved. I introduced myself, and explained my intention. I had heard he had a reputation for being 'difficult'. He could not have been more helpful to this total stranger.

I heard he had a reputation for being 'difficult'.
He could not have been more helpful to this total stranger.

All the competitors in the 'Cadet' class in which Henry was competing had similar equipment - 60cc Comer two-strokes, which projected these young chargers to speeds approaching 60 mph. There was very little the regulations allowed by way of tuning or modification, so it was all down to driver skill and preparation, at which John was a dab hand. It was the very same arena, the very same class in which youngsters like Jenson Button and Lewis Hamilton first turned heads and won championships.

Henry, in only his first season of racing, already looked to be following in their wheel tracks. He was also upholding the family name. In his first heat he came through from ninth on the grid to second in only eight laps, moving through the traffic confidently and effortlessly. In the second heat he went one better, from 14th on the grid. It was clear that John's unflustered, committed presence and enthusiasm were encouragement enough for his boy. During my years of kart racing, I often saw irate dads berating their poor sons for losing a place, or braking too early for a corner. Often attired in the likes of a Nigel Mansell replica helmet, some of these poor lads seemed to be there only to fulfil parental ambition rather than to have fun.

John's unflustered, committed presence and enthusiasm were encouragement enough for his boy.

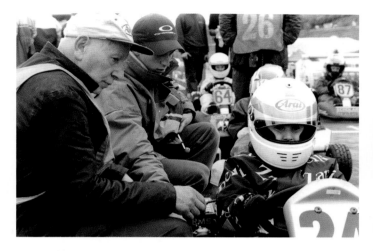

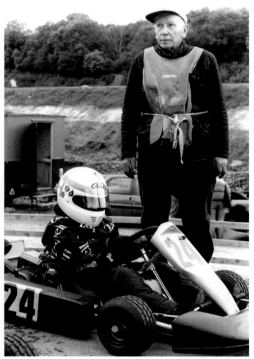

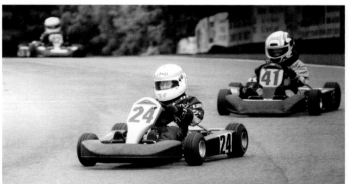

Wets or slicks?

John let his son get on with the driving, acting as 'team manager', checking tyre pressures, adjusting carburation etc. He even consulted me about whether to fit wets or slicks! I told him the first and fourth-placed guys were on slicks, but the second and third finishers were on wets. Henry was thriving. I was impressed. I missed the final since I had to be elsewhere, but I would have been very surprised if he hadn't won. Nobody bothered them. They were just another team out to play on a Sunday, part of a grass roots racing university. John was most hospitable and invited me into their pit, which allowed me some great pictures.

Weeks later, I met him in very different circumstances at the Coys Festival at Silverstone. He had just completed a lengthy stint signing autographs alongside fellow legends Jack Brabham, Tony Brooks, Jackie Stewart, Murray Walker, and Stirling Moss. He was being hustled along by two minders to his next engagement, I hailed him and asked how Henry had fared in the final I missed. 'We had a bit of a hiccup. He came third…'

Then, as the momentum of his minders swept him past and away, he stopped the entourage, turned around, and with a proud smile added '…but he won the "A" final last weekend!'

Chapter 13
Press Pass? Who Needs it?

One of these images was taken by a professional on the 'right' side of the barrier. The other was taken at exactly the same moment by this punter on the 'wrong' side of the barrier.

Sir Stirling says he prefers mine, but then he is renowned for his strong 'underdog' ethic! You be the judge, and enjoy the following gallery of images, all shot without a press pass, and with my old Pentax 'Spotmatic' film camera.

The car in front is a Brabham (driven by Duncan Dayton) and so is the bloke behind. Black Jack (In a Mac) follows one of his own in a car he would later crash at 100 mph, the 72-year-old suffering concussion, cracked ribs, and a damaged vertebra. Pink Floyd manager Steve O'Rourke was standing next to Lady Brabham at the time, as a hush fell over the circuit, like when Moss crashed in 1962. He put his arm around her and said reassuringly, "Don't worry. I'm sure he'll be alright." Her reply was pure Aussie: "He'd better bloody be – he's my ride home!"

In the sixties I was told that a fluffed gear change into Paddock meant a spin. Sure enough, when this guy missed his in 1999, I was ready...

A Hardman to beat. Peter winning the 1999 Sussex Trophy in an Aston DBR1

Win Percy, Jaguar D-type, in spirited
pursuit of Peter Hardman. Win told
me: "Stirling said it was the best drive
in a 'D' he'd ever seen"

500s - The post-war
equivalent of karting

Cooper Concorde

Richard Attwood
flies in his old
works BRM

MGA leads Porsche. From a "Press only" vantage point. Someone
must have been looking the other way...

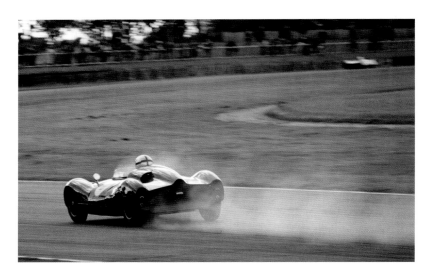

"Smoking kills.
Quit now!"

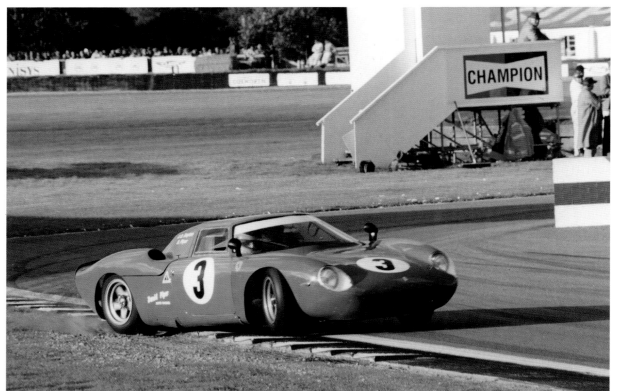

Going...

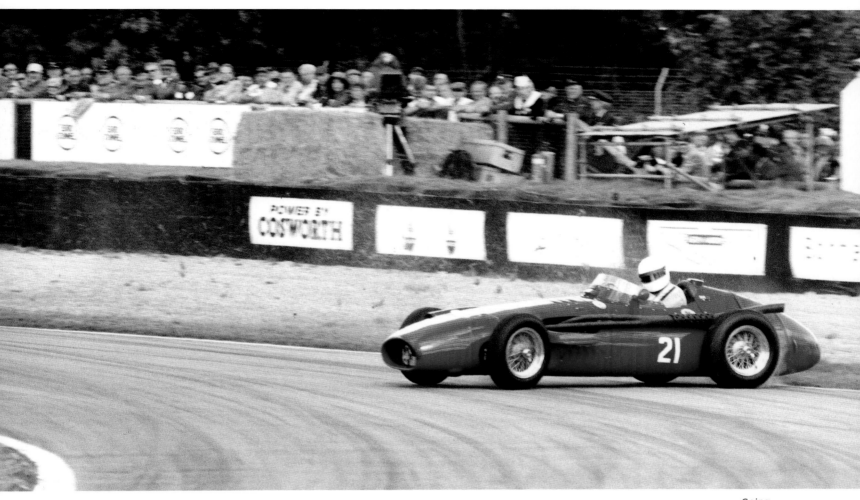

Going...

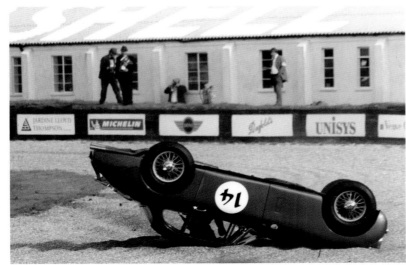

Gone!

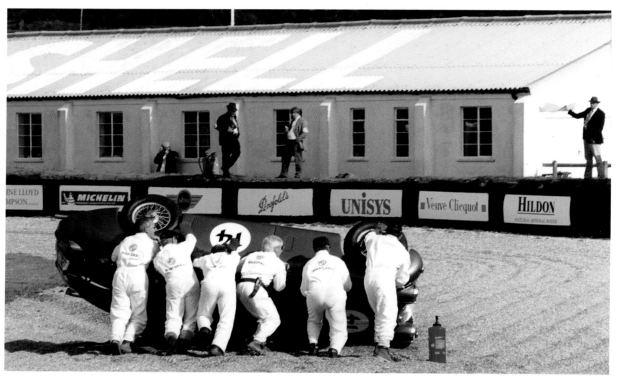

Best of British!

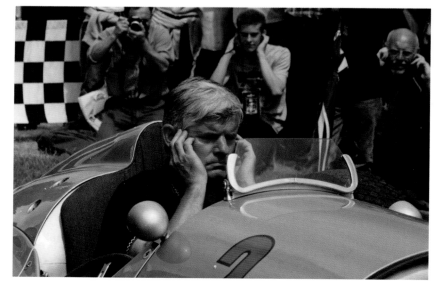

Hear no evil...

Early attempt at an
F1 two-seater...

Cap'n Birds Eye (rhyming slang for "Doug Nye")
tames the 24-litre "Beast of Brooklands"

A brace of bonnets

Red Arrows

Red Arrows, flying Jaguar

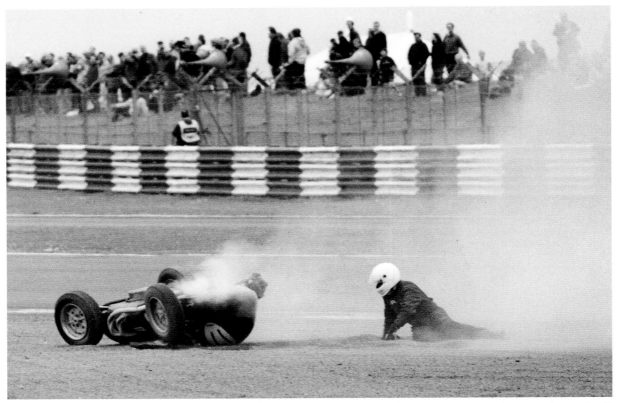

"You picked a fine time to leave me, loose wheel"
(with apologies to Kenny Rogers)

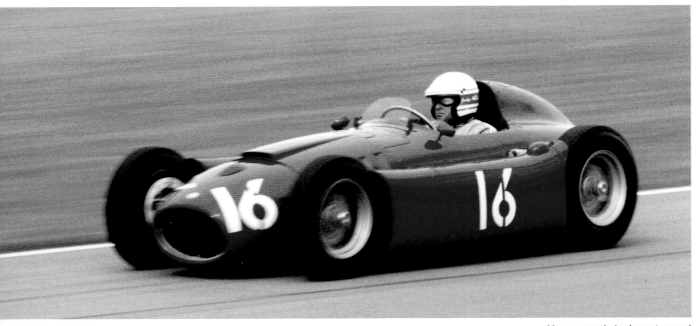

Mass appeal. Jochen at speed

Elbows out!

"Goodwood - The right crowd and no crowding!"

"Go ahead,
lick it!"

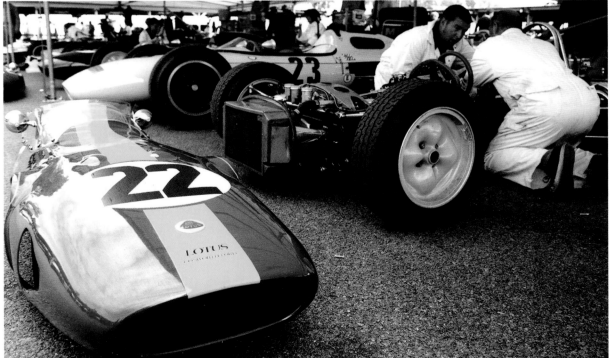

Lotus mechanics

You want to be loved by me?

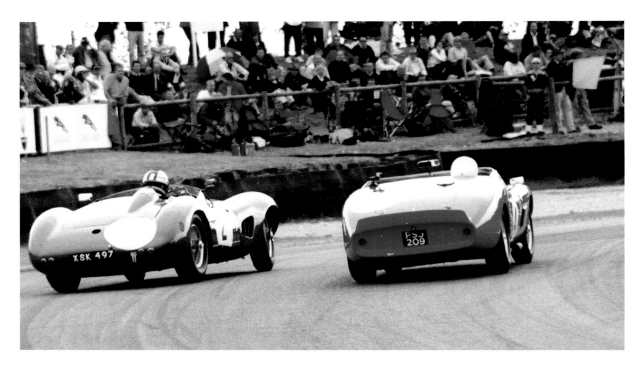

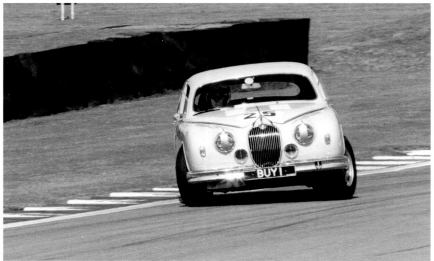

BUY 1! Guaranteed crowd pleaser!
Complete with Grant Williams!

Corvette
capers

TT start 1

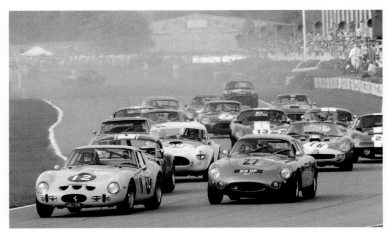

TT start 2

Start 'em young!

"Schumacher suit? Actually, it's an Ascari!"

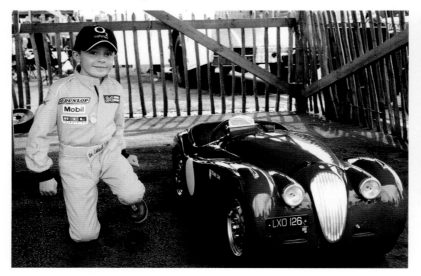

Lightweight E-type about to
become more lightweight

A mechanic's work
is never done

Gullwing
sculpture

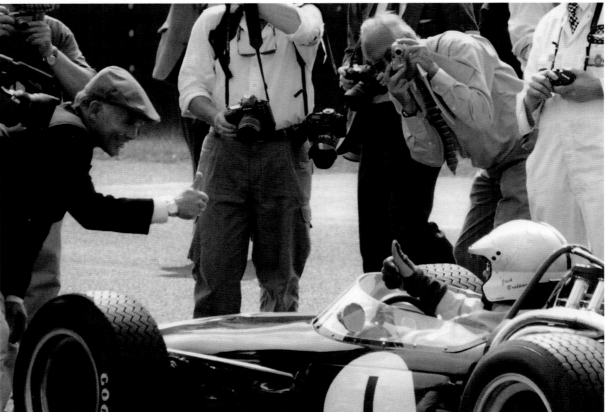

Thumbs up: Peter Windsor
and Jack Brabham

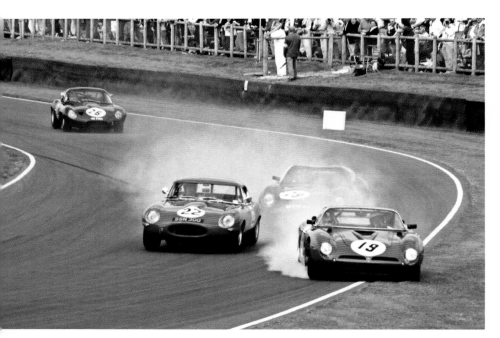

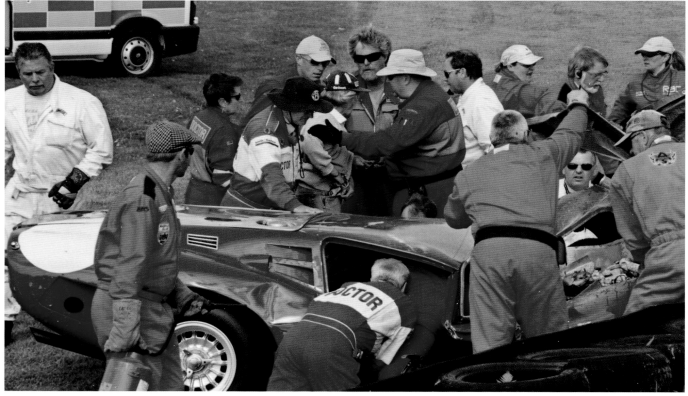

Loads of money in the bank. Martin Stretton was lucky to get away with a fractured arm

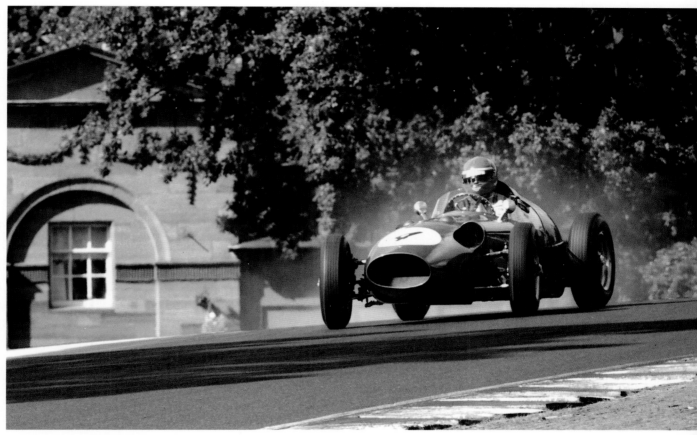

Classic Oulton backdrop; classic "Whizzo" pose

Oulton Park. View
from the bridge

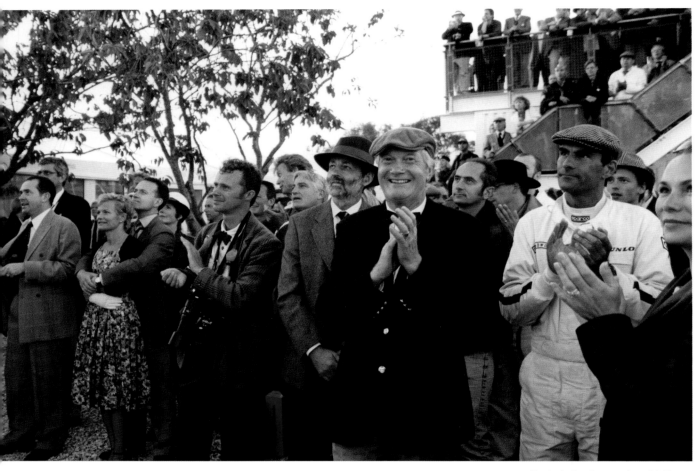

Porkpie for Pescarolo, with Percy
and Pirro, at prize-giving

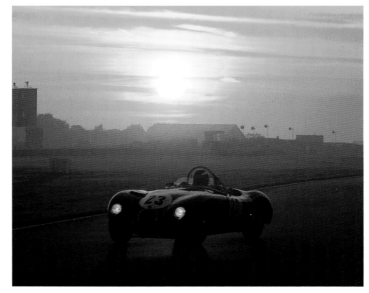

Sunset and C

Barrie 'Whizzo' Williams - Driver of the Day

TH *"Could you explain what's going on here?"*

BW *"Well it looks like I'm out of control. It's probably right actually! I'm having a bit of fun! At Goodwood! That's what we're all here for. It's a privilege to be here. The spectators, all our old friends - it's lovely to see them all. I'm just showing you what it's all about."*

TH *"And what was that sign on the windscreen?"*

BW *"Midwife on call!"*

TH *"Is that your day job?"*

BW *"I'm an ex-gynaecologist or something. I'm always checkin' 'em out!"*

Chapter 14
Moments with Moss 1

Festival of Speed 2000: Jaguar XK120

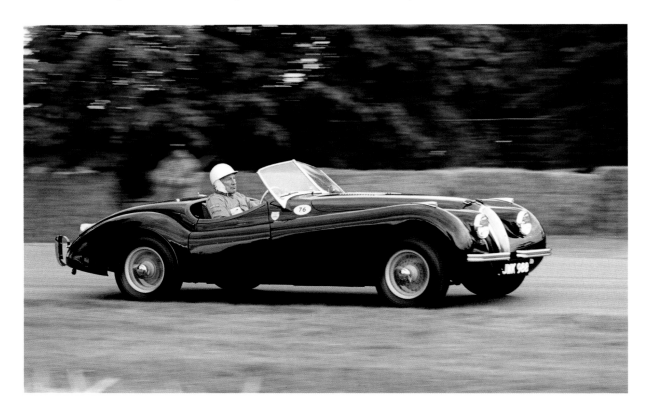

MM

SM *"Was this the Tourist Trophy car, 1950? Dundrod. I must say the thing about Dundrod and the Jag of course was that the Jag brakes were not capable of keeping up with the performance of the car. Because in those days brakes weren't. They weren't bad but they weren't as good as they might be, but because it was wet it was easier on the car all round. Just as well really that it was a wet race. Pouring with rain."*

Mercedes Gullwing

In my quest to add another Moss chariot to my tally, I awoke early with a plan to intercept car and driver at the start of the course, before he drove it up the hill. I found myself stealthily skipping a rope barrier (not recommended), hopping a hay bale with a 'Motor Racing is Dangerous' sign perched on top (definitely not recommended) and heading for the 'Gullwing' Mercedes waiting in line to be driven up Goodwood hill. Not surprisingly, I was intercepted by a marshal who respectfully told me that I could not proceed without a press pass. 'It's alright,' I pleaded quietly, 'he knows who I am. Please give me a moment.' Thankfully he stepped aside. I came away with this, and the cover picture, in which he seems to be saying, 'Hop in, old boy.'

MM MOSS MOMENT

SM *"I had a Gullwing you know. I bought it in 1954 I think. I had a green one and they put a white line down the centre which made it one of the first things with a go-faster stripe on it."*

Merc SLR 722

SM *"That's the SLR. Looking more spotless than when I drove it. Probably the most valuable car in the world actually. This actual car won the Targa Florio, the Mille Miglia and the Tourist Trophy. I don't think the windscreen there is original. It looks too upright. I'll have to look it up. I've just found a really good picture of the Mille actually, showing you what the roads were like. Almost dirt. Because there were no dual carriageways at all. No autoroute. And this picture I've found shows it much better."*

722. The number denotes the exact time, 7.22am, when Moss was flagged away to start the 1955 Mille Miglia, which he famously won at an average speed a whisker under 100 mph…for 1,000 miles. If you don't know the story you owe it to yourself to read Denis Jenkinson's account from the passenger seat - a classic piece of motor racing journalism. Forty-six years later, at the Goodwood Festival of Speed, '722' still tempts its heroic pilot to 'have a go.'

The festival crowd grows larger by the year. I was lucky enough to be invited into a special enclosure by Susie, where I did not have to struggle or compete for my one and only chance to get the picture I wanted.

Moss and the Merc have often been reunited. In 1988 my step-brother-in-law David McLaren, a second cousin to Bruce, was driving a Ferrari in the second recreation of the 'Mille'. He never had any pretensions of emulating his famous cousin, but was successful enough in business to be able to indulge his passion for fast cars.

David was driving a Ferrari belonging to David Piper. He had been following Stirling and '722' for a while, just to 'enjoy the experience' of following such an iconic car and driver. He pulled up beside Stirling at some traffic lights. Stirling leaned over and shouted 'Fancy a coffee old boy?' They then peeled off into a village, saw a tiny coffee bar, and parked (both) with two wheels on the pavement, and spent about an hour and three quarters alone together, whilst the 'factory minder' accompanying Stirling stayed with the car. David was treated to Stirling 'telling stories I'd never heard before.'

Meanwhile, word of Moss's presence had spread around the village. A line of devotees began to form outside the cafe. Old men began to walk in. Some bowed their heads, some shook his hand fervently, some even knelt and kissed his hand. David likened it to a 'Papal audience'. Some unfurled newspaper articles from their pockets for Moss to sign, browned with age, dated 1955.

A little later the 'crumpet' arrived. Aged approximately 18-26, Stirling was amazed by their knowledge, commenting that they weren't even born when the race took place!

He pulled up beside Stirling at some traffic lights. Stirling leaned over and shouted "Fancy a coffee old boy?"

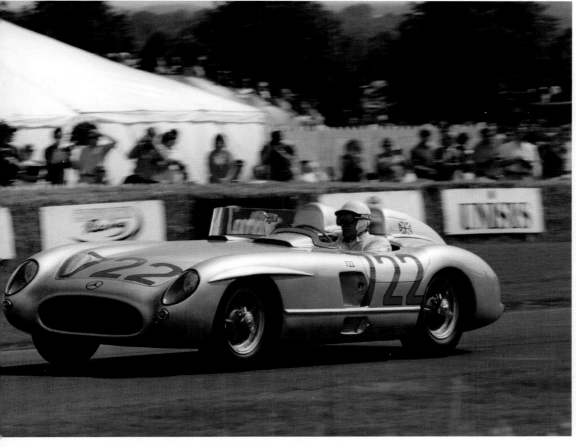

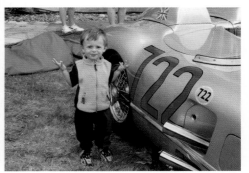

SM: Tim has even caught me napping, asleep at the wheel...

Jenks Tribute

Any portrayal of '722' has to honour Denis 'Jenks' Jenkinson, the eccentric, outspoken, famously bearded journalist who was the 'other half' of Stirling's Mille Miglia victory. He did ride up the hill at the Festival Of Speed in the car with Moss - a hugely popular moment - before he died. Sadly he just missed the Revival, though I could have sworn I saw him a few times. However, it turns out that one of these imposters was actually Tony Smith

Birthday Bash! Revival 2000

I was looking forward to this race. It was Stirling's 71st birthday. I wanted him to do well, but his grid position was not that great. Then came the accident at the start which I saw on the big screen by the chicane. It looked horrendous - Nigel Corner ejected from the cockpit, flying through the air in formation with his Ferrari, and landing in hospital. From Alain de Cadenet's perspective: 'It all went badly wrong when Nigel Corner's Dino swung across the front of me. Then Stirling Moss comes along and has a go at me as well.

So he too was out on the spot. I did not realise that Stirling had been involved until, race red flagged, his Cooper came by on the end of a tow rope with its nose severely crumpled. I was immediately concerned that his feet and legs might have been underneath whatever had landed on the car.

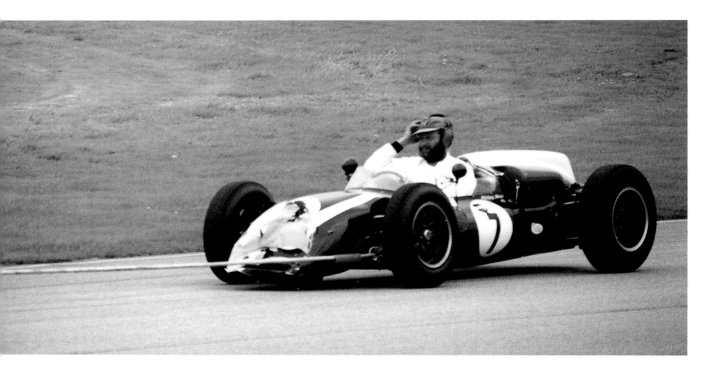

A flashback to Easter Monday 1962, and then I was off like a shot to the paddock. I had yet to see him that weekend, yet to deliver the birthday bottle of Burgundy in my camera case. I bumped into Rob Wilson, whom I recognised from the test day at Silverstone. He reassured me that Stirling was unhurt. So would he kindly deliver the wine? Better still, he offered to escort me past security and into the drivers' mess' so that I might deliver it myself. The birthday boy was delighted, and in his rush to be wherever he had to be, gave me his keys and asked me to place the bottle in his private locker.

Much later, his stint in the fabulous Tourist Trophy race over, I realised that I still had his keys on my person. I headed swiftly back to the enclosure, feeling a little sheepish. 'Excuse me sir, d'you have a pass?' asked the guard.

'No,' I replied, 'but I've got Stirling Moss's keys!' I waved the bunch at him and in I went. It's not who you know, but what you've got in your pocket.

Stirling was surprised. 'Good job you remembered. I'd forgotten all about them! I'd have been cursing you, boy!'

He then expressed his views on the birthday race that was over before it began, bullish despite his narrow escape: 'I was really looking forward to the race. Practice wasn't much cop, but they had the car set up beautifully. I was able to go through Fordwater flat!'

Susie stood by wide-eyed, still in shock at her husband's near miss. It was hardly the 'Birthday Bash' they had anticipated. Alain's comment to me later was, 'The problem with Stirling is he still thinks he's 25!'

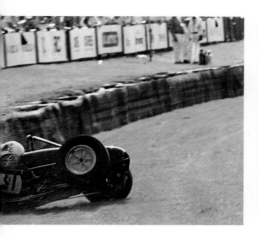 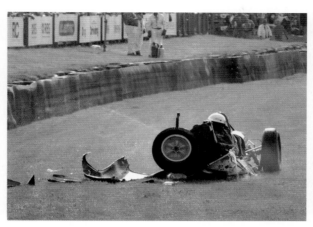

Moss on Cooper versus Lotus

SM *"The Cooper was one of the easiest cars to drive of course. Just to show how easy that car is to drive, John Surtees came into racing from motorcycles and was really very talented though fairly wild, and with a Cooper, same as with Jack, you'd get the back out, and as I used to say to John, 'Following you I'd see more of the front of the car than the back because you get it all over the place,' But really a very nice car to drive, probably the most forgiving.*

 The Lotus was the better car, that's if it kept all its wheels on. But certainly it was nowhere near as nice to drive. But I think if sufficiently experienced, a good driver would be better in a Lotus than in a Cooper but at the expense of it not being as nice to drive and over the course of three hours which was the minimum length of time, it was considerably more stress on you. Much more concentration required."

TH *"You compared the Cooper and Lotus to different kinds of crumpet."*

SM *"Well the Lotus obviously would slap you in the face before it kicked you in the balls if a wheel came off!" (Laughs! This actually happened to Stirling at Spa in 1960, causing one of the worst accidents of his career).*

TH *"I've got this photo of a Lotus 18 going into the bank. It was an accident that was very reminiscent of your own. I remember thinking 'Oh my God this guy has been saved because Charles March has put tyres all the way round the circuit.' I think he had a broken leg."*

SM *"Whereabouts did it happen?"*

TH *"Madgwick. He went straight on when he came into the corner."*

SM *"Mechanical failure."*

TH *"Well it was a Lotus."*

SM *"Exactly."*

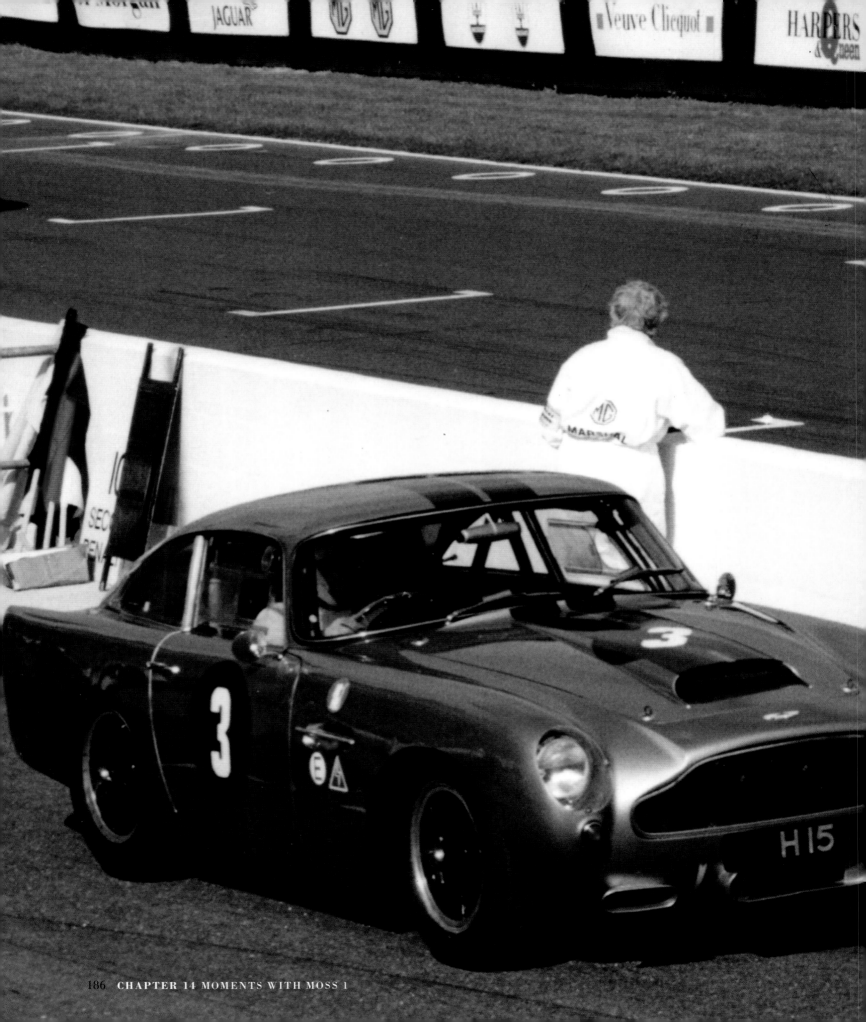

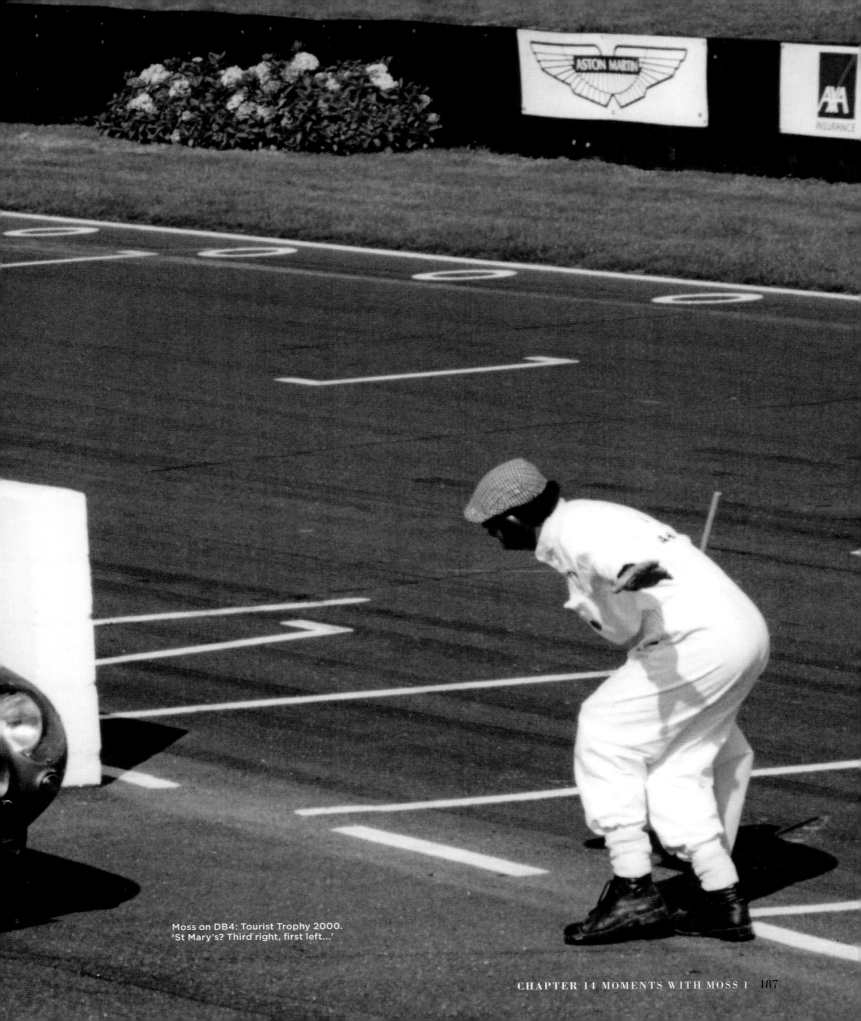

Moss on DB4: Tourist Trophy 2000.
'St Mary's? Third right, first left...'

Two Tons of Fun: Jaguar Mk 7 - 2001

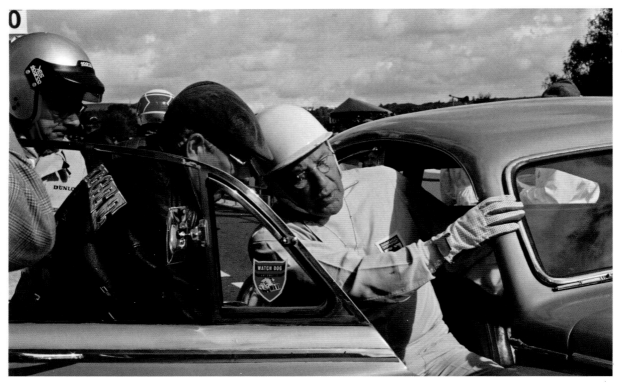

Driver change with
Rowan Atkinson

TH *"You had a rather well-known co-driver there…"*

SM *"Oh that's Rowan isn't it? I saw him the other day.*
 He's still got the car. He's quite shy you know."

TH *"On TV I saw Rowan claim 'it handles surprisingly well for such*
 a big car', a euphemism for what Stirling describes as 'like trying to steer
 a lump of jelly with reins.' Does that sum it up?"

SM *"(Laughs) That's very good! I didn't say it I'm sure, but anyway*
 I wouldn't ruin it by saying I didn't!"

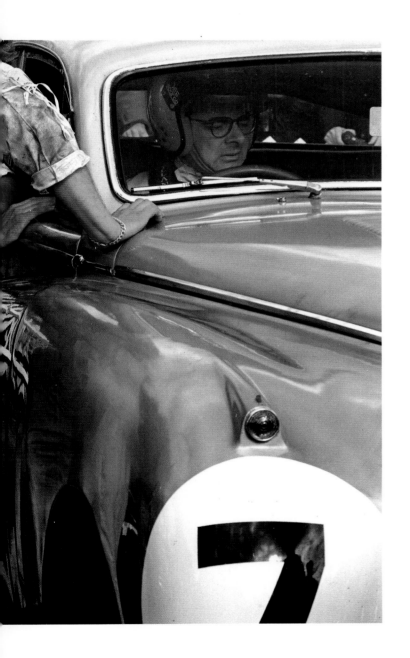

Two tons of fun. Probably the heaviest car Moss ever drove, and the least nimble, this Jaguar Mk 7 was hardly likely to win the St. Mary's Trophy, up against its younger relatives the Mks 1 and 2, not to mention the Minis and the Lotus-Cortinas. And how long would the brakes last?

Stirling could never resist a challenge, nor a good laugh, so his teaming up with its owner, the maestro of British lunacy 'Mr Bean' himself, could not have been more appropriate. If the car is a heavyweight, then so was this driver pairing, arguably the least likely, and the most charismatic of the 2001 Revival.

The car is regal, if a touch ridiculous. It did look jolly spectacular drifting through Madgwick with enormous body roll in the company of its sister car with Jack Brabham at the helm. Its owner claims that it handles 'surprisingly well for such a big car,' a euphemism for what Stirling describes as 'like trying to steer a lump of jelly with reins.'

If the car is a heavyweight, then so was this driver pairing, arguably the least likely, and the most charismatic of the 2001 Revival.

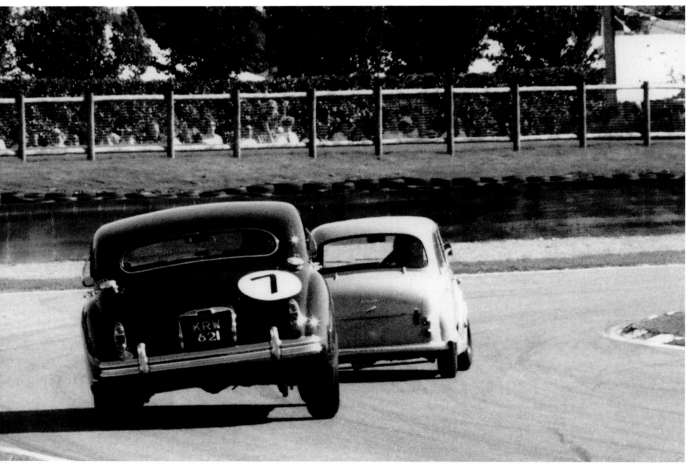

Like trying to steer a
lump of jelly with reins...

If it was a trifle incongruous to hear the commentator refer
to the race leaders as '...coming up to lap Stirling Moss,' it is to his
credit that he gave them plenty of room, waving them through with
the same energy with which he used to shake a fist at stubborn
back-markers who tried to impede his own progress. 'She's an old
girl,' he said afterwards, 'but I think she went well. I enjoyed it.
She leaned over, and was as I remember!'

Sweet Revenge

It was my good fortune to be invited into the pits by Susie Moss, which gave me the opportunity of capturing on film the drama of the driver change. She also told me it would be fine for my friend to join us. Thus she unwittingly conspired to help me get my revenge on an old pal who has long teased me mercilessly for being a name-dropper.

Alan and I go back a long way, with similar tastes in wheels, women and whiskies. We had long ago decided to attend the Revival together, but when I met him at the main gate early on Sunday morning, I had a little surprise up my sleeve. I told him we needed to hurry - there was a photo opportunity I did not want to miss. I 'forgot' to tell him that the saloon cars were in the 'starting enclosure' and about my special connection with Jag number 7.

We crossed the paddock fairly briskly - a challenge given that Alan had never before set foot in this treasure trove. I did my diplomatic best to drag him away from irresistible objects of desire - GT40s, 250 GTOs etc - and on to our rendezvous. Before he knew it, he was in 'Legend Heaven', rubbing shoulders and sharing jokes with the greatest of them, and telephoning his mum to tell her that he was standing beside her idol!

Beauty and the Bean

Revival 2002 – C-type Jaguar

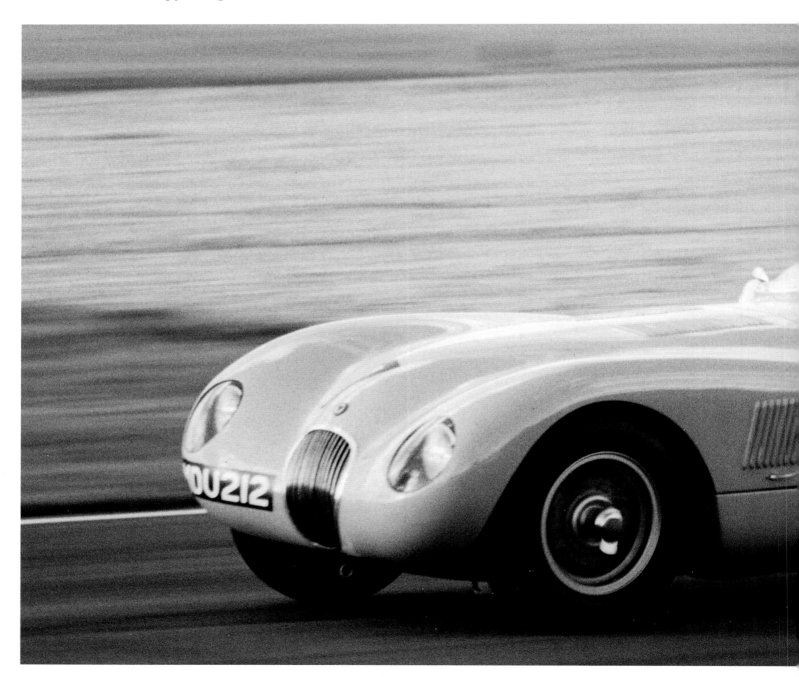

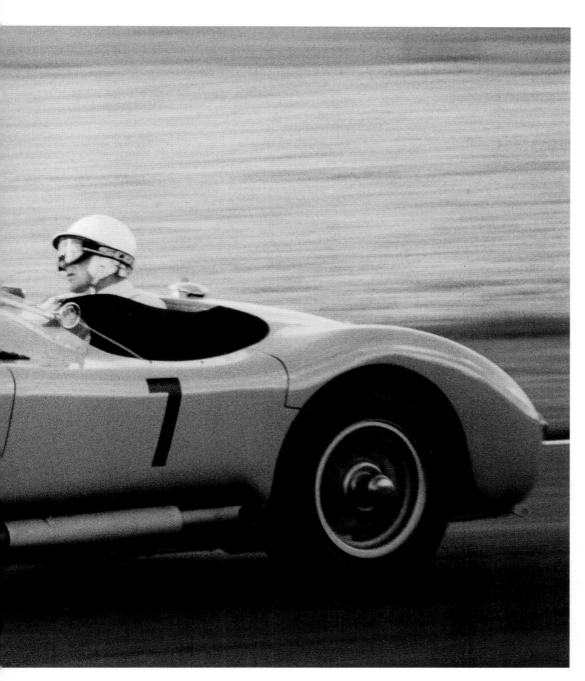

C-type Jaguar:

SM: 'Fifth was as good as we could have got with the C-type in the Nine Hours recreation, so I'm quite happy about that. I enjoyed it, and the car was quite good.'

I missed day one of the fifth Revival due to a gig in Glasgow which ended at 3 on Saturday morning. By 6.30am I was on a flight back to London. I stopped at home for a quick nap arriving in time for this race, which recalled the famous into-the-night races of the fifties. At the end of a long weekend with little sleep, I left the circuit physically exhausted yet inwardly refreshed. My only worry on the way home was avoiding drivers who think that they're Stirling Moss

Chapter 15
The Interviews

Meet the Queen! Reminiscing with Bette Hill, "The Queen of Motor Racing"

I visited Bette Hill, wife of my first hero Graham, and mother to Damon, at her home in Surrey in the summer of 2000. I spent a fabulous, fun hour with her revelling in nostalgia, anecdotes and insights into life on the pit wall as wife to one world champion, and mother to another...

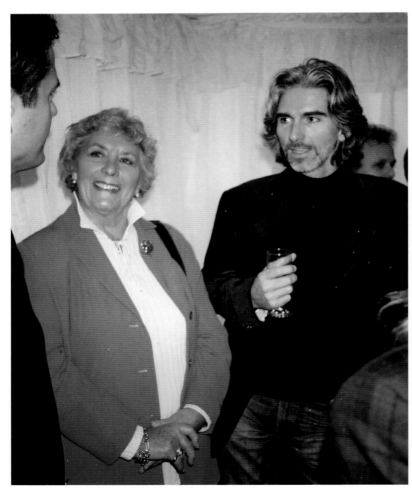

Bette and Damon at BRDC photo exhibition

Graham Hill, Ferrari driver

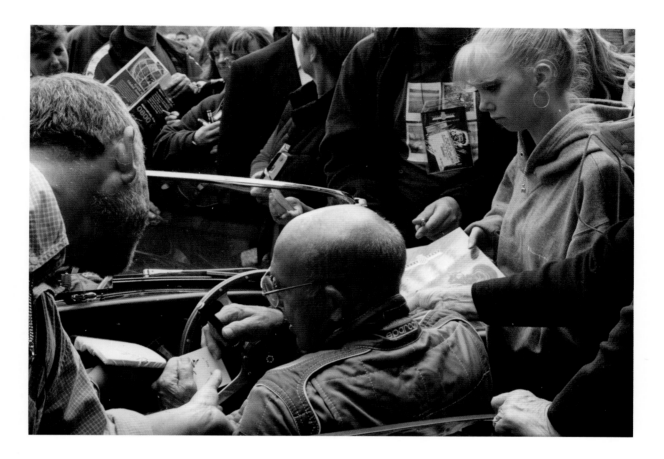

BH *"That's how Stirling is. Stirling is sociable. Wherever he goes he's the hero. He's 'Sir' Stirling now, which is long overdue."*

TH *"I must say all the people of his generation have been so helpful."*

BH *"Because they're enthusiasts. Today they all hide away in their lovely motor homes. I used to sit on a pit counter for two hours or more and then have nowhere to go! Stirling had his father who was a dentist and his mother who used to support him. They were racing enthusiasts. Graham was the only person in the sport who was on the dole. He used to go up to Brands Hatch to teach people to drive, then go back on Wednesday afternoon to sign on, and eventually they said 'I'm terribly sorry, we don't have any racing drivers on our books...or anybody who wants one!'"*

TH *"I was just reviewing a piece on TV, saying how determined and resourceful he was."*

BH *"He had to be. As with Damon, he was a little bit older than most of them. He'd done an engineering course at Cheltenham College so they sent him to make clocks and speedometers in Cricklewood. He hated it. He'd just come out of National Service and someone threw him an Autosport. It said you could go to Brands Hatch and have four laps of the circuit. So he went on his motorbike and was hooked. He gave up the job. And I was going out with him. There were plans for us to get married, but there were no prospects because he was desperate to get into motor racing. And he did, by hook or by crook. Bloody hard!"*

TH *"Many things make him utterly unique."*

BH *"I tell you something. I'm very unique!"*

TH *"You're the only person who's been married to a World Champion, and mother to one!"*

BH *"Absolutely!"*

TH *"I can't be the only one who's realised your unique status. Has it really not been publicised?"*

BH *"Not a soul has mentioned it - not even my son!"*

TH *"Well you have my acknowledgements. Graham was Formula 1 World Champion, won the Indy 500 and Le Mans."*

BH *"He won what was called the Triple Crown. He's the only person who's ever done that."*

TH *"I can't think of anybody else who raced in three eras of Formula One - front engined cars when he started with Lotus, then rear engined cars, and then slicks and wings."*

BH *"Those wings were a disaster. Those drivers were the pioneers. Colin Chapman worked for Aerospace in Hertfordshire. He said a car was like an aeroplane - you've got to keep it on the ground, so put wings on it! But they put those stupid things on, up in the sky! A full frontal picture of the grid with all those wings, all different heights was a sight to see - really frightening! The start was always nerve-wracking. But I never used to mind it until they had those wings, because they flew off. Poor bloke at the back!*

We formed what was affectionately called the 'Dog House Owners Club'. We used to encompass girls who were new to the sport. It was a very difficult world to break into. I remember inviting Susie Hunt over. 'Would you like to come and have a cup of coffee and meet some of the girls?' She nearly cried because she was so alone! We cared about each other. And if there was an accident and there was a girlfriend or wife or child, our club used to send them money. I remember this girl didn't even have enough money to buy a pram, so we bought that. The men cared about each other. Obviously they raced against each other and wanted to beat each other but they were comrades.

I remember 'Taffy' von Trips at the old Nurburgring. Graham and Cliff Allison were there for the first time. They asked Taffy to take them round. He said 'As long as I drive!' So he drove them around the circuit in their hire car. Can you imagine anybody showing someone the ropes today? He was racing for Ferrari, and they were racing for Lotus! They were opposition! They helped each other. It was wonderful."

TH *"There's that famous story of how Stirling Moss lost the championship by sticking up for his main rival, Mike Hawthorn."*

BH *"But look at Stirling, he should have been World Champion so many times. I don't think they even give a nut or a bolt to each other these days which is very sad."*

TH *"It got to the point where Senna purposely turfed Prost off the road at the start of the Japanese Grand Prix, and thus won the championship. The most horrific thing I've seen in motor racing."*

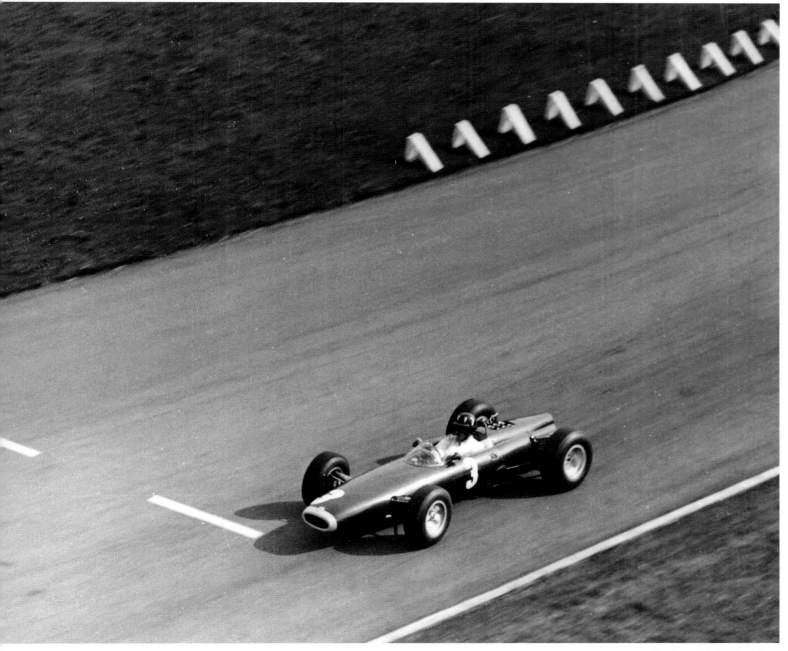

Graham Hill, BRM, Aintree

BH *"But why weren't they penalised? It's like that blatant act of Michael Schumacher's when he drove into Damon at the Australian Grand Prix."*

TH *"He'd already gone off, and then he turned in on Damon."*

BH *"Exactly. I've watched it so many times. It is not racing. Like with the Senna incident, the powers that be should have disqualified Schumacher and let Damon have it. Alright, I'm biased!"*

TH *"Of course! But it was not clean."*

BH *"It wasn't sportsmanship. Murray said he was a 'worthy champion' and I wrote to him and I said 'Worthy champions do not do what he did.' Graham should have had three world championships but he was taken off by Bandini in Mexico…"*

TH *"…So that Surtees (Bandini's teammate) could win the Championship."*

BH *"Jo Bonnier and Stirling were going to have a go at Bandini because they knew that it was deliberate. We loved Bandini though. A lovely guy. But it should be nipped in the bud."*

TH *"As Jackie Stewart says, it sends a bad example right through the entire racing community."*

BH *"Absolutely."*

TH *"When I was racing karts it was starting to creep in. Fathers were seeing their boys as investments - 'He'll be the next Ayrton Senna.'"*

BH *"Yes exactly."*

TH *"One time this guy who was the champion came on my inside, but I held my ground. I gave him racing room. We could have had a nice race, but I was on the inside for the next bend, so instead he drives me towards the wall, like, 'if you don't back off you're going to crash'. And there was loads of room! To me that is stupid, and I thought, 'OK, mate, I'm not even in the same race as you!' And I later saw this same guy punch a back marker who got in his way! Where does the example come from?"*

BH *"I had to laugh when Schumacher was there on the outside, with Zonta in the middle, and Hakkinen overtook the two of them. I've seen Graham do that hundreds of times! That was what racing was about - overtaking and competing with people."*

TH *"It was a great move, but when people said it was the 'greatest' overtaking move, they should have said it was the ONLY overtaking move!"*

BH *(Laughs) "Yes, exactly. In the whole of Formula 1 racing for the past five or ten years!"*

TH *"Max Mosley tried to brainwash us with this idea that 'It's not the racing. Not the overtaking. It's the strategy.'"*

BH *"What is motor racing these days? It's won and lost from the pits!"*

TH *"Stirling said, 'The strategy began when the flag fell.' I was watching World Superbikes on TV. Derek Warwick was on the grid, and Suzi Perry asked 'Do you prefer bikes to Formula 1?' He said, 'Every time! This leaves Formula 1 in the shade.'"*

BH *"Absolutely. Damon loves bikes."*

Damon with former motorcycle champ
John Surtees and Martin Brundle

TH *"That was his entree wasn't it?"*

BH *"Yes. But he wished he'd got into cars earlier. The bikes were a struggle. There aren't many things I haven't sacrificed to get my men where they are. I used to look forward to going to a race. I loved the whole atmosphere of it."*

TH *"How did the threat of danger affect you?"*

BH *"You didn't think about it. You couldn't have lived with yourself if you did. Obviously it was brought home when someone was hurt. There was one tragic year when Piers Courage and Bruce (McLaren) died and Denny (Hulme) burnt his hands. But I never really used to worry about Graham. I worried more about the others. There were one or two I didn't totally trust."*

TH *"Like Willy Mairesse?"*

BH *"He was just a daredevil racer. I mean more like your kart fellow. Stirling Moss has such modesty. I love Nigel too. He was exciting even out of the car! And always very caring, very warm. I did know one or two of the drivers when Damon was racing. They were always very polite and respectful. I love Keke Rosberg..."*

TH *"One of my favourite drivers of all time."*

BH *"Nice man. And Jacques Lafitte! What a darling man!"*

TH *"Sense of humour. Turned up in his pyjamas for qualifying because it was so early!"*

BH *(Laughs) "Oh I love him! When Graham and I were racing, they used to call me 'The Queen of Motor Racing!'"*

TH *"When I was a boy we'd see you in the paddock and my mate would say 'Oh look, there's "Beet"!' That's how you were known to us boys!"*

BH *"Stirling told me that when he was President of the Grand Prix Drivers' Association the guys who were intent on starting the safety movement were Graham and Jo Bonnier."*

BH *"I'm so glad you said that! It has been said so many times that Jackie was foremost in safety. I've written to Murray Walker and I've told him that it was Graham who actually started it. But you see the reason Stirling has a great respect for drivers like Jo Bonnier and Graham is because after his crash he had a head injury, and they went and sat with this brain specialist and her team, so that they could assess Stirling and bring him back to the mental position he was in before he crashed. She was wonderful. I remember her very clearly. Stirling would tell you her name."*

TH *"Because of his position Jackie was able to pursue it, and build on it. Credit to him, but I guess it wasn't his idea."*

Graham Hill with commentator Anthony Marsh

Bette with Jackie Stewart

BH *"He obviously followed it up, from the moment he was hurt, and after Francois Cevert died. But I remember Graham and Jo, together with Louis Stanley, going at their own expense to check out circuits to make sure that they were safe. They felt it was their duty. I'm delighted to hear that Stirling recognises that. I love Jackie. He's a great guy and he looked after me tremendously well when Graham died."*

TH *"When I went to Goodwood in 1962 Stirling Moss was the only person on the grid whose name I knew."*

BH *"He was the hero."*

TH *"When he had his accident it really hit me that this is serious. Of course that was the day Graham won his first Formula 1 race so he became..."*

BH *"...The hero!"*

TH *"In Stirling's view, the dilemma of Formula 1 today is that the safer things get, respect between drivers goes out of the window. When there was no safety net, people wouldn't dream of driving into each other. When Senna punted Prost off the road, before he owned up to doing it intentionally, his excuse was: 'Prost left a gap.' Mario Andretti, whom I greatly admire, responded, 'If there hadn't been a gravel trap, there wouldn't have been a gap!'"*

BH *(Laughs) "Exactly!"*

TH *"I always found myself rooting for Rosberg. He would pull something out of the hat. He was a great racer. Fantastic car control."*

BH *"I loved him! A genuinely honest man. A sportsman."*

TH *"Everyone else had trainers and physios. He had a hamburger and a fag... just to demoralise people! A real character."*

BH *"Wonderful."*

TH *"Of the modern drivers whom Stirling particularly likes, he feels Villeneuve is a leftover from the old school."*

BH *"Oh he's lovely. We were at Silverstone and Damon pipped Jacques for pole position. Jacques came in and ripped off his balaclava, took his gloves off and chucked them across the pits. And I said 'Spoilt little brat!' Then Damon took me skiing to Villars, which is Jacques' home, and he was so charming. I changed my opinion of him. He was a pure gentleman."*

TH *"He wouldn't do this argy-bargy stuff."*

BH *"But I always thought Gilles Villeneuve was an accident looking for somewhere to happen. He frightened the daylights out of me! It was a shame. All that talent..."*

TH *"But Jacques seems to have a bit more "up here"'*

BH *"Self-preservation! He didn't know his father that well. He was only seven when his father died."*

TH *"I followed him in 1994, his first year in Indy cars. He won his first race, beating the 'big 3', Emerson, Unser and Paul Tracy. He kept them all behind him for the last twelve laps, and they were really hounding him. Just like his father in that Spanish Grand Prix he won. I thought, 'this guy is going to be World Champion.' And two years later..."*

Mario Andretti at Covent Garden book signing. "If there hadn't been a gravel trap, there wouldn't have been a gap!"

BH *"Yes exactly."*

TH *"There are extraordinary parallels between Graham and Damon."*

BH *"Damon did the same for Williams when Senna died..."*

TH *"...As Graham did with Lotus when Jimmy died."*

BH *"Exactly. He picked them up by the earlobes. That was horrendous. We thought that Jimmy was invincible, indestructible. And they needn't have been there which was so dreadful. They had the BOAC Sports Car race at Brands but they were signed up to do this insignificant Hockenheim Formula 2 race. Everybody was totally devastated. And then we went off to Spain. The mechanics didn't have the appetite for it. Colin didn't even go, but Graham rallied them round. He was exhausted at the end of that weekend because he'd taken on that responsibility, and he won the race. Thank God. He won it and won it well."*

TH *"A lot of people levelled this criticism at Damon - that he won because he had the best car."*

BH *"What they forget is he was the test driver for three years. He'd worked with the team to make it the best car."*

TH *"And to become Champion when you know you've lost your job. A huge hurdle."*

BH *"That was terrible. He had a party when he won the Championship. Someone made a cake - a Williams car. And sitting in it was a driver - Damon. When he went to cut the cake he said 'That won't be there next year' and he took the man out of his seat, and my little Oliver who has Down's Syndrome grabbed it and ate it. We all screamed with laughter!*

Graham was with BRM for seven years. They had a fantastic combination there. It was a great big family. The only reason he went back to Lotus was he thought that a change would be good. It worked because he won the Championship. Graham picked Lotus up when Jimmy died and then got the sack when he broke his legs. (Laughs) Well that was inevitable, poor devil - he could hardly stand!"

TH *"I'm reminded of how Innes Ireland learned that he'd been sacked by Chapman through somebody else..."*

Graham Hill spotted at the Revival

BH *"Innes had won the only Grand Prix for Lotus, and he got the sack! It just doesn't make sense to me. Maybe I'm too loyal."*

TH *"It depends what your parameters are. I don't know that 'too loyal' exists."*

BH *"Damon and Adrian Newey are still great buddies. If Adrian had had his way Damon would have gone to McLaren. They understand each other."*

TH *"Going back to Goodwood I was amazed to see Stirling racing. And he was racing!"*

BH *"Absolutely. He doesn't mess about. Graham had this ability. I watched him at the Nurburgring in a BRM. His new car had been wrecked and he walked in with a camera in his hand which had fallen off the car of this lovely guy - de Beaufort, causing the accident. So he went out in the race in 'old faithful.' the conditions were appalling. Dan Gurney and Surtees were up front and Graham just drove them into the ground. They were given signals 'Graham Hill!' You could almost see their shoulders flag because they'd been driving their hearts out and Graham was coming up behind them. Given a good car on a good day… "*

TH *"But this was a bad day!"*

BH *"Appalling! I had plastic bags over my shoes to stop my feet from getting soaked! He won."*

TH *"I remember. I was thrilled. I was at Brands Hatch that weekend watching Dizzy Addicott race this little Elva in the Guards Trophy. Graham came back having won at the Nurburgring. He brought the bad weather with him, and promptly crashed the Jaguar in the saloon race! (Bette laughs) So he couldn't compete in the main race. I was really disappointed, but then Dizzy saved the day because he came 7th overall in this tiny Elva against all the huge Ferraris etc. He won his class by miles."*

BH *"Is Dizzy still alive?"*

TH *"I just met him again after 35 years. He's nearly 80. Just had a heart op; just given up smoking; just bought himself a motorbike! (Laughter)"*

BH *"There you are you see. That sums them up, doesn't it?"*

TH *"Absolutely. A real rebel! It seemed to me that Graham had this wonderful mix of irreverence and dignity. I remember before the start of the Aintree 200, they played the National Anthem. He was the only guy to get out of his car and actually take his helmet off. But you know if Graham was still around, I'm sure he'd be at the Goodwood Revival. I'm sure he'd still be racing."*

BH *"Oh yes, definitely!"*

Ray Bellm

Bellm and Bell!

When I was a boy, I had a pair of school friends called the Gandy twins. One afternoon they dropped by with their mate from Weybridge, known simply as 'Bellm'. He had a go-kart with gears, and we had a driveway long enough to take it. I don't recall that 'Bellm' and I said much to each other, since the twins had preempted a rivalry between us. I do recall trying to prove myself, having never previously driven a kart with gears.

Over the years I became aware of the name, in *Autosport* and on TV, and of his reputation as the 'ultimate gentleman racer', and often wondered if it was the same bloke. Seeing him listed among the entries for the 2003 Goodwood Revival, driving a Ferrari 250 GT and a Ford GT40, I decided to satisfy my curiosity.

And so it was that 'Bellm' was approached by a virtual stranger who asked him if, as a boy, he had owned a go-kart. He gave me the strangest look, and answered in the affirmative. I then asked if he ever knew the Gandy twins. His eyes widened! Did he remember visiting a house in their neighbourhood with his go-kart? He now looked completely astonished. Yes, he did remember. 'I know who you are!' he said. 'You're the chap who lived a mile down the road from them in the big house on the left!'

Ray invited me to his home in Hampshire for a proper chat, shortly after his appointment as chairman of the British Racing Drivers' Club, celebrating its 75th year. It was fascinating catching up with a man whom I had met but once, on a sunny afternoon 40 years previously. Our conversation covered all sorts of topics from astrology to parents, and revealed some interesting parallels and insights. Here are some excerpts:

TH *"That day you came over, 40 odd years ago, the Gandy twins spoke of you in a way that sounded in-timidating. I was supposed to be quaking in my boots! 'We're bringing "Bellm" over with his go-kart! He's really fast!'"*

RB *(Laughter) "I can remember you were pretty quick. I can remember the house vividly! Our karts were silver and red and we used them on our lawn. The arc got wider and wider as you went quicker and quicker, until you landed up in the rose bushes! It all started because my dad was into cars. He used to do trials - up rocky hills with this person bouncing in the back - my mother! Then he did rallies with an Allard and a TR2. I remember him coming home from work with an MG Magnette which was the dog's b*******. I used to think, 'God I love cars!' even at that age.*

Ray leads in Ford GT40

RB *All I'd ever wanted to be was a racing driver. At university I bought a Lotus 6 and I tried to do trials. You always try and emulate your dad don't you? I was not mechanical and the cars always broke down. My dad said 'I can't help you - you'll have to work in the family business!' In the end my wife persuaded him. 'If you don't let Ray go racing, he'll do it anyway when you die!' So my dad said 'OK'.*

I always had nice cars so I started The 96 Club with Michael Scott. We were going to call it The 69 Club because we were childish! We swapped it round because we didn't want to be rude! The first meeting was at Mallory Park and there were no regulations. My wife did a picnic and 20 of us would turn up and drive our cars round all day. No marshals, nothing - just hell for leather, uncontrolled! It was great fun. Then two guys called Akin and Kugby wrote off this Lotus Esprit against the bank. I thought 'Oh my God what have we got ourselves into?'

I only started racing when I was thirty. Most people finish when they're thirty! My first race was at Donington - I came 4th. My second race was at Silverstone - I came 2nd. I thought 'Bloody hell, this is alright!' My first full season cost £8,000 - nothing!

Do you think you're born with some natural ability to drive a car?"

TH *"I don't know. Why do I love speed but hate heights, whereas some people love to jump out of aeroplanes?"*

RB *"I've been up in a balloon and it's not my scene. My kids are into horses, but they scare me just to sit on! But I don't mind going down any straight at 220 mph. Once you've got this feeling of wanting to control a car at high speed, it doesn't go away. You can't make it go away."*

TH *"I took a nice sequence of pictures of Gerhard Berger sitting in Nick Mason's GTO, and the look on his face - he's really into this thing!"*

RB *"Because they're actually more fun to drive than the modern cars, which are so technical they take over so many of the functions that you would normally do. In terms of what I would actually call driving, there's no comparison. The fun is in controlling the beast that's underneath you.*

I'm a sports car driver really. I was always too fat to fit into single seaters. I have had them - I had the P261 BRM. I had an FW07 and an FW08 Williams - one was the Alan Jones car, and one was the Lafitte car. Bought them off Frank when he was hard up."

TH *"That's hard to believe!"*

RB *"I paid him 15 grand for the '07, and 50 grand for the '08. I sold them both at a vast profit. I started on Chevrons, then a Lotus Eleven. Then I met Gordy Spice and went Group C racing. Then I moved into touring cars and learned how to race properly - sports cars were always run to a fuel efficiency formula. I raced a BMW with Will Hoy. I was overtaken by about six cars at the first corner. I thought 'F*ck me this is no good!' I realised you have to drive them absolutely balls out - no 'mechanical sympathy'. We had Hollinger gearboxes where you didn't use the clutch. Using the clutch lost you time. I came 4th in the British Touring Car Championship in 1990 or '91.*

I decided to go back into sports cars and bought a Porsche Carrera for the BPR series. Great fun - back to long distance racing, but driving them hard. Then Ron Dennis launched the McLaren and I had chassis no. 2. That project started sitting on our lawn the weekend after Senna died. Ron came over to avoid the press who were hounding him. He and Senna were very close, even though he was no longer at McLaren. We won the first race, at Jerez, with Luis Sala - a historic victory.

If I had one undiluted desire it would be to be on the podium at Le Mans. I shall go to the grave with 'if only!' I was in the lead and I

> *"I paid him 15 grand for the '07, and 50 grand for the '08. I sold them both at a vast profit."*

Ron Dennis with Lord March

*"I'm thinking I'm f*****g better than all these guys – get out of my way!"*

crashed! Hit the barriers in the rain – it was awful weather. In the end we lost by four laps. So I had myself to blame for not winning Le Mans – we had the strongest driver pairing, and eventually came fourth."

TH *"What are you thinking when you're bombing down the Lavant straight at 160 miles an hour and Woodcote is coming up fast?"*

RB *"I'm thinking 'I'm f*****g better than all these guys - get out of my way!' My wife doesn't understand it (the competitive spirit) at all!"*

TH *"My burning desire, which gets more concentrated every year going to the Revival, is 'Hell, I wanna race here!'"*

RB *"It's good, Goodwood! It's THE aspirational event for motor racing people. You can't touch Formula One because they've made it remote, but you can touch old cars, and even buy one for not too much money, which people can then look at, and it builds up your ego. Lord March has made it all the more desirable because you can't buy it! You have to be invited. That's why everyone wants to race there. Anything you can't have in life, you want!*

People want to be a member of the BRDC but you have to have a race history. You have to be invited. The BRDC was formed by four amateur racers - the Bentley Boys. Goodwood is so successful because (Charles March) is a creative genius. He's got beautiful vision, he's determined and he has the perfect venue. It's an event, like Henley.

I never got paid to race, but I made it pay, so I am the ultimate gentleman amateur racer, taking it to its utmost level of professionalism. And that's how I view my racing career. It hasn't finished yet!"

TH *"I should hope not!"*

Sir John Whitmore 1937-2017, Interviewed in 2004

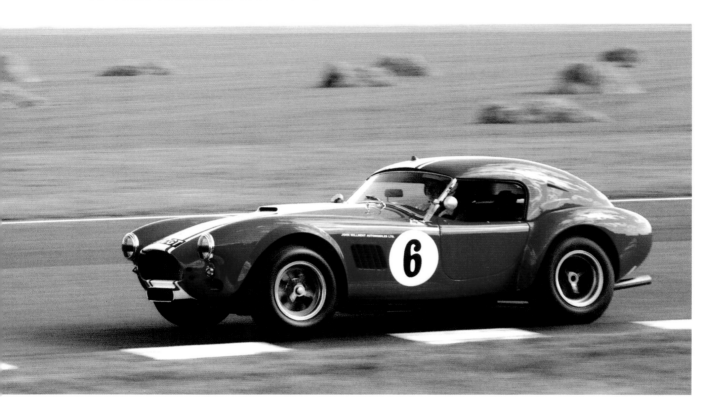

When Nico Rosberg retired at the end of 2016, on the back of winning the Formula One World Championship, there was much talk about the daunting prospect of "life beyond Motor Racing". Sixties British and European Touring Car Champion and sports car ace Sir John Whitmore was another who retired abruptly at the height of his powers, but he never looked back. We met through the secretary of a club in Bath for whom I did a presentation. We immediately found much in common.

He became a dear friend, and frequently came to hear me play. Sadly, a skiing accident caused a blow to his head which left him increasingly bereft of his sharp mind. After a period in a care home in Surrey - a shadow of his former self - he had a stroke and died shortly after, in April of 2017.

TH *"I read that you'd dropped off the map after the 60s and followed the hippie trail. Where did that perception come from?"*

JW *"I retired from racing in 1966, and unlike most racing drivers I was not interested in cars. I was merely using cars as a means of competitive expression but I had no particular interest in them. I quit racing and had nothing more to do with it. I just got on with the rest of my life.*

When my father died I inherited the family business and then I had a Ford main dealership. So I had all this material success. I had everything you were supposed to have to be happy by 1968. But I felt there was more to life than that. I decided to go to California and began to study psychology. I studied at the Esalen institute. Time magazine said it was a dangerous place to be and so I thought it was probably right for me!

I had such a positive wake-up experience there that I wanted to share it with others. The result is that I became a communicator about these things. I began to practise the Inner Game stuff (with Tim Gallwey - an old acquaintance of mine too!). Inner Game was applying the new psychology to sport, and I ran a tennis school and a ski school which was a completely different way of teaching. I've written five books. My most popular, Coaching for Performance, has sold a quarter of a million copies. I write quite a lot. I write for the Telegraph as you know. I use my various experiences to bring about change wherever I can, through communications, through media and through film."

John leads a group of Grand Prix drivers, past and contemporary, including Alan Jones, before succumbing to the pressure and spinning off. He still finished third

"I've written five books. My most popular, Coaching for Performance, has sold a quarter of a million copies."

John showed me some of his favourite 'portraits in action' which adorned his living room wall. They included one of him testing a very sideways Ford GT 40 prototype at Goodwood on what looked like a very cold day - he helped develop the car. Many of his pictures featured cars that warrant the term 'hairy' - at exotic angles. Despite his protestations of having no more need for racing, his enthusiasm rather got the better of him.

TH *"I have a friend in the music business, James Willment, whose dad was 'Willment' of Willment racing. You drove for them didn't you?"*

JW *"I did the South African season in 1963 - Cobra, Galaxie, Lotus-Cortina. I won the East London Grand Prix. The second car was a lap and a half behind. I think it was an MGA. Ridiculous race! That Cobra I drove then is the same one I shall be driving at Goodwood in ten days' time. You know I drove for the team Stirling put together when he was recuperating - SMART - the 'Stirling Moss Automobile Racing Team?'"*

TH *"... and here's a picture I took of you in the SMART Porsche."*

JW *"I think that's the only car I've driven that I don't have a picture of! When I drove for Stirling I got an offer from Ford, the bonus being that I could do the South African season over winter, but it meant giving up my thing with Stirling, with whom I had a three-year contract - which was very tempting for a young driver, but then the Ford Motor Company comes along and says 'do you want a works drive?' I really wrestled with this one - the opportunity on the one hand that if Stirling Moss thought I was good, then that's great publicity, and I was the only driver - Hugh Dibley came along later. Stirling was not easy at that time. He had serious brain damage and it's incredible how he's recovered. He effectively lost part of his brain, and took a long time to recover. He was fairly irrational about some of the things we were doing. Anyway, I eventually signed with Ford."*

MM MOSS MOMENT

TH *"And here's a chap who drove for you once."*

SM *"Oh John Whitmore, yes. He was quick, you know, John. Bit wild I think but very quick. He's a very changed guy, my gosh he is."*

TH *"He came over from Australia to the Revival a couple of years ago on the Thursday, put a Mustang he'd never seen before on pole on Friday, on the Saturday led five current or past Grand Prix drivers for two thirds of the race before spinning off, and still came third. He then raced a Cobra on Sunday and flew back to Oz on the Monday!"*

SM *"Really?"*

TH *"When I first met him he was telling me 'I'm not interested in competition anymore. I just did it in the sixties to prove something to myself.' I thought 'yeah right!'"* (Stirling laughs)

John catches up with his former team boss

JW *I think what Charles March has done is extraordinary. Very imaginative, but very sensitive with it. His capacity to do a good job is apparently boundless - he's incredibly popular with the staff, and they do it unbelievably well. There is more freedom at these events than there is anywhere else. There's no trouble - people don't take advantage of it. You'll be there, presumably?*

TH *"Oh yes. I haven't attended every Festival of Speed but I've been to every Revival. My book will contain encounters with people I've met including Dizzy Addicott, my old friend and mentor when I was a kid..."*

JW *"I've got a wonderful picture of Dizzy. We flew together in the Vickers Gunbus -World War 1 fighter - which he and his mechanics built out of parts, and I had an airstrip up in Essex. Dizzy flew this thing up there and took me up in it. It was ridiculous - here am I sitting in this thing with a machine gun between my legs flying around the fields! Is he still alive?"*

TH *"Yes. I lost contact with him for 35 years until after the first Revival. It was like we'd never been apart. He's 80. Two years ago he gave up his 60 year, 40 a day smoking habit, and bought himself a trials bike. He fancies his chances with Kylie Minogue, so, yes, he is still very much alive! Occasionally he comes over on a Sunday and we watch the DTM or the Superbikes. (Dizzy died in 2005, suffering an aneurism on his way to a pilots' reunion in his modified VW Corrado.)"*

JW *"I said hello to him at one of the first Revival meetings. He wasn't driving or anything."*

TH *"It would be nice to get him involved somehow. We've just located his Lotus Fifteen."*

JW *"Really? That's when I first knew him. The guy who helped me get started was Alan Stacey."*

TH *"The guy who got killed at Spa?"*

JW *"Yes. Alan and Peter Ashdown were the two works Lotus drivers in Lotus Elevens. Alan persuaded Colin Chapman to sell me one of the pre-production Lotus Elites which I really got established in. I then drove with Jim Clark at Le Mans in 1959 in an Elite, and nobody thought a Lotus would last 24 hours but it did. I was just in New Zealand and I was asked to go to a track and there was a Lotus Elite going past. So we went down to the pits and the guy drove up with the Elite and said 'I brought this to show you', and I said 'Well I have seen one before!' and he said "I know! This is the car you drove at Le Mans with Jim Clark.' It had been in New Zealand for a couple of years.*

 I drove another car there - a mini with 400 horsepower! Well, I stuffed it! Bloody embarrassing! It was wetter than hell and you've got a rev limiter on the thing anyway, thank goodness, but whenever you accelerated in the wet, you'd lose your front end immediately. I was just trying to get used to this thing. I'd only done three laps and I spun it into a barrier! 400 horsepower in a Mini is quite something."

TH *"That's twice the power of Jim Clark's Lotus 25!"*

JW *"Ridiculous. I mean, really ridiculous! I don't know why. I don't even know what sort of engine it had in it..."*

TH *"Would you say it's the scariest car you've ever driven?"*

JW *"I wouldn't say it was that scary, it was just... silly! Id love to get used to it! That Mini was such a joke. It was just fun. The guy who owns it is a pilot with Air New Zealand."*

TH *"So what would your favourite car be?"*

JW *"The first 850 Mini I had which I won the British Saloon Car Championship in. You drove it flat out everywhere – you didn't have to lift. You'd just throw it sideways when you got to the corner."*

TH *"What about the chicane?"*

JW *"You didn't have to slow down. It required a particular sort of skill but it probably had very little to do with driving! The Lotus Cortina was quite a challenging car to drive. I really enjoyed that, but it's still easier to drive than things like the Shelby Cobra and the GT40."*

TH *"Are you driving a Shelby Cobra at Goodwood?"*

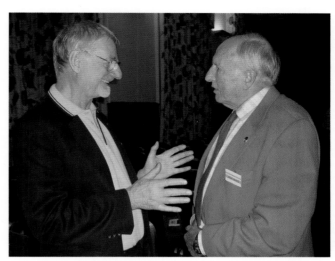

John with old friend and rival "gentleman" Jack Sears, at the Jim Clark Film Festival and dinner, where John discovered just before the meal that he was supposed to be the keynote speaker! Unfazed, he gave a wonderful off the cuff speech, with no script, in which he foresaw that cars would become the horses of the future – merely recreational vehicles, while the human race moves on to non-polluting forms of transport. He managed not to insult anyone with his vision. His talk was very well received

JW *"No. It's an old thing and an early one, so it won't be that fast I'm told, and that's in a sense a relief because otherwise I'd get competitive and try to win the race or something like that which I don't want to do!"*

N.B. Come race-day, John was down in about 14th place when the flag fell, but had worked his way up to 6th before the driver change. This was not due to attrition. I saw him pulling off great passes on the likes of CUT 7, the legendary lightweight E-type. As John Watson once observed, "show them a green light and instinct takes over."

JW *"In some ways the car I enjoyed most was the GT40. I did quite a bit of the early testing at Goodwood and at Monza. Roy Salvadori, Dickie Attwood and I. The Shelby Cobra was very fast due to brute power and wide wheels. Every car was different. Very hard to say what was more fun to drive."*

TH *"To what do you attribute the success of the Goodwood Revival, leaving aside the answer we've already touched on - Charles March's artistry and vision?"*

JW *"One is that Goodwood was always a romantic circuit, very different to the eternal airfield which wouldn't have attracted so many people. It is an airfield still but it has a feel about it that Silverstone doesn't. I think it was a window of that period when motor racing was becoming professional but it was still a lot of fun. Even the professionals were enjoying it, so I think it symbolised that era before it closed in 1966. That was the backdrop to it working well. But the main thing was the idea of doing it as a celebratory event rather than another in a line of classic car races. This was a different kind of theme, so people felt it wasn't going to be terribly serious racing..."*

TH *"...unless you're Frank Sytner!"*

JW *(Laughter) "I think what lots of us oldies want to do is get back together again, see each other and have fun, and both the Goodwood events provide an opportunity to do that, still drive some cars but not in such a serious way. Having said that, once the starter's flag drops everyone gets pretty serious. It really doesn't matter - it's not like the classic racing series - I did that in 1990 in an M8F McLaren, a big old orange thing - 8.4 litres, and it was fairly serious. I think it's a combination of those factors that made it work. But if you wanted to put it down to one thing it would be Charles March's personality."*

TH *"For me it's the thirst in people for nostalgia."*

JW *"I think it's an escapism as well. In our world there are so many bad things, that when you get a lot of people together to celebrate, it's fairly meaningful because a lot of things are not that way, and there are certain things that have been done that bring out the good in people - Bob Geldof has been involved in most of them! Goodwood has a feel of 'this is a celebration of life' rather than a reminder of the bad things in the world, the fierce competition and the aggressiveness. It sounds a different note and I think people are hungry for a different note."*

TH *"I thought you'd say something like that! What about Jim Clark? (John was Jim's team-mate at Le Mans in 1959, finishing 2nd in class in a Lotus Elite)."*

JW *"In 1959 Jimmy Clark was just out of Scotland, off the sheep farm - a bloody good driver but that was about it as far as his worldly experience went. So we were at Le Mans in this little village where the Lotus team used to stay, because it was cheap! I was sharing a room with Alan Stacey and we were looking at this newspaper that had these one liners about the race - I was translating these to Alan and Jimmy. It said one of the drivers has got a wooden leg and Jimmy said 'who's that?' and Alan said 'It's me.' Jimmy said 'Be serious!' because nobody would be allowed to drive with a wooden leg. Alan said no, it was true. Jimmy changed the subject. The next morning he comes bounding in. 'Come on guys, wake up!' He looks down, and there was Alan's leg lying on the floor and Jimmy was so embarrassed he hid himself for the whole morning. Alan and I thought the whole thing was hugely funny, but Jimmy was so naive, he didn't know how to handle it - he thought he'd mortally offended Alan!*

You had to do this reaction test in the medical where they ask you to cross your legs and then they tap the knee. So Alan would uncross his legs and then cross them again the same way round. He was passed in England to drive, but it was easier to get him to do this than go through all the medical hassle!

There were lots of accidents in those days. I guess Stirling's was a bit like Senna's. When someone is at a certain level they seem to become 'it couldn't happen to them.' The same with Jimmy. You must go to the Chirnside museum (of Jim Clark). It's very nicely done."

TH *"What does that tell you?"*

JW *"It tells me that I got it wrong! That was a sad moment for me. I was in the lead of the race."*

TH *"Leading five current or former Grand Prix drivers."*

JW *"Right! They were pushing me fairly hard, my tyres were starting to go off and I was starting to get a bit nervous, and the combination of that put me in the dust!"*

TH *"Well, it's nice to meet a man who admits his own mistakes!"*

JW *"Well racing drivers have all sorts of excuses. The one I like best is 'my brakes locked!' Well the reason your brakes locked is that you put your foot on the pedal too hard!"*

TH *"What other ones? I wouldn't know because I'm not a racing driver. How about 'I might have been a racing driver but I wasn't!'"*

JW *"I couldn't afford to at the time!"*

TH *"No, so I stuck to go-karts and won lots of races in them, and I've got the cups to prove it. Stirling says that's kids' stuff! What else can we talk about?"*

JW *"How nervous I am right now! I'm in the St Mary's Trophy in a little Austin A50 and I had a problem in practice which means I'm at the back of the grid so I can only get better, Which is easy, but in the TT my partner Rob Hall has done the fastest time ever in a Cobra round Goodwood As far as I can figure out, at 1.27s, so now I've got to go out. Practice now, race tomorrow. We're third on the grid, so let's see what we can do. I just drove four laps to break it in…if I get to the 1.29s I'll be quite happy."*

TH *"That'll satisfy your non-competitive instincts!"*

JW *"Well there's a part of me now that says don't try and beat the quick guys. I mean, look, I drive once a year. Its crazy if you don't have much practice. We all tend to drive as fast as we did before, but you've got to have continuity there. I don't drive enough."*

TH *"But you still landed on pole position! (In the Mustang)."*

When we met John told me how he and Bob Marley had a former girlfriend in common! He subsequently brought her to a gig of mine which she much enjoyed. Esther Anderson, former actress and Marley's photographer, is responsible for many iconic pictures of the 'King Of Reggae'. She subsequently became a good friend, using a song of mine on a documentary she produced about Bob. John and I stayed in touch pretty much until his death.

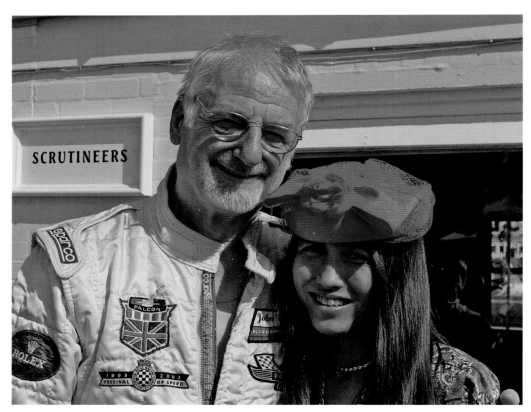

John with girlfriend

Jim Clark Revisited

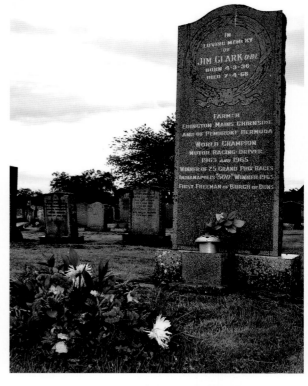

In June 2017 I found myself in Edinburgh and decided to follow John's advice and make a little pilgrimage. I rented a car and drove south to the little market town of Duns, where I spent a solitary, meditative couple of hours at the Jim Clark Memorial Rooms, soaking up the atmosphere and immersing myself in memories of my great boyhood hero.

 The strangest thing happened. Mark Craig's excellent documentary, *The Quiet Champion*, was playing in an adjoining room. I went in. The moment I sat down, John's familiar face came on the screen, talking about his old teammate and flatmate. It felt like he was talking to me, and we were back in one of our many conversations. He had passed away only weeks before, and I'll readily admit to shedding a tear. I then drove on to Chirnside to visit Jim's grave. All in all, a deeply poignant and nostalgic day.

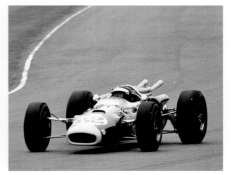

John Surtees

This conversation took place in July 2009, at John's headquarters in Edenbridge

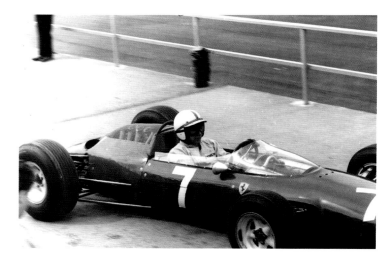

John Surtees,
F1 Ferrari, at
Silverstone,
early sixties

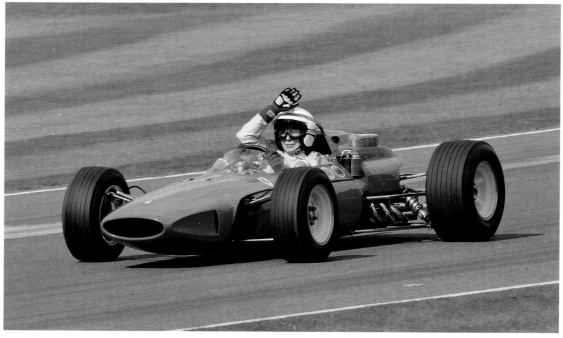

Same driver and car 50 years later – John
takes a lap of honour at Goodwood

TH *"This is the first picture I ever took of you, at Silverstone in 1964."*

JS *"I think you'll find it's 63 not 64. That's a V6 car in my first year with Ferrari when we were latching a car together out of all the different bits that had been left over from the previous year."*

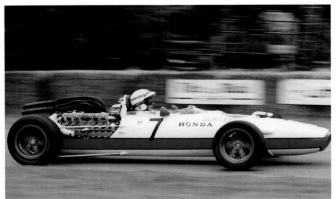

JS *"One of my MVs and of course it's Goodwood. A modern picture... and a rather aged rider and bike!"*

JS *"That was one of the first Hondas that I drove. Main problem with that was that it was so heavy. We were 180 lbs heavier than a Cosworth engined car, so you realise the sort of struggle we had. A whole new design team came in after building the 1.5-litre. They built a very large engine, which needed a very large gearbox and the chassis was constructed relative to that and it was all heavy. It made a lovely noise though!"*

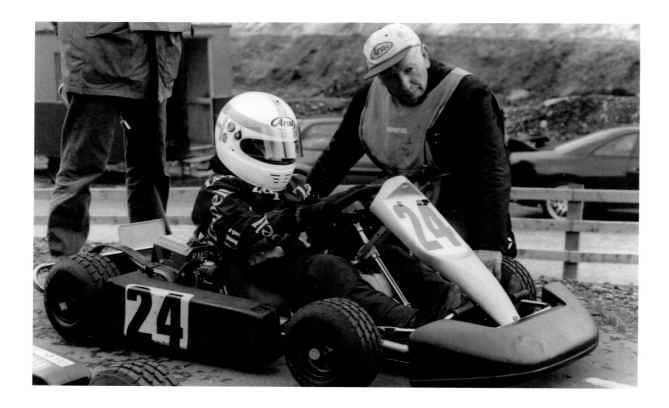

JS *"I never introduced Henry to karting. A very good friend dropped in and said 'John, we're going karting. How about Henry coming?' And so Henry went off and came back and said 'Daddy that's what I want to do!'*

So ever since then it's been team manager, chief mechanic, cook and bottle washer, and everything else when we've travelled round the circuits…"

TH *"How's it going this year for him?"*

JS *"I hate to talk about racing and bad luck. He's had a measure which he certainly doesn't deserve. He had one mechanical failure but the others were mainly brain fade on the part of other competitors who had accidents, but unfortunately involved Henry. (This is eerily foreboding.) It severely damaged the car on every occasion. In Formula 2 we have some excellent drivers but like in all formulas you have some of the other type as well! The incidents at Spa, and where his back wheel was taken off before we reached the first corner at Brno was nothing to do with him…"*

TH *"I was watching the race at Spa and he just disappeared on the last lap."*

JS *"What we didn't know was his alternator had failed, and on the last lap the battery went flat and that was that. This is how his season has partly gone. Note the familiar helmet pattern, pretty much as I had in my motorcycling days, but with the 'H' on the side. 24 has a number relationship because when I first started racing cars I had 24."*

TH *"I must say I was very impressed with his driving at Buckmore."*

JS *"Buckmore is a very good circuit. It's like a mini Brands Hatch. It has a little bit of everything and presents a somewhat better challenge than the flat playground type kart circuits."*

TH *"At Buckmore when I asked you if you were going to be at the (2000) Revival, you said, 'I hope they give me something with more bloody oomph than last year!'"*

JS *"One of the problems is that the GTO is too expensive a car to get involved in major upgrades of performance. In the GTO I lapped very nearly as quickly as I did when I drove one in anger in my racing days. But the GTO had 280 horsepower back when they were racing and the Jags had the same, with maybe more torque, but the GTO was more nimble, so it was normally quicker. In this day and age you're racing against Jaguars which have got maybe 100 horsepower more, and are lighter. It isn't a very even playing field. I did some of the development work with those cars originally (at Ferrari)."*

TH *"And you ended up in that!"*

"MORE BLOODY OOMPH" indeed! At the 2000 Revival, the 69-year-old "guest of honour" put David Piper's bright green Ferrari on pole by some margin for the 1 hour, two-driver Tourist Trophy race. He then proceeded to romp away from the field, building up a huge lead. When the driver change happened they were seriously delayed by the awkward installation of the one legged owner. Such was John's advantage however, that the pair still finished 2nd. This happened on a day when he was also "guest of honour", with a parade of his cars and bikes

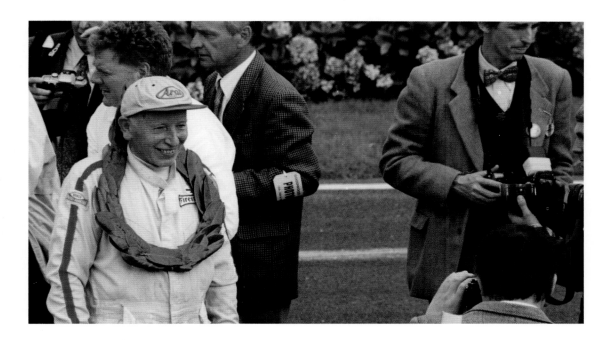

JS *"It was very frustrating to say the least that we threw the race away by David having one of his friends try and fasten the seat belts. But it was enjoyable to drive - the last time I went to a Revival meeting. Since then Henry's been involved in a race meeting somewhere so that has come first. That was quite enjoyable because Goodwood was where my motor racing career started. First time I saw a racing car was at Goodwood. The Aston DBR1 being the first race car I ever drove. Reg Parnell asked me to do a test. I sat in Stirling's car which had won the Nurburgring 1000 km. I did a few laps and I came in and Reg said "'sign here please John!" I said "What's this - a contract? No, no, no! I'm a motorcyclist!"' It also led to me driving my first Formula One car because Tony Vandervell said 'What are you driving that car for? I'm sending a Vanwall down for you!' So I drove two of Stirling's cars immediately one after another. Then Tony offered me a contract!"*

TH *"That explains why you were driving a Vanwall at the first Revival. I hadn't previously associated you with one."*

JS *"The Vanwall was developed directly from a Norton motorcycle engine. The Vanwall is purely four Norton engines put together."*

JS *"I'm wearing one of my original pairs of overalls from when I was racing the Honda and the Canam car. The pre-war Mercedes cars such as the W125 are great cars. With the Mercedes historic group it was great fun. I went all over the world driving those cars for them. Nowadays they seem to use more journalists etc. I think they should be demonstrated possibly more often and perhaps maybe a little more... (pauses)"*

TH *"Enthusiastically?"*

JS *"Enthusiastically!"*

TH *"Everybody's thinking about the repair bills!"*

JS *"Yup. Too great!"*

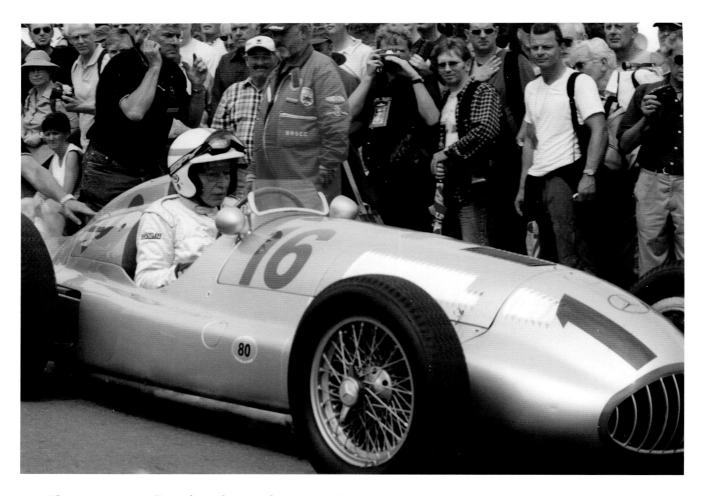

TH *"So many pictures I've taken of you in the Arai cap."*

JS *"Well not necessarily the same one! I've worked with Arai now for many years and it's been a very pleasant relationship. Good products. and helping some of the projects I'm involved with, especially supporting young drivers."*

TH *"Who was your favourite rival to race against?"*

JS *"Probably Dan Gurney and Jack Brabham."*

TH *"Why, particularly?"*

JS *"Such enthusiasts. Dan was very quick and a top man. Jack Brabham was a trier who never gave up, so if you had Jack around you knew you had a fight on your hands. Jack would use the road and a bit more! A real 100 percenter."*

TH *"I remember seeing him on TV at Monza. Did he come down into the Parabolica and outbrake himself?"*

JS *"Luckily! Knowing Jack he was not going to let that opportunity go, and I had to make sure he took that opportunity! The last lap scramble round that corner. I just made it to the line to win that race. Jack took the choice of going on the oil and cement, but at the point we were braking it wasn't going to work. But he was a good racer also because of his engineering. He always made sure he had a pretty good car for himself. As with Dan, we never had the best cars of the time."*

The League of Legends: John at Silverstone with Moss and Brabham, signing autographs in Arai cap

TH *"There's a great article about you in* Motor Sport *saying you went to a team that was in the doldrums, lifting them up. That must have been incredibly satisfying."*

JS *"Yes, but frankly I probably wasted time in my career. It probably satisfied me at the time but on reflection you're letting people win that you were quicker than, just because you'd taken a challenge on. But it wasn't always your decision because oil companies also had a say of who drove where. In a way I blew my chances after I'd walked away from a number one position at Lotus. It didn't endear me to Esso. When the Ferrari thing all blew up I should have probably gone back to Colin."*

TH *"The thought always comes up about Lotuses how they would, as Stirling would say, 'kick you in the balls' with bits falling off etc."*

JS *"You did take the chance. Perhaps if I had signed with Lotus in 1961 I wouldn't be here now! If anything I was a bit more forceful than Jim, and it may have been that I'd encountered problems earlier. It was a period when the engineering of the car didn't match the concept. But the car won on its design. Different age. Minuscule budgets compared with now. One mechanic per car and suchlike. You'd have your own mechanic and maybe another helper for the gearbox. It was very, very different. Not relative to what is required from a driver or from the other personnel, but relative to the environment you're racing in. People*

who race today don't realise the privilege they have with the safety factor - the money they get paid and the fact that they have cars which on the whole can be driven hard for a total race. It was not that often that you had that situation in my time. You were compromising from a very early stage."

TH *"I remember Lewis being interviewed at Brooklands and he was just about to drive the old car, the W196, and he said 'I wish I'd been racing back then. More racing. Less politics'. He had some sort of recognition that things were different and perhaps for the better in those days."*

JS *"Some factors. There was still the politics there. One of the sad things about racing today, and I see it first hand because of my involvement with youngsters, is this: I won world championships on motor-cycles and I was immediately asked to try out a race car. And when I sat in race cars that had been driven by Stirling and went as quickly as he did, people wanted to put me in cars. I said no, and then Ken Tyrrell said 'try and race a car.' I had my first car race ever in 1960 at Goodwood. Then I did two races with my Formula 3 car that I'd bought, and then Colin asked me to go in the Forrmula One team. That certainly wouldn't happen today.*

You find this structure in junior formulas where largely the people with the deepest pockets get in the best teams. And that's why I sincerely hope that this Formula 2 actually succeeds because it can be a relatively level playing field for someone to show their abilities. Other than that, on the back of the vast monies which have gone into Formula One, all the costs in motor racing have risen, whether it's karting or the formulas you go into after karting. And that is very restrictive. Great shame. In the Rac-ing Steps I'm involved with lads who would not have been able to advance their careers through BMW, Renault, the World Series etc. can do so. But that's just three lads. We need a bigger scale. Frankly we need Formula One to put more into the catchment area that they draw their talent from. We shall see."

TH *"As Frank Williams says, it's still a sport between one o'clock and three o'clock on a Sunday."*

JS *"To some people it is. To others it's a business. But the motivation is still the competition first, and second the sporting aspect. But as things have grown in all sports you have a bigger percentage of people who are there for the money."*

TH *"One of the saddest things I saw when I was karting was this kid in a Mansell helmet and his father almost with a whip beating him into the ground."*

JS *"This is one of the things I saw and that's why I think the MSA should insist that kids still go to school and don't get driven on as a potential pension pot for the family! We need to take sport more into the community and karting can do that. Schemes where you can go along and try a kart for five pounds are superb.*

We could also do with government treating motor sport as something that is important rather than just paying lip service to it - it's ridiculous that Sport England and people like this ignore motor sport. Lottery money for sports that have very little real benefit to the country as a whole, whereas at least with motor sport you actually have a major benefit because of the motor sport industry."

John in Aston Martin DBR1, the first racing car he ever drove. At Goodwood. Sets off, with a touch of opposite lock, for his last drive – also at Goodwood 2016

TH *"Still, when the flag falls nothing can beat the sound of Mark Webber screaming into his helmet with pure joy."*

JS *"That's good to see. Mark had a bad start to the year and what is nice is that he has a very, very talented teammate, probably the best driver in the world at the moment, and he's risen to the occasion and taken the fight to Vettel, who is a superb driver. Your main competitor is normally your teammate. It's good for motor sport because he hasn't been a whinger when he's had misfortune, and he's been the 'nearly man' for so long. He's won one, and on merit because he dominated that meeting. Also the team did a wonderful job. A good result."*

TH *"One for the heart! Excellent. Well John, I could happily sit here all day but I'm sure you have lots to get on with. It's been an absolute pleasure and a privilege. I'm not sure which is the greater. Probably the pleasure!"*

JS *"Let's keep it that way! Its nice if you can actually do things which give you pleasure and I think one of the greatest privileges I've had, is I've been able to earn a living doing things that I loved."*

TH *"That is priceless."*

Five days after this interview I was watching Henry in an F2 race televised from Brands Hatch. He vanished from the coverage and the commentator expressed increasing concern. He had been involved in someone else's accident, something his father had talked about five days earlier, and was struck on the head by a wheel which flew off a rival's car when it hit the bank. The chances of it hitting him were so slim, as in Senna's accident when the suspension arm pierced his helmet. I listened for news as the day wore on, only to learn that Henry had died as a result of the blow to his head. As a father of two very young children, and having met Henry with John nine years earlier and followed his career, I was deeply shocked and saddened. It brought home to me the downside of the era I celebrate, in which so many friends and familiars were lost, and also the dreadful irony that having survived that era, John would lose his son in this way.

It is to his great credit that he turned 'poison into medicine' by stoically setting up the Henry Surtees Foundation 'to assist people with brain or physical injuries caused by accident.' But I doubt his broken heart ever recovered. I noticed that whenever he spoke about the work he was doing with the Foundation, he would always use 'we' rather than 'I'. I believe this was more than just the traditional racer's preference of using the plural, but rather his way of keeping Henry alive.

Ten years on, I am still saddened by this story. It has taken me this long to bring myself to watch this interview for the first time. Yet it is obvious that I had to include it, as a tribute to a great man, an energetic ambassador for the sport, and a tireless supporter of young talent. He was always kind to me and ever so helpful when I met him for the first time as a 'karting dad' at Buckmore Park kart circuit.

John died in 2017.

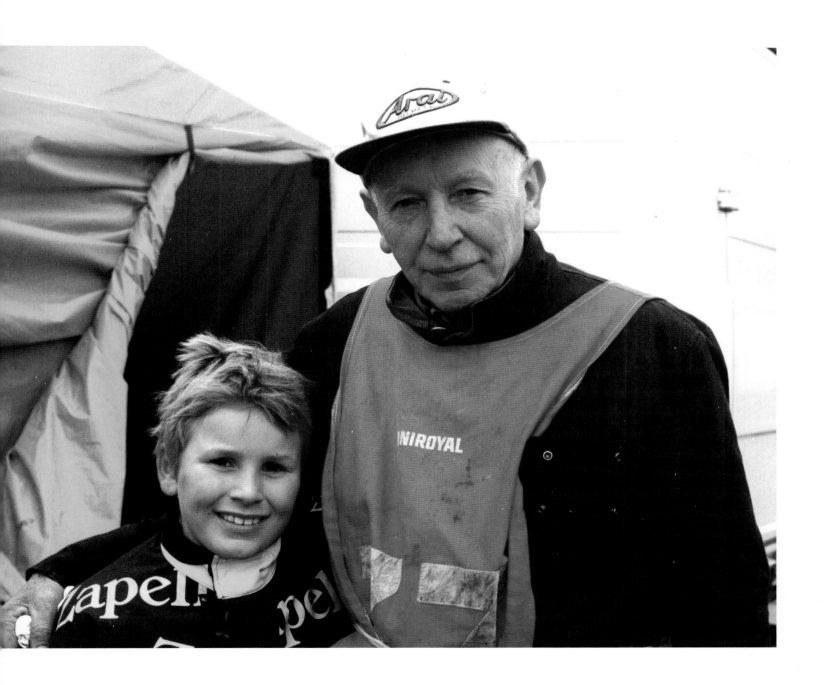

Chapter 16
Moments with Moss 2

AC Cobra

In the week following the 2002 'Revival' Stirling phoned in an article to *Autosport*, describing his exploits at the event. The printed piece reported him as saying: "I'm not as fast as I was. I drive as hard as I used to, but my balls are smaller..."

Really? Any 73-year-old who chooses to race an AC Cobra can hardly be accused of being less than well endowed. Just ask Sir Jack. In 1999, he lost a wheel on his!

Not your average 73-year-old's choice of ride, for sure.

Ford Galaxie

MM

SM *"That's when I got talked into driving this great big heap by Charles. Charles can be so persuasive. He had this bloody thing and nobody would drive it! And they'd gone along to Gerhard Berger who said 'No way am I going to drive that thing - dreadful car!'"*

MM
MOSS MOMENT

SM *"I don't know what Susie's doing there (laughs) She looks dreadful! She won't like that!"*

TH *"I think they were having a little joke. He's a very funny man."*

SM *"Oh yes. Very funny man."*

Ferguson F1

MM
MOSS MOMENT

SM *"A very interesting car because it really was very neutral and people say if a car is very neutral, not much understeer or oversteer, it's very easy to drive. It isn't actually. It's far more difficult to drive because it's a very precise car. And the brakes and the roadholding particularly in the wet was absolutely stunning. To split the drive so you've got four-wheel drive which of course isn't allowed now…It really was a very, very good car. I won at Oulton Park. I think I would have won the British Grand Prix but Charlie Cooper had me disqualified. My car was out and I'd taken the Ferguson over from Jack Fairman. He had me disqualified because I hadn't practised it. I was going right through the field passing everybody. I could pass the Ferrari on the outside in the wet on the fast corner onto the straight because it was so good in the wet…the best car in the wet. Terrific."*

Susie and Erik Carlsson

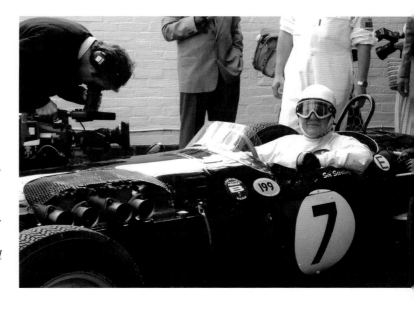

Aston DB3S

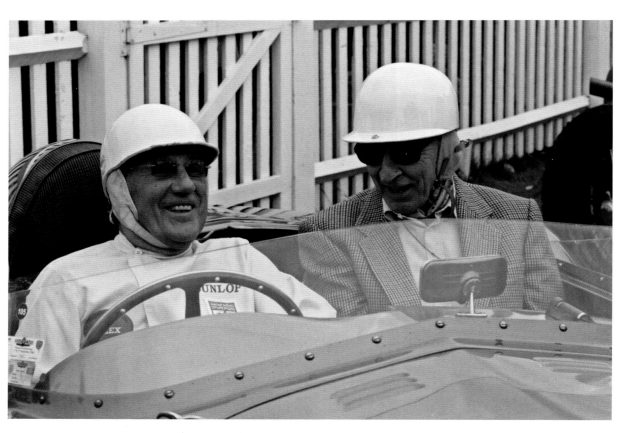

MM MOSS MOMENT

SM *"That's a DB3S. Roy (Salvadori) was quoted as saying 'I hope I can afford it to have me (SM) driving!' All I can say is thank God he wasn't driving or he'd have frightened the hell out of me!"*

The voice of Silver Hatch Race Track with Roary The Racing Car

"You had to start on 500s..."

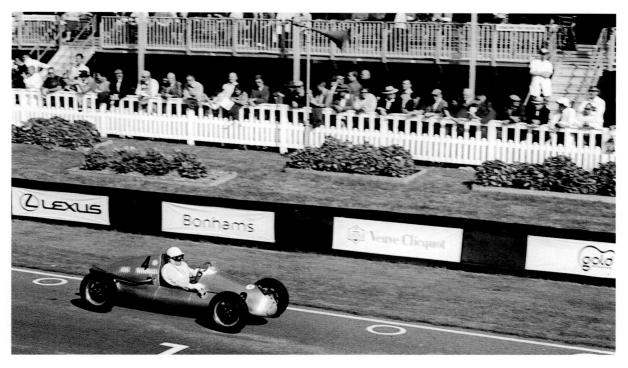

MM | MOSS MOMENT

SM *"Is it a Kieft? No I don't think it is actually, but the Kieft was fantastic. At Goodwood, the corner after the pits was my favourite. You'd take that flat out, so it was for Fordwater. It was no problem because it understeers. The circuit itself is literally the same as it was. Quicker obviously because the cars are quicker. There are very few cars out there that haven't got more horsepower than they had 60 years ago. They're running much higher tuned engines, better tyres, so obviously it's faster. The track's so much bigger in a little car, and that makes it really nice to drive."*

TH *"So would you say that this (the 500cc category in the late 40 and early 50s) was the equivalent in your day of what karting is today?"*

SM *"Well it had to be. You had to start on 500s. There was no alternative. Now of course by the time they're old enough to drive they've already done eight or nine years. I mean, look at Lewis Hamilton. He's got years of experience before he even got a road licence. We couldn't. So that's why I think karts are really good for these kids."*

Aston DB3S

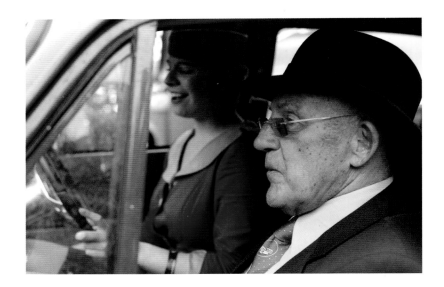

SM *"Oh, that's one of those girls that runs the taxi thing. Really funny because they speak (puts on posh accent) 'frightfully frightfully' like this: 'Oh absolutely'! Oh God yes, that's part of the deal you see. You get in and I thought 'God that girl's so affected'. Yes! Really laid it on!"*

TH *"Glamcabs!"*

SM *"That's it, Glamcabs yes! Really very good!"*

SM *"That's the hat that old Jochen Mass gave me."*

TH *"Do you know what the car is?"*

SM *"Is this the thing the kid had made for him? Oh God yes!"* (Laughs)

Moss and Murray: Mint Moment!
Introducing the World's Favourite Commentator, of Whom Clive James said, "In His Quieter Moments, he Sounds Like a Man Whose Trousers Are on Fire." (Jaguar XK Festival 2008)

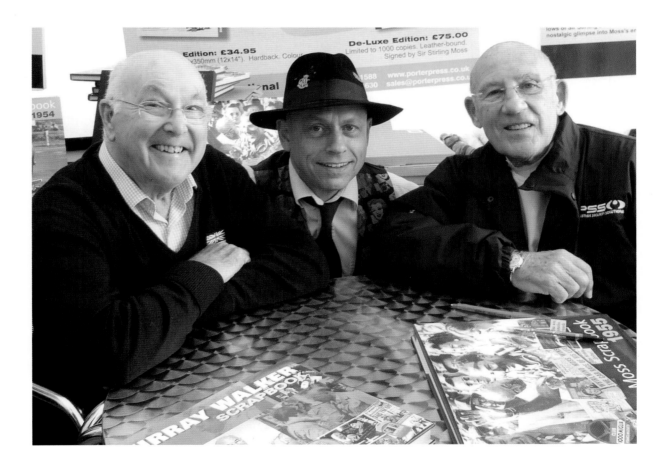

MW *"Well I told you they were follically challenged! A little rub on the head encourages hair growth! That's at the Revival – I can tell by the fence in the background there."*

TH *"May I say, Murray, that's at Coys Silverstone 2000!"*

MW *"No no! I wasn't at the Coys Silverstone in 2000, that's Goodwood. I recognise the picket fence (Stirling is creasing up laughing). And I recognise the buttons on Stirling's shirt!"*

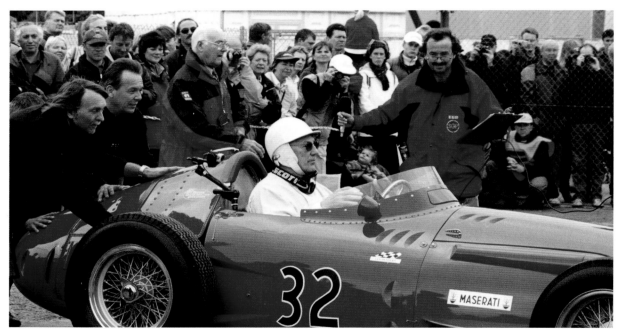

MW *"I don't know if Stirling agrees but this is the most evocative racing car that was ever designed, the 250F Maserati. Fantastic! This chap (with the microphone) I know. I cannot remember his name but he's a television producer…which would account for me being there, and I remember this was at Coys in 2000, wasn't it?"*

SM *"Unless I'm very much mistaken! (We all laugh heartily. Not least the man Stirling affectionately calls 'Muddly Talker.')"*

Stirling on Maserati 250F

SM *"The 250F was probably the nicest balanced, most user-friendly car of all the front-engined Formula One cars. The Merc was probably a better car because it was stronger and so on but this was certainly nicer to drive, a really beautiful car to drive."*

TH *"You told me once that if you changed the tyre pressures by one pound per square inch you'd feel the difference, that's how good it was."*

SM *"If somebody let a bit of air out of the front or back, I'd know, yeah! That was the final adjustment. You'd get all the shockers set up depending what the circuit was like; if you could tolerate a bit of understeer or whatever. Different times…"*

"If somebody let a bit of air out of the front or back, I'd know, yeah!"

Mega Moss Moment: 80th Birthday Revival Celebration - 2009

'M' is for Moss; Maestro; Mister Motor-Racing; Meteoric; Mesmeric; Monaco; Mille Miglia; Mercedes; Maserati; a Multitude of Mighty Motor Races in a Myriad of Magnificent Motors.

(With apologies to Michael Frostrick and Louis Klementaski – authors of the 50s book British Racing Green*).*

One for each decade – 1

One for each decade – 2

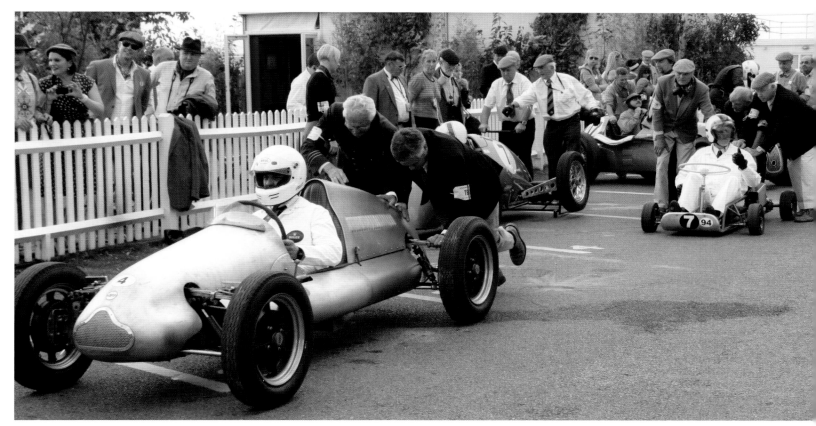

A few of the 80 assembled vehicles
Moss has driven in his 80 years...

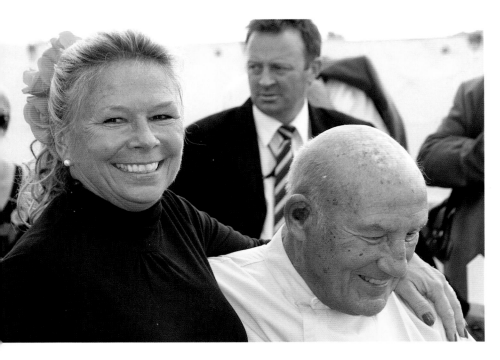

Sir and Miss
Goodwood

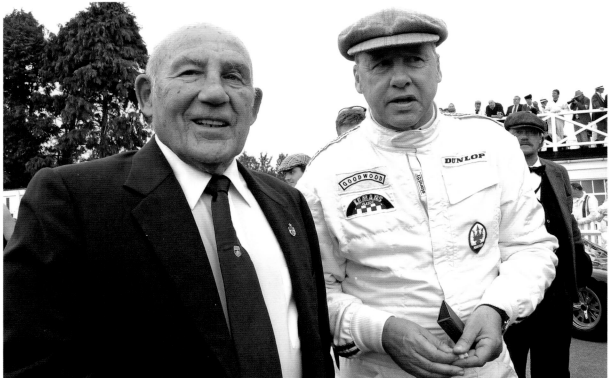

Stirling, with Mark Knopfler

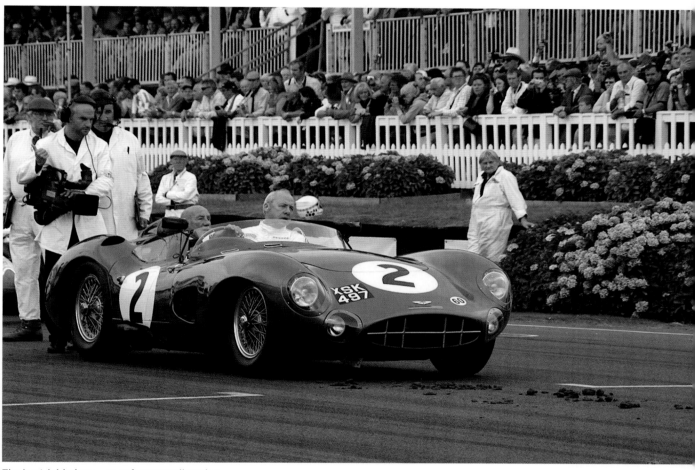

The best-laid plans – an unforeseen diversion

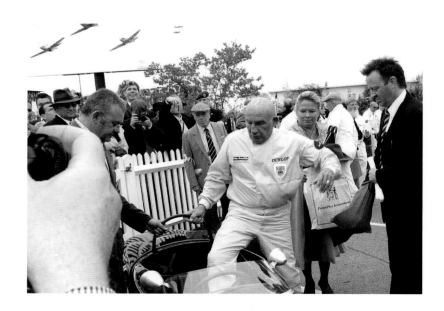

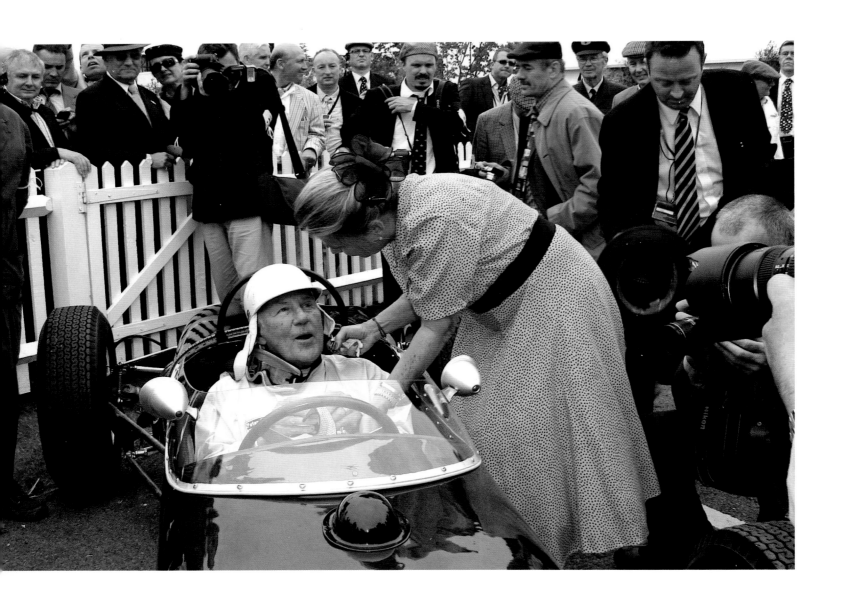

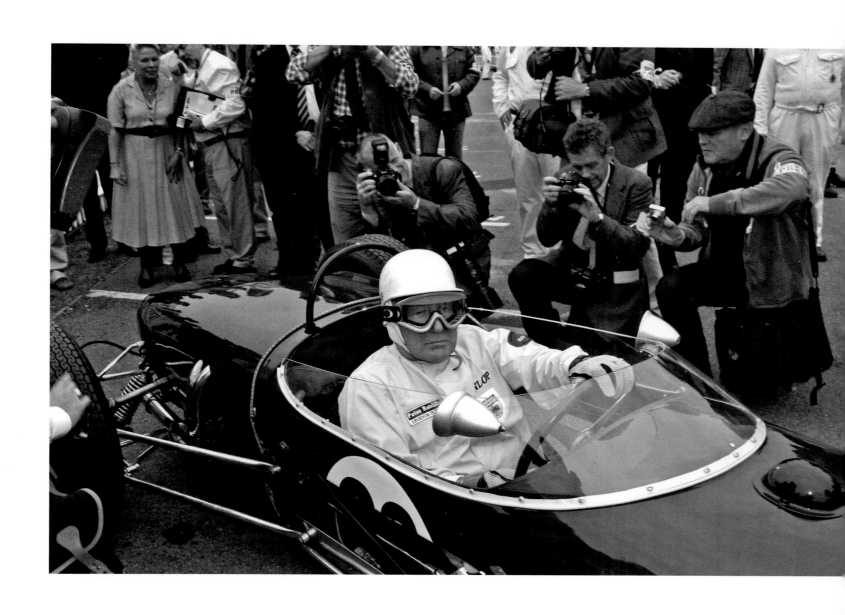

80th Birthday Wishes

Alain de Cadenet:

"If you drive race cars yourself, not that one ever emulates him because he's special, but it's nice to think you can live to a ripe old age without too much trouble but still be able to get yourself into a racing car and go round in it. I mean just all the getting in and the changing gear and all that sort of thing. He can still do it all. Which is great. It just comes naturally of course. Eighty - that's his bone age, but he still has the mental age of a teenager!"

Tony Smith:

"Ah Stirling! Well Stirling just keeps on going on and on. Congratulations on his 80th birthday is all I can say. He's still going. Still out there driving, and good on him."

Canon Lionel Webber:

"I drove Tom Wheatcroft's 250F at Donington two years ago, and it was like a dream. He said 'Take it out lad', and I didn't race it. Stirling once said to me: 'You and I can both drive a 250F. You can drive it, but I know how to race it!' But it was just amazing to put your backside where Fangio and Stirling and Villoresi and Collins had once put theirs, and I got out on the back of the circuit, and I stopped and I revved the engine and I cried my eyes out. I couldn't believe it...it was just wonderful. I did 35 laps in it! Stirling will still be here next year (for his 80th). There's not room for two Gods!"

Nick Mason:

"I hope I'm driving that well when I'm 80.
Well I hope I'm driving at all when I'm 80."

Marilyn Monroe:

"He's my toyboy. I think he's seven years younger than me. He looks fantastic, don't you think? Not as fantastic as I do…I look a lot better, but then I'm a girl. And I'm Marilyn Monroe. I was going to get a restraining order on him but I kinda like him now! He's really nice. But every year he finds me. He keeps turning up here. I don't know why he's here! I heard he's a racing driver or something."

Moss and Marilyn Moment

SM: "She's a good Marilyn actually. She could probably pull a younger man if she wanted to!"

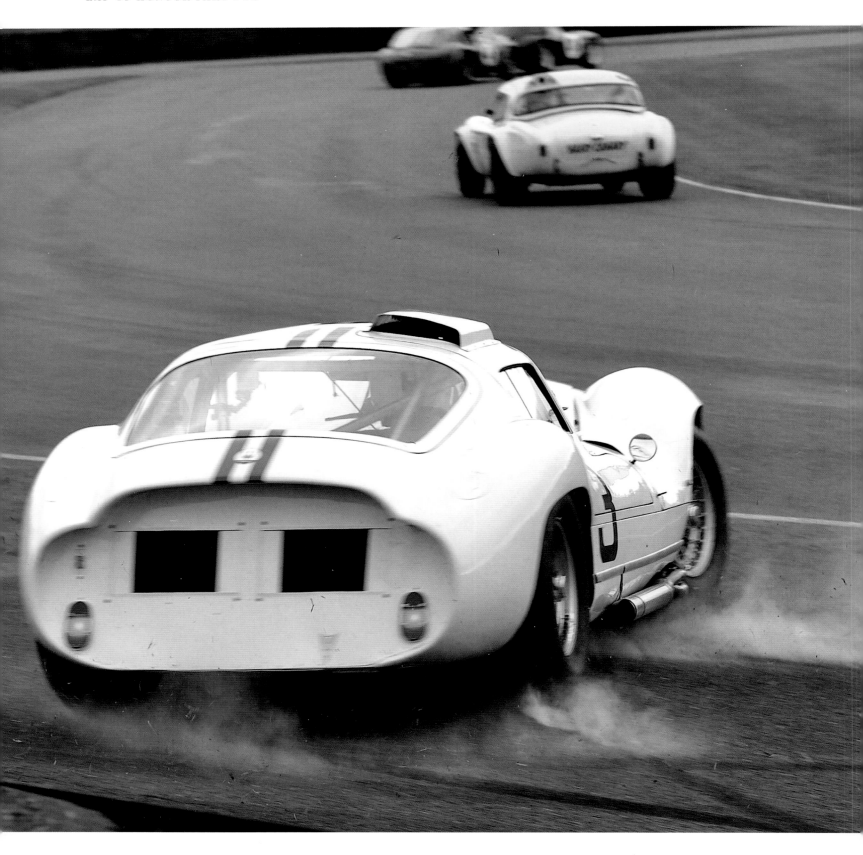

Chapter 17
Planes, Dames and Automobiles

When the Green Flag Drops

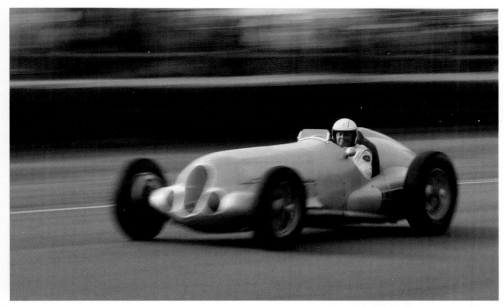

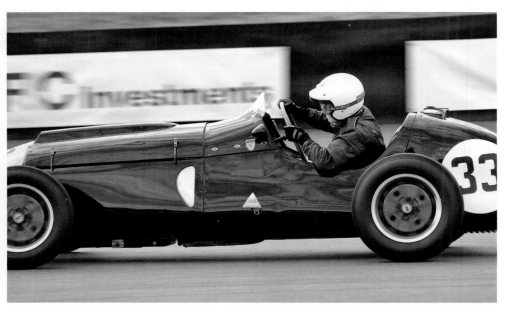

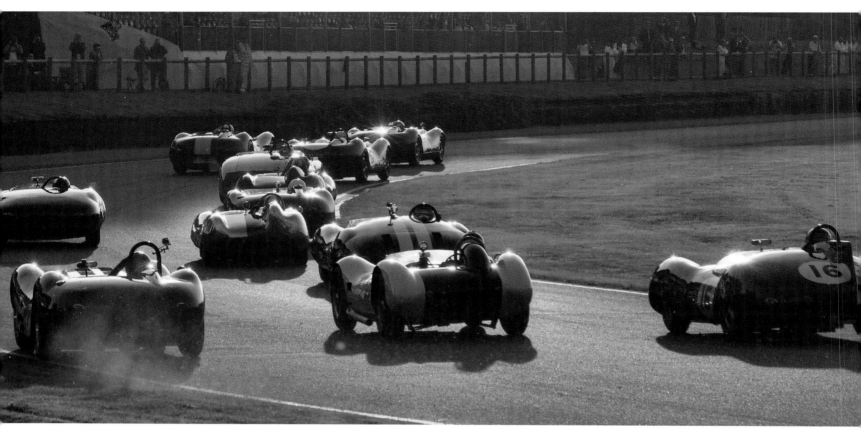

Nigel Mansell. I will never forget staying up to watch the Australian Grand Prix 1986, and that moment when he lost the World Championship. At around 4am, his tyre blew at 200 mph, and I jumped out of my skin

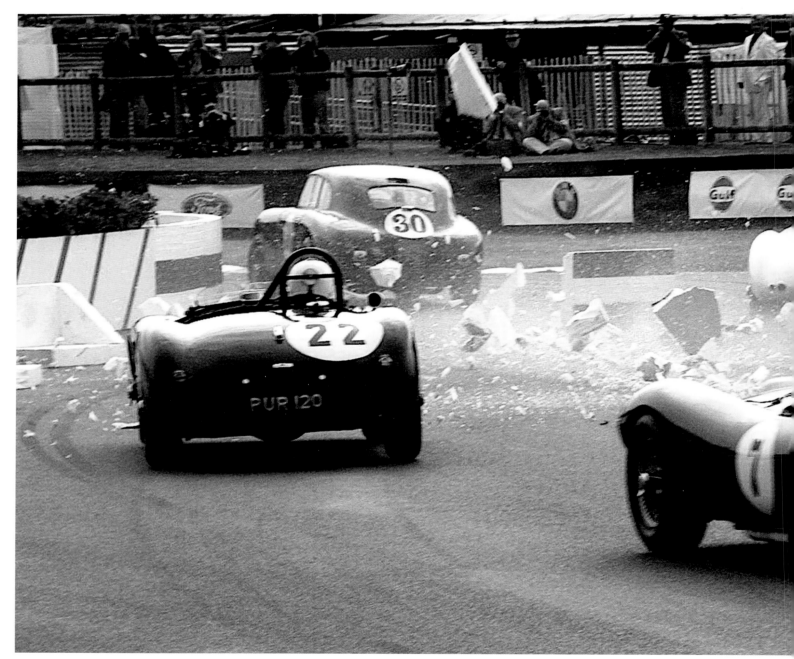

"Crunch time"

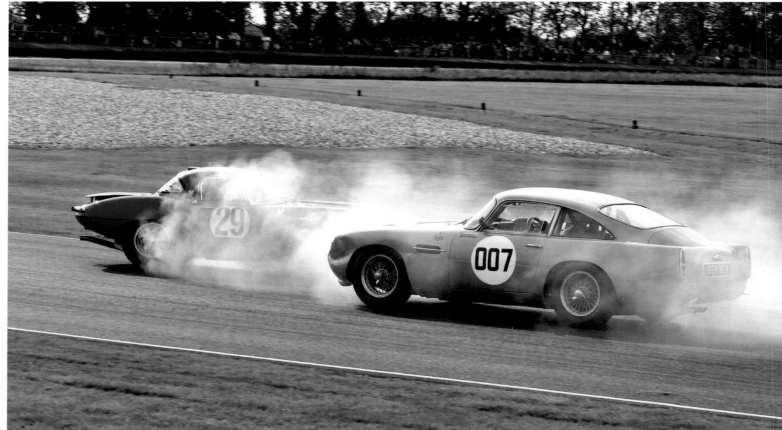

"Mr Bond, do you destroy every car you get into?" 007 demonstrates that despite being incredibly valuable, these cars are raced hard

Big Mac. My son's favourite

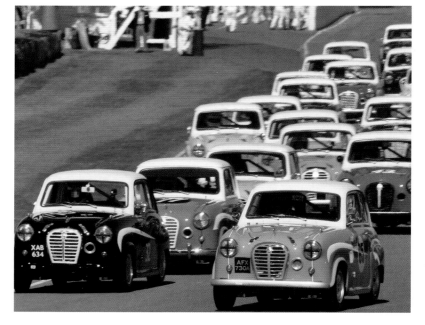

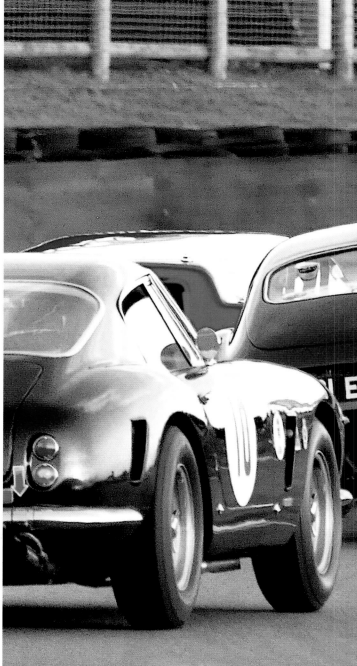

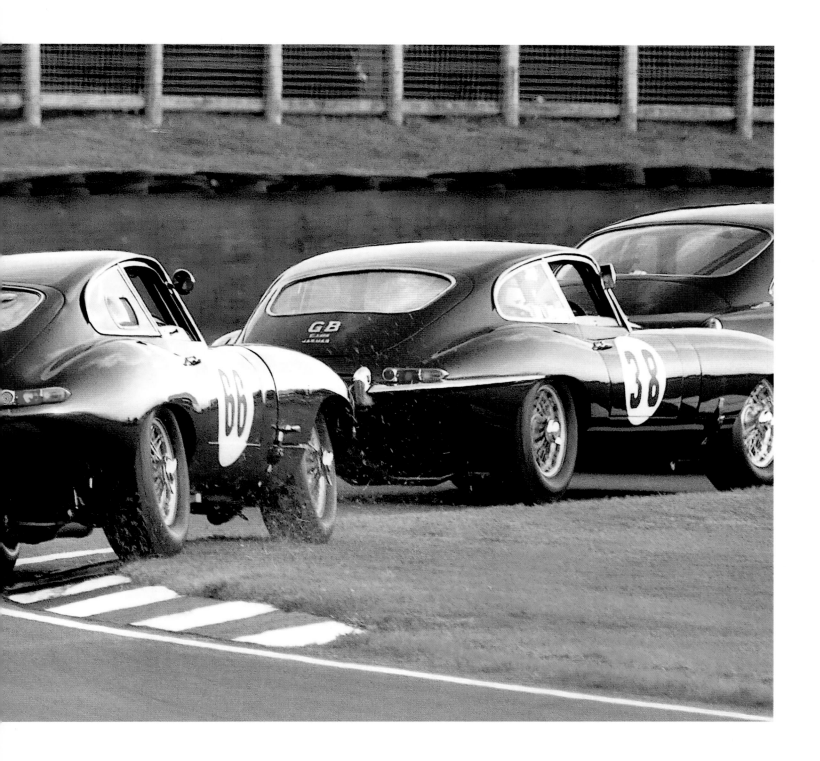

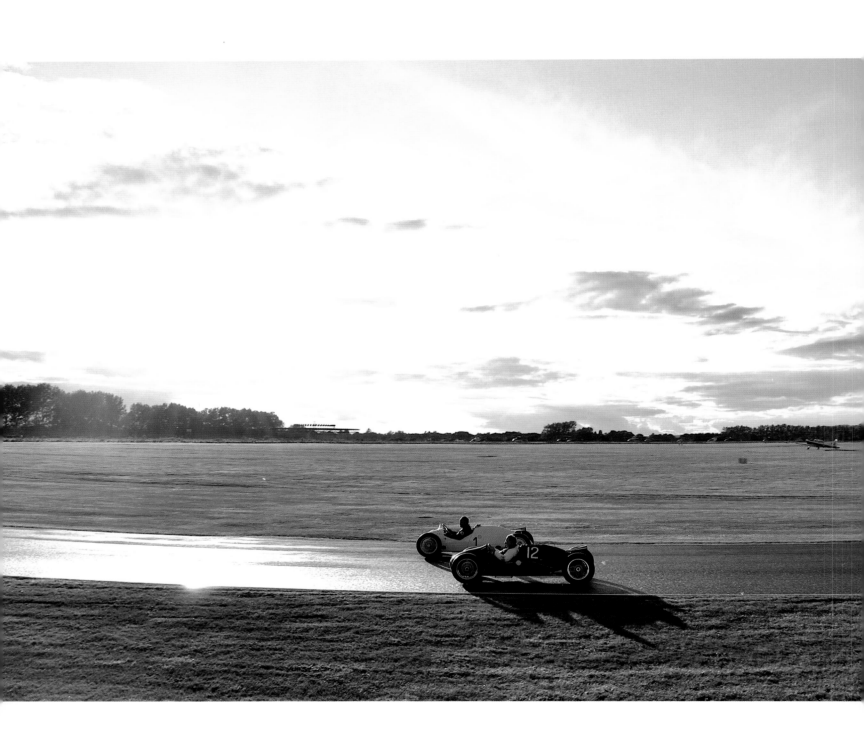

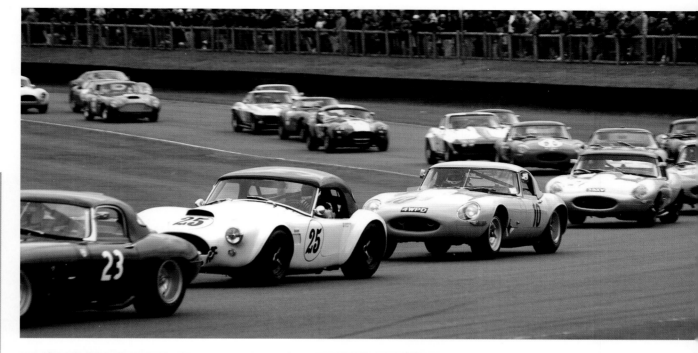

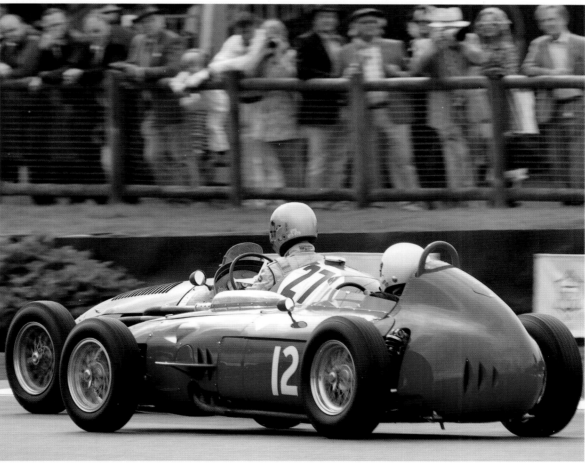

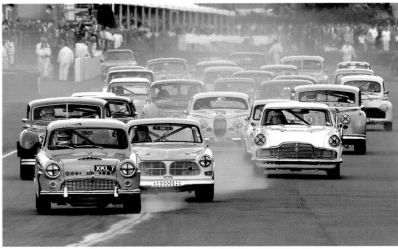

"Race to
the shops"

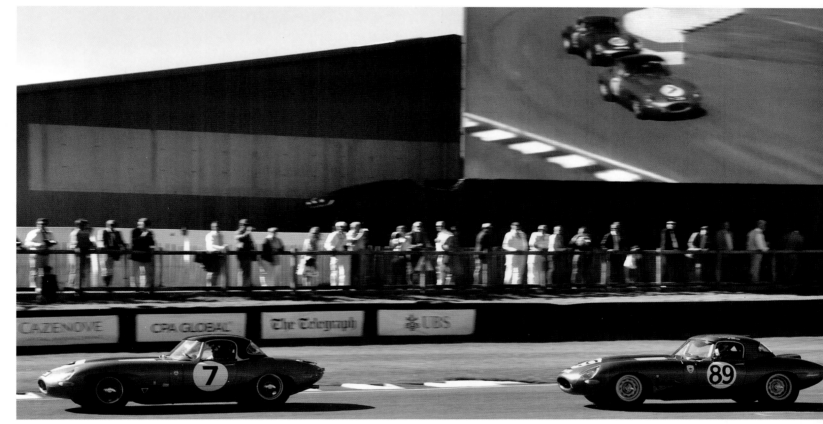

"Mirror image"

"TT start – always
the most exciting
Revival moment

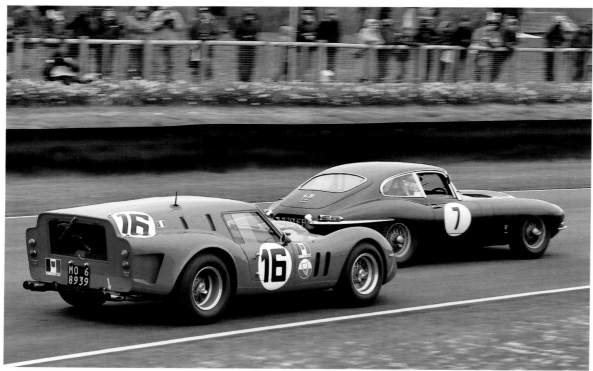

"He'd race it harder if he owned it!"
Spectator's comment

*"He'd race it harder
if he owned it!"*

"Fire and Ice"

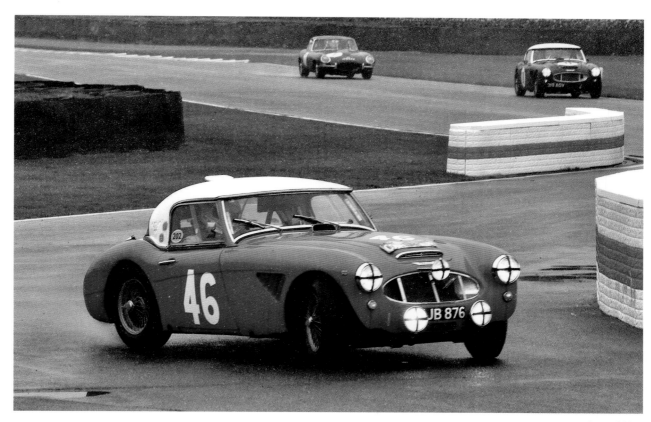

Snowdrift 2

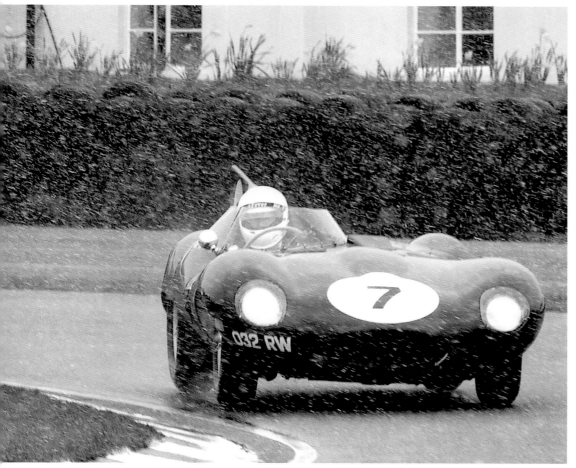

"Snowdrift" - Goodwood Members' Meeting 2018

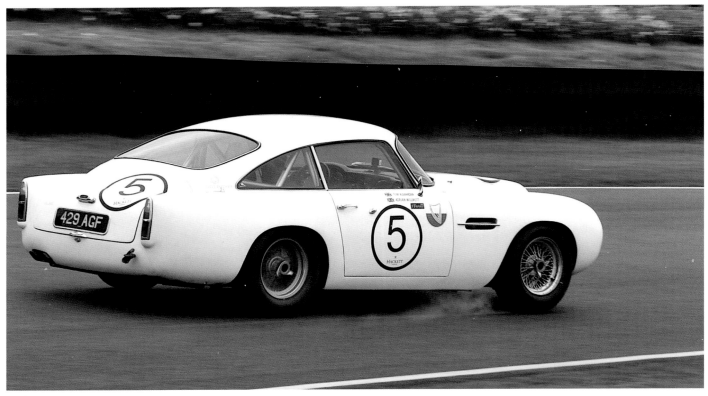

Lock up

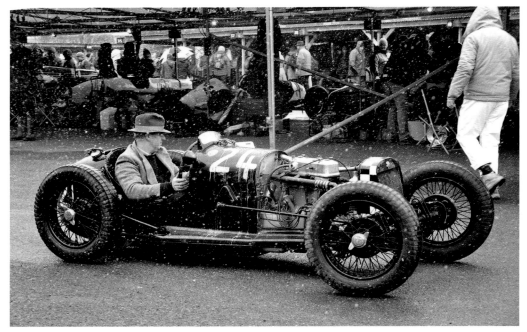

"Snow place like Goodwood"

"Snow place like Goodwood 2"

"Splash"

The legendary 'Sharknose' Ferrari: Tim Hain: "I hear Chris Rea wept when he saw this."
Tony Smith (racer and Phil Collins' manager): "It wouldn't surprise me"

"Cobra in the Grass"

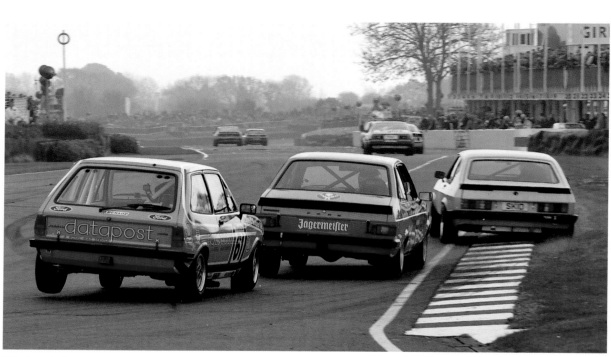

"Skid marks!"

"Corvette gets out of shape"

"Jaguar preys on Cooper-Bristol"

Star Cars

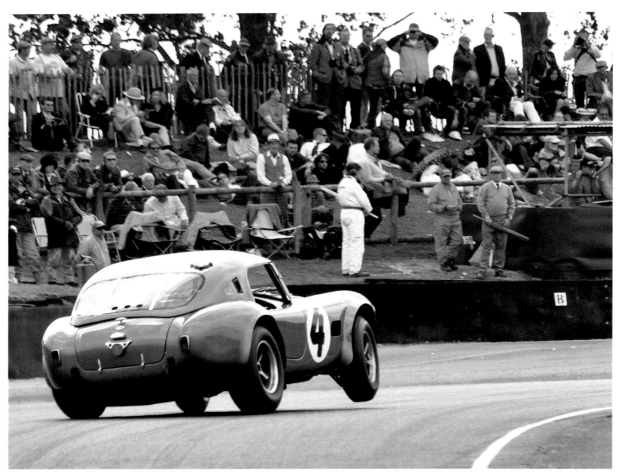

AC Cobra

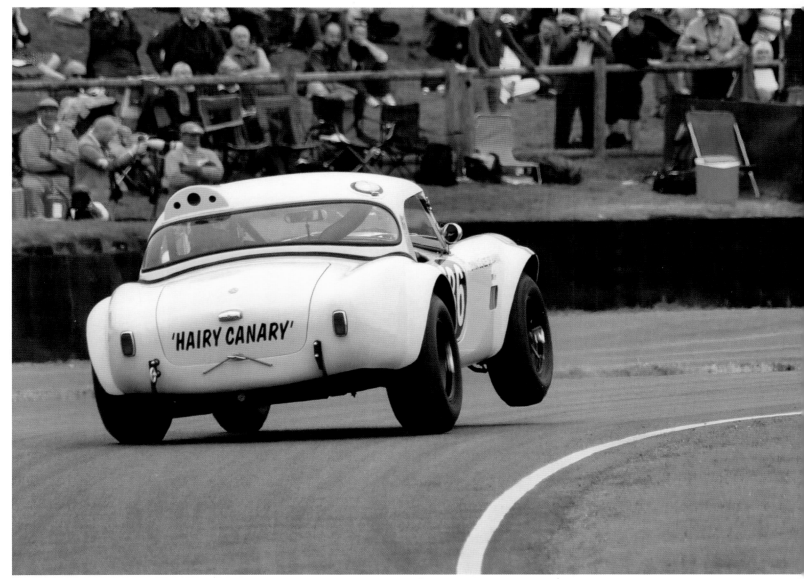

AC Cobra

Longnose
D-type Jaguar

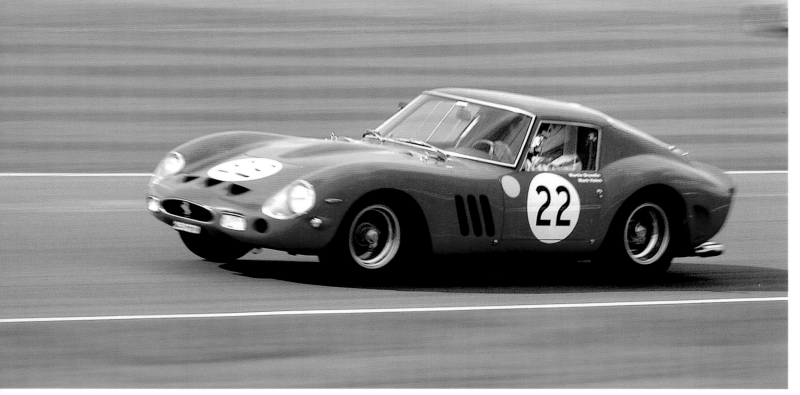

Ferrari 250 GTO

Lotus 25

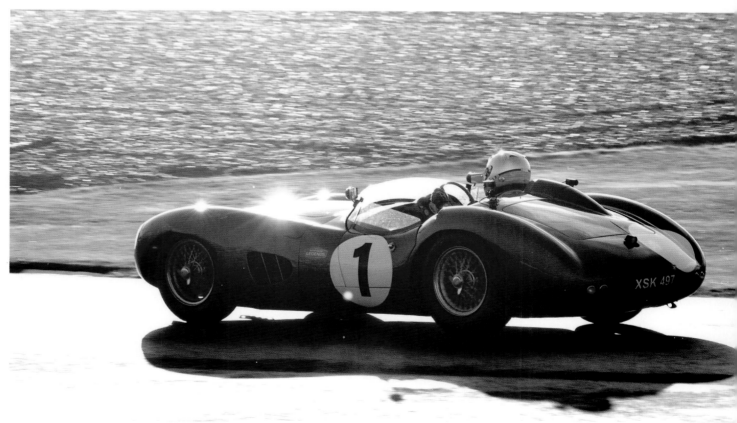
Aston Martin DBR1

BUY 1. The Most Photographed Car in the Book

A conversation between Murray Walker,
Stirling Moss and Susie Moss:

MW *"I know that's a very famous Jaguar.*
 I can't remember who owned it."

SM *"Coombs? Isn't it a Coombs car?"*

MW *"I think it had four wheels when he owned it!"*
 (Laughter)

Lady SM *"Somebody didn't pay full price!"*

All the Fun of the Fair!

British icons

Remembering Bruce

Down at the Demon Drome

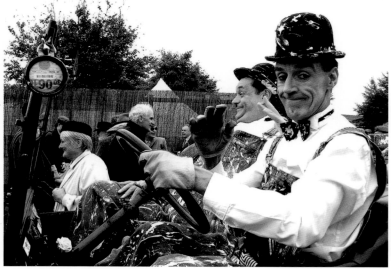

Harvard landing

Canberra and Hunter

Hurricane, Lanc n' Spit

Vulcan

Spitfire Cafe

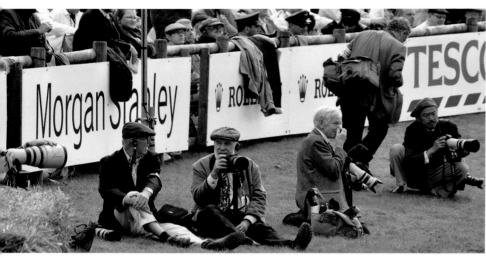

Those lucky men with passes! Jeff Bloxham fancies his chances at a better shot

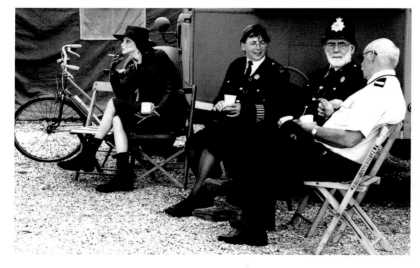

"Senna was here..." (his old car)

On your marks...

"Dan Gurney for President"

Miss Auto-Union

Bentley Belle!

Bugatti Boy

There's always one...

Lush moment...

Someone's got a new hair dryer

Each to his own...

Open All Hours

There is indeed always one!

Un-aFORDable...

Jukebox Jury

Our latest model – built for speed AND comfort

Somebody's watching you...

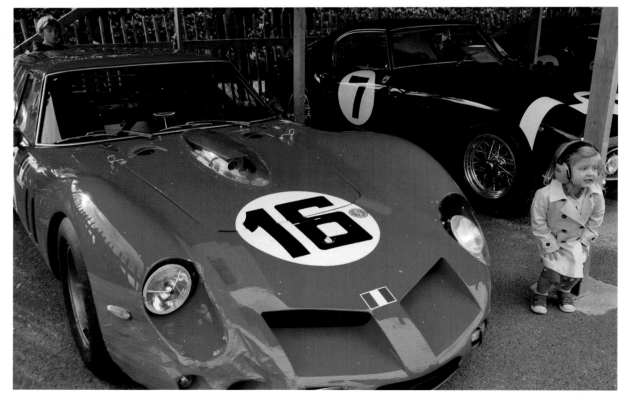

I wouldn't let my children loose in the Ferrari pen

GLAMCABS!

Tony Smith goes 'Green'

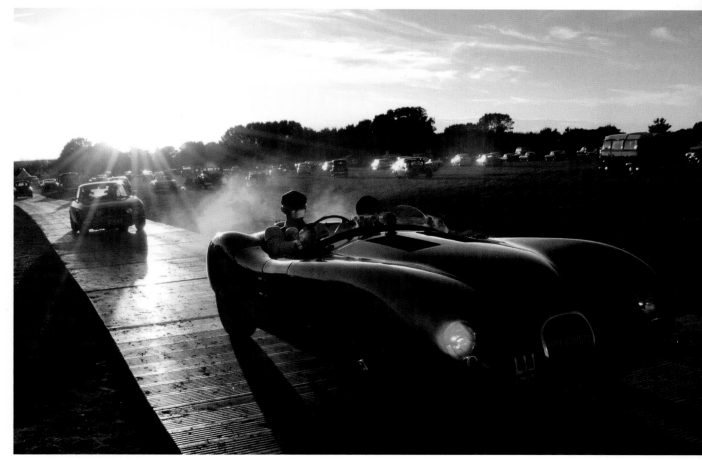

Goodbye Goodwood. Until next year...

Photo-Autographs

"I like playing paparazzo! A candid picture has always meant much more to me than an autograph" TIM HAIN

Happy boy! Arturio Merzario

Laid back chap! Jacky Ickx

Tony Brooks

Norman Dewis with Susie Moss

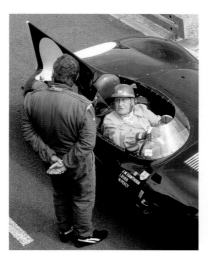

Norman Dewis, driving 90

Nigel Mansell. *Murray Walker: "Nigel looks like he's catching fish there!"*

Rob Wilson. Scone paradise!

Emerson Fittipaldi

Lewis Hamilton

"In 2000 I gave Stirling a video of young Lewis winning a kart race in pouring rain. I said, 'This guy's going to be World Champion. He reminds me of you...'"

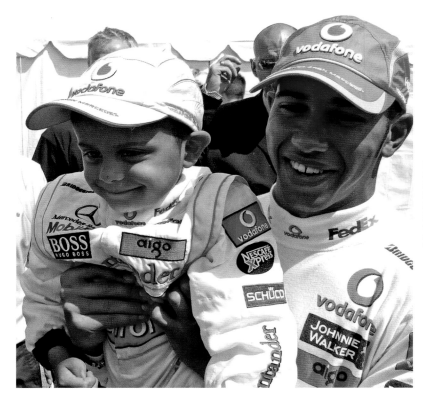

Lewis Hamilton: Right place, right time! Good job the young man didn't have a Johnnie Walker Logo

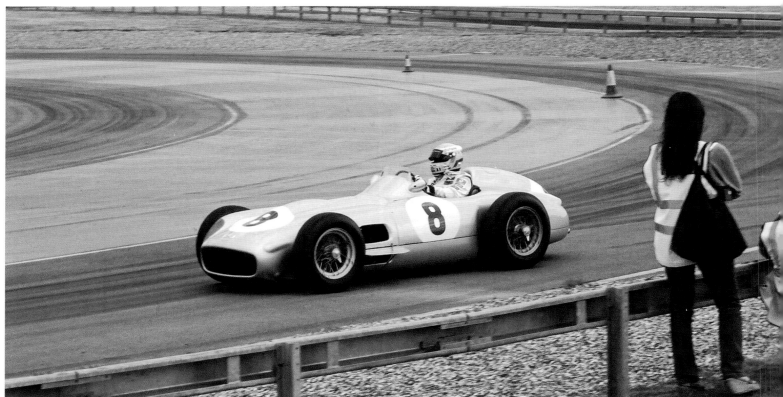

Lewis tries Stirling's 1955 British Grand Prix winning Merc W196 at Brooklands

Sir Jackie Stewart

'JYS' gets comfortable with his old Formula 3 Cooper in which he will lead a parade of cars he has raced

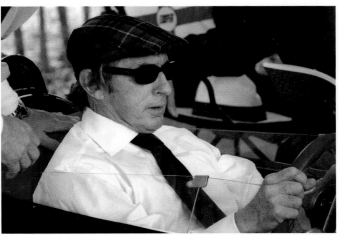

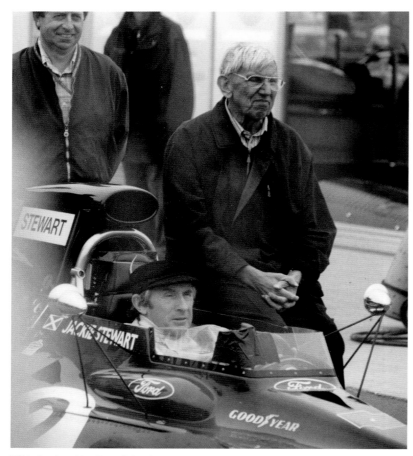

With the late Ken Tyrrell, his former team manager

JYS MOMENT

'Starting money' is a 60s term not heard these days. Interviewed by the lovely Amanda Stretton on the Goodwood grid, Sir Jackie, Guest of Honour, gives it a welcome revival:

AS *"Why have you got lipstick on the corner of your mouth?"*

JYS *"Because a racing driver gets kissed by an incredible number of girls."*

AS *"Well let me add myself to the list."*

JYS *"That's my starting money for the day."*

Amanda
Stretton

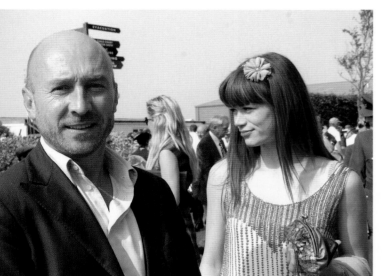

Stig without wig!

Alan Jones: "The
older I got the
faster I was!"

One half of the best
dice in history with
Gilles Villeneuve -
Rene Arnoux

Chris Rea, after enjoying the Road to Hell...

Piper and pipe. Stirling Moss: "You knew
David worked for my father on the farm?"

Murray Walker and Gerhard Berger

Murray Walker and bride – someone else's

Murray doffs to Susie Moss

Murray with my daughter Jemima

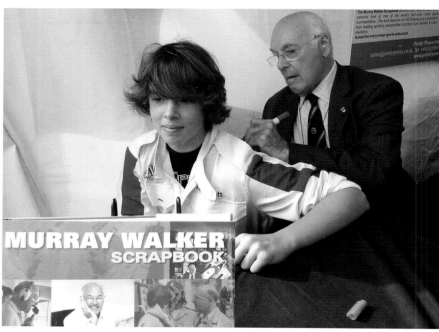

Murray signs

Gerhard Berger relaxes before the TT

MURRAY WALKER ON GERHARD BERGER:

"Ah, Gerhard Berger! Gerhard, the world's best practical joker in Formula One. A friend of mine was with him in his car in Rio once. They were going to the hotel when my friend said, 'There's a terrible smell in this car Gerhard.' And Gerhard said (Murray puts on accent) 'Zat will be ze fish!'

It was about 40 degrees, so he stopped the car and opened the boot lid, and he'd got a box of rotting fish in there – fish heads and fish tails and fish bodies. They drove to the hotel and he blagged his way past reception and into Ayrton Senna's bedroom and he distributed these fish in the television set, on top of the wardrobe, underneath the bed, which Senna wasn't best pleased about.

About a fortnight later in another country in another hotel the phone rang and it was Senna and he said 'Have you put all these frogs in my room?' And Gerhard said 'How many haff you found?' And he said 'Twelve!'

Gerhard said: 'Zere are still four more!'

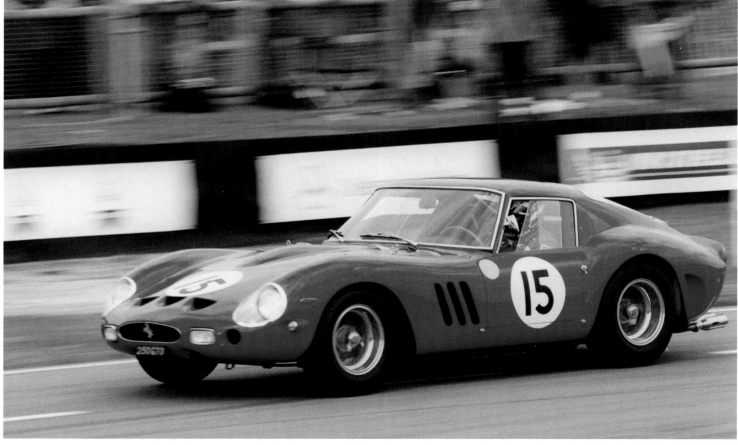

NICK MASON:

"Is that Gerhard in the car? Great. Terrific. It was so unfortunate the car broke after 10 minutes or so of the race. Great fun to drive with. And very quick in the car of course.

And no practical jokes! Very well behaved! Once he got used to the idea that nothing was adjustable except tyre pressures he really dialled in to what was there."

Jochen Mass
and companion

Malcolm
Ricketts

DC and Mark Webber

Chris Evans selfie!

John Watson: "Pour me the perfect pint and I'll try and beat 1'55'"

Sandra Bullock, appropriately, at The Festival of 'Speed'

Tony Smith goes 'red', in the last front engined GP winner: Ferrari Dino. Phil Hill. Monza 1960

Danny Sullivan

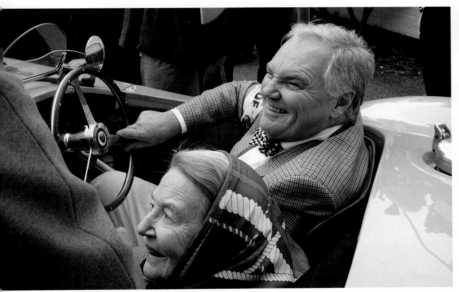

Patrick Head

David Brabham and friend

Grant Williams, the man who tames Jaguar "BUY 1"

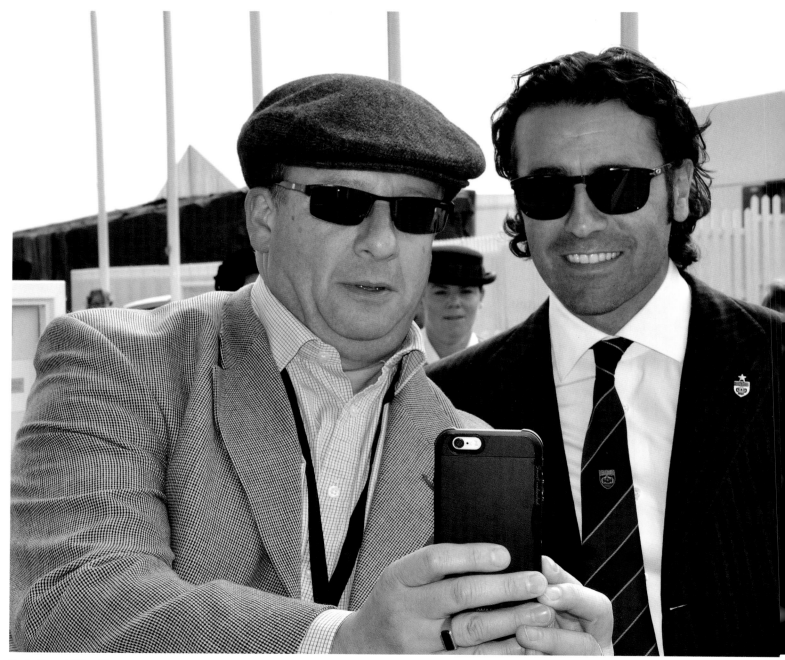

Dario Franchitti selfie...

Karun Chandhok with
Gerhard Berger

Hans Herrmann,
Mercedes legend

Laps of Honour

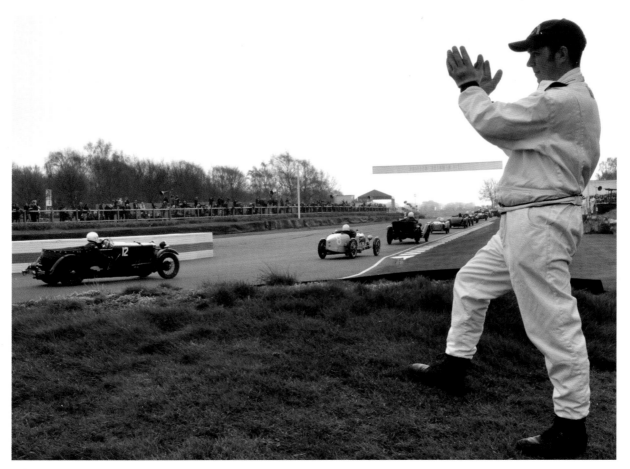

"Clap of Honour"

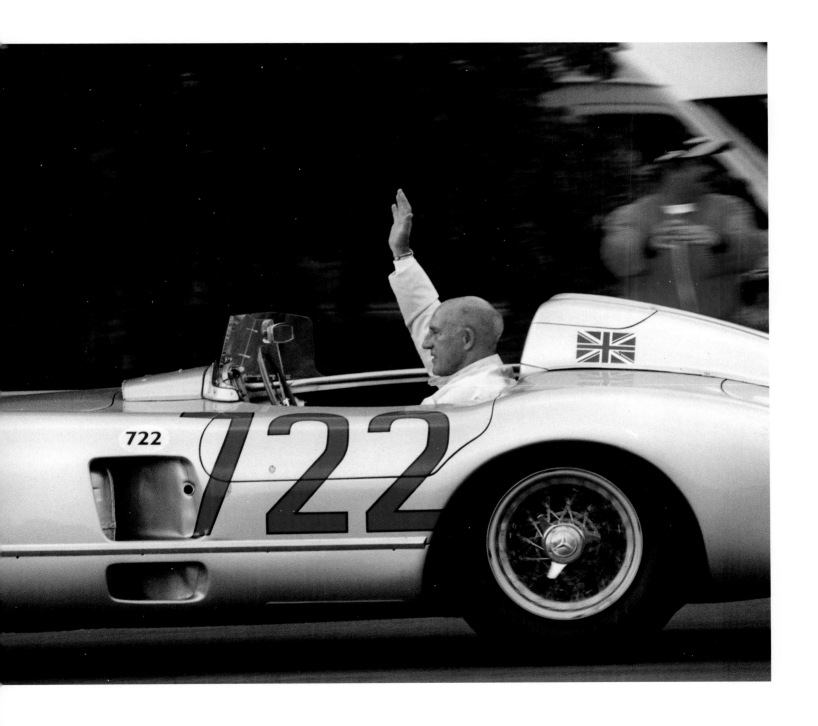

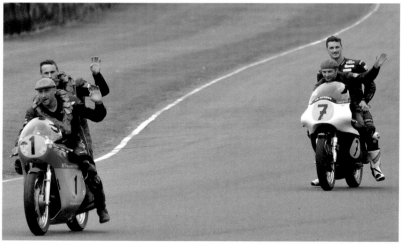

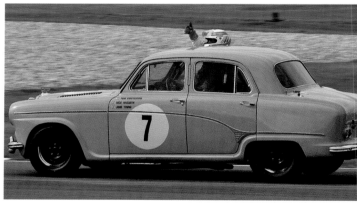

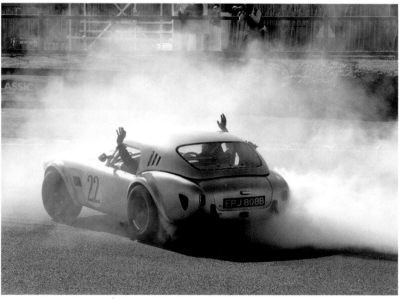

Genius, Organiser, Director – The Earl of March

CM: "Have you heard the forecast for Sunday, Murray?"
MW: "Yes, I think Schumacher's going to win"

CANON LIONEL WEBBER:
"Incredible. I know from the small part I have in it that his attention to detail is absolutely amazing. I have nothing but admiration for him in what he's created. If I invite someone into my home for a meal, you do it the way you want it. He invites you into his home for a motor racing meeting and if you don't like wearing the jacket and tie, go and do the other thing. He gets away with it, but it makes it so very, very special. It's a great sort of festival. I love it, it's wonderful."

RAY BELLM:
"Lord March is a creative genius. He's got beautiful vision, he's determined and he has the perfect venue. He has made it all the more desirable because you have to be invited!"

SIR JOHN WHITMORE:
"What Charles has done is extraordinary. Very imaginative, but very sensitive. There is more freedom at these events than there is anywhere else. It's an escapism, but it's meaningful because certain things bring out the good in people. Goodwood has a feel of a 'Celebration of Life' rather than a reminder of all the bad things in this world."

NICK MASON:
"Quite remarkable job he's done, really. Not only to see it through but the attention to detail that is so impressive. Tribute to him but also to the whole team that he uses. Everything is so beautifully done."

SIR STIRLING MOSS:
"Charles's artistry is so great."

Chapter 18
Fond Farewell

George Harrison (1943-2001)

George attended the first Revival and had this to say: "I've been in motor racing longer than Bernie Ecclestone. I'm not in fifties clothing because I didn't have any clothes in the fifties. I only had a school uniform."

Picture taken at the premiere of The Beatles film *Help*. 1966

"A truly lovely person."

SIR STIRLING MOSS

Rob Walker (1917-2002)

Rob Walker was the owner of the most successful privateer team in history, running Stirling Moss to famous victories in Argentina, Monaco and the 'Ring. On a beautiful, uplifting sunny morning in October 2018, the streets of Dorking reverberated to the sound of his cars being paraded vigorously.

The streets are alive with The Sound of Music

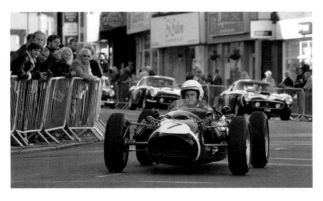

Barry Sheene (1950-2003)

Wayne's Pain. Wayne Gardner descends from the prize-giving podium, having just collected the 'Spirit Of Goodwood' award on behalf of his friend and former rival Barry Sheene.

His face betrays the emotion of knowing only too well that Barry, who had initially turned down an invitation to race at the 2002 Revival only to change his mind at the last minute, was not long for this world. Consumed by cancer, he was unable to resist taking part in what turned out to be his last competitive race.

This award was Barry's poignant final accolade, and arguably his most heroic.

Wayne's pain

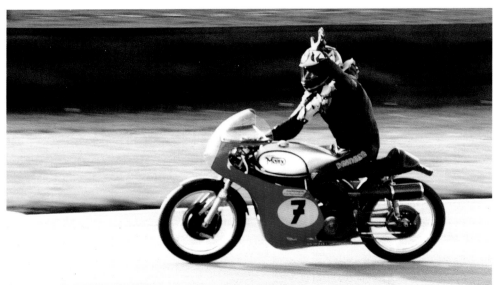

Gerry Marshall (1941-2005)

Gerry Marshall, popular larger-than-life 'tin-top' ace, and winner of over 600 races, who continued to express himself at the wheel despite challenged mobility

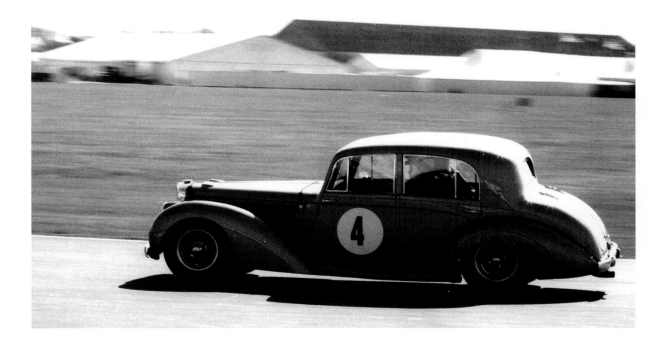

Dizzy Addicott (1922-2005)

It's a shame that Dizzy never got to drive at the Revival, or any
other historic event, but it was not for want of trying. We were
invited to Silverstone for the final HSCC meeting of 2000 by
Clerk of the Course John Smith. There we met Marcus Pye,
who wrote in *Autosport*: 'The highlight of my weekend (despite
having just stepped out of a Chevron B19!) came after the
racing. I was introduced to a fascinating fellow who last raced in
1964, when I was six - Dizzy Addicott. He fancies another shot
in a Lotus 15. Any takers?'

The dream was so nearly realised. Dizzy and 'DIZ1'
(his Lotus-Buick) were this close to being reunited on track
when fate intervened. Early in 2005, Dizzy, John Dabbs and
I met with Stewart Couch, who had sourced and rebuilt the
car – same engine, and mostly original rolling chassis. He had
promised Dizzy a drive, a prospect we all relished. Shortly
before Christmas, the phone rang. It was John Dabbs telling me
my childhood hero and dear friend had suffered a fatal stroke
at the wheel of his VW Corrado, en route to a pilots' reunion.
He was 83.

In 2008 the car was again seen hustling around
Goodwood, with Anthony Reid on 'sorting' duty. Couch
honoured its creator by painting it black, and adding the
original number plate. Sadly this legendary hybrid is no more.
I recently saw it advertised as the 'ex-Graham Hill, David

*"He was very good.
He was a great pilot."*

NICK MASON

Piper, Dizzy Addicott car,' restored as 'original' with a Climax engine, and painted green. I felt as if a
part of my past had been hijacked. Stewart clearly told me that his restoration had involved taking bits off
another chassis. Had Dizzy still been with us, I know he'd have kicked up a stink.

On my way to his funeral in sombre mood, I stopped for fuel. A classic *Sun* headline caught my
eye. I instantly heard Dizzy's irreverent guffaw in my head and felt lifted. Everyone at the wake agreed he
would have loved it. It read:

'Elton takes David up the aisle.'

Within the grounds of the Brooklands Museum there is a wooden bench with his name engraved
on it. John often used to visit, just to sit and reminisce. Sadly, he too is now gone.

'I loved my life in those days,' Dizzy told me. 'I loved every minute of sticking my neck out.
Huge fun!'

Amen to that.

Phil Hill (1927-2008)

*"Phil Hill. World Champion 1961.
Lovely man"*

MURRAY WALKER

Sir Jack Brabham (1926-2014)

I only had a few brief but memorable exchanges with this pillar of motor racing history, and head of a racing dynasty. He obviously loved his racing right until the end. Tough as old boots he was, but with an equally soft heart. A couple of years after his 100mph accident in an F1 race at Goodwood, which left the 73-year-old unconscious with three cracked ribs and a damaged vertebra, I found Sir Jack sitting alone sipping a cup of tea, and asked him if the rumours of his impending retirement were true.

'I'll review it when I'm 80,' he replied.

Eric Thompson (1919-2015)

I do believe Goodwood 9 Hours winner Eric was in love with my mother back in the day, and whenever we met in the paddock, he would ask after her. I have a soft spot for this man, who nurtured her love of racing, and therefore my own. They both died the same year, she a month after him. My wife mischievously points out that I don't look like him!

Eric Thompson outside his Surrey home

"A good driver.
A proper amateur.
A lovely man."

SIR STIRLING MOSS

Keturah Hain MBE (1923-2015)

Mum at Farnborough 1964, with
Dizzy Addicott in the background

It is thanks to Mum that I was introduced to the world of motor racing. She took me to my first race meeting, at Goodwood on Easter Monday 1962, and six months later at Crystal Palace lent me her camera. She arranged two trips to Aintree, introduced me to Dizzy Addicott, funded my SLR camera and darkroom, and decades later, set up the connection that led me to Stirling Moss. I'm so sorry she never got to see the fruit of her input - this book.

Modern F1 became the perfect context for lunch together on Sundays. She was a big fan of "Schumi" and of Murray, who would often give us reason to laugh. I remember him saying, on the final lap of yet another dominant performance by the Ferrari driver: 'Michael Schumacher, that talented German, and I use the word advisedly...' whereupon my mother chimed in: 'Which word, "talented" or "German?"'

Wherever you are Mum, I hope you and Eric are enjoying some fabulous memories...

Sir John Whitmore (1937-2017)

It was Susie Moss who called to inform me of John's passing. My tribute letter was published in *Autosport*:

A big thank you to Paul Fearnley for his touching, colourful obituary to Sir John Whitmore. I'm so glad that it included much to give us a picture of the man and not just the racing legend.

We met in 2004 and immediately found much in common, such that it took us two hours to even mention motor racing! Two weeks ago I received a call from a mutual friend telling me he had gone. I am sad, though not surprised. To witness his decline over the past few years following a skiing accident six years ago eerily similar to Michael Schumacher's was heart-rending, since he had been a man of great mental agility.

Though he claimed to have 'moved on' from the need for 'competitive expression' motor racing obviously remained dear to his heart. I will always remember his exploits at the 2005 Revival. He flew in from Australia on Thursday, put the Alan Mann Mustang on pole on Friday, led four past and current F1 drivers on Saturday before spinning off ('My fault' he typically admitted) eventually finishing third, raced a Cobra on Sunday, then flew back 'down under' on Monday - at the age of 68!

He told me a great Steve McQueen anecdote. He was relaxing in his motel room in California when there was a rumpus outside, bright headlights shining into his room. It was Steve, who dragged him out in his underpants and convinced him to ride spreadeagled on the roof. They rode off into some canyon and were stopped by a cop on a 'bike who asked the driver 'What the hell do you think you're doing?' Steve answered 'We're just looking for coffee.' at which point the cop, realising who he was talking to, changed his tone completely, gave John his jacket suggesting he ride inside, and then escorted them to the nearest coffee shop. When they arrived, the car park was full of police vehicles who had all been alerted to the imminent arrival of the star!

Sweet memories of a gifted individual with a heart for 'life, with all its complexities.' Unique, bright, strong-willed, a little eccentric, but with great depth and kindness.

John Surtees (1934-2017)

"Il Grande", honoured for being the only world champion on two wheels and four, is in my view a bigger hero for his response to his son Henry's death - setting up the Henry Surtees Foundation for trauma victims. He was always helpful and friendly to me.

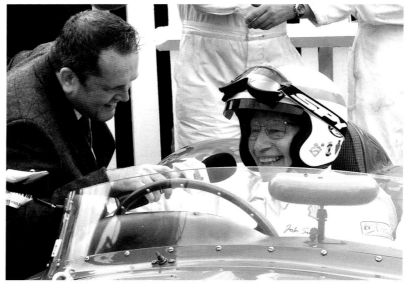

The much missed 'Voice of Goodwood', Henry Hope-Frost, interviews John Surtees, at what would be John's last appearance at Goodwood

Dan Gurney (1931-2018)

First American to win a Grand Prix in a car of his own design - the Eagle, and the driver Jim Clark most feared. Dan gave me his autograph when I was 12 at Aintree: 'To Tim, All The Best, Dan Gurney'.

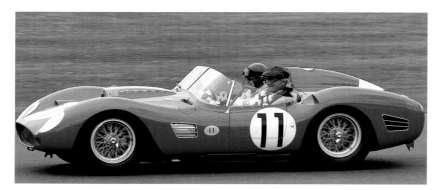

Guest of Honour at Goodwood - garlanded and chauffeured by Tony Brooks

Henry Hope-Frost (1970-2018)

I was playing at a wedding several years ago when a very friendly chap introduced himself to say how much he was enjoying the music. It was Henry. I'd seen his name in *Autosport*. We had a long, warm chat about the sport we love. Killed on his motorcycle in 2018, his death came as an enormous shock and a huge loss to the motor sport community.

Barrie 'Whizzo' Williams (1938-2018)

Perhaps the most versatile driver of the Revival, a winner in any car, and a throwback to the days when a top driver such as Jim Clark would race, and win, in several different cars on the same day. 'Whizzo' was much loved because he totally embraced and embodied the spirit of the Revival with his sportsmanship, skill and good humour.

To the victor, the spoils...

"I'm just showing you what it's all about...
Having a bit of fun! At Goodwood!"

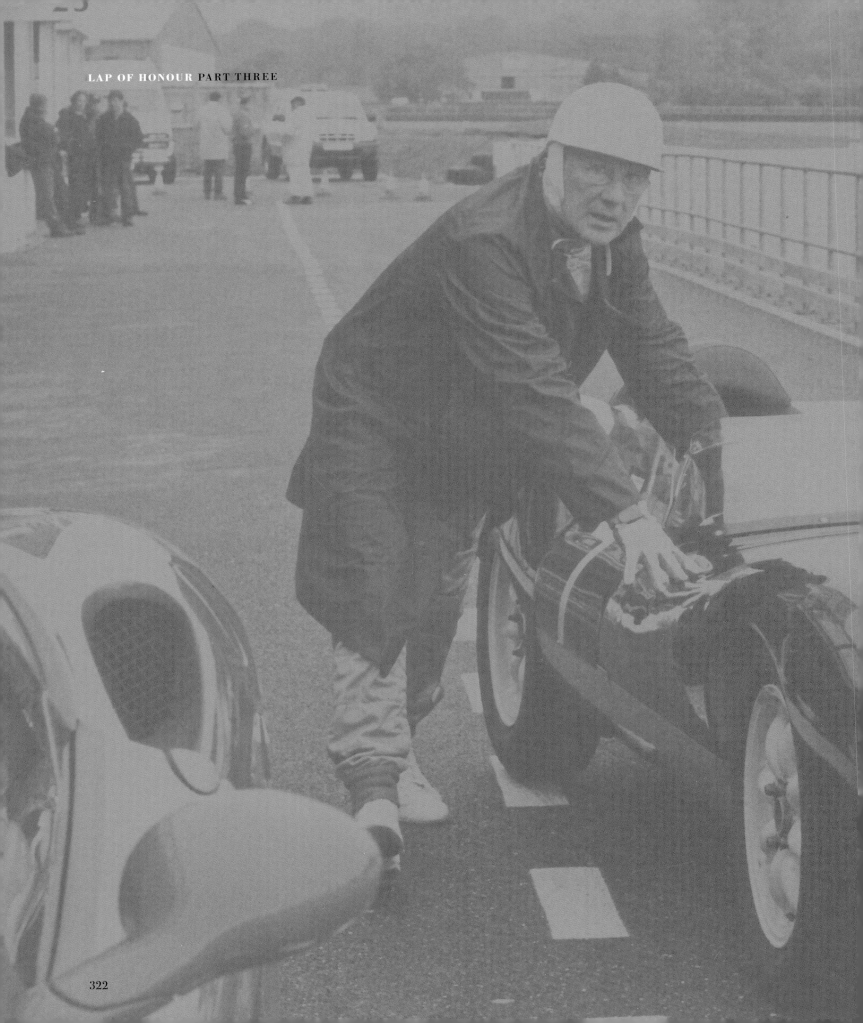

LAP OF HONOUR

Part Three WHO DO YOU THINK YOU ARE, STIRLING MOSS?

"In which this schoolboy photographer captures and enjoys extraordinary times with an extraordinary chap who has done extraordinary things in an extraordinary life."

Chapter 19
Stirling Talk May 2000

The big day has finally arrived for my meeting with Stirling Moss. I try to take it in my stride, but the 12-year-old in me is very much alive, almost on overdrive. We have already spoken briefly on the telephone, three times in all. I called him first at a time suggested in his chirpy letter. He sounded a little abrupt, and I was slightly unnerved. He then called me twice to postpone our meeting, to accommodate such simple but important matters as watching the qualifying for that weekend's Grand Prix, and fixing a shower in one of the properties he leases out.

My instincts tell me to be punctual - not too early and certainly not late. I walk apprehensively from Green Park Underground station following his directions, trying to remain calm, only too aware that I am about to meet the greatest of living legends, the greatest ambassador for motor sport in my life-time, and in some people's opinion the greatest driver of all time. This is the man whose tragic accident hooked me into the world of speed, and whose performance at the first Goodwood Revival in the Aston so impressed me. A household name for five decades, an "International Treasure" recently knighted for his accomplishments, he has long been the epitome and the yardstick of a true sportsman.

I don't quite know what to expect. My awareness and fascination for him have grown hugely over the past few years, rediscovering him, and perhaps unknowingly priming myself for this meeting. If I was called upon to name my favourite racing drivers according to how much I enjoy reading about them, I would list Jim Clark, Keke Rosberg, Mario Andretti, Gilles Villeneuve and above all, Stirling Moss. Long before this meeting was even conceived, I'd read several interviews, and watched him in discussion on TV or video. I had found myself in agreement particularly with his views on the erosion of racing ethics. I have at least come prepared, with a list of 'conversation points' which I feel are a little out of the ordinary.

I dip into the side door of a pub and race downstairs for one last nervous pee...

I steel myself and ring the doorbell. The front door opens and I am greeted by Lady Moss. "Ah, you must be Mr Hain...' Instantly, I relax. I swear she was born to put people at their ease. I realise she has had years of practice. As we ascend the spiral staircase to an immaculate but understated reception room, the conversation and conviviality flow. I already feel welcome.

'Sit wherever you feel comfortable,' she says. I trust my instincts and sit at one end of a sofa next to the solitary swivel chair which I know is not for me. 'Stirling's out and about at the moment, off on his scooter,' she says, continuing to inject informality into the proceedings. We converse about everything: our mutual friend who made the introduction; about the piano in the corner that plays itself; about Stirling having been thrilled at some recent gala with a performance by Eric Clapton ripping into some down home blues.

She tells me how difficult he finds all the adulation - the 70th Birthday Celebration at Goodwood for example. 'But imagine if it had been for Fangio,' she had told him. Then he sort of understood. A journalist had recently sat where I am sitting, in tears of awe: 'The great Stirling Moss! I can't believe it!' he had sobbed. That he definitely could not relate to! 'I know he was a bit gruff with you on the phone, but he's a pussy cat really,' she says reassuringly.

Stirling Moss once explained that "the advantage of losing one's hair at 21 is that thereafter one always looks the same age."

"If anyone qualifies as ageless, it has to be a 69-year-old racing ace who neatly overtakes his rival's Ferrari on the outside of Woodcote Corner, delivering the 'Moss thank-you' with one hand, whilst perfectly controlling his drifting Aston with the other..."

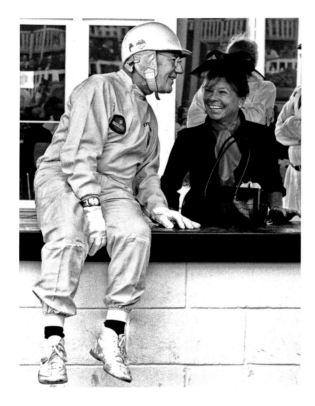

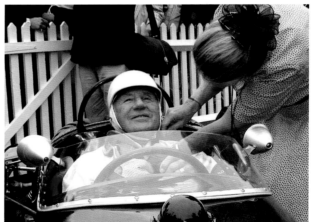

It strikes me how the two of them make a great team even though I have yet to see them together. I tell her that the age difference between them is the same between me and my girlfriend - 21 years! When Stirling finally arrives, sporting a pair of Mickey Mouse suspenders and an almost tangible charisma, she draws upon this common factor as a way of breaking the ice.

Not that there is any ice to break. This little statistic seems to amuse him, and puts him at his ease. He seems a little shy. As he sits himself down in that vacant swivel chair, I warm to him immediately. I hardly notice Susie leave the room. The conversation rolls effortlessly.

So comfortable do I feel that it takes me a while to realise that I have forgotten to switch on my tape recorder...

"He seems a little shy. As he sits himself down in that vacant swivel chair, I warm to him immediately."

By the time I remember, he is in full flow on the subject of ethics, both in the world at large and on-track, citing Senna, and Schumacher as drivers who, whilst he admires them greatly, were unethical in combat. To some degree, he sees them as products of their era:

Stirling in Lotus Cortina. 'I drove in touring cars. I was appalled!'. Excellent shot by my friend Keith Beauvais, signed "To Keith. Have fun! Stirling Moss!"

SM *"I like to hope and think that if they were around in the 50s they'd have been the same as we were. I think they would. Obviously you can only criticise if you're in the heat of the kitchen. I criticised my blokes correctly. There were some bloody idiots racing when I was racing. They were told fairly forcibly. I guess it's a different sport. Jenson Button surprises me in the same way that Derek Bell was really not of his era. I think Jacques Villeneuve is a leftover of the old."*

TH *"When I was racing karts in the early nineties, Jenson was this little blond kid, ten years old, four paddock spaces away..."*

SM *"So the name wasn't new to you?"*

TH *"Not at all. I'd seen his whole career through karts."*

SM *"And he was that good when he came up?"*

TH *"He was very good. But even in karting there were people who would think nothing about punting you off. I just thought it was stupid."*

SM *"Touring cars are like that. I drove in touring cars. I was absolutely appalled! I watch it on the box now and it's amazing to me they don't get their licence lifted. I think those who raced before the war were very similar to those who raced after, whereas I don't think those of my era have any similarity to this era. In my opinion one of the worst things that ever happened in racing has been bringing in safety, because the ethics go.*

I think if you're a driver it needs danger to be there for the exhilaration. From my point of view, if there had been a safety net around I don't think we'd have had the same pleasure. Not that I wanted anyone to die, nor myself particularly. If you gamble for chips it's not very serious, but as soon as it becomes a penny a point it becomes very serious. A pound a point it becomes bloody serious. To gamble my life it really is serious, and I think those are necessary ingredients to make the cake taste properly.

The safety thing started with Graham Hill and Jo Bonnier. I was President of the GPDA (Grand Prix Drivers' Association) and I said to them: 'The only thing we should really be concerned about is the safety of the public and the marshals, not our personal safety. You don't have to drive any faster than

"I think if you're a driver it needs danger to be there for the exhilaration."

you want to drive. No-one's putting a gun to your head.' I get the minutes of the GPDA now
and they have to look at the safety of every damn thing. They say 'Cars are much faster now.'
It's true, but it's just different. Thank God I was in when the pleasure was there."

TH *"You said in* Motor Sport *'It's a great occasion but not a sport.'"*

SM *"I still enjoy it."*

TH *"We're all glued to the TV on Sunday."*

SM *"Yes, exactly. It is technically interesting. The tactics: 'When is he going to make a pitstop?'
And the strategy is fascinating. In my day we didn't often stop. You would usually get through
on fuel and therefore the tactics were different. They were race tactics."*

TH *"How much did you pre-empt a race?"*

SM *"The strategy I was going to use began when the flag fell. I once said to Rob Walker in Holland,
'Look, I have so much criticism that I'm leading races and the car is breaking. I'm fed up with all
this. I know I can win this race. I'm going to sit behind Jack Brabham and I'm going to take him
at the end.' So I follow him. The bugger runs over a paving stone! Flicks the thing up in the air,
a great big thing, this big! It lands on my front tyre. It burst, so I had to go in and change, by
then I'd lost two minutes or more and all I could do was get back to third. So I thought 'I deserve
that!'(laughter)...But that was the only time."*

TH *"What inspired the quote they used in the 'Revival' programme?"*

SM *"'I'd rather lose a race driving fast enough to win than win a race driving slow enough to lose?'
Nowadays in Formula One, they aren't after winning. I've seen Emmo, (Emerson Fittipaldi) who's
a lovely guy, try and be third or fourth in the US Grand Prix. He didn't try to win because he only
needed 'x' points to take the title. I can understand it. I can't agree with it. It's right, but I wouldn't
do it. And that's the difference. I'm a racer and he's a driver. But there aren't many people like us
stupid enough to do it, where racing means more than the result! Every race I started I tried to win.
I certainly wouldn't pace myself in any one race. It's just not my character."*

TH *"I always enjoyed the pure racers most. You; Mario; Keke Rosberg. His was an interesting time.
You had five or six drivers who could win. Rosberg always seemed able to pull something out of a hat.
He made the car dance. He was always on a charge."*

SM *"He was a racer. If you go through the whole history there are not many racers."*

TH *"I loved the persona - hamburger and a cigarette! Forget the personal trainer."*

SM *"Now these guys are fantastically fit, and quite frankly they are overtrained. I was racing 57 times a
year, driving 150 days a year; racing every single week and then practising, and I reckon I was fit.
I never did any training in my life except when I had an accident. Why should I? If you're playing
football every week you don't damn well need to keep fit. Therefore every single muscle that I used to
race was all toned. The muscle I needed to be a ballet dancer I hadn't bothered with because I wasn't a
ballet dancer. The muscle you need for singing or shooting a bow and arrow, that wasn't there!*

TH *"Would you say a few words about the gentleman to your right?"*

JB *"Well I've got a good chauffeur, I've got a lot of confidence in him! In fact I think he's got a lot of experience anyway!"*

SM *"I got my experience following you you old sod!"*

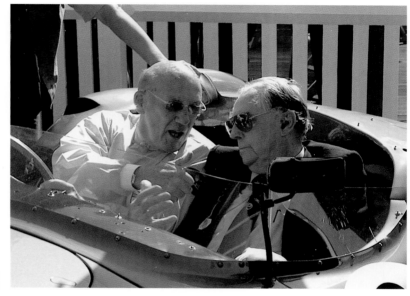

Moss with Jack
Brabham in Aston

I admire what these guys do but I think it is beyond the call of duty. In my day I was as fit as anybody. When the real heat was on, in temperature and so on, stamina would show. I didn't drink. I smoked five or six a day. I think it's really important to respect your body. It's different now. I wouldn't enjoy it the way I did. I do like discipline. I get up every morning and I go and work out downstairs. Not for very long you know! I wouldn't think of doing a couple of hours like they do. That's why I took up racing, so I wouldn't have to walk! (Laughter) Susie, she loves walking. If God had wanted you to walk, he'd have given you pogo sticks as legs. God's not stupid!"

Stirling chats with Emerson Fittipaldi

TH *"Emmo has a great head of hair for a 70-year-old."*

SM *"Yes, but who needs it?"*

TH *"A friend of mine said, 'If God had wanted us to blow each other up he'd have put hand grenades on the trees and not apples.'"*

SM *"Yes, but what would Eve have done?" (Laughter)*

TH *"You mentioned earlier the word 'ballet'. Looking through the BARC (British Automobile Racing Club) archives, I came across a review of a book about you, from the sixties, which I'd love to read if I could get my hands on a copy - All But My Life. (Stirling subsequently lent me his copy to take on holiday in Greece, on condition that I didn't let it distract me from 'the lovely Lucie!') This quote caught my eye: 'Driving as practised by very few people in the world is an art form and related to ballet.'"*

SM *"Ballet from the point of view of flow. I don't know anything about ballet. I can appreciate it though I have no idea how one does it. But when you're in a car some circuits flow well. Even if a circuit doesn't flow, you as a driver try and get into the flow. If you can get a rhythm going, that is a tremendous exhilaration. When you really get your adrenalin up, it's amazing how much quicker you go without realising how you're doing it. In practice you go out and you set a car up. You try for 'pole position' and you start working on things like braking a fraction earlier but putting your foot down (on the throttle) a little bit earlier after the braking. But when you're actually driving in a race you don't think of those things. I just think of driving as hard as I can. Then you go faster without bothering to think, or concentrate on how you're doing it. It is one of the beautiful rhythms of racing. When that takes over, it becomes like a song."*

TH *"You've taken the words right out of my mouth! Having raced karts, I understand what you're saying to some degree. I'm a performer and every night is different, every guitar solo is a new adventure. I liken the two, in terms of the feeling, the adrenalin or the sense of being at one with yourself that comes - on the edge of uncertainty and yet pushing the envelope."*

SM *"Which is why a lot of people in the entertainment world are into fast cars."*

TH *"David Gilmour (of 'Pink Floyd'), drove me round Goodwood in a Porsche 928 one time, which was very interesting..."*

SM *"They're all doing it. Steve McQueen was quite a good driver."*

TH *"Paul Newman..."*

"He was a racer. If you go through the whole history there are not many racers."

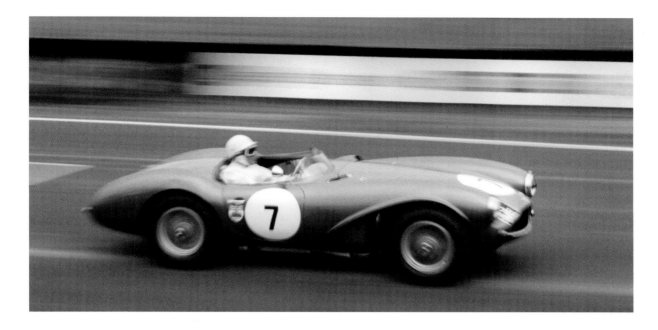

SM *"Very classic driver! He really is excellent. No-one could believe that a guy who looked so good and was a film star could drive so well, but there is no doubt he drives well."*

TH *"I saw a film of him racing a Porsche 944 at Road Atlanta. Fabulous! Three years ago he won his class and came third overall at Daytona. I saw it on ESPN (American Sports network). His physique is incredible. He looks like a 25-year-old. At the pitstop he leaps into the car...you wouldn't think the guy was 70."*

SM *"Amazing!"*

TH *"I'm a performer and every night is different, in terms of the sense of being at one with yourself that comes on the edge of uncertainty and yet pushing the envelope."*

SM *"Which is why a lot of people in the entertainment world are into fast cars."*

TH *"You were talking about where the adrenalin comes from, and what makes a really good driver. Whenever I was involved in some incident (racing karts) I noticed that when I got going again my driving was much sharper, more aggressive. I then realised that the really great drivers could turn that on right from the start, without needing a negative experience to spur them on."*

SM *"Certain drivers can get on the pace much quicker than others. I count that as a great advantage. On the second or third lap I reckon I could get right down. It depends how naturally you get into the rhythm. It depends on the car. Some cars are much more rewarding than others. They don't have to be great cars. I've driven this thing called a Healey, which was not a great car. I felt really good when I got sixth - a fantastic sense of achievement. I really did a good race in that car. Sixth is nothing, but what I got out of it - I knew this was one of my better races.*

My Monaco win in '61, that was interesting, because I set pole. If you look up and see what my pole time was, and you multiply that by one hundred(for the 100 lap race), the race would come out only 42 seconds longer! To me, that was probably the best achievement I ever did because I didn't start to go really flat out until 12 laps after the start. And then the Ferraris started pushing, and I thought 'I've got to go now!'"

Nick Mason of Pink Floyd, a very accomplished driver, with Stirling

TH *"As a boy I remember being very impressed by a picture of you on the lap of honour at Monte Carlo, helmet and goggles off..."*

SM *"Garland."*

TH *"And a cigarette! And the caption was 'You're never alone with a ...'"*

MM MOSS MOMENT

SM *"I must say the Healey was remarkably good when you consider it was virtually a truck with a six cylinder engine. I drove one of those at Sebring. I think I finished sixth, which considering what they are like wasn't too bad. My sister of course swears by them, because she won the Liege-Rome-Liege (rally) with a Healey."*

"If you could handle it the Lotus was probably a better car"

> "Certain drivers can get on the pace much quicker than others. I count that as a great advantage."

SM "...With a Craven 'A' or something! The ad. ran 'I don't smoke often but when I do I choose Craven A!' I said to them, 'Look, it's no good you having me, because I'm not going to be seen smoking! I don't smoke until after lunch. I only smoke if I have a chocolate or something. I only smoke six a day.' I tried at one stage Capstan Full Strength. They knock the collar studs out!"

TH "Make you dizzy..."

SM "Oh God, yes. Are you a smoker?"

TH "No."

SM "Very wise."

TH "Something Niki Lauda said, I'm sure you can relate to: 'You drive a racing car with your head and your heart, but mostly with your heart.'"

SM "I would stroke it now and again on the side: 'You're doing well!' or whatever. There's quite a relationship between driver and road and car, if you get your car set up properly. I mean, no way would I have been as quick in Jack Brabham's car as I would in mine, nor he in mine. If I had my car, say the (Maserati) 250F set up correctly the way I want it, if you took a pound or two out of the front or back tyres I would know it. I would know the balance was changed. You get that close where literally one

pound would change the handling. And that I suppose is the sign of a good car, one that you could get that close. To get it properly balanced, so it does what you want it to do, so it doesn't necessarily mean you've got to amend your technique for different cars."

TH *"I remember reading about you comparing the Formula One Cooper with the Lotus. The Cooper was more fun, whereas the Lotus arrived as a package, set up by Colin Chapman. Not so much fun maybe, but very precise."*

SM *"If you could handle it, it was probably a better car. It's rather like going out with a tomboy or a really stunning bird I suppose. If you want to go out and enjoy yourself you take the one that's more fun!"*

TH *"It's taken me a while to work that one out! Now I have someone who's both."*

SM *"You've never been married?"*

TH *"I was kind of a late starter. As Tina Turner once said 'People think I'm getting old. I'm just getting started!'"*

SM *"Yeah, but you don't want to hang on too long in case somebody else realises what you've got! This is my third. The first one couldn't work because of the life. It was just too public a deal. Nowadays, if you want to know who's won a race you look on the sports page. In my day it was either on the front page if somebody was killed or on the third page if you'd been out with a crumpet. We hear people bitching about the press but they have no idea what it was like. Not a clue. If it worries you don't come into the kitchen! I must say it gave me a good life and I've enjoyed it. I can't think of any other*

Susie Moss. SM: "Take the one that's more fun!"

"There's quite a relationship between driver and road and car, if you get your car set up properly."

life I could have had, all the various ingredients that go into it. Not just the racing itself. The opportunity of meeting interesting people, right across all walks of life. It's a very socially accepted sport, from the road sweeper right through to kings and queens."

TH *"Well, everybody drives a car! I wanted to ask you - the famous wave everyone goes on about, is that manners or psychology?"*

SM *"A bit of each, I guess. I like to believe that a driver who was realistic, I thanked. Those that weren't, I'd shake my fist at! Sometimes you'd lap a guy, and he's trying to show you how good he is, which is ridiculous! I mean, you take three minutes off the bastard and now he's trying to show you. They're rather boring.*

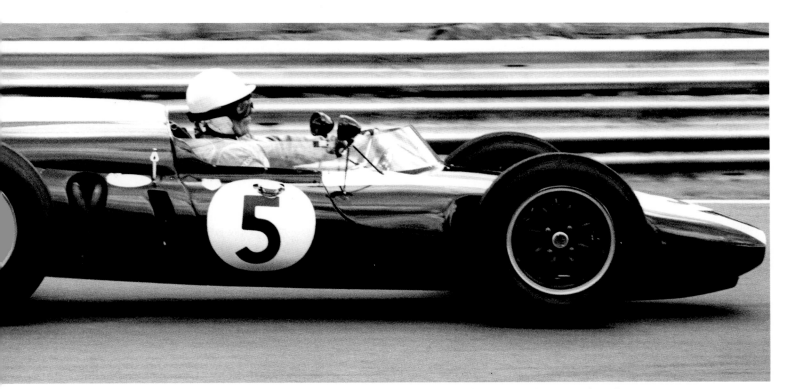

"I follow Dr Farina, a very relaxed driver. That's why I use straight arms." Susie: "Happy boy..."

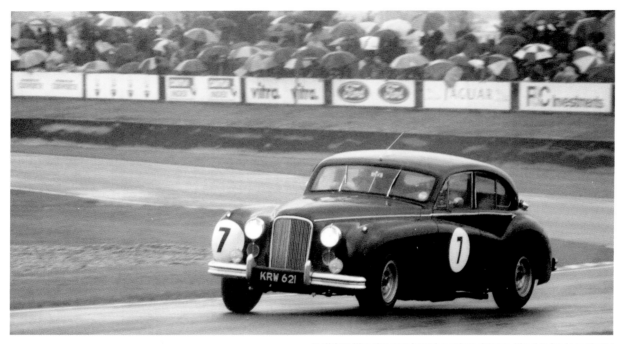

"I didn't like the wet but the other drivers liked it far less than I did." You can see he's got the opposite lock on...

It's important to get certain things. First thing you've got to command is the respect of the other drivers and the only way you can get that is to go out and drive quickly. One of the important things is to appear relaxed. I follow Dr. Farina, who I always thought was a very relaxed driver. That's why I use straight arms. You can cross them much further without getting locked up. It also gave me more room. I lean back a long way, so the only thing I had to do with Dan Gurney as co-driver, who's 6' 3", is lift myself up and see over the screen. I'm only 5'7" and 1/8th in thick socks!

I didn't really like the wet but I know the other drivers liked it far less than I did. That (reputation) came from the TT, when I was about 20 years old, and it was pissing with rain. The Jag XK120 handled reasonably well, but it had very poor brakes. They were very prone to fade. I won the damn race. It was pouring and I quite enjoyed it. I didn't like the rain going down my neck, but it didn't worry me as much as the others. I think one has to have certain things that will mislead the others. You can test the strength of a piece of steel with machines, but you can't test the tenacity of a person. There's no way I could tell how good you'd be under pressure until you get under pressure. It's the same in racing. You don't know what stamina a man's got until the weather's bad, when the heat's gone, when the oil comes up and you've got slippery pedals. All these things come in to make it difficult. Some people just give up and some like me say 'sod it, I won't give up.' I'm a bit of a cussed person I suppose."

"I have driven modern Formula 1 cars – a Tyrrell, so I have a bit of an idea..."

TH *"Prost came in for a lot of stick for stopping twice in the wet."*

SM *"If it really worries him then frankly it's not worth it. Luckily it didn't worry me. I happen to like Prost. He is a Frenchman with a sense of humour! (Laughter). He had a wonderful career, what he achieved and the way he achieved it. As they say, 'The Professor'."*

TH *"I am curious to know if you have ever driven one of the pukka 100cc karts like Button or Schumacher drove?"*

SM *"No, I would be interested to try it, but those things are very difficult because if I do it is leaked or fixed up. For instance if I have to go and do a PR thing, meeting the people and so on. They asked me to take people for rides around Goodwood. That I'll do. If they say 'Go on the Scalextric', I won't do it because it has no relationship whatsoever with what I did. Unfortunately, having a go in a kart, which I would love to do because it would be fascinating to know what they are like, it can't be done. I have driven modern Formula 1 cars - a Tyrrell, so I have a bit of an idea what they are like, but I wouldn't even try to set a bloody time. I would literally drive past the pits and back off! Once people try to see what you are up to it just isn't worth it."*

TH *"I ask because a friend of mine owns a 100cc kart. He would definitely keep his mouth shut! Johnny Herbert said it's the closest thing to Formula 1."*

SM *"Oh yes! I can see why people have done it. Michael Schumacher did a kart race last year. Wiped the lot out. When I was racing, people would come up and say 'Come and drive my Aston'. I was, thank God, naturally quick, so to get into another person's car, it would give me great pleasure if I could get five or six seconds off their lap time. But it is a very difficult situation. I have to be very careful about damaging my name. That's what I sell. I have got a lot of business, thank God, because of my name.*

I make more money now selling limited edition autographs than I did when I was the highest paid driver in the world. In 1961 I did 57 races and my total gross was £32,700. When I was racing with Jack Brabham, one place said 'we've got Jack Brabham for $5,000.' I said 'I want $6,000.' (Laughter). No good having Jack Brabham in one car if there is no one to race him is there? It's like putting Cassius Clay up against someone who can't fight. I remember going to Jack and saying 'Jack, if you let me know how much you get, I'll go for $1,000 extra and we'll split the difference!' (Laughter)"

TH *"So there was honour among thieves in those days!"*

SM *"Absolutely! Masten Gregory. Grand Prix of Cuba. 500 km race. Masten is in the lead and I follow him, and then a bridge fell down. Probably just a couple of ladders with a plank across. Anyway, they had the red flag out which means 'The race is being stopped'. I knew the rule book and the red flag is only allowed to be put out by the clerk of the course and he had to be at the start-finish line. He couldn't have got to where the thing had fallen. So, we picked our way through this very slowly and were cruising around to the start line. I see it, I slip it back into second, put my foot down, passed him and won! Masten came up (SM mimics Masten complaining) 'I was in the lead!' and I said 'Yes Masten, if you knew the rules you'd know damn well no flag marshal had the authority to put out a red flag unless instructed by the clerk of the course. If you shut up we will take first and second and we'll split!' Which is what we did. You have to know the rules. I knew the rules. It was stopped after only 10-15 laps. He could understand that I was pacing myself and would race later if we were both still running."*

TH *"I've heard it said that if someone like Jim Clark was around these days he wouldn't even touch Formula 1. Nothing to do with skill, he just wouldn't be the right character to deal with it the way it is now."*

SM *"I know I wouldn't change my era for now, even though I would be far richer."*

TH *"You only have one life."*

SM *"And what is the value of life? I've got to lecture 1,000 people for 25 minutes at the Detroit Grand Prix. I've been asked by Jack Nasser of Ford to do this on their behalf. That frightens the hell out of me! Apart from a few things like that my life is fantastic. I'm very busy. I run properties. I don't have much time to waste, which I like. To me movement is tranquillity."*

TH *"I suppose people look up to you because they see you doing what you love doing and that is what they'd love to do."*

SM *"Being able to do what you love doing and being paid for it, which is probably the same in your business, is just fantastic. I made a lot of money for my time but Schumacher is making now, index linked, a few hundred times more than I ever made."*

TH *"Absurd, isn't it?"*

SM *"Michael is making $70 million US gross. I grossed about half a million pounds in today's money. And he's doing 16 races. I did 57. But you see I wouldn't swap it, that's the point. Now if I need something, if I want to go away with Susie for example, I can afford it."*

TH *"You have a sense of perspective."*

SM *"I think I have a value of things. The trouble is if you have got a lot of money you worry about it."*

TH *"When I was young my mother met this chap who was flying aeroplanes - he was a test pilot and a racing driver, a guy by the name of Dizzy..."*

SM *"Oh, Dizzy Addicott. Dizzy's wife Judy was my secretary for years!"*

TH *"He was right there for me. He took me in his racing cars, took me to the Farnborough Air Show and introduced me to legends like John 'Cats Eyes' Cunningham...My dad wasn't around which is where motor racing was so good. It represented many powerful things; like courage, honour, and excellence."*

SM *"Yes. But people are so different from what they were. I don't really know any of the modern drivers. I know Johnny Herbert to sort of say hello to. Before, I knew Peter Collins, Mike Hawthorn, Behra and so on."*

TH *"Johnny Herbert was the reason I started racing karts again. I was testing this 135cc machine. Enormously quick. Not very grippy tyres. Herbert happened to be there. It was just before he had his huge accident. He was a multiple kart champion. They sent me out on this thing and it was absolutely thrilling. And then this bloke said, 'You were only 8/10ths slower than him! You ought to race!' So I did. I had no idea anyone was timing me."*

SM *"I think karts are tremendous, to teach these guys tactics, technique and feel."*

'Wild Man Andy' at Buckmore Park 1988 at the wheel of his 135 c.c rocketship. Andy encouraged me to go karting again, twenty years after I had stopped. A few years later I won my class in the National Kart Racing Association 'Grand Final' at Three Sisters

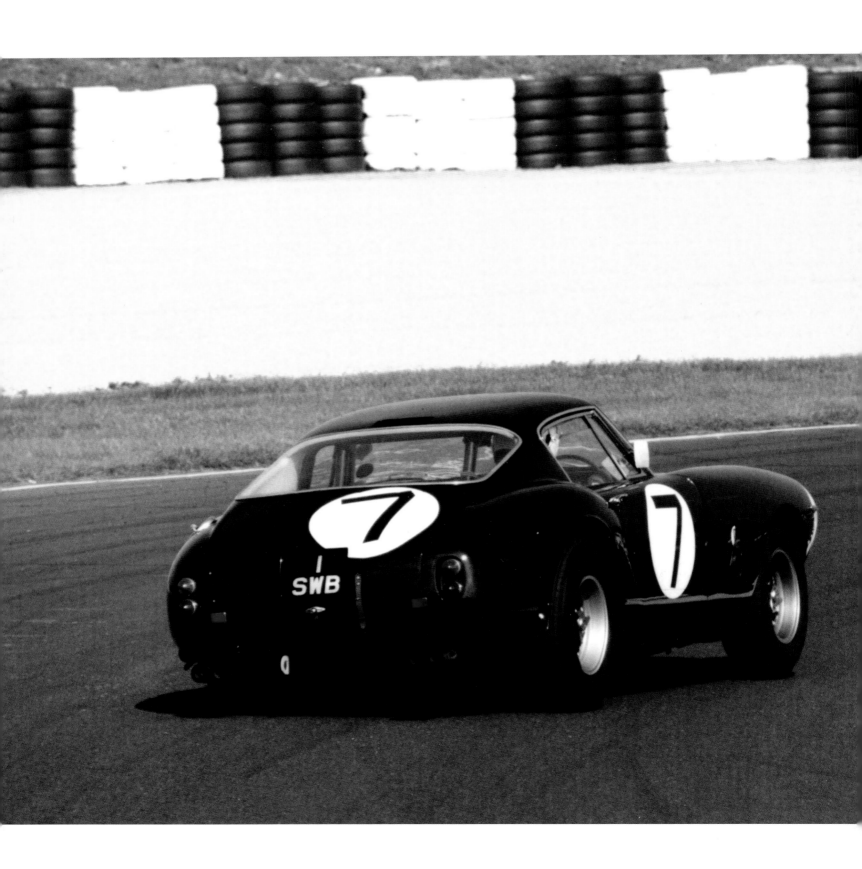

SM: 'I'll be driving my old Ferrari at the Revival. A lovely car. One of the nicest cars actually. I don't know if this was the actual one or whether it was the following year that I had a radio in there, and people say 'what was I listening to the radio for?' I was listening because if I tuned in to the BBC or whatever it was, Raymond Baxter was giving a report of the race. So the pits would give me my position, but then I could hear what other people were doing. That's about the only car you could do it with - it wasn't very noisy. And in those days the ear plugs we had weren't that effective. That's a really nice handling car'

TH *"This may be asking the impossible, but long before the possibility of meeting you had even come up, I'd visualised a photographic chapter of you. I have this ambition to photograph you in as many old cars as possible, if I knew where you were going to be this year."*

SM *"I'll be driving the Gullwing at the Festival of Speed, my old Ferrari at the Revival. I'll be testing on Wednesday at Silverstone. Some Ferrari. it's an interesting vehicle. And a Cooper at Brands on Friday."*

TH *"Would it be very cheeky to turn up to the test and take some pictures?"*

SM *"Yes sure. If you want, you can come up with me. Just be here at 11 on Tuesday. Not sure if I'll be going up in my Merc Sports or my Smart…"*

Chapter 20
It's Such a Perfect Day May 2000

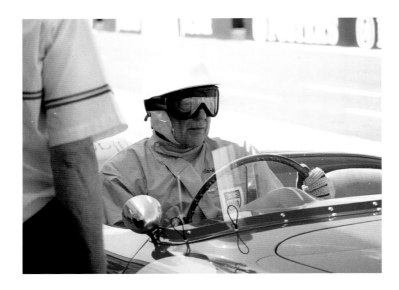

S o here I am, sitting alone in the darkness of a little garage at the end of a narrow cul-de-sac in Mayfair. The midday sun beats down outside as I wait for my driver. By his unexpected invitation I am about to be chauffeured to Silverstone in this stunning dark blue Mercedes sports saloon, numberplate SM7.

'Mister Motor Racing' kisses his newly titled Lady Moss goodbye and eases in beside me. As we pull out of the garage and negotiate West End streets, I experiment with electronic seat adjusters - gadgetry which befits the driver's love of custom technology. I had just seen an example in his office - a carbon fibre lift.

We are soon heading north along Park Lane then west along Motorway 40 to our destination, where he will be testing a couple of classic racing cars. Riding with the world's greatest racing legend with whom I have spent only one hour of my life feels strangely normal. I feel as if I'm catching up with an old friend I haven't seen for years.

Our conversation begins, naturally, with us talking about our women. I tell him my girlfriend is the youngest I've had but the most level-headed. 'That's because she's special,' he replies. 'You should marry her before someone else cottons on!' He offers snippets of wisdom from his three marriages. He was once the most eligible of bachelors and never short of opportunities to capitalise on it. As he put it: 'I couldn't go out with a new crumpet without it being on the front page.' He is clearly content with Susie. Having known him since she was five, she grew to become his confidante and advisor in affairs of the heart - he used to date her older sister - and then his organiser, housekeeper, cook, companion, friend, and finally his wife, mother of their son Elliot, Lady Moss, and of course 'Miss Goodwood'.

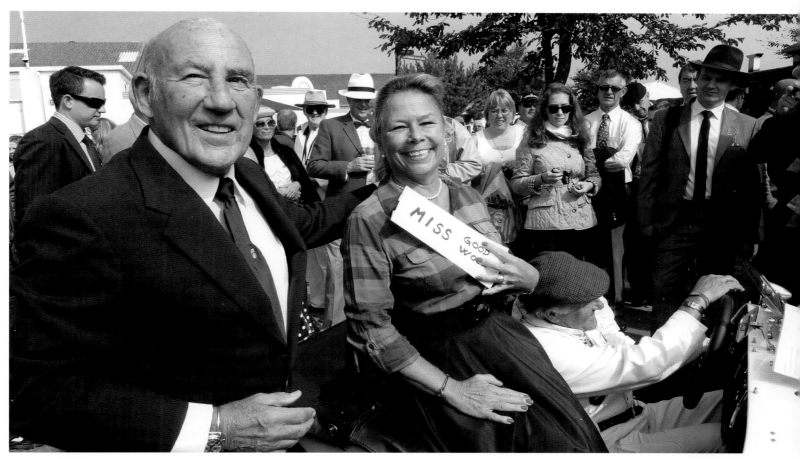

Miss Goodwood

The conversation turns to music. He tells me about a songwriter friend who drops in to play their piano which otherwise plays itself. He asks if guitars vary much. I remind him of his comparing the Cooper and Lotus of his heyday to different types of women - one a tomboy you could have a lot of fun with, the other a more sophisticated model that requires special attention. Likewise the Fender Stratocaster and the Gibson Les Paul. The Fender is more versatile, more durable, and probably more fun. It was a Fender that Jimi Hendrix used to set fire to. It took him a lot longer to smash a "Strat" to bits than it took Pete Townshend to destroy his flimsier Gibson, when such onstage vandalism was the rage.

I tell him I leave my guitar case unfastened after a gig. Should anyone try to steal it whilst I am loading my equipment, it would simply fall out and draw attention to the thief. It would not be harmed by the fall, whereas a Gibson would probably break. Yet the Gibson's inherent tone is deeper, more sophisticated. Like the Lotus, or that stunning model, it rewards a more considered approach, but doesn't take kindly to knocks.

He finds this fascinating. We are drawing a link between cars, guitars, and women. I tell him I am one up on him. Despite his expertise and experience with the first two, I have at least managed to handle all three!

All the while I perceive a sense of growing excitement in him, something I recognise from my own trips to test or race a kart. After a lifetime of doing this, his enthusiasm is still in good health.

The Silverstone security officer welcomes him warmly. Having signed on and located the appropriate garage, he insists on driving the short distance to the canteen. Just as he had told me at our first meeting, he hates walking. As we queue to buy salty Silverstone soup I notice that people do their best to treat him as 'one of the boys'. Nobody crowds him.

Seat fitting 1

*"Riding with the world's greatest racing legend with whom I have
spent only one hour of my life feels strangely normal."*

Lunch is quickly dispensed with, due in part to its unappetising nature,
but mainly because of the urge to get on with the day's business. Awaiting his
pleasure inside the garage is a gleaming 1952 Ferrari sports car, finished in a rich
red, and a beautiful Cooper single seater, both tended to by a devoted team.

I take a step back behind the lens and watch a lengthy seat fitting with the
Ferrari, during which the seat itself is removed and replaced with foam. Fellow racer
Frank Sytner arrives, announcing his presence with a cheeky tap on Stirling's head.

Stirling frowns a lot. Then he dons a replica of his original peaked white
helmet, not the modern model he had worn at the Revival. It's a touch I like. He
starts the engine, lowers goggles, eases out the extra sensitive racing clutch to biting
point, and coaxes the magnificent scarlet beast out of the garage and onto the circuit.

I position myself at the end of the pit-lane, camera at the ready. After a
surprisingly long lap, the Ferrari appears, trundling along the pit wall. Moss throws
both hands in the air in a gesture of frustration. Next time round he is back in the pits.

Seat fitting 2

Frank Sytner arrives

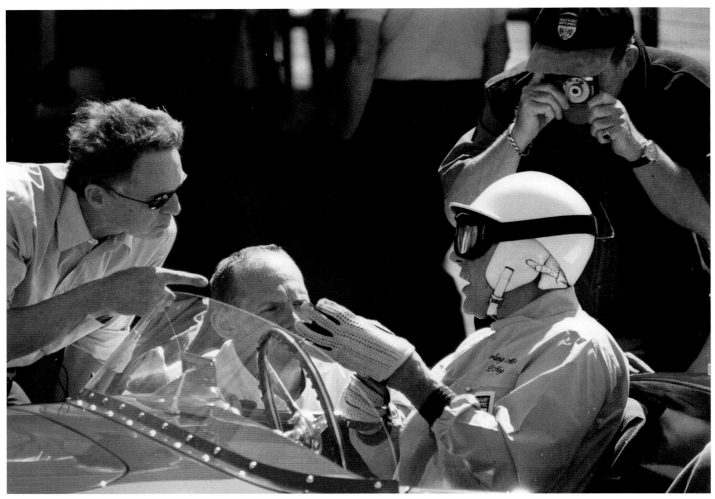

SM in pits with crew - the man with the camera is Eoin Young, who brought the young
Bruce McLaren to these shores in the late fifties

After conferring with the gang who have been drawn to his garage, including racer Rob Wilson who once coached a young Kimi Raikkonen, and the legendary journalist Eoin Young who brought Bruce McLaren to these shores, he goes out again. A handful of laps later he's back in. Out he climbs. Long faces all round. My suspicions are correct. He is not at home with this car.

"It goes like stink," he explains to me later, "but I can't drive it on the throttle. I wouldn't enjoy it, so what's the point? A pity. Those boys have done a marvellous job."

The team are quietly disappointed, hoping he might have driven their treasure at the upcoming Monaco Classic. This episode gives me insight into how my new pal, lest I forget, is a global legend who gets to pick and choose which exclusive piece of motor racing history he will drive next.

Days later, I introduce myself to John Surtees, overseeing his son Henry's stellar progress at a kart meeting. Curious to know what Stirling had been driving that day, he smiles mischievously at my description of the Ferrari in question and says: "They tried to get me to drive that one!" The Cooper is a different story. Finished in 'works' colours, parallel white stripes on a bottle green background, it takes me back to Aintree in 1963, and my first visit to a Grand Prix paddock. Pit stops are now occupied with dialling out understeer; stability under braking, and rear-wheel camber - topics only worth addressing if a car is basically right.

He's animated now, and enthused. His only concern on track is keeping out of the way of the 'slicks and wings' brigade whose aerodynamic and tyre technologies allow them to corner far more quickly. He is having to watch his mirrors constantly, unable to stick to his own line. He voices a wish for separate sessions. At Brands Hatch three days later his wish will be granted. He and the Cooper will have the track to themselves for the entire lunch hour.

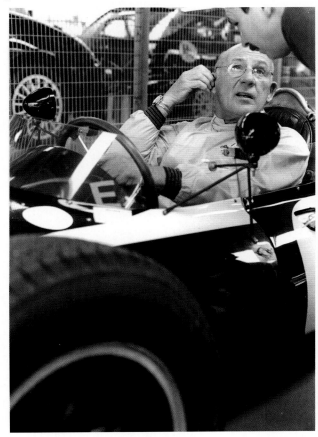

Before we leave, a pretty young TV presenter requests his presence on camera. He is happy to oblige, or unable to resist. He entrusts me with his famous helmet. I hold his iconic lid tight in my left hand so as not to drop it, and continue taking pictures with my right.

And with that, this absorbing, exciting session winds down, and we prepare to leave. My mind cannot compute my great good fortune. As the song says: "It's such a Perfect Day."

But there's more...

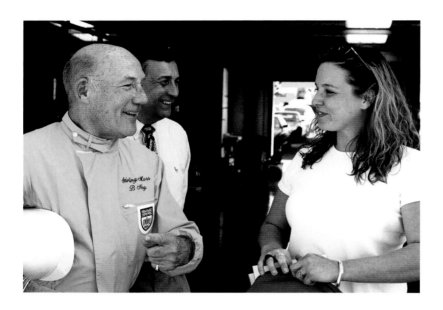

Movement is Tranquillity

Can a perfect day get more perfect? I'm about to find out. Stirling turns left out of the Silverstone gate, choosing the scenic route home. 'This could be good,' I'm thinking. Initially I find myself tensing up as we approach a kerb a little too closely, but realise I'm forgetting who my chauffeur is. I make the mental adjustment and relax. I sit back and enjoy his deft handling of the car through twisting narrow lanes saturated in afternoon sunshine.

Then comes the overtake. On a narrow undulating stretch of country road, following a line of cars with nothing coming towards us, he sees a gap and can't help himself. He pulls out to pass a Golf GTI with barely inches to spare on either side of the Merc. I find myself momentarily sitting between Stirling Moss on my right, and Boy Racer on my left. Stirling is giving "the wave", polite but de-moralising. Boy Racer is flashing a "who do you think you are, Nigel Mansell?" v-sign. If only he knew…

He speaks of topics dear to him - pivotal moments and cars in his racing history, such as the Vanwall, which in his hands became Britain's first Grand Prix winner. It was a classically beautiful car to look at, but ugly to drive, which for a patriot like Moss was a challenge to be relished.

"I find myself momentarily sitting between Stirling Moss on my right, and Boy Racer on my left."

SM *"This is Tony in the Vanwall. A great driver. The most beautiful probably of all the front-engined racing cars, and really one of the most unattractive to drive. To start with it had a very bad flat spot when we were running on alcohol, then when we went to petrol it got a bit better, but the gearbox was always nasty and now it's greatly improved, but it won the world championship so one couldn't criticise it, but it was never really nice to drive. Although it was fast, as was proven at Pescara."*

Then there's his 'David and Goliath' 1958 victory in Argentina in Rob Walker's Cooper - the first Grand Prix win for a rear engined car. It was 'conquest by stealth' - taking a gamble on tyre wear, and some theatrical gamesmanship in the pit-lane. The tiny privateer British team tricked the more powerful Italian 'works' teams into believing that this funny little English car, which only qualified near the back of the grid, was about to stop for tyres. They could not afford to, since the Cooper did not have "knock on" wheel hubs, only bolts with nuts that would take far too long to deal with. They had to chance it. Thinking their victory secure, the Italians eased the pace. Moss never made the stop. He won by less than three seconds after three hours of racing, his tyres worn to the canvas.

He speaks with matter-of-fact humility. I tell him how sorry I am to have missed his epic drive in the 250F in monsoon conditions at the Goodwood Revival, marking his 70th birthday. As John Surtees put it, 'he plugged into an old program,' sailing majestically up the order to claim fourth place from a lowly 16th grid slot for which he offers no excuses - 'I just couldn't get it together in practice'. I had been booked to play at a 21st party late the previous night and only made it to Goodwood after the deluge. 'Never mind,' he says, 'you were doing your own good works.'

We approach Buckingham and conversation turns to 'the best doughnuts in England.' He stops in the town centre on a double yellow, and like two eager schoolboys we bound across the road to buy a bagful, to be consumed at our next stop - tea with his sister Pat. She was an exceptional rally driver, now married to former World Rally Champion Erik Carlsson, a born comedian. Sitting in on this family visit, I am made comfortable by the constant wisecracks which flow from this huge and humorous man.

Stirling and Pat were both skilled horse riders, but only Pat persevered to become successful on four legs before switching to four wheels. She has always lived on family land, and though her brother has long been a city boy, he has roots here.

Afterwards he drives me round the neighbourhood - his boyhood stomping grounds - until he feels the urge to press on and beat the worst of the rush hour traffic. He is quickly back in the groove, and knows all the 'slink routes'. As we fly along a stretch of deserted country lane, strands of sunlight filter through the overhanging branches, creating ever-changing patterns on the road in front and turning the interior of the Mercedes into a kaleidoscope. He remarks upon the beauty of the tunnel effect of the trees as we rush beneath.

The car is moving ever more quickly, its occupants silent. Encased in a bubble of stillness as the countryside flashes past outside, I glance across at my driver. He is totally focussed on the road ahead, in his element. In that timeless moment I get it - his favourite motto:

"Movement is tranquillity."

At a small roundabout a queue of cars is waiting to turn right, which is what he also needs to do. The left lane is empty, and offers an open invitation he cannot resist. He jumps the queue, sees a gap, and accelerates hard as he makes the right turn, squeezing precisely past the nose of the car at the front with

Nervous passenger? Susie rides with Stirling in Maserati sports

just a hint of opposite lock, again giving "the wave". Just like a 'Le Mans Start', only one-handed! I can't help but smile. 'For God's sake don't tell Susie!' he says, 'she's always criticising me for that sort of stuff.' A bit like my Lucie…

On a fast dual carriageway, we are entertained by a Yugo - a matchbox on skinny tyres batting along at about 90. The driver negotiates roundabouts with great panache. He's taking the racing line, and we have trouble keeping up. 'He's doing a great job,' remarks Stirling: 'It must be Jenson Button!' He admires Button greatly, as much for his ethics as for his expertise. When 'Jenson' finally turns off the main road I say, 'Just think! That guy is going to die without ever knowing that he was followed by the great Stirling Moss congratulating him on his driving!'

He asks if I ever heard of Jethro Tull. I tell him my schoolmates and I were fans. At the height of their fame they invited him to introduce their show. "Ladies and Gentleman: Jethro Tull!" was all he had to say, five nights running, for a grand a night!

Inevitably we hit the same road as every other impatient rush hour commuter. We crawl into London and stop at one of his apartments near Maida Vale to pick up a vacuum cleaner. He dashes inside, leaving the keys in the car, and instructs me to move it if needs be. I am glad I do not have to. He returns moments later minus vacuum cleaner: 'Must have left it in Battersea old boy'.

Back in Mayfair, Susie thanks me warmly, explaining that Stirling really appreciates company. Naturally, I feel all thanks are on my part. She invites me to phone in on Friday morning to confirm whether Stirling will be at Brands to test the Cooper, should I wish to turn up.

I've just spent a really fun afternoon with the Legend Formerly Known As "The Most Famous Man in England". He has been delightful and easy company, and I am left with the impression that he still cannot fully understand how the mere pursuit of his passion could have led to a remarkable half a century of celebrity. And what a pleasure it is to spend time with someone who is so comfortable with who he is, even though he admits to feeling shy and ill at ease in a crowd.

He reminds me of an artist who inhabits his own realm and speaks first and foremost through his art, who sets his own standards, which in his case are high, and lives by them. Best of all, he knows how to enjoy life.

On the other hand his 'name' is his business, and he works hard at it. A friend of mine who saw him sweating under the summer sun at Goodwood, signing books for his fans, said: 'I wouldn't want to be him.'

As his motto implies, he seems to be always on the move, yet happy in the moment. And maybe that is the secret of how he manages to make time for everyone.

"He's doing a great job," remarks Stirling.
"It must be Jenson Button!"

Time for Everyone

"Just amazing to be involved with such an icon.
 He's got time for everyone." JUSTIN LAW, RACING DRIVER

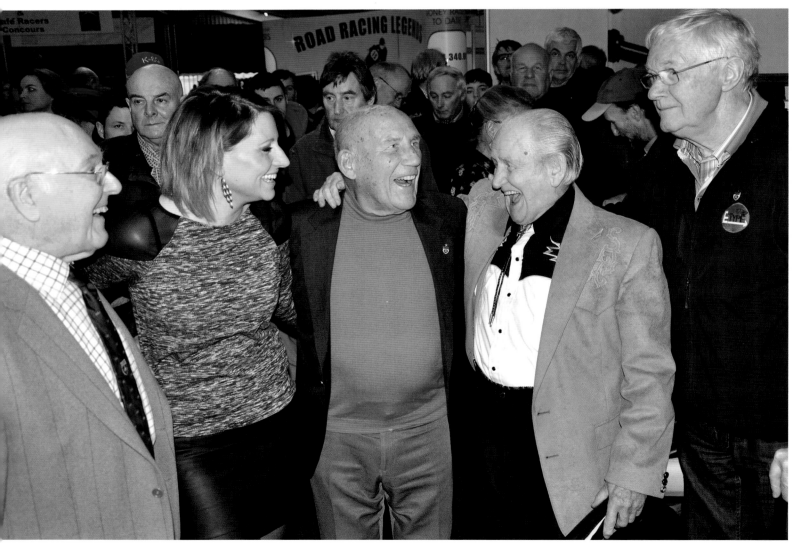

Time for the League of Legends

Time for 'crumpet' (once a perfectly PC term!)

Time for a very young girl who wasn't even a twinkle in her grandfather's eye when he was racing

Time for an interview – with the late Henry Hope-Frost

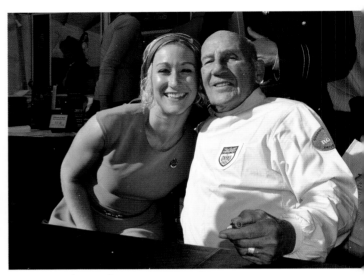

Time for you know what!

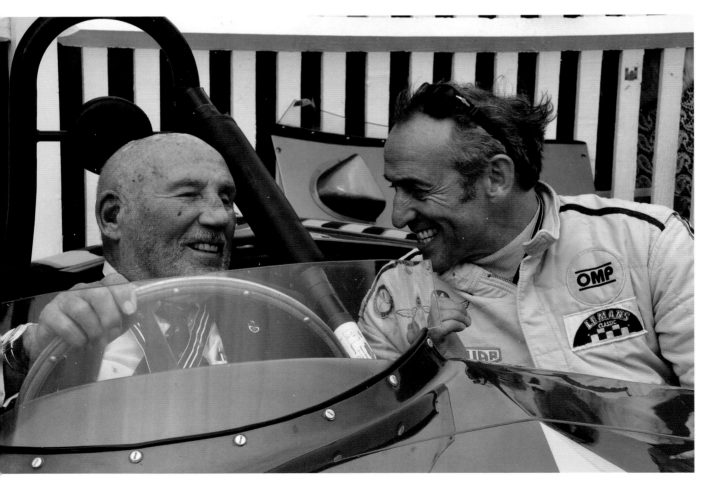

Time to whizz a mate round the track

"Where's the boy gone?"

Time for an autograph

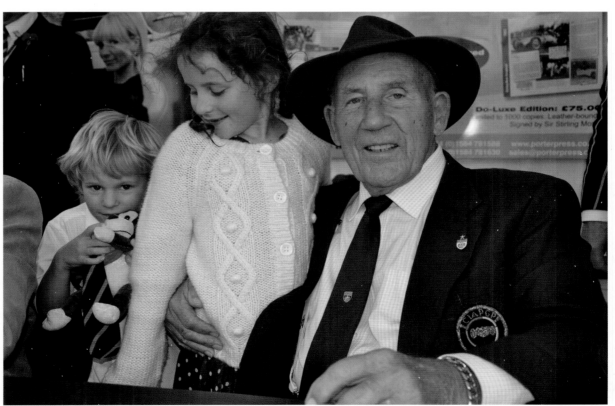

Time for my daughter

Time for a student

Time for more you know what!

Time to monkey about

Time to be admired... by women on a poster!

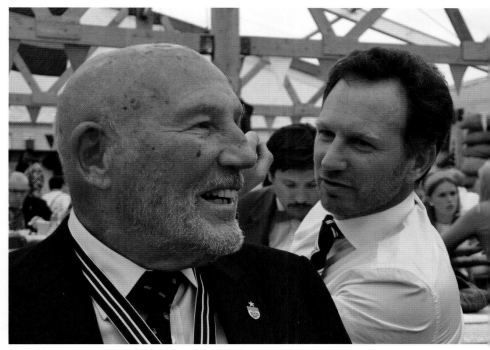

Time for a team manager (with Red Bull's Christian Horner)

Time for the Goodwood Girls

Time for me! (Photograph by Nigel Cull)

Time for a young fan

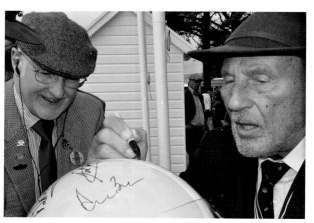

Time for yet another autograph

Time for a leg-up!

Time for a handshake... and a kiss on the cheek!

The Team

SM: "That's a nice picture of Soozles actually"

The Boss, The Boy

Emanuele Pirro: "The sweetness she had every time I saw them together, for me it was really remarkable. I think she has been important for him, and for him in relation to the outside world"

Broke down at Brands. The crew chief lays on hands

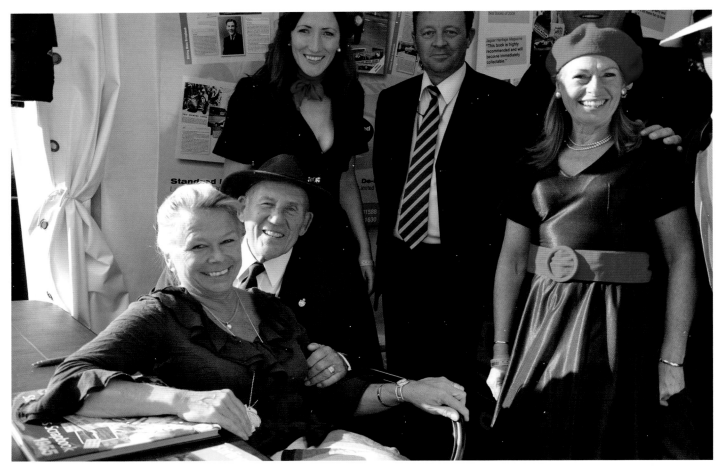

With Philip Porter's 'Scrapbook gang'. You never have to say "say cheese" - There's always a joke on the go. Usually dirty, always droll. Stirling has a healthy repertoire

Susie Moss: 'Did I ever tell you my "Mother Duck" story? I went for a walk without Stirling at the Festival Of Speed. I realised I was being followed, not just by one but a line of people. I said "Are you following me?" And someone said "Yes, because where you'll go we'll find Stirling Moss!"'

Body language: Respect and affection

Darren Smith, Stirling's long-time liaison and security man – and a great ally to me

Chapter 21
March Magic 2002

Expect the Unexpected!

My request to photograph Stirling in yet another car - this would be the fourteenth - is granted with unexpected hospitality. Hearing that another photo op is on hand, I asked if I might turn up with my camera. In response I am invited to bring a toothbrush, stay the night, and accompany him on an early morning trip to Goodwood where he is to shake down his Lola sports car prior to the upcoming 'Old-timers' Grand Prix' at Pau.

I ring the doorbell late in the evening. He answers with telephone in hand. Covering the mouthpiece, he conveys sad news: 'Rob's dead.' Rob Walker, for whom he drove exclusively during the final years of his career, had passed away that morning.

Stirling wakes me at seven with a cup of tea, a biscuit, and a 'hurry up' - the Bentley will be arriving shortly. The two-door Continental 'R' numberplate 'WO 1', supplied by the factory, is soon at his door, to be reviewed by him for a magazine. The numberplate has history. My father once told me that in the early 1930s he had seen it on founder W.O. Bentley's own 8-litre.

At 7.45 I am standing at Stirling's door, watching as he tries to figure out the car's electronic security system - the instruction book is locked inside! He works it out eventually, and I suggest he includes a memo in his report to the effect that book and Bentley be supplied separately. Once on our way, via Knightsbridge, the A3, and especially on the lovely winding and slightly misty A286 over the South Downs, the big car seems to shrink in his hands.

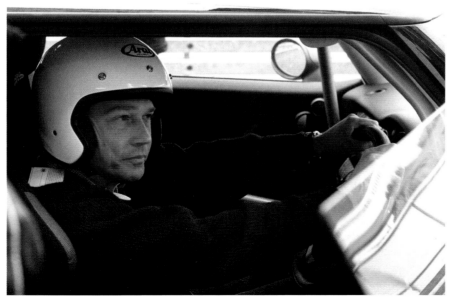

Our host – Lord March

At the circuit, I am puzzled by the presence of some notable guests: Indianapolis 500 winner and multiple champion Bobby Rahal; Pink Floyd's drummer and rapid racer Nick Mason; JK of Jamiroquai; Kimi Raikonnen's former coach Rob Wilson, who also played bass for Edison Lighthouse. Musicians are well represented, but still the penny hasn't dropped as to why they are here! I am further surprised to be welcomed by Lord March's PA as one of a select group of personal guests. She asks for my name so that it can be placed on the table for luncheon at Goodwood House! Since I was expecting to be out on the track all day photographing Stirling in his Lola I have come dressed for the English weather, in jeans and dirty old trainers. I apologise for my footwear, but she assures me it matters not.

Stirling in Lola mirror

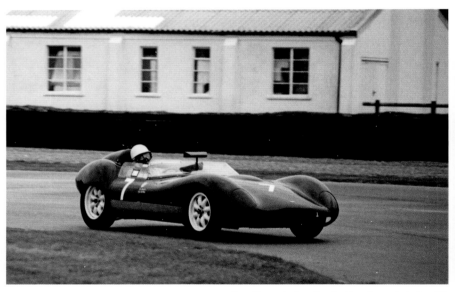

An attempt at a classic Goodwood shot, with the Shell building in the background

Nobody stops me trekking to the inside of Woodcote to get a trackside shot of Stirling in action. After his stint in the Lola, a car he much enjoys, Stirling expresses interest in driving a Mini Cooper sitting in the pit lane along with a couple of Ferraris, courtesy of Lord March, for his guests' amusement on this cold but warm-hearted March day. I point him towards Mike Cooper who supplied the car. He is not about to turn down Stirling Moss.

'Do you fancy a passenger?' I ask hopefully.

'Sure, old boy. Grab Sue's helmet. It's in the boot.'

'By the way don't worry, I'm not a nervous passenger.'

'You don't think I was about to slow down for you, do you boy?'

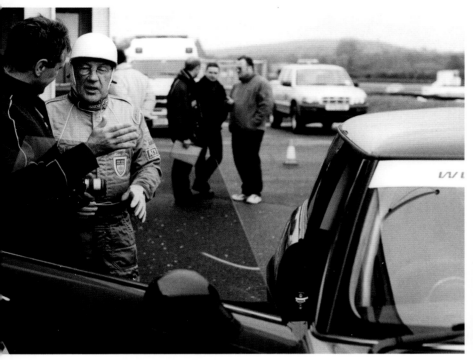

Stirling with Mike Cooper

Sitting beside Stirling on the Lavant Straight

After several spellbinding laps as passenger to Stirling, we pull into the pits. Stirling suggests I take it out. He hops out of the driver's seat and I hop in. Seeing Stirling get out and usher me in before he ventures off, not one of the obligatory driving coaches approaches me to offer their services, thank goodness! So I fly solo for a dozen or so fun laps. On the Lavant Straight, I look in my right hand mirror and see my favourite car bearing down on me. I pull over to the left to allow a classic red Ferrari 250 GTO to whizz past - numberplate 250 GTO - Nick Mason's. I would pinch myself but Woodcote Corner is rapidly approaching, and both hands are required on the wheel.

I later request a drive in the modern Ferrari and am accepted, but with coach of course! It is fitted with traction control to tame the wheel-spin and to keep the rear end planted. My request to turn it off is refused, so there is no driving it on the throttle. This, to be honest, is a bit of a let-down. Sincere apologies to the Earl - I don't mean to sound ungrateful - but I suspect he will understand!

I can now say that I have driven a Ferrari around Goodwood, but although its top speed is considerably higher, it is far less fun than my fling in the Mini.

On-board with Moss, passing the place where he had his terrible accident in 1962

Attacking St Mary's. Note the angle!

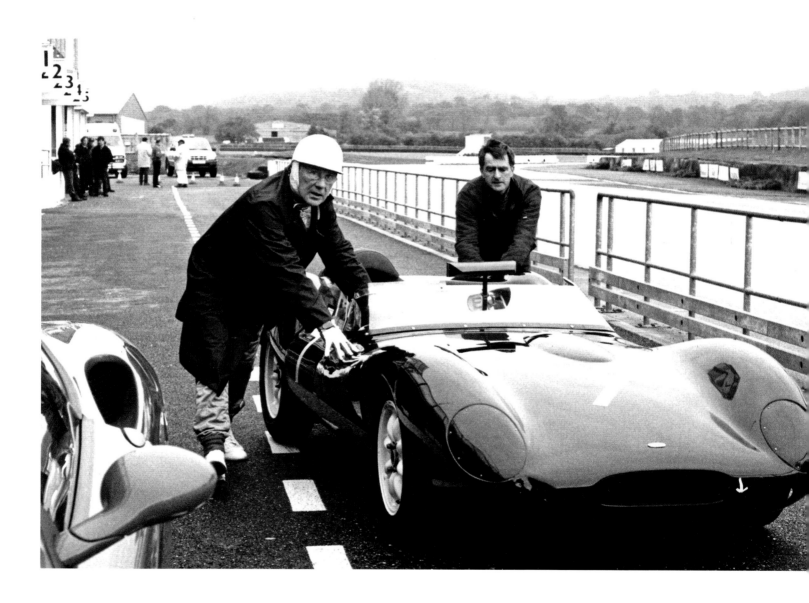

MM

TH *"I love this picture. Dare I say it reminds me of my karting days…and pushing your own kart to the grid!"*

SM *"This little Lola. Lovely! Of course I never raced this in my career purely because I was driving bigger cars and really if you're racing you'd drive the Jaguar or the Aston, but this was terrific. So well balanced. One of the nicest handling front-engined cars going. Nice picture."*

We are eventually bidden to lunch at Goodwood House. My feet feel distinctly out of place in my muddy trainers, in such a historic dining room, and in such distinguished company. The rest of me however, is perfectly comfortable. The meal is superb - my first lobster - and I have much in common with the gentleman on my left, a Mr Clarkson, whose son is editor of *F1 Magazine*. He too attended his first race meeting at Goodwood on Easter Monday 1962. He too adopted Graham Hill as his hero following Stirling's accident, and subsequently switched his allegiance to Jim Clark. As my mother always says: 'Like attracts like.'

Luncheon over, Stirling indicates that he needs to leave, whereupon the entire party come out to the front of Goodwood House to bid him and his anonymous friend farewell. Lord March very graciously says to me, 'So glad you could make it,' and JK shakes my hand: 'Pleased to meet you man!' As we begin the drive home we marvel at our host's artistry, his eye for detail, and his hospitality. Goodwood has once again worked its magic.

I just wish I had asked Susie, rather than Stirling, about the dress code! I didn't have an inkling about the status of the occasion. Maybe they both wanted to surprise me. Susie later admits that she was supposed to be going with Stirling - hence her helmet in WO1's boot, but she had stood aside to enable me to go. Funny that. Whenever I have asked anything of Stirling or Susie, they have always given me more.

As they say, 'Expect the unexpected!'

"I just wish I had asked Susie, rather than Stirling, about the dress code!"

Chapter 22
Driving Sir Goodwood November 2007

'You drove Stirling Moss across London? No way!' Cue telling another gobsmacked listener about my navigating Sir Goodwood through the rush hour traffic. Or rather, about him navigating me.
I know of only two other chaps who have been driven by Stirling, and have also had the opportunity to drive him. The first is his American buddy Chuck Shields, and the second is Sir Patrick Stewart.

Stirling has agreed to record captions for the photographs which illustrate all the 'Moss Moments' in the book, And I have been offered a recording studio in Shepherds Bush at a ridiculously low rate - 50 quid for as long as it takes.

Stirling in the passenger seat. Coy's 2000 Silverstone

The owner, who will also engineer the session, is delighted at the prospect of hosting Stirling Moss.

I turn up at the appointed hour outside his Mayfair home in my humble Honda Civic with its vague pretence of oomph - a V-Tec, whatever that means, and low profile tyres. I am a little worried that driving him might tempt me to either show off, or feel nervous. Thankfully, when he answers the door, he is ranting about unwanted emails and how they waste time. I catch his mood and assume a sympathetic grumpiness that gives me the 'couldn't care less' attitude I need.

Turning his mood to the traffic, Stirling becomes my co-driver. I join him in cussing other cars and drivers as we inch aggressively across four lanes of uncooperative Park Lane traffic, in order to go south, make the first available u-turn and head up to Marble Arch. We now have another busy four lanes to cross to turn left , and not a lot of road to do it. Staring into the passenger mirror, he shouts 'There's a Porsche coming up on your left old boy. When it goes past, move left…GO!' Perfect! What a team! It is as if he already trusts my judgment, and naturally I trust his. I never expected that "Driving Sir Goodwood" would be such fun.

Another legend is due to join us. As a 'thank you' for having contributed a beautifully poignant piece for this book, I have managed to track down and invite one of my favourite musicians of all time - Mark Knopfler. His numerical presence in my record collection exceeds every other artist, including the Beatles, Bob Marley, Hendrix, and the three blues Kings combined - B.B. Freddie and Albert.

I first met Mark at Buckingham Palace, as you do, where Mark was picking up an OBE. I found myself walking beside him as we left the Great Hall following the ceremony. He politely asked me what I had received an award for. I explained that I was there to witness my mother receiving her MBE for charity work, and somehow we struck up a conversation about old racing cars. I met him again 18

months later doing up his pads at Lord March's pre-Revival cricket match. He remembered me from 'The Palace', and was amused that this had been our meeting place. I had since got to know Stirling, and the book was already in its infancy. There in Lord March's back yard we quickly discovered that we had a boyhood hero in common. I asked him there and then if he would consider writing something, which he graciously did. An elegant and moving piece was soon on its way to me, for inclusion in a later chapter.

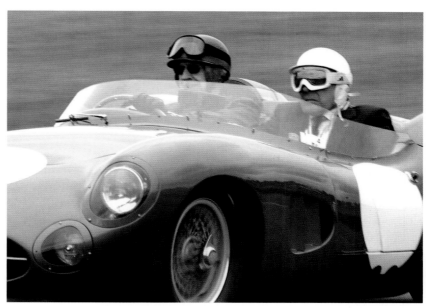
Nervous passenger? With Tony Brooks

So as we approach Shepherd's Bush, I play Stirling a track of Mark's - the instrumental version of Why Worry? With Chet Atkins. Stirling asks 'Do you think Mark is skilled ?' It's an unusual choice of words, and reminds me of when he asked me 'Would you say Jimi Hendrix was the Fangio of the guitar?' I remember thinking then "what a great question!" I had told him that I felt Jimi was probably closer to Gilles Villeneuve, since both had otherworldly talent but characteristic wildness. Stirling has boundless respect for Fangio, but I don't think Gilles' style particularly impressed him. This time I come up with an answer that I figure will make him think: ' One of Mark's great skills is knowing what notes not to play.'

Mark had told me initially that he wouldn't be able to come to the party, since he had planned to meet his best friend for dinner, just in from Canada. I suggested he put off dinner by an hour and bring Paul along too. Thankfully he does. We spend two hours sipping Chardonnay as we listen to Stirling comment on my pictures with his customary wit and amazing memory, which he claims is not so good. This is followed by a colourful conversation between Mark and Stirling, who is enjoying himself so much he forgets to look at his watch. When he does so, he realises he needs to get home sharpish for dinner. He immediately changes gear, which leads to slightly hurried but very cheery goodbyes, with Mark quoting his friend and driving coach, Australian racing legend Frank Gardner: 'Time to piss off into the sunset!'

As we buckle our belts, I ask Stirling 'Are you giving me permission to be Stirling Moss?'

Permission granted, driving Sir Goodwood home is even more fun. I take the lines, find the gaps, enter the zone. I am totally relaxed, and I sense he is too. Susie later tells me that had he been unhappy with my driving, I'd have known about it…

Chapter 23
Stirling Company

Stirling and Mark Knopfler in Conversation – November 2007

When I ask Mark if he has any questions for Stirling, it creates an interesting dynamic. Here I am, hosting a meeting with two chaps I admire enormously in their respective fields. Yet from another perspective, here I am with a fellow fan of our childhood hero in common, the pair of us listening as he holds court. And (to quote Murray Walker) 'unless I'm very much mistaken' I'm sure I detect a momentary schoolboy shyness in Mark, which is graciously defused by Stirling, allowing Mark to dive in with informed questions. They prompt lively answers.

TH *"Mark, do you have a question for Stirling?"*

MK *"I have a thousand questions but nothing of any importance at all."*

SM *"Anything you say will be important."*

MK *"Can you just make it out to cash?"*

 (Laughter)

MK *"I'd be interested to know whether you felt that of the great sports car and grand prix manufacturers, the Maseratis seemed to be better made than the Ferraris. When you compare those great sports cars of the fifties the Ferraris seemed to be slightly more agricultural than the Masers. Everything on the Masers seem to be toolroom built."*

SM *"Masers handled better. Ferraris always had the better engine. Ferraris understeered badly. They were never as nice to drive as the Maser. But having said that I think I did 22 races with the Ferrari. 18 or 19 I won. Never had one mechanical breakdown with a Ferrari. Never. Which is amazing when you think about it."*

MK *"And speaking of reliability there were drawbacks with the front engined BRM, which was the first car I ever saw you drive."*

SM *"Well it's the only car that now probably handles as well as a Maser. But it didn't then. When it came out it had the brake at the back and there's no reason why it shouldn't work - back*

With Mark Knopfler and our mutual boyhood hero
Picture by Mark's friend Paul

"With the tape still running I ask Mark if he has any questions for Stirling..."

Mark in his Maser 300S – Goodwood 1999

wheels only do 35% of the braking anyway. People say you shouldn't have the brake there - nothing wrong with it actually. It was never seriously sorted out until now. People know a lot more about what they're doing I think. Nice car though."

MK *"Nice looking car I always thought. Very evocative. You were talking earlier about racing the Aston and finding yourself in the same vicinity as a D-type, and you thought 'well that can't be right'. What do you think about the tuning up of old sports cars and grand prix cars?"*

SM *"The problem is half the people cheat. All they are racing for is the kudos and yet they'll cheat like buggery to try and make you think differently. Having said that it is very difficult to build an engine up using modern bits that were as bad as they were when they were new. Obviously a piston today is lighter, better than it ever was, and you wouldn't go along and pick one off the shelf particularly because it was worse than the other*

BRM with Tony Brooks. "Nice looking car I always thought. Very evocative." Mark Knopfler

one. The DBR1 is a good example. Beautifully prepared. The gearbox now is a dream where it was a bastard. Also when I used to race you could not get more than 6.1 or 6.2 (x thousand rpm) and now it's round about 7. And, who drives it now?"

MK *"Peter Hardman."*

SM *"Quick guy. Drives bloody hard and he does a good job! But no way is he using the revs that we used to because the car is so much better. So I can see there's two sides to this. It's very difficult to keep it as it was, and having said that there's a hell of a lot of people who are putting Can-Am brakes on some cars that didn't have them and 3.8 engines on Jags that didn't have them. It's terrible really."*

MK *"You see these pantechnicons pulling up at all the vintage races now and you realise that there are people getting into it who are investing huge amounts of dough."*

SM *"I don't know what the budget is to run historics but it must be pretty big. I was seated next to a guy at lunchtime who is just getting into Formula 3 and he needs a half million pound budget (in 2007!). But I reckon if you had a decent historic car and you were doing quite a lot of racing you'd need a budget like that."*

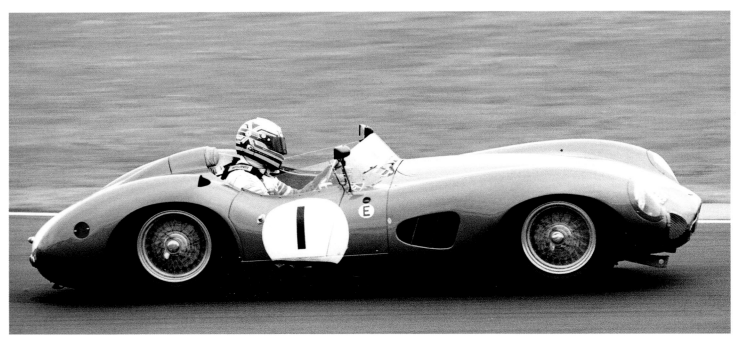

Drives bloody hard and he does a good job. Peter Hardman in Moss's old Aston, Silverstone 2000

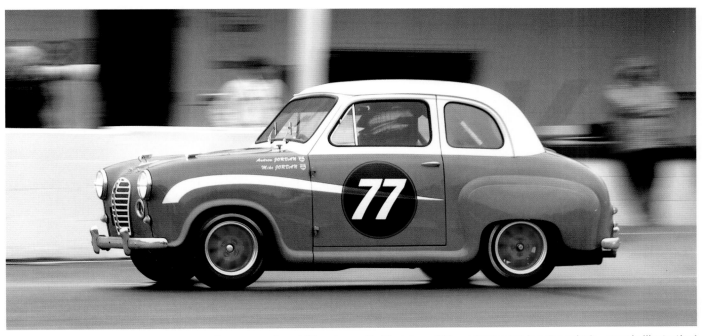

No way was it an A35 underneath. Disclaimer: This particular car is not a culprit – merely illustrative!

TH *"There's been a big hoo-hah about all this. I know of a guy who was excluded for having special cams on his Ford GT40 which let it rev higher. Then there was the little Austin last year. Might have looked like an A35 but no way was it an A35 underneath."*

SM *"Yeah, well exactly. A guy came up to me in America and said would I like to try a Sprite, and I'm thinking the last thing I want to drive is a Sprite! He's a friend of mine so I said alright. Beautiful car. I got in the thing and said 'What do I rev it to?' He said, 'Try and keep it to 8 but if you need 8.4 you can use 8.4.' Now I look in my diary. I raced it for Donald Healey when it was brand new in 1950 or something, and I saw it was getting valve bounce at 6.9. Well, they build this thing up with a Formula 3 engine or whatever it was. But it was wonderful to drive. I was racing and beating Porsches with this damn thing! That's not what it's about but in America if you're cheating or you've got a non-standard car you just put 'M' after your number which means 'Modified'. You're saying OK, I've got a D-type Jag or a C-type Jag or whatever, but 'M', means I've buggered about with it and it isn't as it was which I think is a good idea. Over here there are so many bent cars it's ridiculous!"*

MK *"There are so many professional drivers. When the flag drops these guys are really competitive."*

SM *"Yes, but what is interesting is they are only professional amateurs. In other words if you brought Lewis down, or someone who's really top, the times that they're doing would be wiped out! There are people out there who think because they are doing times faster than they were then, that boy they must be on the limit, but they're nowhere near it! There's a lot of difference between a real pro and an amateur professional. I think these guys like Hardman do a terrific job but I think one has to realise that they are professional amateurs. When we were racing the really good people who were not professional were people like Jack Sears, Mike Parkes, but they still wouldn't beat a really top line driver, but they were pretty damn close."*

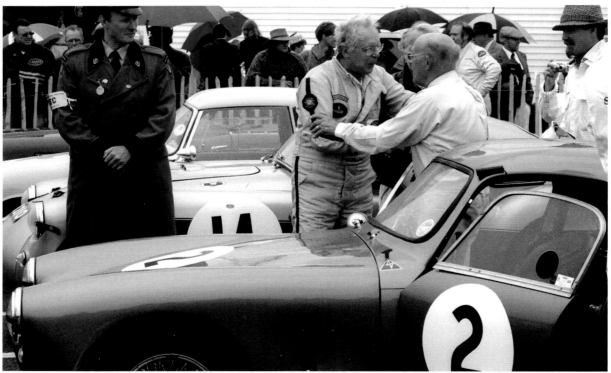

Moss with rival after race in Sprite

"Well they build this thing up with a
Formula 3 engine or whatever it was."

CHUCK SHIELDS ON SPRITE:

"We began racing the Sprite together during the Bahamas Grand Prix in Freeport, in 1986. As he's mentioned, he was surprised at how the engine compartment had been fitted with gobs of aero quip and other doodads, so we had a long chat about the history and the restoration work. I asked if he cared to give it a go, which he did - about five laps on that short street circuit. The car was perfect for both the track and for Stirling - quick, agile, and a winner.

We met again a few months later, at the West Palm GP. The track was well suited for the car, several tight turns, short chutes and a high speed twisty. After a few practice laps, he tried to go though the twisty flat out and spun the car, flat-spotting all four tyres, but no damage. When he got out he profusely apologised and said he thought he could take it flat out. We reshoed the car and sure enough he did from then on. He had a very spirited race with a 356 Porsche during the Sunday race swapping leads several times until SM swept past in the twisty and nipped the Porsche at the finish. Everyone there was in awe of that race and Stirling's handling, none more so than the Porsche driver himself who came by and spent 30 minutes re-hashing every bit of the race with Stirling. This was so typical of his kindness and generosity which I have seen so many times over the years."

MK *"Another thing I've thought about a lot over the years is: what do you think makes a really good test driver?"*

SM *"Well that's only come up in the modern era, they have their test drivers and all this sort of crap, I mean we never had test drivers!"*

MK *"You had to be the test driver!"*

SM *"Absolutely. If you're going to make the car the way you want it, it's no good me asking you to do it because your style would be different from mine. If Jack Brabham had set my car up I'd have been in a bloody mess! His style was different to mine. The car was different. I can't speak for nowadays, I can only speak for my era but if we had such a thing as a test driver, when he'd finished all his testing I know damn well I'd have changed a lot because even though it's the best for him doesn't mean it's going to be the best for me. If you took John Surtees, Jack Brabham, Bruce McLaren and myself, there would be four fairly different cars. They would be set up quite differently because of the style of that driver. I mean Jack had his arse out and all that sort of thing, and he had his cars set up perfectly for that. But if you don't drive with that style then you're going to change it. It depends how good you are as to how much oversteer you can handle. Rule of thumb, the better you are the more oversteer you can use. For ordinary people the safest cars are understeering. But when you get to the limit understeer is unsafe. If you know what you're doing though you can have oversteer and temper it down to be the way you want it. But to accommodate oversteer you have to have a different sense to people who want it understeering. I don't know what it's like today because they engineer out so many different things.*

Take the slicks off mate – I can't get my arse out!

"*Rule of thumb, the better you are the more oversteer you can use. For ordinary people the safest cars are understeering.*"

SM *When you buy a car, like I bought a 250F Maser, you gradually begin to make the car the way you want it. I remember going to the start line at Monza and we had a full tank in the back, 42 gallons or something, and I'd get on the back and push it down as hard as I could and if it came back up too quick then you'd tweak the shock absorbers to tighten it a bit. If it was slow and wouldn't come up you'd loosen it a bit. I mean just a fraction. As a driver you would know that much. If you're talking technically then I wouldn't have any idea. I know what understeer is and*

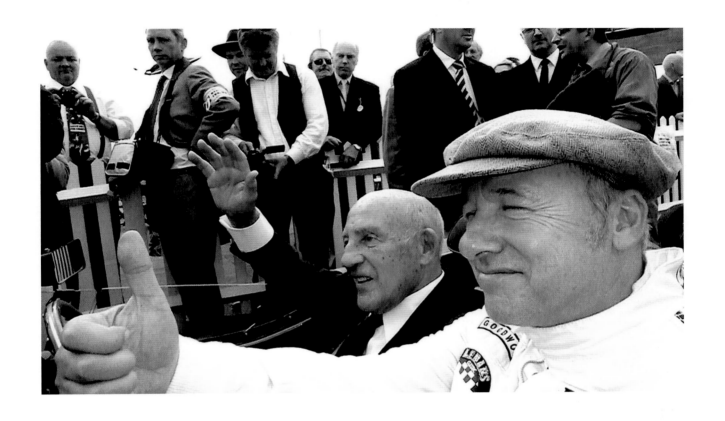

I knew the sort of thing you'd do to get over understeer. But the final tuning is so much closer than that. These guys like Pedro de la Rosa (McLaren test driver) and Davidson are obviously pretty bloody good, but how good are they compared with the people they are trying to get to? Very very difficult to say. If you have got someone like Lewis, that's where he's so good. I think Lewis is in a class of his own, I really do. I think he'll walk away with it. (Lewis subsequently became the 2008 World Champion).

JOURNO: *"So Mark, how does it feel sitting next to Stirling Moss on a day like this?"* (SM'S 80TH CELEBRATION)

MK: *"Well he's my hero. He's the only man on earth I've ever asked for an autograph. And this is one of the great moments of my life obviously."*

Chapter 24
Sterling Comebacks

Stirling has outwitted death on countless occasions throughout his chequered life. During his recent hospitalisation with a lung infection, I feared the worst. I had just seen my brother-in-law Gino pass away, a very dear man, and 'only' 82. I shared my concern with Mark Knopfler, who in his reply wrote: 'I agree it's not a sunny prospect but if anyone can come through this it's Stirling. He's tougher than anyone I know of.'

Some of these skirmishes with the grim one were won at a hell of a price. At Spa in 1960 his Lotus shed a wheel on the fastest part of the circuit. He was thrown from the car, landed in the middle of the track unconscious, broke two legs, three vertebrae, several ribs and suffered cuts and abrasions. Weeks later he was winning races again.

His Easter Monday accident at Goodwood in 1962 ended his front-line career and left him in a coma for a month and paralysed for six. But his enthusiasm did not retire. In later life he came back to compete in the British Touring Car Championship, and he subsequently spent decades racing the cars of his era in Classic events.

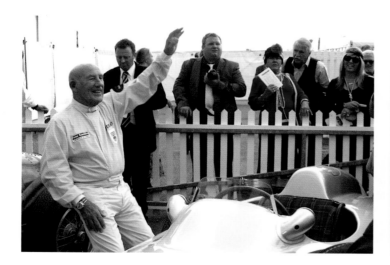

At the 1999 Revival, on the weekend of his 70th, he raced his favourite F1 car - the Maserati 250F. He started from a lowly 16th place and in monsoon conditions he sailed up to 4th place.

Only in 2011, at the tender age of 82, did he finally decide to retire.

There is another kind of comeback at which he's a natural, driven by his quick wit and sense of mischief. At the 2016 Revival I bumped into Darren, their long-time security man, as he grabbed a coffee. Perfect timing. He took me straight to meet them outside the nearby Shell building.

Stirling greeted me in his usual chirpy way and the jokes began to flow immediately.

The next day I introduced my long-time LA actor friend Michael Nouri to him at a signing of his new book written with Simon Taylor, *My Racing Life*. Michael had just bought a copy and handed it to Stirling for his signature. A little nervously he said, 'Tim's been a friend of mine for a long time.'

Cue mischievous grin from Stirling: 'Well, we all have our problems.'

But his greatest comeback has to be from his frightening three storey fall down the shaft of his in-house lift, at the tender age of 81, breaking both ankles. All the relevant signals indicated the 'cab' had arrived. The door opened. Stirling, talking to his daughter-in-law and therefore looking behind him, stepped into an empty shaft and fell in darkness three floors. Horrific to contemplate. What creeped me out was that I had ridden in it with him just a week before, and there had been some minor malfunction then. I suggested half-joking, half serious, that he contact the designer, but he didn't seem too concerned.

He was pictured in the *Daily Mail* in a wheelchair, both legs in plaster, wearing a big grin and a 'British Racing Drivers Club' badge on the side of his chariot. The headline of this full-page article read: 'Mr Indestructible'. Reggae singer Jimmy Cliff sang 'You Can't Keep A Good Man Down' and no elevator shaft is going to swallow Stirling Moss. It's a modern-day Jonah story if ever I heard one.

I called him a few weeks later to see how he was bearing up. 'Walked 15 yards today. Furthest yet. Plus I have Soozles with me and this lovely nurse so I'm well looked after. By the way, you've just saved me the price of a stamp! I was about to write and thank you for your lovely card which is right

here at the top of the pile.' My 'get well' card depicted a cat lying on a hospital bed with a bandage around its privates. The caption read 'When Poozles woke up, he sensed that something was missing.' I asked the patient if he had looked at what I had written inside. He chuckled as he read: 'You see Stirling, it could have been worse.'

Several months later I visited him, fully recovered, and walking well. After a cuppa he suggested we go downstairs so that he could introduce me to Mandy, his new PA. 'She'd love you,' he said. 'She loves the blues.' He started towards the lift.

'Stirling,' I said, 'you don't still ride in that thing do you?'

'Sure old boy, I just have to file a flight plan before I get in.'

Born raconteur meets attractive interviewer. A match made in Heaven, or Coventry, in this case

An Old Fart

Old Fart Racing is a distinguished society of 'senior racers' who own high performance cars and whose track days raise thousands of pounds for charity. Their members rejoice in such names as Turbo Fart; Can-Do-Fart; German Ausfart; Fortified Fart; Designer Fart and of course, the Old Fart himself. Stirling, in his foreword to their limited edition book, *20 Years Of Farting Around*, describes them as '*a happy band of comrades who represent nearly every discipline of motor sport from marshals and timekeepers to circuit racers. A motley crew indeed you might think, but they don't take themselves too seriously. Their hearts are in the right place, as they provide seriously ill children and their families with recreational opportunities and financial support.*

It was not until 2011 that I discovered that, despite continuing to race, I was considered by a select group of racers and ex-racers to be an Old Fart! To most individuals this would be considered an insult and make you question your competence in other departments. However far from being an insult, to be asked to be President of Old Fart Racing turned out to be an honour!'
Sir Stirling Moss.

"*Their members rejoice in names such as Turbo Fart, Can-Do-Fart, German Ausfart, Fortified Fart, Designer Fart and of course, the Old Fart himself.*"

Chapter 25
Final Fling

The 2010 Revival offered Stirling another opportunity to race the scarlet Osca he loved. Such a pretty car, and pretty nimble too I would imagine, being effectively a scaled-down Maser. I'd already witnessed him and Susie enjoying it one sunny Sunday at Brands. Shame it broke, but that's racing.

Between those two meetings he fell down his private lift shaft. Both ankles were broken, but not his spirit. 81 not out. To have survived such a fall at his age is one thing. To then think about racing a car is quite another. Makes me shake my head and wonder. But then, I'm not Stirling Moss.

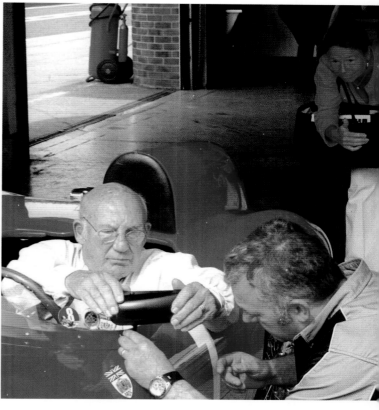

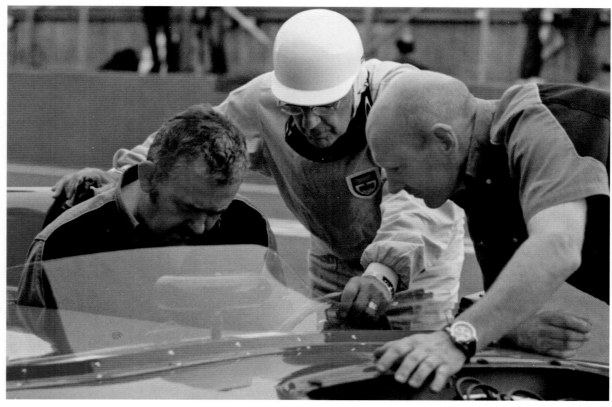

Maybe his punishing Revival schedule was getting to him, but to me he seemed to lack his usual spark and urgency. I asked Susie during his stint if she worried about him going out on track. In 11 years it had never occurred to me to ask such a thing, though a near-miss at the 2000 Revival when another car landed on the nose of his Cooper had certainly worried her. 'I only wish he looked like he was enjoying it,' she replied.

After only a few practice laps he pitted. When asked what was wrong with the car he simply said, "Nothing wrong with the car. I'm just not quick enough."

She later told me that at the inaugural Revival meeting in '98, there was some doubt as to whether he'd be up for racing the Aston. She advised him to bring it in after a few laps if he wasn't into it, and they'd find "something wrong" with the car. However, when Willie Green in a Ferrari and then Martin Brundle in a D-type passed him, he decided to put his foot down and get 'em back. He famously got Green on the outside of Woodcote, holding the car one-handed mid-corner whilst giving Willie "the wave".

Next stop for Stirling and the Osca was the Le Mans Classic the following year. After only a few practice laps he pitted. When asked what was wrong with the car he simply said, 'Nothing wrong with the car. I'm just not quick enough.' He climbed out, and that was it. An official announcement soon followed stating that he would no longer be engaging in competitive driving. I sent him a card with as positive a message as I could muster, expressing my conviction that he would still be much in demand, and no less in peoples' affection. He sent me this upbeat reply: *'Thanks so much for your kind card following my retirement - whatever that means! I am hoping that nothing whatsoever will change, other than the fact that I am not going to try to win anything!'*

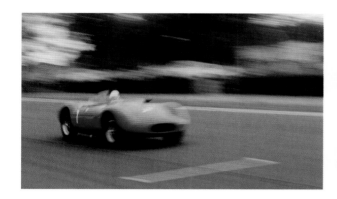

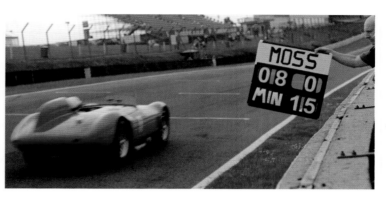

Chapter 26
Open it Old Boy

What a pleasure it is to raise a glass to Stirling Moss - no better excuse - even if the liquid in the glass is not to his liking.

Spoilt for choice after an invitation to help myself to whatever I could find in his drinks drawer (the only drinks drawer I have ever seen) I spy an interesting unopened bottle - The Jim Clark Festival Malt. Enchanted by the label with its pictures of the man who became my number one after Stirling's accident, I hear the command 'Open it old boy!' You don't refuse Stirling Moss…

Many moons later, emboldened by a (not so) wee dram given to me by Keith at The Vintage House in Soho, I stride straight from Old Compton Street to Shepherds Market and ring the Moss doorbell. I had just told Keith this story, and mindful of his shock that I had actually opened such a rare and potentially valuable bottle, I ask Susie if I might photograph it. She goes upstairs to find it, and with typical disarming generosity hands it to me to keep, still half full. 'He won't drink it. He hates the stuff,' she says.' Give it a good home.'

I tell her what the man had said about its potential worth, had I not followed Stirling's instruction to open it. She smiles mischievously and says, 'If you don't tell him, I won't!'

"I spy an interesting unopened bottle – The Jim Clark Festival Malt."

Jim Clark Festival Malt – Song Lyric

If the Maestro invites you to help yourself,
It's an offer you shouldn't refuse.
And if your hand hovers between two malts
And you're wondering which one to choose
The feisty Laphroaig or the Cragganmore
Or this mystery malt that you've never seen before
And as you examine it the Maestro says 'open it!'
He won't be drinking it for sure.
He doesn't like whisky, so go ahead and pour

The Jim Clark Festival Malt
Drink the stuff of legend
From the Maestro's collection.
Jim Clark Festival Malt
Let it linger on your lips
And savour every sip

Jim farmed the Lowlands, so this could be
Bladnoch, Auchentoshan, maybe Glenkinchie
Maybe a vatting of all three
Maybe the Soho specialist can help me.
'Oh my God' he said, 'You didn't open it did you?
You know that bottle could be worth a bob or two!'

I told this story to the Maestro's good Lady.
She just smiled and said 'If you don't tell him I won't!
Here, take the bottle! Why don't you give it
a good home?'

Now the Jim Clark Festival Malt
stands in my collection
Next to my Lagavulin.
Jim Clark Festival Malt lingers on my lips
And I savour every sip

How is it the good die young
Like Scotland's smiling champion?
Jim is alive in his Lotus 25
In the memories that make me who I am.
Alive - in this magical dram

Jim Clark Festival Malt
Every sip a recollection
of my hero in action
Jim Clark Festival Malt
Let it linger on your lips,
And savour every sip.

Years later I manage to sell 60 bottles of a single cask Glen Moray as a revived 'Jim Clark Malt', to commemorate the 40th anniversary of his death. By way of honouring Stirling's part in my little enterprise, it crosses my mind to give him a bottle. But then I think twice. To satisfy my increasingly fickle memory I ask him:

"Am I right in thinking you don't drink whisky?"
"That's right old boy, I'm far too young."

Dram For An Absent Friend

Fast forward ten years. I am invited to tea with the Mosses, along with another friend of theirs. Not wishing to arrive empty handed I bring a bottle of Chardonnay. Susie asks me if I would like a glass of wine, or something else. I say, 'If I have something else, there'll be all the more wine for you.' She seconds that emotion and leaves the room. Moments later she returns with an old unopened bottle of Glenmorangie 10 year old, a classic malt long since remixed and repackaged. In its original tube, it is now a rarity. 'Open it! Help yourself! We got this for Sid but he never got to drink it.'

'Sid' was of course the late F1 doctor, Sid Watkins, whom I knew to be partial to this particular dram. I let that sink in. I soon figure I need a large one just to get over the overwhelming sense of being honoured in this way. Besides, the Twilight Zone theme has begun to play in my head. Just the night before I was watching the movie *Senna*, and had been deeply moved by the haunting San Marino '94 sequence in which Senna ignores heartfelt pleas not to race, from his dear friend…Doctor Sid Watkins.

Slainjeva.

Chapter 27
Peerless Among Peers

M ost of these tributes from Stirling's peers, friends and fellow legends were recorded off the cuff in the Goodwood Paddock. Others were sent by email. All responded generously to my request with great respect and affection for Stirling. Apologies to those I didn't manage to ask.

DEREK BELL:
"He's the king of the sport. He's the name on everybody's lips, and he was my idol at school. So for me to be a close friend of his is very special, and something I'll never forget."

PHILIP PORTER:
"Stirling became patron of our XK Club. I used to go to his house and he showed me his wonderful scrapbooks and I thought gosh, these should be seen by a wider audience, they're amazing, they're fabulous. I suggested it to him. He said, 'I think you're crazy but…OK!' Fabulous man. Incredible to go out with on the track. Brings so much pleasure to so many people. True with Murray also. People look up to them, revere them. It's such an honour to meet them. They just bring so much pleasure. Delightful. Normal. As you say, love a joke, and you can wind them up, and be totally irreverent. Just have a good laugh together!"

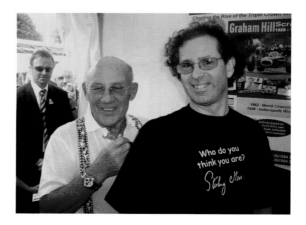

ALAIN DE CADENET:
"It's always a joy to go anywhere that Sir Stirling is because A) he's good fun; B) you always get stories - the man's got more stories than I've ever heard in my life."

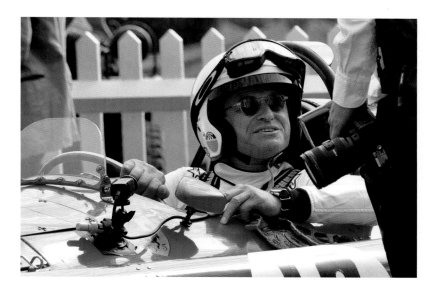

BARRIE 'WHIZZO' WILLIAMS:
"What an incredible man. He asked me to drive the Ferguson instead of him. So I have the hugest respect. And I hope I'm going as quick as him when I'm his age. I'm not far behind! What a history. And what a gentleman. What an amazing memory."

TH *"Especially for jokes!"*

BW *"Mostly dirty ones!"*

BOBBY RAHAL:
"He's a wonderful man, when I was growing up you read about Stirling Moss. Super guy."

MURRAY WALKER:

"Ladies and gentlemen, we are lucky to have with us today one of the three to four best racing drivers ever. He's a lovely bloke and very elegant…er… eloquent. So please put your hands together and welcome, with a huge amount of respect, affection, and idolatry, SIR… STIRLING…MOSS!"

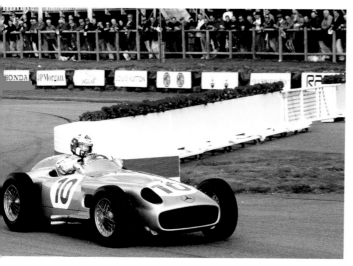

DAVID COULTHARD:

TH *"You drove the W196. Could you give me a word on how it felt to be in that particular seat?"*

DC *"Ah, well, having had the privilege to drive the W196 I definitely don't do the car justice in the spirit of how Stirling and the likes were racing it, but of course I have a healthy appreciation for the history of the sport, and Stirling is one of the true legends of motor sport and it has been a tremendous honour to have been able to spend time with him during my racing career."*

TH *"And to have had your bum in the same seat."*

DC *"Yeah! It makes me very happy and very proud."*

TIFF NEEDELL:

"What can you say about Sir Stirling? He's 'the Maestro'. I stood at the fences at Goodwood watching him go by making me dream of being a racing driver! So Stirling to me is 'Mister Motor Racing'."

JUSTIN LAW:

"I raced a C-type Jag here for years and Stirling in the end bought that car. It was dark green when I raced it but Stirling said 'I want to have it Aston Martin racing green and then I want to re-trim the seats and then I want to go and do Monaco Classic with it' so we (Justin and father Don Law) went and ran Stirling - we were with Stirling and Susie out there, and he's such an amazing man. Every minute of the day was filled. We had lunch together and we said 'what you doing after lunch?' And he said I'm going to do an interview here, then I'm going up to the hotel to give a speech up there, then I'm going to meet Prince whoever it was! He was just all over the place absolutely flat out, and he had the time of day for everyone. Just amazing to be involved with such an icon.

It was nice he bought the C-type that I raced because clearly he knew it was a good one because we were winning everything. It was a pleasure to run him for the short period we did. Then we sold the car for him and my father wrote his first million pound cheque - to Stirling, for the car - to buy it back. So we got that framed on our wall at the workshop. He cashed it and then we called up and said 'Listen, do you think you could get that cheque back for us?' So when the bank had processed it they sent it back! So we kept the cheque, got it all mounted with a picture of the car. A pretty cool thing..."

JACKIE OLIVER:

"He had his accident here in 1962 and I started racing in 1968. So my friendship with Stirling was really after he stopped racing. The photographs really tell the story. I've said to Stirling he should have been World Champion, but the rules weren't as they are now which would've made him one. But that is the way of life."

EMANUELE PIRRO:

"He's like a bridge from the past to the present and for us it has been an incredible privilege to have the chance to share and spend time with him, and sometimes you tend to forget you're talking to the real Stirling Moss who has been living this incredible time and era. Because that time in your mind is really the past, and you are not used to see in reality people who belong to that time.

Every time I spoke to Stirling I was amazed by his humbleness. When you are a survivor of this time you can tend to make up stories. You catch a fish from 50 years ago and from a sardine it becomes a tuna! I think with him it's the other way round. Because to have someone who says 'In Formula One Fangio was a little quicker than me' is an incredible lesson for all these juniors who always find excuses when things do not work. And of course life goes on and you can't have the privilege to hear these stories forever. I'm sure in the future we will appreciate even more the privilege we have had. I was always trying to find opportunities to ask for stories and to hear first hand, like it's a treasure and you have to dig information out as long as you can.

So I'm an optimistic guy, I don't like to say racing in the past was so much better than now, but definitely that time was very, very, very special. Life had a different meaning and drivers were driving a lot more with their heart than now. I'm a steward now in Formula One races and you do need someone who is ruling your behaviour because, I don't say there is no respect for each other - but there's less at stake. Often I think about the past, and before the risk was so high that they did not need stewards to tell them what to do and what not to do. They somehow fixed it by themselves. So yeah, every time we came here (to Goodwood) it's been an incredible privilege to spend time, and also with Susie because, especially at that time, the partner or wife of a driver was part of the package. Often I felt about Susie to be somehow both in the shade but in the front line. And I think she must have played a very important role for a long time. It was like she was preserving him in a way but didn't want to hide him! The sweetness she had every time I saw them together, for me was really remarkable."

TH *"My first impression on meeting her was she put people at their ease, people who might be very nervous at meeting 'the Legend', at book signings and so on. You say Stirling was the bridge. In a way she was the bridge between regular people and him."*

EP *"Yeah, yeah, an open bridge. I think she has been important for him, and for him in relation to the outside world."*

STUART GRAHAM:

"For all of us Stirling's always been a role model for everybody in motor sport, because even as a child you knew about Stirling and my father being a motorcycle racer knew Stirling and got a job at Jaguar and got to know him a bit there. Obviously a young guy then, but over the years having become friends with Stirling, which you'd never have imagined originally. It's great, and I remember one particular event I was driving an Austin Healey 100S at Le Mans Classic some years ago, and Stirling was in his C-type, and we were going down the Mulsanne straight and the light wasn't very good and we were looking for the braking markers and I thought, 'I'll follow Stirling because he's bound to know where they are,' and at the end of it all we were discussing it and he said, 'No boy, I has hoping you'd be in front because I couldn't bloody see it either!' So we've had lots of little things like that. He's a great guy, wonderful, and we all wish him well."

TH *"I think role model applies as much to the man."*

SG *"I think everything. He was the young professional, and he drove everything, and those were the days when a guy would jump out of a saloon car into a grand prix car at the same event and just get on with it. And those wonderful times with Merc and Fangio and all that were brilliant and I remember seeing the 1955 Italian Grand Prix which we were invited to as youngsters.*

He's given the sport everything. He's been a role model to so many generations it's hard to decide which ones, and he and Susie have become friends over the years and he's just such a special guy. He's a one-off."

3 legends: Richard Attwood, Brian Redman, Spitfire

RICHARD ATTWOOD:

"He's a great guy. The best driver of his era by a long way. There are different eras, different drivers, but Stirling was the best. He always felt bad that he hadn't won the World Championship, but he beat them all anyway!"

TH *"I think he's rather proud of that title now!"*

RA *"Well he may be but it's taken him years to recognise that, but he'd drive any car. And you know I'd talk about Clark the same way. I was in both their eras but if you're the best, you can't do any better than that! I don't give a shit who's world champion, I really don't, because you've got to be in the right car. Like winning Le Mans, you've got to be in the right car, and have the right co-driver, and it comes to you, or it doesn't come to you. And you can't make the difference in certain races, but Moss and Clark in certain races made it happen because they knew exactly how far they could push and how far they could go, and they were just bloody good at their jobs, both of them."*

BRIAN REDMAN:

"I did actually see him win the British Grand Prix at
Aintree in '55."

TH *"And in your opinion did Fangio lift off?"*

BR *"I asked Stirling this at Amelia Island about five
years ago when we were having a drink at the
reception before the dinner. I said 'Stirling, may
I ask you a question old boy?' He said 'Yes old
boy!' I said 'Did Fangio let you win the British
Grand Prix?' He said, 'I've often wondered
about that!' (Laughs)*

*I don't know if the story about John Surtees testing here in a car for the first time is true, but
at the time it was said that John Surtees said to Stirling, 'How do you take Fordwater, mate?'
And Stirling said 'Absolutely flat old boy. Flat out.' So when John finished spinning and came
back to the pits he said, 'Hey, Stirling mate, I thought you said Fordwater was flat out!'
And Stirling said, 'You didn't actually believe me did you, boy?' Well it sounds good!*

*He's a remarkable character. Arguably the greatest British racing driver.
He had a wonderful career. Wonderful person."*

JO RAMIREZ:

"When I was starting my career I wrote to everyone. When I was in Italy working with racing cars I wanted
to come to England and I wrote a letter to many people, and Stirling was one of the few that answered. And
then I met him at a restaurant called El Cubano in London - the same road that Harrods is - Cromwell
Road! I just went there with a friend of mine and he was sitting there with some friends. I couldn't believe
my luck! Stirling Moss! And actually I went to him and said hello and I told him 'I wrote you a letter and
you answered.' I said I was a friend of Ricardo Rodriguez and I wanted to start my career in England, and
he was ever so friendly. We had a chat and racing drivers in those days were not like prima donnas. He was
a very approachable person. It's such a shame he didn't get the World Championship."

TH *"Well you know I think he's rather proud of that. Nobody else can be 'the best driver never to win the
world championship!' He was very worried about Nigel Mansell at one point!*

He thought Nigel wasn't going to get the title which would put his unique title in jeopardy!"

JR *"Haha! Never!"*

SIMON TAYLOR:

"Forget world championships. Sir Stirling Moss was the greatest racing driver of his era, and remains one of the greatest of any era.

Although he continued to race historic cars well into his 80s, his professional career lasted barely 15 years. Yet, half a century later, his name remains a household word. He is a true British sportsman whose achievements live on.

The best word to describe his extraordinary talent is versatility. He was quicker than the rest just about everywhere, from daunting road circuits like Spa, Pescara and the Nürburgring to flat-out blinds like Monza and Avus. He was at home tackling the snows and mountain passes of the Monte Carlo Rally, setting land speed records on the Bonneville Salt Flats or completing the 1,000 miles of the Mille Miglia in a time that would never be beaten. In exhausting heat or in teeming rain, on a track covered with oil or breaking up into potholes, that relaxed, laid-back stance at the wheel never changed, and that ability to find a fifth of a second here and a tenth of a second there was always his secret weapon.

He was versatile where cars were concerned, too. He saw being a racing driver as his job, and he rarely turned down a drive: 'got to pay the rent, boy'. So at British meetings he would often compete in several races in one afternoon – Formula 1, sports cars, big saloons, small saloons – and win with them all.

But there is much more to S. Moss than that. It's an old-fashioned word, but he is a true gentleman. In his racing he was a hard man to beat, but he always cared about sportsmanship, even appealing against the disqualification of his closest World Championship rival because he thought it was unfair. It's a concept that would not be understood in the pitiless commercial world of modern Eff Wun.

He is proud to be British. He earned well at the height of his career (although a tiny fraction of the insane sums paid to the top drivers today) but unlike others he would never dream of leaving his country for a tax haven. There has never been any false modesty – he knows how good he was – yet with members of the public as much as with his friends he is always polite, courteous, happy to sign an autograph or pose for a selfie. Ever since his professional career ended in an unexplained accident at Goodwood in 1962 he has continued to earn his living just by being Stirling Moss, with personal appearances, commentary work, public relations and endorsements. Only a nationally well-loved character could have done that. It's a cliché maybe, but Stirling Moss is an institution."

LEWIS HAMILTON:
"I would like to say that Sir Stirling is an amazing man with huge character and charisma." (From his foreword to Stirling Moss' autobiography with Simon Taylor - My Racing Life, reproduced with permission.)

Mutual admiration Society. "I think Lewis is in a class of his own, I really do." Sir Stirling Moss

JAY LENO:
"One of the great thrills of my life was being driven around Laguna Seca Raceway by Stirling Moss in the 300 SLR that he used to win the Mille Miglia. In this era of multi million pound racing drivers Stirling always seemed to be racing for something more than money, King and country. Being the feisty underdog, often times taking hopelessly outclassed cars and pushing them beyond their limits. He cared about patriotism, pride and winning the right way, not at any cost but with sportsmanship and the respect of his fellow competitors.

He also had a wonderfully ribald sense of humour. When I would see him every year at Pebble Beach he would call me over and ask 'what's the latest joke going around?' When I would tell him he would let out a hearty laugh. That would make me feel like I was the greatest comedian in the world.

If a life could be measured in pound notes he's surely one of the richest men in the world."

MARK WEBBER:
"The name represents an absolute global icon of motor sport. Hard to itemise which of those guys was before his time but obviously Stirling was a tremendous pioneer in so many ways. It's so easy to use trivial words: 'Icon'; 'Gladiatorial' etcetera, but what those guys did, I mean like the Mille Miglia with Jenks, all the Formula One stuff, just absolutely…it's like comparing them to fighter pilots who did some amazing things, just so brave. And 'Stirling Moss' is just such a famous individual and name, and a class guy. It's so easy for that generation to be a little bit negative towards our generation because the type of cars that we drove were so much safer and frankly, less stimulating, but he's still so respectful of what we did, because he knew why and how we did our profession."

ANTHONY REID:

"He is an absolute icon of global motor sport, not just British motor sport. A global superstar, a very recognisable name and figure. That astonishing achievement of winning the Mille Miglia - that goes down in history! What he did in grand prix racing, sports cars, a broad range of talents there. And many of us got a second wind because of Goodwood, and Stirling was revitalised in his later years by being the guest of honour, and driving the Mille Miglia car with Denis Jenkinson up the hill at the Festival Of Speed. Or being here driving the Ferrari 250 short wheelbase, so it's a real pity he can't be here today. I wish Stirling all the best."

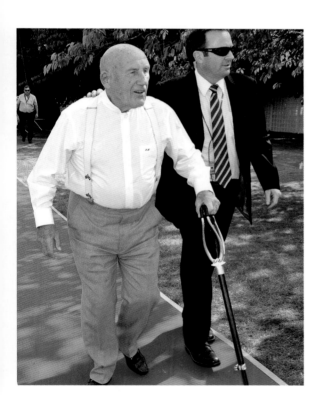

DARREN SMITH:

"I see him from both sides. I see him as Stirling Moss the legend who is adored by all these people at these events who I'm supposed to be looking after, but I also see him as a cheeky chappy, flirty, pointing out all the women as we drive past in the buggy! He's my friend and with Susie there as well sneaking off for a quiet wine while he's doing his book signings and signing all his autographs…just the most lovely, lovely people."

TH *"I had this thought the other day. Would he have been the legend he is just because of his record? Absolutely not! It's because of the man he is - the endearing character he is."*

DS *"Absolutely it's because of who he is, and the fact that he's got time for everybody all the time, and that's frustrating sometimes because we're running late and he'll insist on sitting there and signing another ten autographs or signing another ten books or more photographs and then we end up perpetually running late for everything, but…everyone can wait, because it's Sir Stirling!*

I was lucky enough to go round the track once with him in the Ferrari 250 GT, the dark blue number 7. A competition winner was supposed to go round but never turned up and of course we had to get the car out on track so Stirling said, 'Why don't you come with me instead?' So I climbed into the car, we did the formation lap, we lined up on the grid and then it was the rolling start lap, and as we're coming down the Lavant straight I happened to glance in the rear view mirror and saw all the cars warming their tyres, doing the old side to side thing, Stirling saw me glancing in the mirror and said 'Darren are we going quick enough? Do I need to speed up?' It was so funny! And I said, 'You're Sir Stirling Moss. You can drive as fast or as slow as you like and everyone else will just have to join in behind us!'"

DOUG NYE:

"Well if you ask me about Stirling Moss the immediate answer that comes to mind is 'the greatest living Englishman.' I don't think we had a world standard setter who was better known worldwide than Stirling, and I think it's very unfortunate that too many people think that games like football are more important! Because in comparative terms did we have a Pele, or any of these absolute footballing superstars? I've got enormous admiration for Stirling and I always have had ever since I was a small boy, and people think that kids in the 1950s were split into Stirling Moss fans or Mike Hawthorn fans. It's complete toffee as far as I'm concerned. I think enthusiastic small boys in those days regarded any of those people as supermen, and the most super ones of the lot were Hawthorn and Moss and Stirling demonstrably was the standard setter of his time.

Essentially he built a brand didn't he? And then he invented the profession of being a 'retired motor racing driver' and did brilliantly. And it is true that Stirling turned into a much nicer man than perhaps he had been sometimes during his front line career, but having said that I do remember many of the race mechanics from the HWM team he started with, or the Maserati that he ran for himself, say what a great man he was to work with at that time, and my late great friend Denis Jenkinson who so memorably navigated him in the Mercedes around the Mille Miglia when they did 1,000 miles around Italy in 10 hours and seven minutes, just short of 100 miles per hour - I've got Jenks' little roller map that he used by the way - and Jenks and Stirling, you can't describe it as a love-hate relationship (laughs) but they had a very clear view of each other's shortcomings and they also had a very, very clear view of each other's capabilities, and in that Mercedes, on that day, May the 1st 1955, they were just invincible."

JOCHEN MASS:

"Well for me Stirling was always an icon, I mean he was a fantastic spirit in motor racing. He came through very difficult days. It was not easy. It was dangerous, I mean it remained dangerous for a long time after. What he went through is remarkable. There was very little 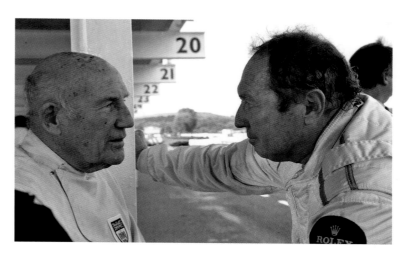 *money to be made so it was a labour of love really and I think Stirling is Stirling - he was a shining light. He came up with some exceptional performances like the Mille Miglia and some Grands Prix he won and so on. Fantastic things, that's what I admired him for - his tremendous strength of character and perseverance.*

A wonderful man, a very friendly character. He's very humorous, that's what I like about him, and I really hope we can see him soon again. He's someone we hold close to our chests. We think about these people and then they're gone and you think 'Damn'.

He's full of jokes, but he's sincere, even in his jokes there's some human aspect that comes through which not everybody immediately realises. I think you sometimes have to experience some things in life that are not always the best, to bring out the best. With Stirling the amazing thing is, it brought out a very, very good person, and that's wonderful."

SIR JACKIE STEWART:

"Stirling Moss has been my hero almost since he started to drive. I remember going to a race as a young lad in the 1950s, where I got Stirling's autograph and he made an immediate impression on me. He was immaculately dressed; his racing overalls beautifully ironed. His autograph, as it remains today, was easily recognisable. His charisma was so intoxicating. I just thought he was the perfect racing driver. Fangio has always been my ultimate hero but Stirling represented the sport in a way that I don't believe any other driver has. He was glamorous, colourful and exciting, and a great ambassador for Britain."

"Moss is invariably summarised as 'the greatest driver never to win the world championship', but in my eyes that diminishes only the worth of the title: I have always thought Stirling the greatest who ever lived."

NIGEL ROEBUCK:

"In May 1961, before dashing to Heathrow for an evening flight to the USA, there to begin testing for the Indianapolis 500, Jack Brabham finished second – a lap behind – to Stirling Moss in the rain-soaked Daily Express International Trophy at Silverstone.

'Second's not too bad,' Brabham quipped. 'I'd be more upset if I'd been beaten by a human…'

Unless you were around at the time, it is impossible to appreciate just how much Moss was motor racing in Britain back then. There were others – notably Tony Brooks – of great ability, but none captured the public imagination like Stirling, and I would venture that none has since.

Moss is invariably summarised as 'the greatest driver never to win the world championship', but in my eyes that diminishes only the worth of the title: I have always thought Stirling the greatest who ever lived.

'If Moss had put reason before passion,' Enzo Ferrari said, 'he would have been world champion many times.' True enough – but then he wouldn't have been Stirling Moss. Part of the attraction of driving, in his later years, for Rob Walker was the frisson of beating the factory teams as a privateer. For all his artistry, he will say that he prided himself primarily as a racer.

On the day of his last accident at Goodwood, he was laps behind after a pit stop, but going flat out because there was still a lap record to be broken, still something to be taken from the day. And still spectators to be entranced, of course.

At his peak – which he was to the end of his career – Stirling's driving was essentially without flaw. Wet or dry, fast circuit or slow, it didn't matter, and it was the same with cars. When John Cooper and then Colin Chapman revolutionised grand prix racing, he effortlessly adapted: in 1956 he won at Monaco in a Maserati 250F, and four years later did it again in a Lotus 18.

Overwhelmingly, Moss personified 'racing driver', blending the grace of Prost with the passion of Senna. There was a purity in the way he went racing, and if he was fortunate in anything, it was that in those simpler times a great driver could compensate for an average car. As well as that, Stirling was also quintessentially a sportsman, a quality highly valued way back when.

If his most fabled victory is probably the Mille Miglia in 1955, Moss was at his very greatest in 1961, his last full season, when he put his virtuosity to work at Monaco and the Nurburgring, archetypal drivers' circuits both, and beat the more powerful Ferraris in Walker's obsolete Lotus-Climax. No one else beat them all season long.

'There really was no one like Stirling,' Rob said to me one day. 'I thought him the perfect racing driver – when he was driving for me, I always felt that anything was possible, because he was so much better than all the others. It wasn't fair, really...'

'Mr Motor Racing' was how Autosport *headlined its report of Monaco '61. That he was, and that for me he will always be.*

On my study wall hangs a framed photograph he gave me of his 250F - with just a touch of opposite lock - at Goodwood in 1954. Above his signature, he wrote, 'To Nigel - a modern Jenks' - as I'm sure you will understand, nothing would ever induce me to part with it."

LORD MARCH:

"Stirling is not only a great friend but he is of course 'Mister Goodwood.' He is what this place is all about. He had his very first race here which he won, of course, and he tragically had his last race here when it all came to an end. Stirling's been a part of this place for jolly nearly 50 years or whatever it is, so we just wish him all the very best."

"Stirling's been a part of this place (Goodwood) for jolly nearly 50 years or whatever it is, so we just wish him all the very best."

An Appreciation by Mark Knopfler OBE

"My little bed was a drifting, sliding, front-engined BRM and I was Stirling Moss, valiantly trying to catch the Cooper of 'Black' Jack Brabham..."

When I was a small boy, long before I learned to fall asleep behind a guitar, I often fell asleep behind a wheel.

The first car in our family was a long time coming, so my steering wheel was taken from my worn out tricycle, the Dunlop rubber blackening my palms. My little bed was a drifting, sliding, front-engined BRM and I was Stirling Moss, valiantly trying to catch the Cooper of 'Black' Jack Brabham, a new and dangerous adversary from the other side of the world with his engine in the other end of his car.

I now know that the race was the 1959 British Grand Prix at Aintree. for a long time I thought that the pale green BRM Type 25 which had so captured my imagination was white, because I'd sat glued to a black and white television set beside my mother as the classic duel played out. I still think the Type 25 is as beautiful as any open-wheel car ever built.

Time went by and other sporting heroes came along for small boys and for small boys who never grow up. Countless thousands of youngsters wished they could be Bobby Charlton, or years later Gary Lineker scoring at Wembley, Jim Clark with his big grin and a victory wreath, or years later, Nigel Mansell battling his way from obscurity to world championship title, then marching off to conquer the daunting ovals of the USA.

You may disagree, but I think after this, motor racing and some other sports too, were starting to become distinctly more cynical and less friendly. I'm talking about the years before championship contenders took to barging each other off the circuit, before soccer referees were sworn at, or even jostled by players. I'm not pretending to know exactly when or where all this started to happen and I'll admit that it is preferable that sportsmen and women are properly paid but whatever the truth, the small boys and girls are always watching and imitating.

Certainly Moss, Fangio, Hawthorn, Collins, Brooks and the rest wanted to be in the best possible car - who wouldn't? They were all true competitors but more importantly the top-flight racing drivers of this period were all, or nearly all, good sports, a term not heard these days as much as it was. I think it has a chance of making a comeback.

Also, no-one should make the mistake of thinking that the skills and powers of concentration of the present generation of drivers are superior. Take a Michael Schumacher devouring the Monaco

circuit, each lap within one or two tenths of a second of his last. Moss was doing precisely this forty odd years ago, holding off a dominant Ferrari team in his outdated Lotus-Climax, each and every one of a hundred laps virtually the same as his fastest, pole-setting time, all the way to victory, despite an enormous power disadvantage. This was his third Monaco win.

Directed with the throttle as much as the steering wheel, a racing car would snake and slither on treaded tyres which would 'let go' far more easily than modern, sticky rubber. Driver safety was simply not an issue. The frequent loss of friends was a part of the sport which must have been very hard to bear and difficult to imagine for those of us in other fields.

I can remember staying up to watch a television play, again in black and white, describing the epic Moss/Jenkinson Mille Miglia victory of 1955. I still find myself reading the late Denis Jenkinson's vivid description of the race in his book A Passion For Motor Sport - a thousand miles of road racing through the Italian countryside, twisting passes, towns and villages at the unbelievable average speed of a whisper under 100 mph. Moss has always been the first to sing the praises of Fangio as the greatest of racing drivers, but will be modest about the fact that he was frequently more than a match for the Argentinian maestro in a sports racing car.

Nowadays more than ever, we are being invited to read about the flaws in the characters or backgrounds of our heroes - details of their depressions, disorders, damage, divorces - the cracks in their armour. Nobody's perfect, it's true. But some of our heroes are there to remind us, especially when we ourselves are involved in our own struggles, that we are supposed to fight adversity and regain our balance.

Sir Stirling Moss has always been that sort of knight - hero, courteous, modest and brave, and an example to small boys everywhere.

Mark Knopfler OBE

Chapter 28
Living the Legend

Joy for 'The Boy' – Reunited With His Favourite Cars

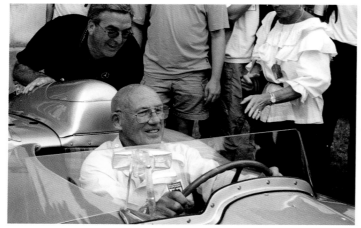

Old flame – the Mille Miglia winning Merc

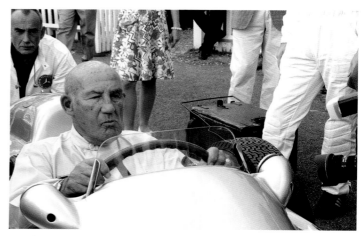

Recalling his first Grand Prix win, in this car?

Aston DBR1

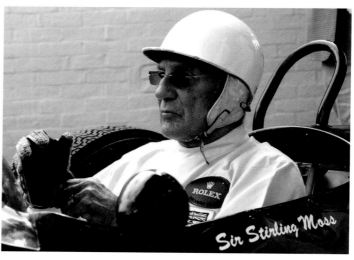

Ferguson-Climax

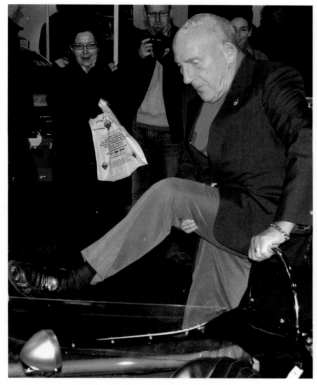

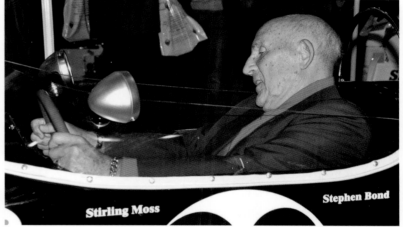

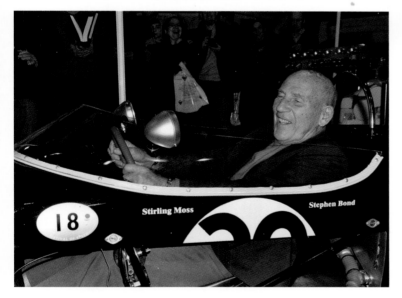

"My Monaco winning Lotus. If you look up and see what my pole time was, and you multiply that by one hundred (for the 100 lap race) the race would come out only 42 seconds longer! To me, that was probably the best achievement I ever did."

What Makes a Legend?

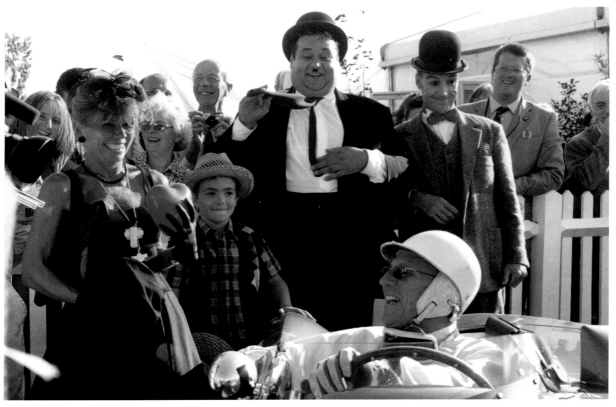

"They're very good, that couple, aren't they? It's all to do with Charles' vision"

They say you should never meet your heroes, for you will always be disappointed. Stirling Moss obviously disagrees, enjoying the company of "Stan and Ollie", two of history's most infamous clowns.

Speaking of clowns, I once wrote a seven word tribute (in honour of Stirling's favourite racing number) after watching him open a letter from someone who professed to be 'a great fan', but who had managed to misspell his name on the envelope:

'Sterling by name and Stirling by nature.'

Whatever my expectations, the man described by the publishers of Robert Edwards' fine biography as 'The First Sporting Icon' has far outgrown them. Back in 1998 I could never have dreamed that my labour of love would capture the imagination of its main protagonist. Yet because of his support and input, and Susie's too, you are reading this, and my 57-year photographic journey has been showcased. I'm still letting that sink in.

Murray Walker once said, 'There are no sides to Stirling.' What you see is what you get, 'warts and all' as Stirling himself puts it. In his company, sharing jokes you would never tell your mother, it is easy to forget the peerless legacy, the life-threatening accidents, a life spent under the magnifying glass of public scrutiny, not to mention half a century of worldwide respect and affection. Every so often I remember, pause, and wonder: Which has been the greater privilege or pleasure - meeting the legend or meeting the man?

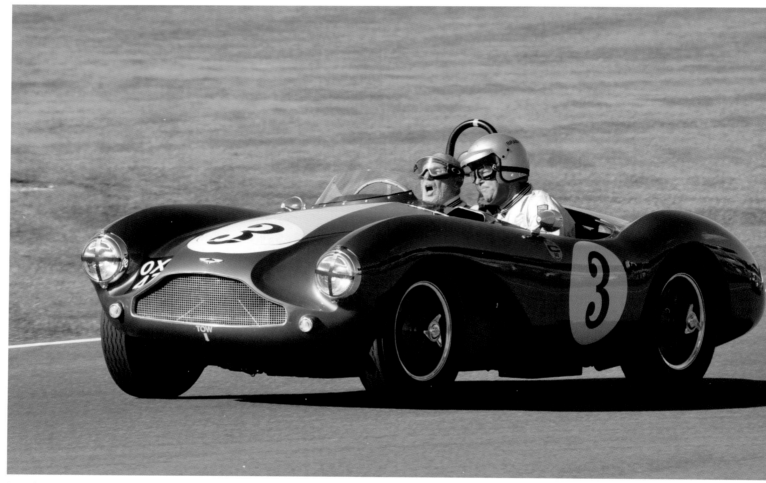

Last time out. Stirling's swansong at Goodwood, and he does look like he's having a bit of a yodel. I once asked him if he could sing. He replied: "No old boy, I'm tone dead!"

For me, Stirling's insights regarding his own mentor Juan Manuel Fangio define both the legend and the man. He told me that he had learned a lot from Fangio, but most of all he hoped that he'd learned humility.

'All the time I was racing there was always someone to shoot at. Outside of Fangio I reckon I could beat anyone. I think I was probably the most versatile driver of my era. I respected Fangio because he was such a great person, apart from his driving ability. I could certainly beat him in sports cars. In Formula One I was very happy to learn from being second to him, the man that I thought of as God.'

Susie sheds light on this. She points out that whereas Stirling would "never sign as number two to anyone except Fangio", Stirling very much wanted to beat him, as illustrated by their duel for pole position at Monaco. It was escalating nicely and both were enjoying it, until the team put a stop to it… and exiting the last corner at Aintree with Fangio behind, he did keep his foot hard down to take his first win! However, he was grateful to be racing in the same Mercedes team, and to honour

his place as number two. He was there primarily to learn from the man he so respected. His being glued to Fangio's tail for much of the season did alarm team boss Neubauer who expressed concern. "What if Fangio makes a mistake?" he said. Stirling replied: "Fangio doesn't make mistakes."

Honour. Of paramount importance to a man with nothing to prove - a true sportsman who lost the 1958 world championship because he stuck up for his rival Mike Hawthorn. Mike had been disqualified for driving in the wrong direction on the track after spinning off the Oporto street circuit. Stirling witnessed the incident and testified to the stewards that, no, Mike push-started himself on the pavement, not the road. Thus Mike's disqualification was reversed and he beat Stirling to the championship by one point. Did Stirling care? No. He knew that according to his own personal ethic he had done the right thing. For me, that legendary anecdote sums up the person I've come to know. Had he been other than a racing driver, a comedian for instance, he'd still be cutting edge, and giving it 'All But My Life.'

Did Stirling care? No. He knew that according to his own personal ethic he had done the right thing.

I was talking about all this with Bob, a musician friend who shares my admiration for both Stirling and Mark Knopfler. He said, 'Let's begin with the premise that we're all born ordinary human beings, but some of us get to do extraordinary things.' Or as Bob Marley put it 'the biggest man was a baby one time…'

Legends don't seem to like pedestals. To me they often look uncomfortable up there. Like the rest of us they prefer *ER* to *EastEnders*, wine to whisky or vice versa, and the open road to a traffic jam.

So what makes a legend? Is it the statistics - the tally of race wins or the 120 million albums sold? Is it the skills, the awards, the accolades, the household name, the odd scandal, the wealth; the presence and profile on mainstream or social media? Or is it that despite all that stuff, despite having everything the world can throw at them, legends are still in love with what they do, and still display that same enthusiasm felt by a teenage Stirling Moss when he first sat in a racing car, or by Mark Knopfler when Dire Straits first played the Hope and Anchor in Islington? It's a timeless and endearing quality, an achievement in itself, and one I've been blessed to witness.

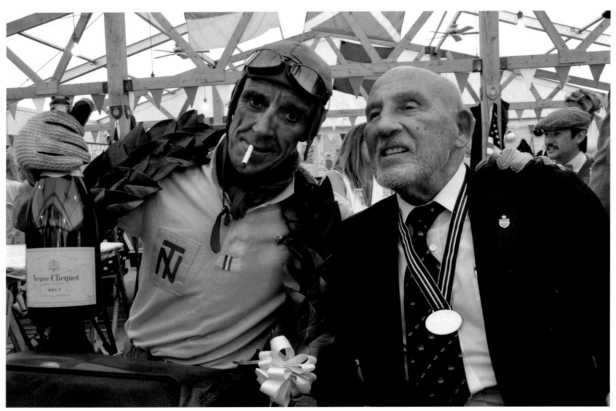

The Goodwood Revival, where legends come together. Moss and Nuvolari finally meet

I was alone, except perhaps for my younger sister
who was there the day my love of motor racing
was born, racing me on the Scalextric.

Maybe the true purpose of a champion is not to occupy a pedestal, but to provide a mirror with a message: 'Like you I was born an ordinary human being. What you admire about me is simply what I have made of my time and talent. So, be the best that you can be whatever that means to you. And despite all obstacles, don't be a victim! Be your own champion! And one more thing: don't be distracted by the pursuit of fame.'

If I have picked up anything from Stirling, it is to never give up on what matters, be it a song, an audience, or a friend in need; to take life seriously lightheartedly; to use my time wisely, kindly, and not waste a moment, because time is all I've got. Again, "movement is tranquillity…"

We were chatting over a glass of something fine. Stirling was curious about my background. I responded by asking him, 'Do you think you'd have been Stirling Moss without your father to support you, guide you, fettle your car etcetera?' He pondered this for a moment and replied: 'I never thought of that. I really don't know. Why do you ask?' I summed up my story: A father who left and moved to Switzerland when I was six; a distant mother who sent me to a boarding school three miles from home when I was eight; a headmaster who beat the crap out of me on the flimsiest of pretexts. Nobody knew. I had no-one to fight my corner. I was alone, except perhaps for my younger sister who was there the day my love of motor racing was born, racing me on the Scalextric. I told him my life had been a comeback from that.

Stirling was silent for a moment, mulling over my words. He said quietly:

"I'm amazed you're as sane as you are."

His response made me feel like Jenson Button in that wild Canadian Grand Prix, when he fought back from last place to first, pressuring Vettel into a mistake to take the lead on that last slippery lap. How can you lose with 'Mr Motor Racing', 'The Maestro', 'Sir Goodwood', 'The Greatest Driver Never To Win The World Championship', Mr Indestructible', 'The Boy' etc. on your side?

Perhaps that same 'underdog ethic' which drove him to find glory with a privateer team inspired him to give this unknown chap with no press pass a chance. Who knows? I've often noticed his inclination to encourage others - just one of many aspects that make him who he is. I'm not trying to make him out to be some kind of saint. He knows who he is. He once admitted to me his impulsive nature, and how difficult that can be for Susie. But then, he's a racing driver, and if you have to think about something (we both blurted out simultaneously) "it's too late!"

His natural talent, and his pursuit of excellence made him an exceptional, exemplary, world class sportsman. He set standards that apply to all walks of life. I reckon his greatest gift to the world is an enthusiasm that has remained strong and infectious even into his 80s. It has certainly infected me, and I'm all the better for it. I raise a dram of something he would never touch (a rare Glen Spey 21-year-old) to a true champion, and toast the fact that he made me feel like one.

He and Susie have come to watch me play a few times. The first time, we were playing way past his bedtime, so they came to the stage to say goodnight. I will never forget the Jamaican twang of my Rastafarian drummer Prince, whose dreadlocks are longer than he is, joyfully chiming through the PA system: "Stirling Moss in tha house!" He liked that. Nor will I forget his cheeky grin, watching us play in the Goodwood paddock at the XK Festival. It was a tune called "Stop The Startwatch", inspired

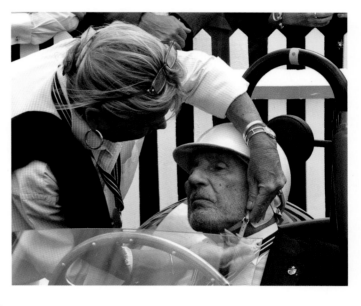

by "Murray misquotes". Afterwards he mischievously admitted that he had just told Murray about it. Murray took it all in good humour of course, coming from the man he greets as 'Maestro'. But he did ask me to warn him should we decide to play it in our next set, so that he could hide…

These people are a rare and different breed. To have spent quality time with Stirling and co. is a priceless treasure that will stay with me for the rest of my days. To me they represent all that is true in human nature - passion, courage, integrity, humility, and above all, humour. May these legends and their qualities live long beyond their time on Earth. May they inspire future generations, just as Stirling inspires young drivers to this day.

My story could have happened to any one of the thousands who came to the Goodwood Revival with a camera, but serendipity chose me. I'm a lucky boy, I know. I began this book by saying: 'Every picture tells a story, but what about the story behind the picture?' Well, here it is - a saga so incredible I can barely believe it myself.

Good job I had a camera.

Ciao, Ciao.

"My story could have happened to any one of the thousands who came to the Goodwood Revival with a camera, but serendipity chose me. I'm a lucky boy, I know."

Acknowledgements

With deep appreciation for my Mum and Jimmy Sanders who took me to Goodwood on Easter Monday 1962, and huge gratitude to all who participated in, and contributed so generously to this book; a few old friends, some no longer with us, and many new ones, most of you giving your precious time to a virtual stranger:

Dizzy Addicott; BARC photographer Ted Lewis; Eric Thompson; Sir John Whitmore; John Surtees, Bette Hill, Mark Knopfler OBE; Ray Bellm; John Dabbs; Derek Bell; Philip Porter; Alain De Cadenet; Barrie Williams; Murray Walker OBE; Bobby Rahal; David Coulthard; Tiff Needell; Nick Mason; Tony Smith; Justin Law; Suzie "Marilyn Monroe" Kennedy; Canon Lionel Webber; Charles Shields; Jackie Oliver; Emanuele Pirro; Stuart Graham; Richard Attwood; Brian Redman; Jo Ramirez; Simon Taylor; Jay Leno; Mark Webber; Anthony Reid; Doug Nye; Jochen Mass; Sir Jackie Stewart; Nigel Roebuck; Martin Ditcham; Pete Shaw; Keith Beauvais and Alan Dublon for the loan of cameras; Robert Burch; Keith Ongley for the gift of a second Pentax Spotmatic after the first one died; Leigh Jones for his encouragement and creative input, and for making the famous Jag "BUY 1" available for my promo video; Martin Goodsmith for filming and editing; Herbert Reiss for forwarding my letter of introduction to Sir Stirling Moss; Jason Jenner, Lance Ellington, and *Octane*'s James Elliott for setting up links with crucial contributors; Darren Smith for facilitating so many photo-ops; Simon Appleby for the webpage; Lord March for creating the context for my extended second childhood; Red Door for opening the publishing door and inspiring me to "get it together"; and ultimately to Pitch Publishing and the Camillins for being brave enough to take a punt; designer Duncan Olner for his patience, professionalism, and a damn good job; my agent Tom Cull for persisting and persuading 'til he landed the deal; my sister Kit for artistic input; sister Fiz for believing in this; my long-suffering wife Lucie and our children Jemima and Oliver for humouring me on all those trips to Goodwood, and during my months of cranky reclusiveness whilst stumbling towards the deadline; and above all to Sir Stirling and Lady Susie Moss for their unfailing support, hospitality and enthusiasm in championing my dream, and for being the catalyst and inspiration for many others' involvement. Lastly, my apologies to anyone I may have missed out, and those I never got to meet, whom I know would have been keen to offer a few words, especially on 'Mister Motor Racing'.

www.timhain.com
www.lapofhonour.co.uk

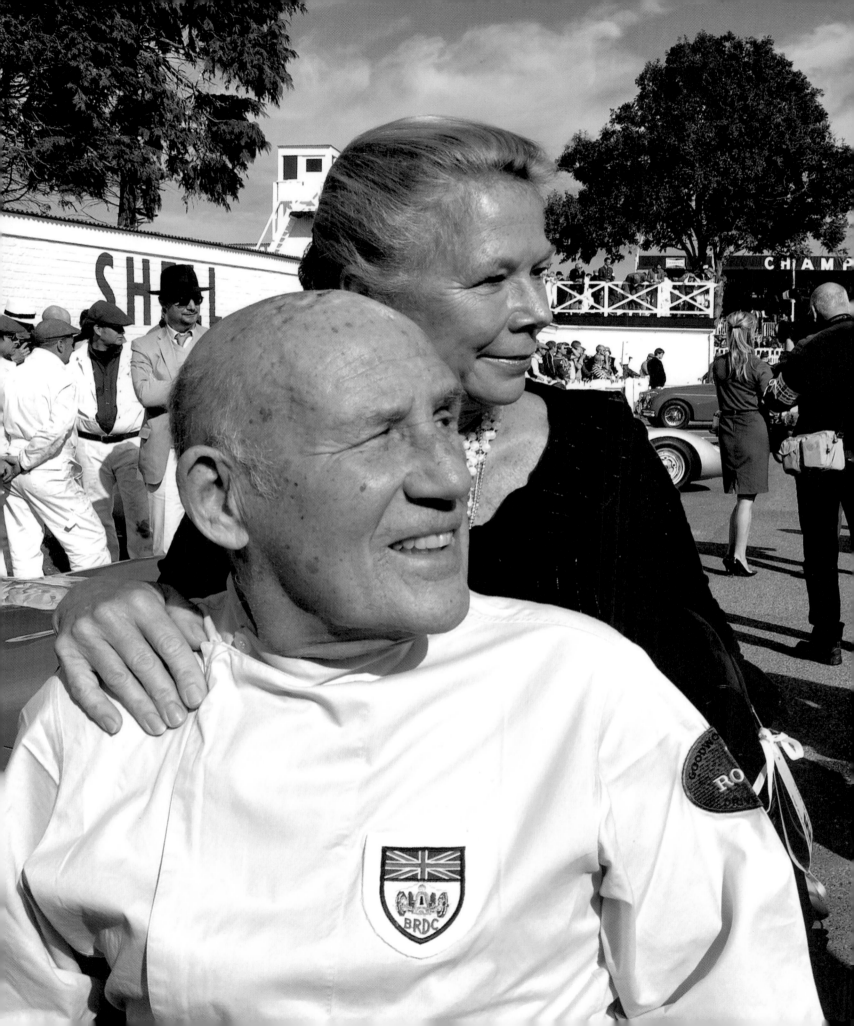